Portugal

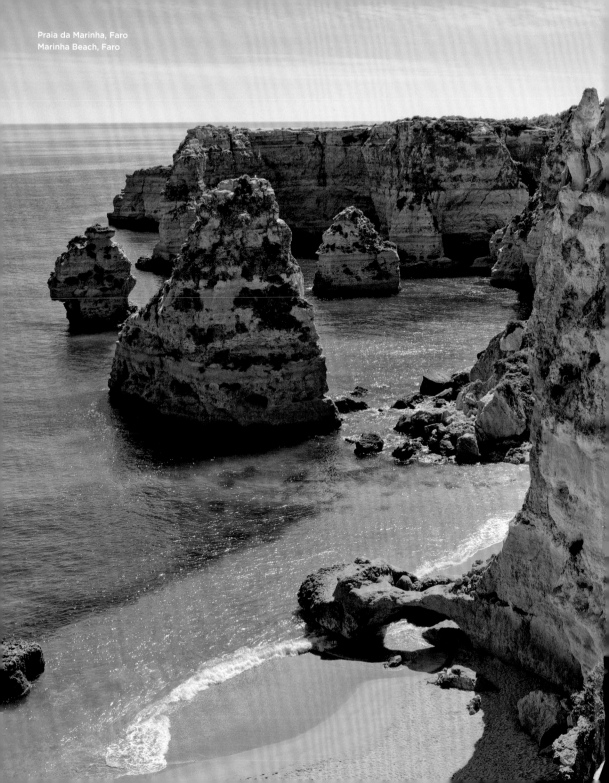

Praia da Marinha, Faro
Marinha Beach, Faro

Portugal

Susanne Mack
Ralf Johnen

IMENSE

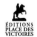

ÉDITIONS
PLACE DES
VICTOIRES

KÖNEMANN

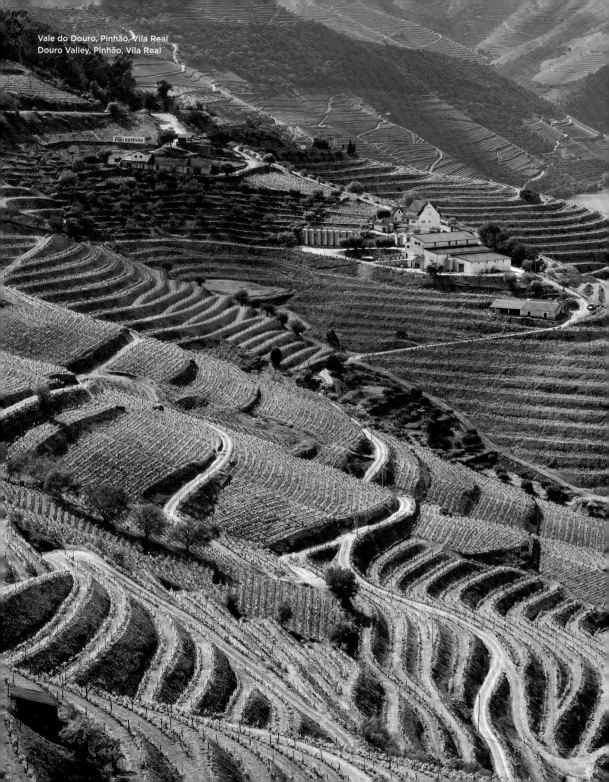

Vale do Douro, Pinhão, Vila Real
Douro Valley, Pinhão, Vila Real

FREI ESTÉVÃO

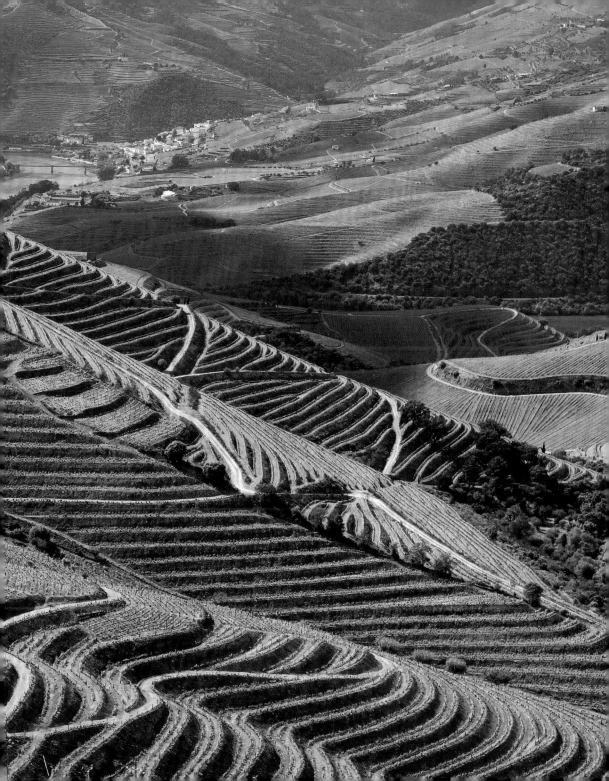

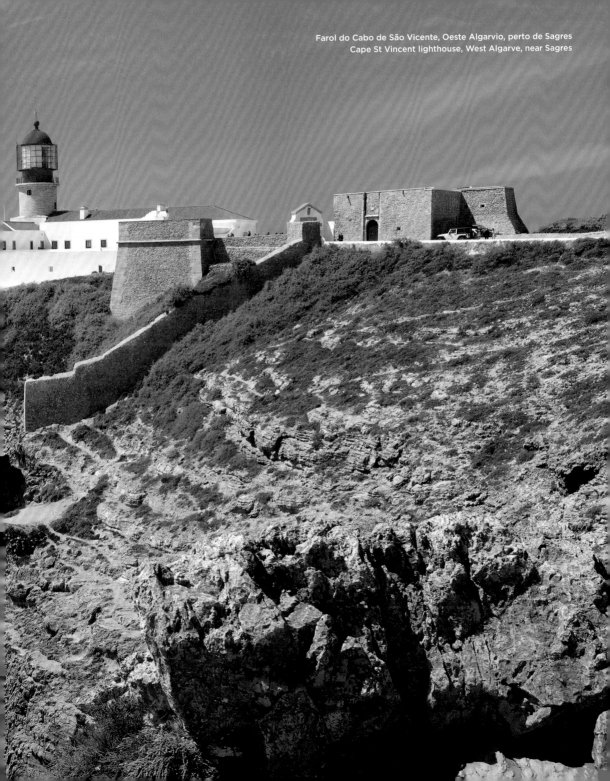

Farol do Cabo de São Vicente, Oeste Algarvio, perto de Sagres
Cape St Vincent lighthouse, West Algarve, near Sagres

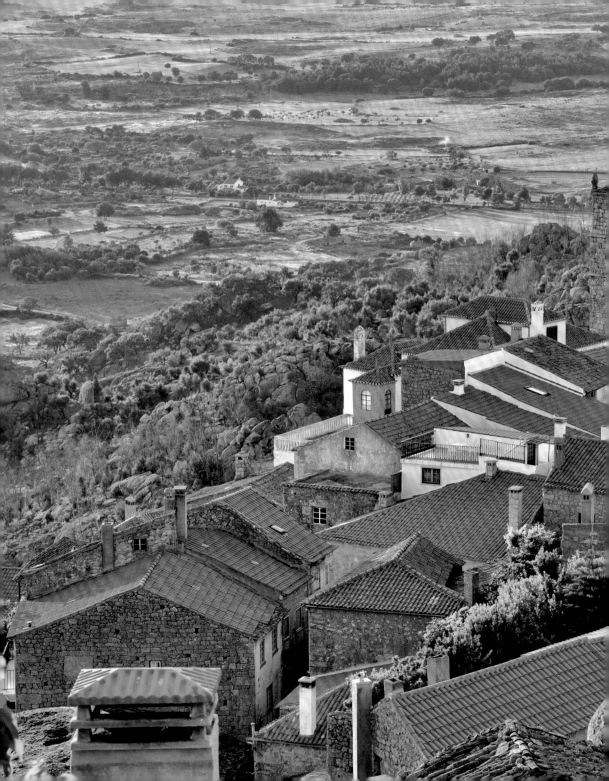

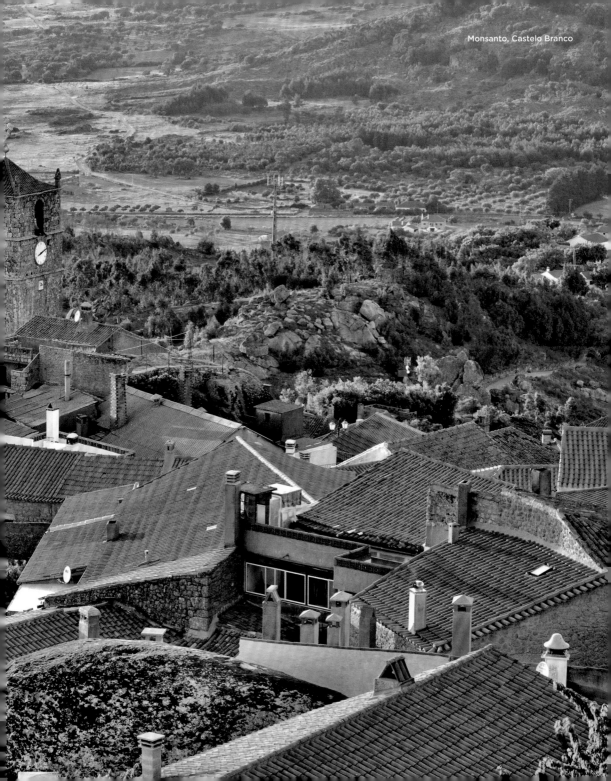

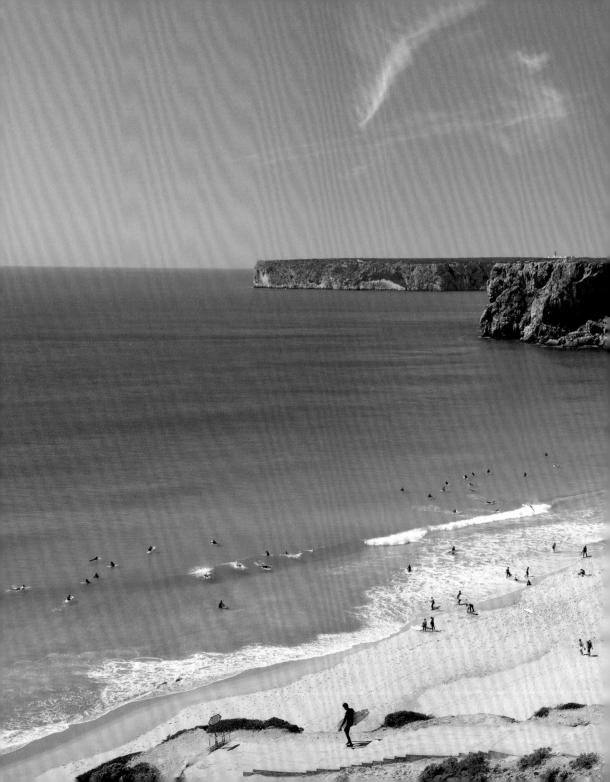

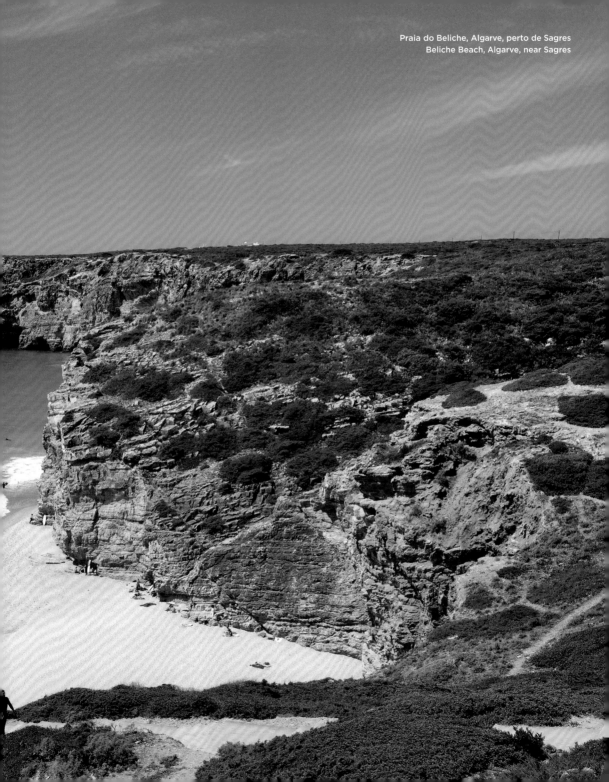

Praia do Beliche, Algarve, perto de Sagres
Beliche Beach, Algarve, near Sagres

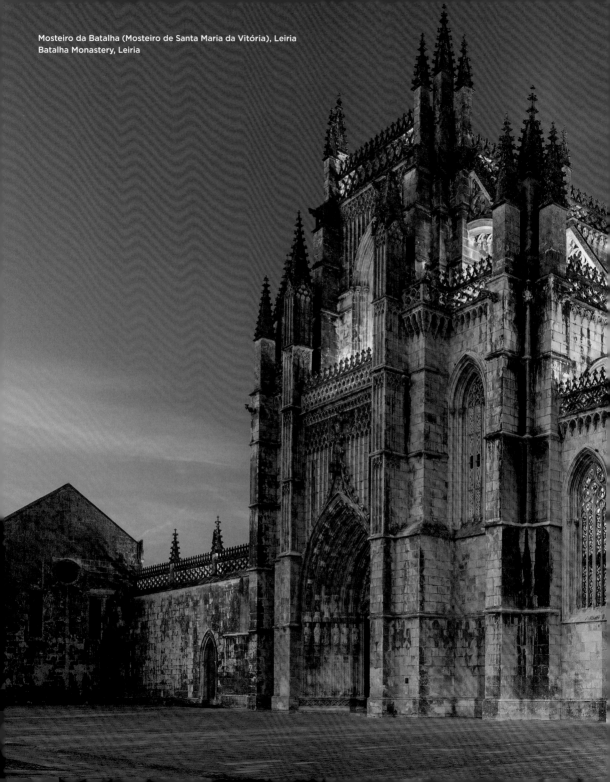
Mosteiro da Batalha (Mosteiro de Santa Maria da Vitória), Leiria
Batalha Monastery, Leiria

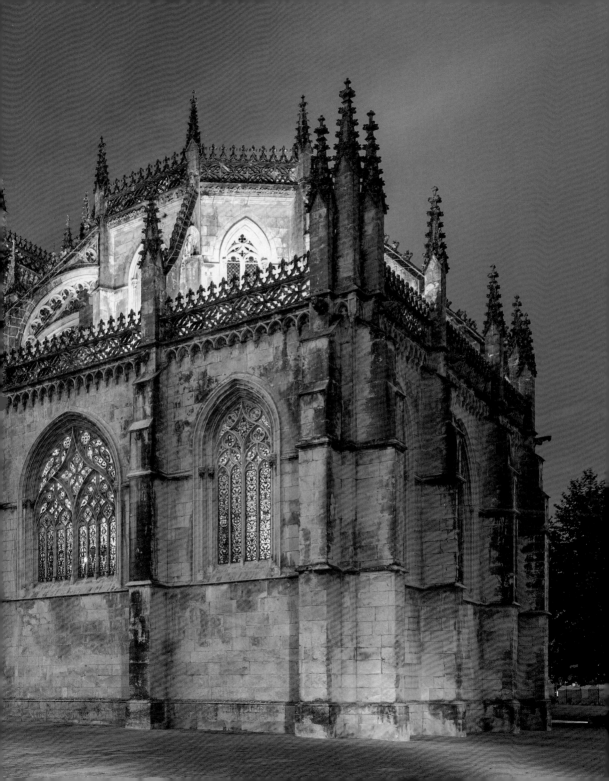

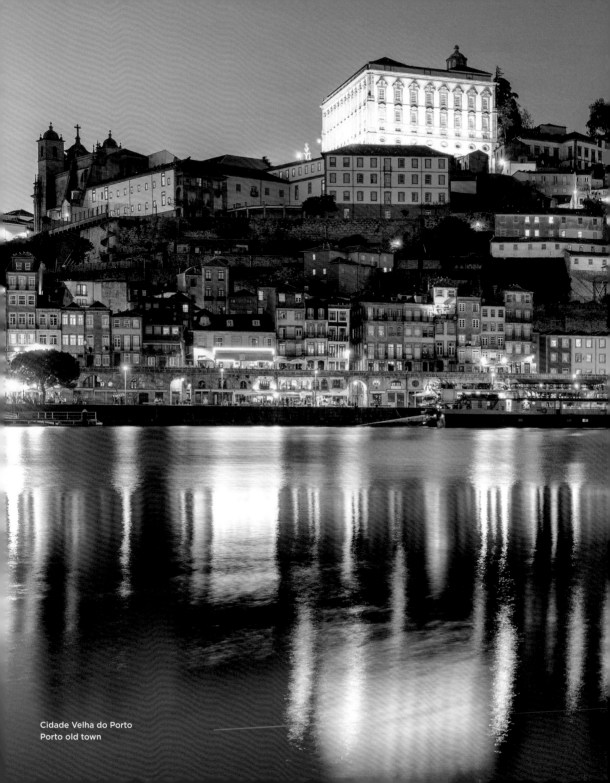

Cidade Velha do Porto
Porto old town

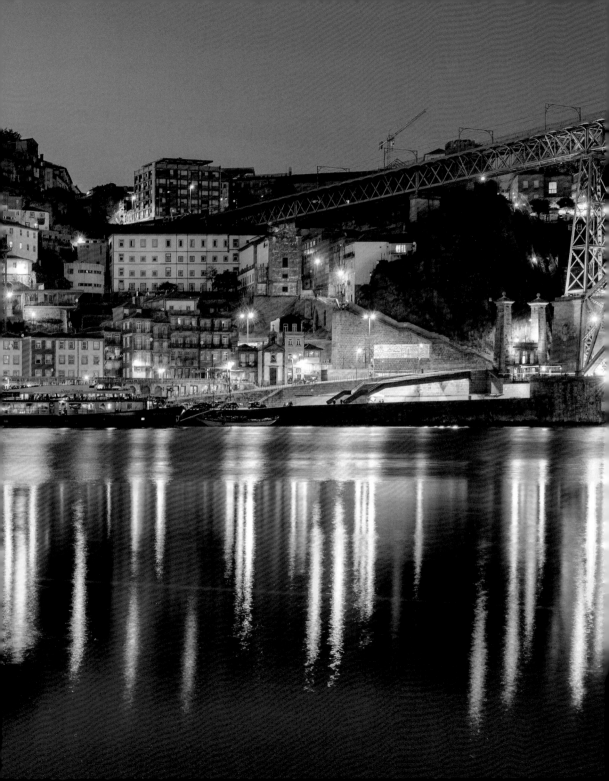

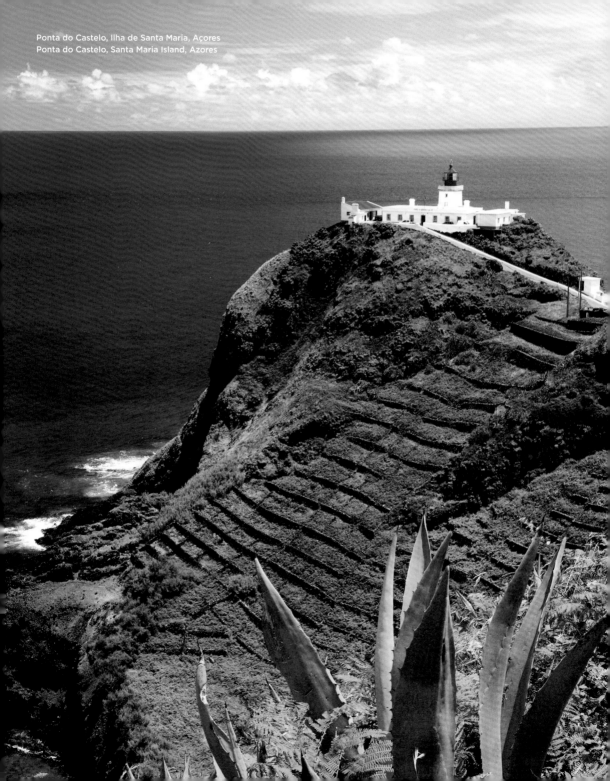

Ponta do Castelo, Ilha de Santa Maria, Açores
Ponta do Castelo, Santa Maria Island, Azores

Contents · Sommaire · Inhalt · Índice · Indice · Inhoud

Portugal

Fissured cliffs, with inviting bays and bizarre rock formations characterize the face of Portugal in the Algarve. On the west coast these merge into landscapes dominated by dunes, often featuring wide sandy beaches, and where the surf of the temperamental Atlantic Ocean guarantees a spectacular show. The Alentejo is much gentler, with its hilltops dominated by ancient villages of whitewashed houses. In the centre of the country, the proud city of Lisbon sets the tone. The venerable capital combines majestic squares, sublime city palaces and bold funiculars with the melancholy of *fado* music and the modernity of a metropolis.

Further north, following a dramatic journey through terraced vineyards, Portugal's most important river flows into the Atlantic: the Douro. At the river's mouth sits Porto, the eternal rival of the capital. The country's second largest city is colourful, lively and pleasure-loving, spoiling its visitors with port wine, fresh fish and relaxed seaside resorts. To the north is the land of the famous Vinho Verde, but the borderland to Galicia can also charm, with enchanting towns such as Viana do Castelo or Braga. Roman settlements such as Ponte de Lima, along with the rugged mountains of the Peneda-Gerês National Park further increase the diversity. What remains are the islands in the Atlantic: the 'flower island' of Madeira and, in the middle of the ocean, the enigmatic Azores. Great material for a voyage of discovery in pictures.

Portugal

Les falaises escarpées, les baies accueillantes et les formations rocheuses étonnantes sont emblématiques de la région portugaise de l'Algarve. Sur la côte ouest, elles se fondent dans des paysages de dunes aux vastes plages de sable, où le ressac de l'océan Atlantique constitue un véritable spectacle. L'Alentejo est beaucoup plus doux, avec ses sommets de collines dominés par d'anciens villages aux maisons blanchies à la chaux. Au centre du pays, la fière Lisbonne donne le ton. La capitale séculaire associe des places majestueuses, hôtels particuliers sublimes et des funiculaires audacieux à la mélancolie du fado et la modernité d'une métropole.

Plus au nord, après un voyage spectaculaire à travers les vignobles en terrasses, le fleuve le plus important du Portugal, le Douro, se jette dans l'Atlantique. Ici, se dresse Porto, l'éternelle rivale de la capitale. La deuxième plus grande ville du pays est colorée, vivante et agréable, gâtant les visiteurs avec du vin de Porto, du poisson frais et ses stations balnéaires paisibles. Le nord est la terre du célèbre Vinho Verde, mais la frontière avec la Galice séduit également grâce à des villes charmantes comme Viana do Castelo ou Braga. Les architectures romaines telles que celles de Ponte de Lima et les montagnes accidentées du Parque Nacional Peneda-Gerês ajoutent encore à la diversité du pays. Les îles de l'Atlantique complètent ce paysage : l'île aux fleurs de Madère et – au milieu de l'océan – les insondables Açores. Le cadre idéal pour un voyage aux photos inoubliables.

Portugal

Zerklüftete Steilküsten mit einladenden Badebuchten und bizarren Gesteinsformationen prägen das Antlitz Portugals an der Algarve. An der Westküste gehen diese in Dünenlandschaften mit oft breiten Sandstränden über, wo die Brandung des launischen Atlantiks ein Garant für Spektakel ist. Deutlich sanfter gibt sich der Alentejo, auf dessen Hügelkuppen altertümliche Dörfer mit weiß getünchten Häusern thronen. In der Landesmitte gibt das stolze Lissabon den Ton an. Die altehrwürdige Kapitale vereint majestätische Plätze, erhabene Stadtpaläste und kühne Standseilbahnen mit der Melancholie des Fado und der Modernität einer Metropole.

Weiter im Norden mündet nach einer dramatischen Reise durch terrassierte Weinberge Portugals wichtigster Fluss in den Atlantik: der Douro. Hier baut sich in Gestalt von Porto der ewige Rivale der Hauptstadt auf. Farbenfroh, lebendig und genussfreudig gibt sich die zweitgrößte Stadt des Landes, die Besucher mit Portwein, frischem Fisch und entspannten Seebädern verwöhnt. Der Norden ist der Landstrich des berühmten Vinho Verde, doch das Grenzland zu Galizien vermag auch mit entzückenden Städtchen wie Viana do Castelo oder Braga zu bezaubern. Römische Siedlungen wie Ponte de Lima und das schroffe Bergland des Parque Nacional Peneda-Gerês steigern die Vielfalt weiter. Blieben noch die im Atlantik gelegenen Inseln: das Blumeneiland Madeira und – mitten im Ozean – die unergründlichen Azoren. Grandioser Stoff für eine Entdeckungsreise mit vielen Bildern.

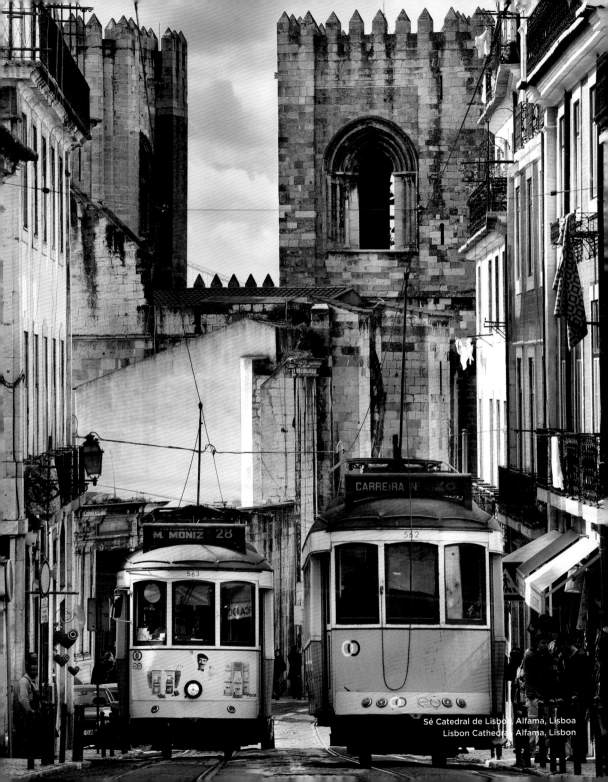

Sé Catedral de Lisboa, Alfama, Lisboa
Lisbon Cathedral, Alfama, Lisbon

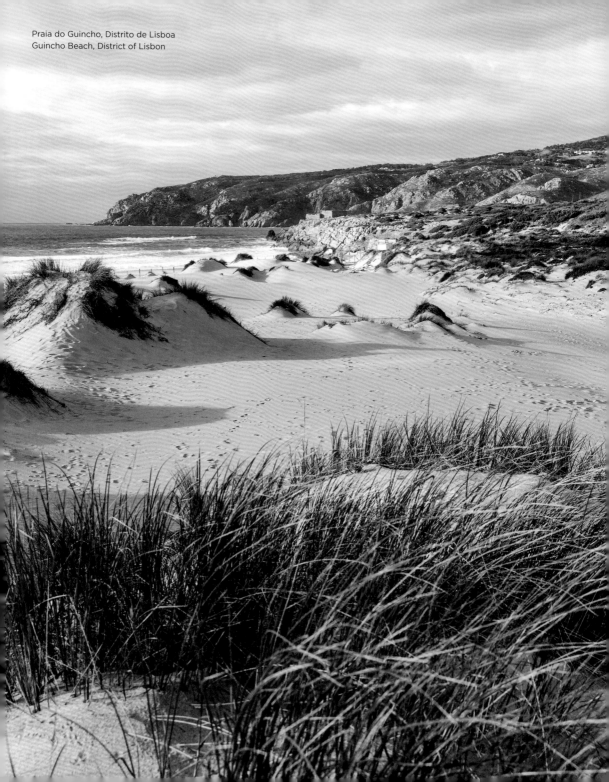

Praia do Guincho, Distrito de Lisboa
Guincho Beach, District of Lisbon

Portugal

Los acantilados escarpados con bahías acogedoras y extrañas formaciones rocosas son característicos del semblante de Portugal en el Algarve. Estos se funden en la costa oeste en paisajes de dunas con playas de arena a menudo de gran amplitud, donde el oleaje del caprichoso océano Atlántico es garantía de espectáculo. El paisaje del Alentejo es mucho más suave; sus cimas están coronadas por antiguos pueblos con casas encaladas. En el centro del país, destaca Lisboa, orgullosa. La venerable capital combina plazas majestuosas, palacios sublimes e intrépidos funiculares con la melancolía del fado y la modernidad de una metrópoli.

Más al norte, después de un dramático viaje a través de viñedos en terrazas, desemboca en el Atlántico el río más importante de Portugal: el Duero. Aquí se construye el eterno rival de la capital en forma de Oporto. La segunda ciudad más grande del país es colorida, animada y divertida, y mima a sus visitantes con vino de Oporto, pescado fresco y relajantes zonas costeras. El norte es la tierra del famoso Vinho Verde, pero la zona fronteriza con Galicia también fascina con pueblos encantadores, como Viana do Castelo o Braga. Los asentamientos romanos, como Ponte de Lima, y las abruptas montañas del Parque Nacional Peneda-Gerês aumentan aún más la diversidad. Lo que quedaban eran las islas del Atlántico: la isla de las flores de Madeira y, en medio del océano, las insondables Azores. Gran material para un viaje de descubrimiento con muchas fotos.

Portogallo

Scogliere frastagliate con baie ammalianti e singolari formazioni rocciose caratterizzano l'aspetto dell'Algarve in Portogallo. Sulla costa occidentale si fondono poi nei paesaggi con le dune e spesso con ampie spiagge sabbiose, dove i frangenti del capriccioso Oceano Atlantico regalano sempre uno spettacolo. L'Alentejo è molto più placido, con le sue colline dominate da antichi villaggi con case imbiancate. Nel centro del paese, l'orgogliosa Lisbona la fa da padrona. L'antica capitale armonizza maestose piazze, sublimi palazzi e ardite funicolari con la malinconia del fado e la modernità di una metropoli.

Più a nord, nell'Atlantico, dopo un viaggio emozionante tra vigneti terrazzati, sfocia il fiume più importante del Portogallo: il Duero. Qui, si erge l'eterna rivale della capitale, Porto. La seconda città più grande del paese è colorata, vivace e deliziosa, vizia i visitatori con vino, pesce fresco e rilassanti località balneari. Il nord è la terra del famoso Vinho Verde, ma il confine con la Galizia affascina anche con città come Viana do Castelo o Braga. Gli insediamenti romani come il Ponte de Lima e le aspre montagne del Parque Nacional Peneda-Gerês ne aumentano ulteriormente la diversità. Restano le isole dell'Atlantico: l'isola fiorita di Madeira e, nel mezzo dell'oceano, le insondabili Azzorre. Un viaggio d'esplorazione con ricche vedute.

Portugal

Steile kusten met diepe kloven, uitnodigende baaien en bizarre rotsformaties bepalen de aanblik van Portugal in de Algarve. Aan de westkust gaan deze over in duinlandschappen met vaak brede zandstranden, waar de branding van de grillige Atlantische Oceaan garant staat voor spektakel. Duidelijk lieflijker is Alentejo, waar op de heuveltoppen oude dorpjes met witgekalkte huizen tronen. In het midden van het land zet het trotse Lissabon de toon. De eerbiedwekkende hoofdstad verenigt majestueuze pleinen, luisterrijke stadspaleizen en gewaagde kabelspoorwegen met de melancholie van de fado en de moderniteit van een metropool.

Verder naar het noorden, na een dramatische reis door terrasvormig aangelegde wijngaarden, mondt de belangrijkste rivier van Portugal uit in de Atlantische Oceaan: de Douro. Hier stelt de eeuwige rivaal van de hoofdstad zich op in de vorm van Porto. De op één na grootste stad van het land is kleurrijk, levendig en gezellig, en verwent bezoekers met port, verse vis en ontspannen badplaatsen. Het noorden is de landstreek van de beroemde *vinho verde,* maar het grensgebied met Galicië kan ook betoveren met charmante steden als Viana do Castelo en Braga. Romeinse nederzettingen zoals Ponte de Lima en de kale bergen van het Parque Nacional Peneda-Gerês vergroten de diversiteit nog verder. Wat rest zijn de eilanden in de Atlantische Oceaan: het bloemeneiland Madeira en – midden in de oceaan – de ondoorgrondelijke Azoren. Geweldig materiaal voor een ontdekkingsreis met veel foto's.

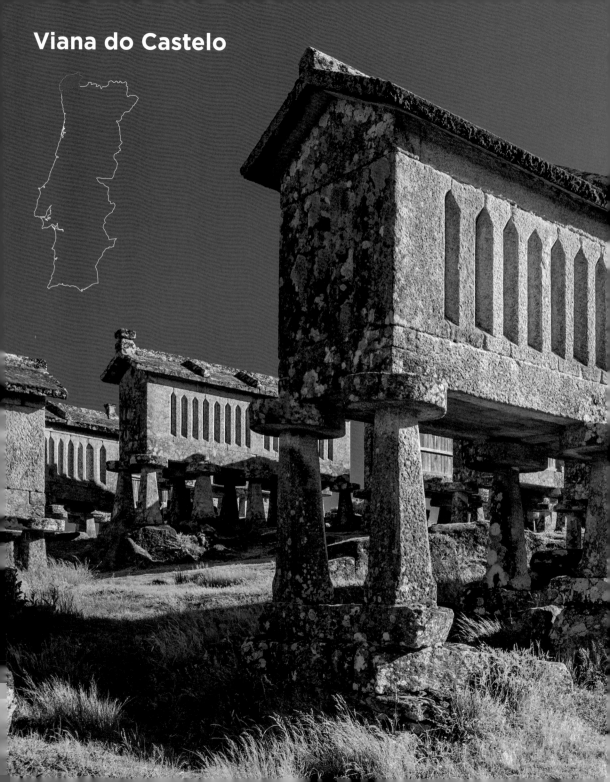

Viana do Castelo

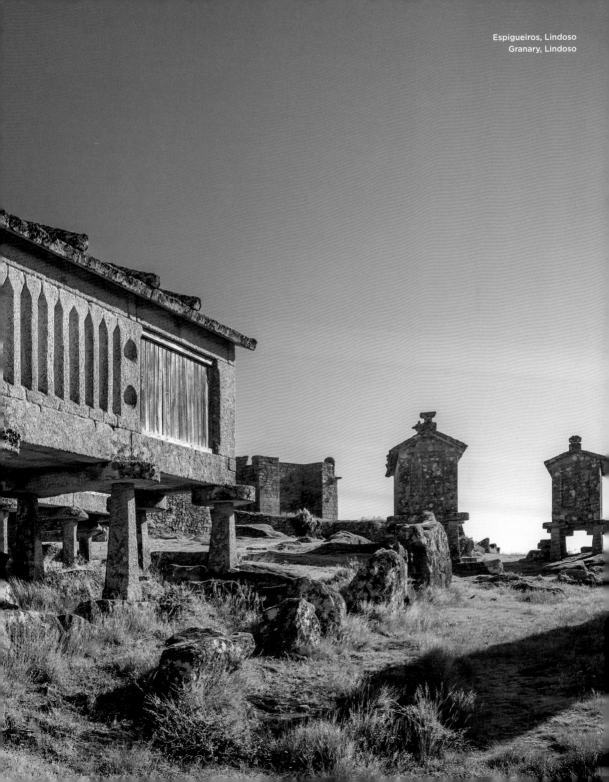

Espigueiros, Lindoso
Granary, Lindoso

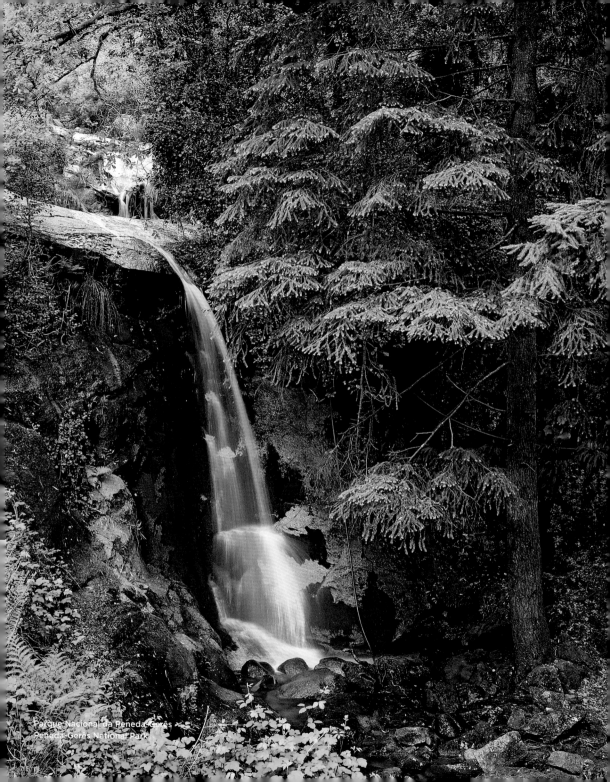

Parque Nacional da Peneda-Gerês
Peneda-Gerês National Park

Praia de Moledo
Moledo Beach

Viana do Castelo
High above Viana do Castelo sits the basilica of Santa Luzia. Below, the port city of the north can look back over a long maritime history. It is here where the river Lima, which originates in Galicia, flows out into the Atlantic Ocean, having made its way through the steeply terraced hills of the Peneda-Gerês National Park.

Viana do Castelo
Sur les hauteurs de Viana do Castelo se dresse le sanctuaire de Santa Luzia. La ville portuaire du nord a une longue histoire maritime : la rivière Lima, qui prend sa source en Galice, se jette ici dans l'océan Atlantique. Auparavant, elle aura traversé le parc national de Peneda-Gerê, dont les montagnes escarpées sont utilisées pour la culture en terrasses.

Viana do Castelo
Hoch über Viana do Castelo thront die Wallfahrtskirche Santa Luzia. Die Hafenstadt des Nordens blickt auf eine lange Historie in der Seefahrt zurück. Hier mündet der Fluss Lima in den Atlantik, der in Galizien entspringt. Von dort bahnt er sich seinen Weg durch den Nationalpark Peneda-Gerês, dessen steile Berge durch Terrassenbau kultiviert werden.

Viana do Castelo
En lo alto de Viana do Castelo se encuentra el santuario de Santa Luzia. La ciudad portuaria del norte tiene una larga historia marítima. Aquí el río Lima desemboca en el océano Atlántico, que nace en Galicia, desde donde atraviesa el Parque Nacional Peneda-Gerês, cuyas escarpadas montañas se cultivan en terrazas.

Viana do Castelo
Sopra Viana do Castelo, si trova il santuario di Santa Luzia. La città portuale del nord può ha una lunga storia marittima. Qui il fiume Lima sfocia nell'Oceano Atlantico, che ha origine in Galizia. Da lì si fa strada attraverso il Parco Nazionale Peneda-Gerês, le cui ripide montagne sono coltivate con terrazzamenti.

Viana do Castelo
Hoog boven Viana do Castelo staat de bedevaartkerk Santa Luzia. De havenstad van het noorden kan terugkijken op een lange maritieme geschiedenis. Hier mondt de rivier de Lima, die zijn bron heeft in Galicië, uit in de Atlantische Oceaan. Vanuit Galicië baant hij zich een weg door het nationale park Peneda-Gerês, waarvan de steile bergen gecultiveerd zijn door de aanleg van terrassen.

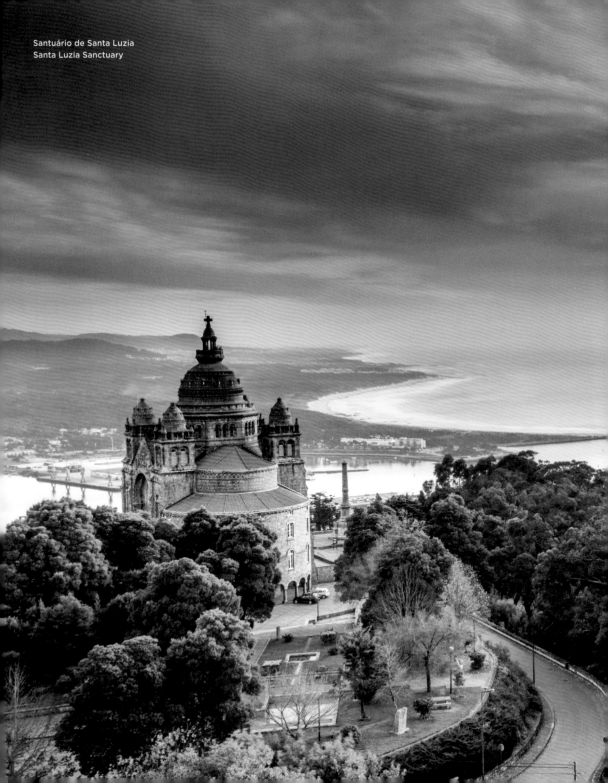

Santuário de Santa Luzia
Santa Luzia Sanctuary

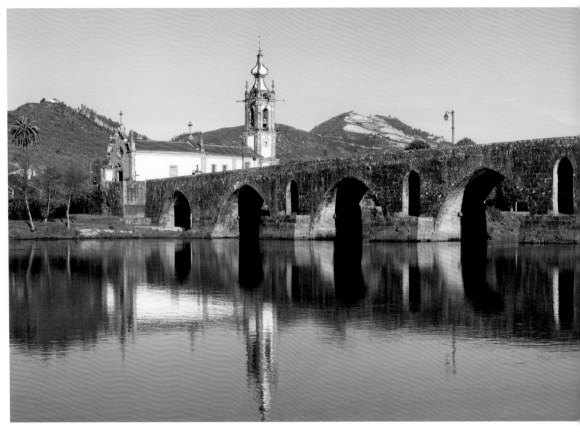

Ponte de Lima

Ponte de Lima

In its lower reaches the Lima swells to a mighty stream. The Romans managed to bridge the flow, and the settlement of Ponte de Lima originates from this time. It has been a town since 1125, and today the river banks are flanked by inviting cycling and hiking trails. Every second Monday it is the venue of the largest market in the region.

Ponte de Lima

À l'intérieur des terres, le courant du Lima est plus fort. Les Romains, déjà, avaient réussi à la traverser, donnant naissance au village de Ponte de Lima, devenue une ville en 1125. Aujourd'hui, les berges sont bordées de pistes cyclables et de sentiers de randonnée. Un lundi sur deux, la municipalité accueille le plus grand marché de la région.

Ponte de Lima

An seinem Unterlauf schwillt der Lima zu einem mächtigen Strom an. Schon den Römern gelang es indes, den Fluss zu überbrücken. Hier entstand der Ort Ponte de Lima, der seit 1125 Stadtrechte besitzt. Die Ufer werden heute von einladenden Rad- und Wanderwegen flankiert. An jedem zweiten Montag sind sie Austragungsort des größten Marktes der Region.

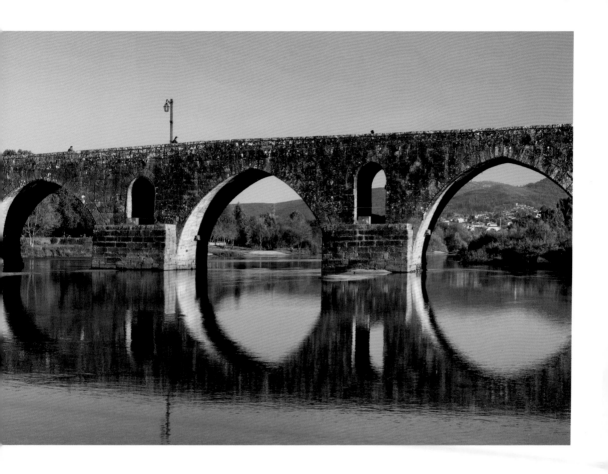

Ponte de Lima

En su curso bajo, Lima se hincha hasta convertirse en un poderoso río. Pero ya los romanos lograron tender un puente sobre el río. Aquí se originó el pueblo de Ponte de Lima, que posee fuero municipal desde 1125. Hoy en día, las orillas están flanqueadas por senderos para ciclismo y senderismo, que cada dos lunes se convierten en la sede del mercado más grande de la región.

Ponte de Lima

Al suo corso inferiore, Lima cresce fino a raggiungere una potente corrente. Persino i Romani riuscirono a superare il fiume. Qui ha origine Ponte de Lima, una città già dal 1125. Oggi le rive sono fiancheggiate da invitanti percorsi ciclabili ed escursionistici. Ogni due Lunedi sono la sede del più grande mercato della regione.

Ponte de Lima

Op zijn benedenloop zwelt de Lima aan tot een machtige stroom. De Romeinen slaagden er al in de rivier te overbruggen. Hier ontstond het dorp Ponte de Lima, dat sinds 1125 stadsrechten heeft. Tegenwoordig worden de oevers geflankeerd door uitnodigende fiets- en wandelroutes. Elke tweede maandag van de maand wordt hier de grootste markt in de regio opgebouwd.

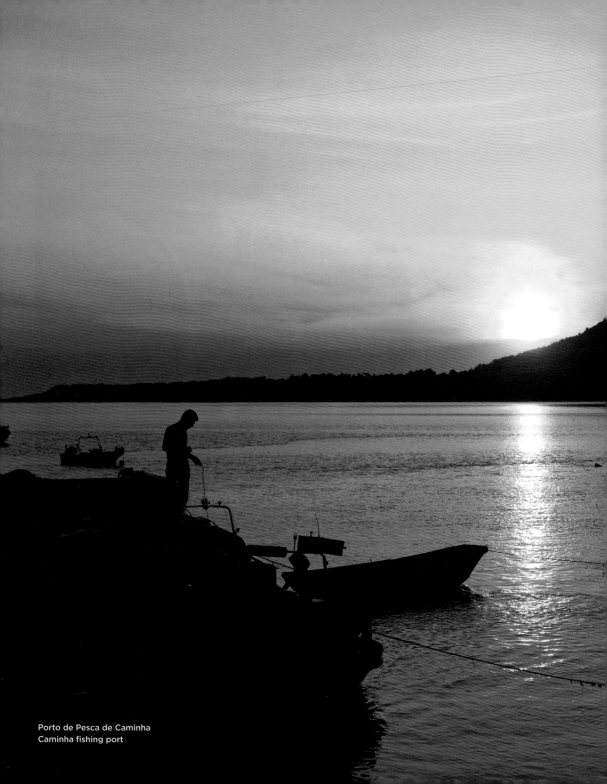

Porto de Pesca de Caminha
Caminha fishing port

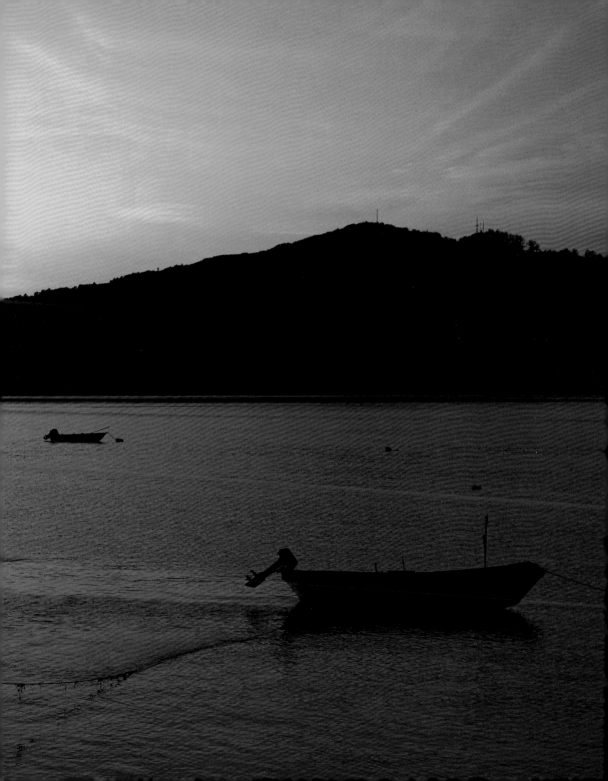

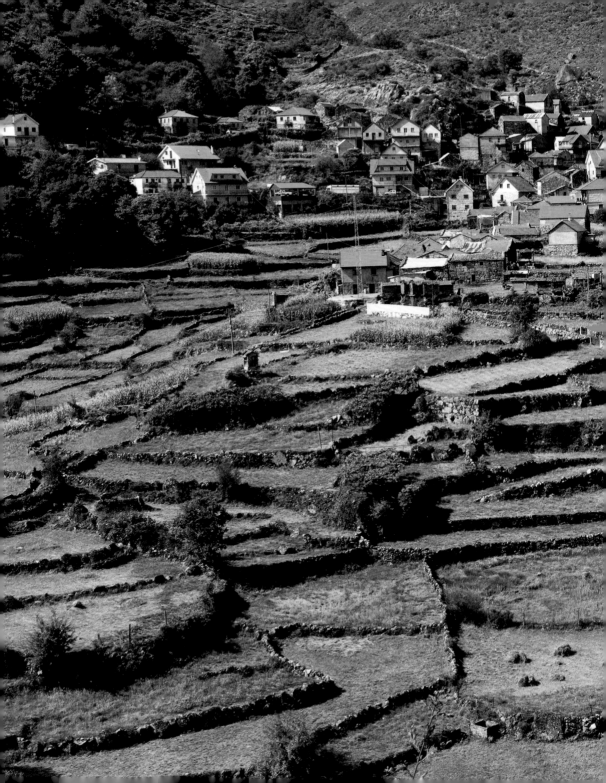

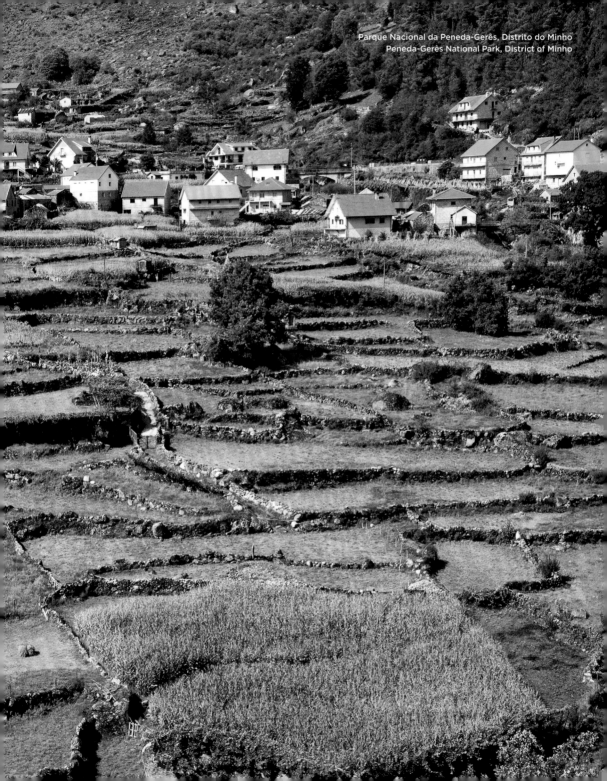

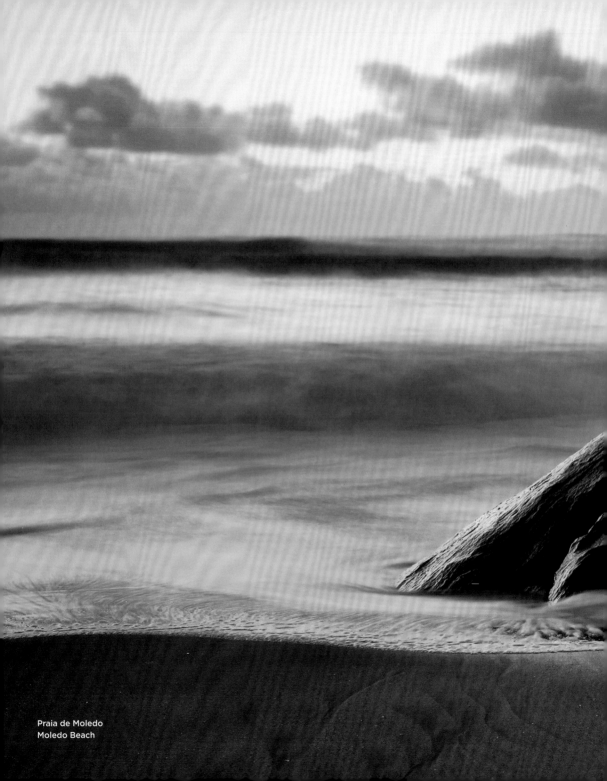

Praia de Moledo
Moledo Beach

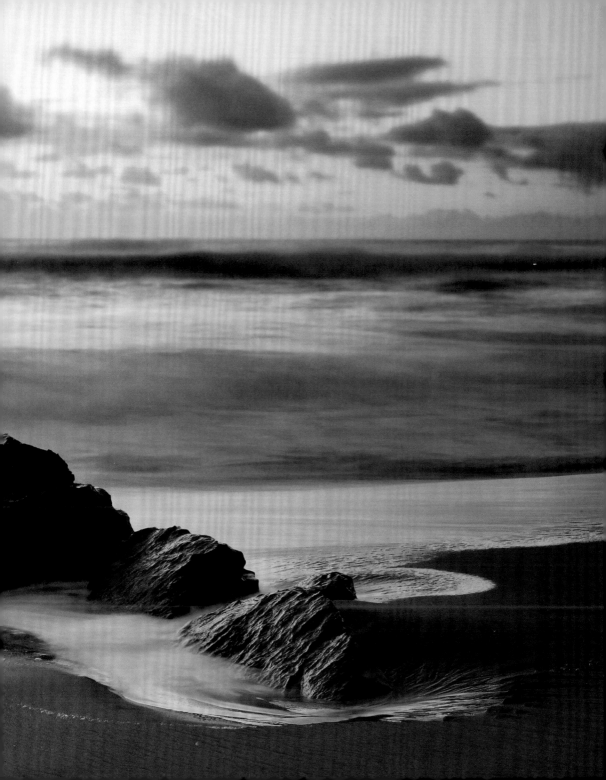

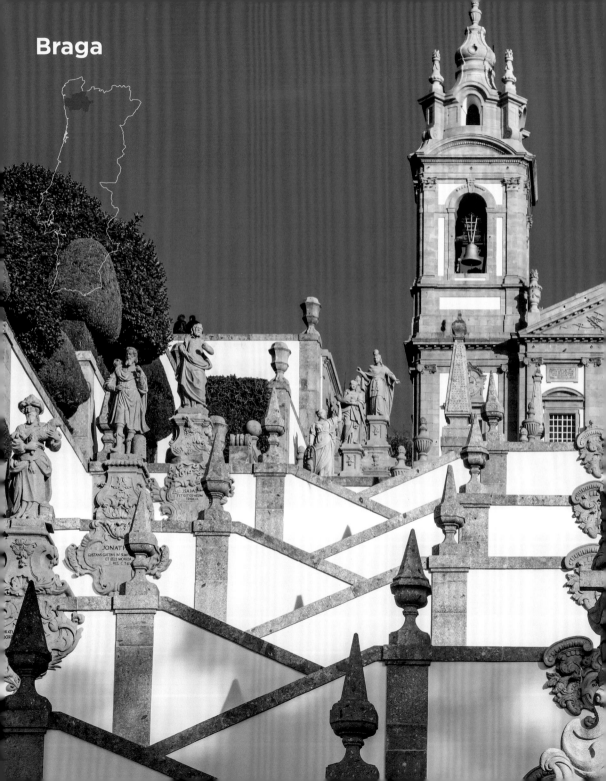

Braga

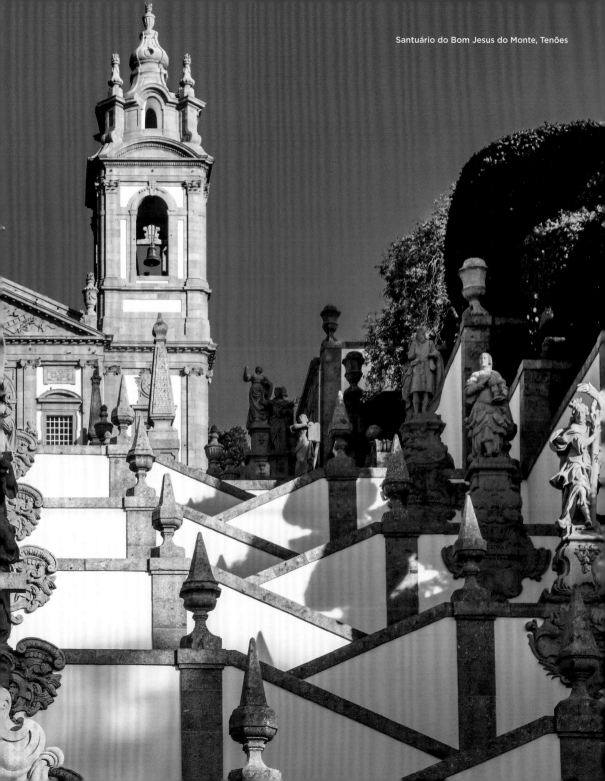
Santuário do Bom Jesus do Monte, Tenões

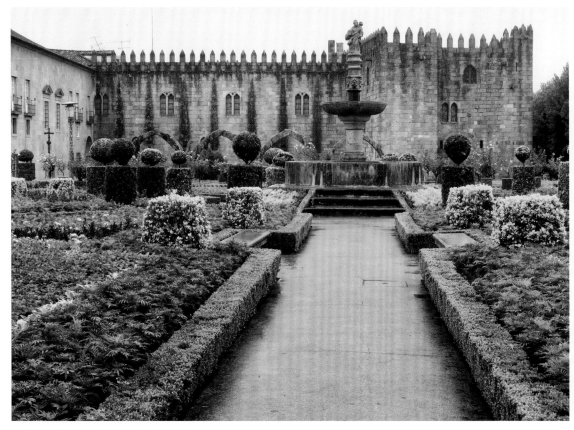

Jardim de Santa Bárbara
Garden of Santa Bárbara

Braga

The monumental stairs of the church Bom Jesus do Monte and the enchanting monastery gardens of Santa Barbara are a reminder of a deeply religious past. However, faith, tradition and monumental buildings are only one facet of Braga, with today's students of the University of Minho also making their impression on the old Roman city.

Braga

Les escaliers monumentaux de l'église Bom Jesus do Monte et les jardins enchanteurs du monastère de Santa Barbara rappellent le passé profondément religieux de la ville. Mais la foi, la tradition et les bâtiments monumentaux ne sont qu'une facette de Braga – les étudiants de l'Université du Minho ajoutent également beaucoup à l'ambiance de la vieille ville romaine.

Braga

Die Monumentaltreppen der Kirche Bom Jesus do Monte und die hinreißenden Klostergärten von Santa Barbara erinnern an die tief religiöse Vergangenheit. Doch Glaube, Tradition und monumentale Bauwerke sind nur die eine Seite von Braga – auch die Studenten der Universität Minho drücken der alten Römerstadt heute ihren Stempel auf.

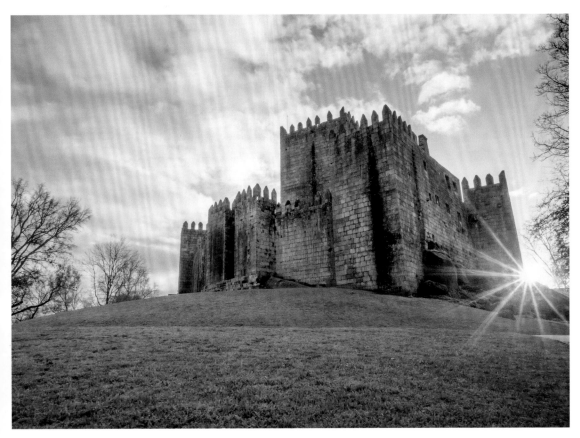

Castelo de Guimarães
Guimarães Castle

Braga

La escalera monumental de la iglesia Bom Jesus do Monte y los apasionantes jardines del monasterio de Santa Bárbara recuerdan el pasado profundamente religioso. Pero la fe, la tradición y las construcciones monumentales son sólo una parte de Braga; los estudiantes de la Universidad del Minho también dejan actualmente su huella en la antigua ciudadromana.

Braga

La monumentale scalinata della chiesa di Bom Jesus do Monte e gli incantevoli giardini del monastero di Santa Barbara ricordano il passato profondamente religioso. Ma la fede, la tradizione e gli edifici monumentali sono solo un lato di Braga – anche gli studenti dell'Università del Minho caratterizzano oggi l'antica città romana.

Braga

De monumentale trap van de kerk Bom Jesus do Monte en de betoverende kloostertuinen van Santa Barbara herinneren aan het diepreligieuze verleden. Maar geloof, traditie en monumentale gebouwen zijn slechts één kant van Braga – de studenten van de Universidade do Minho drukken vandaag de dag ook hun stempel op de oude Romeinse stad.

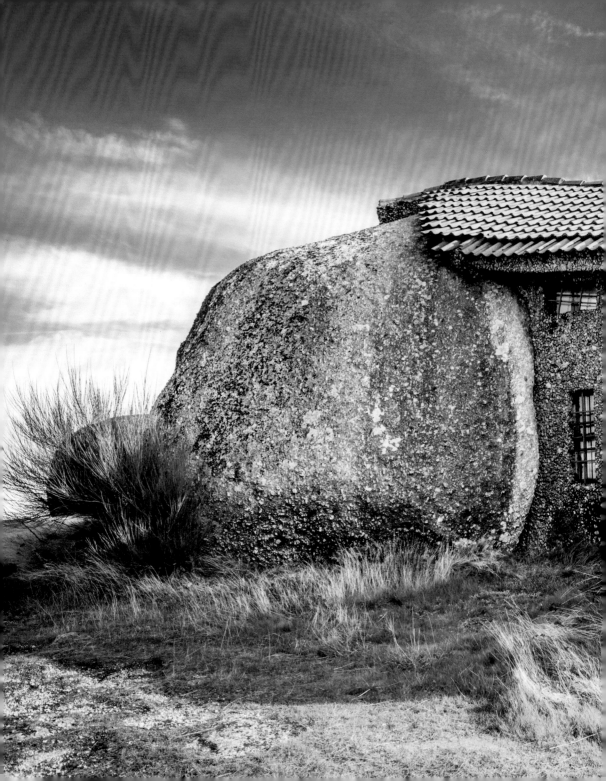

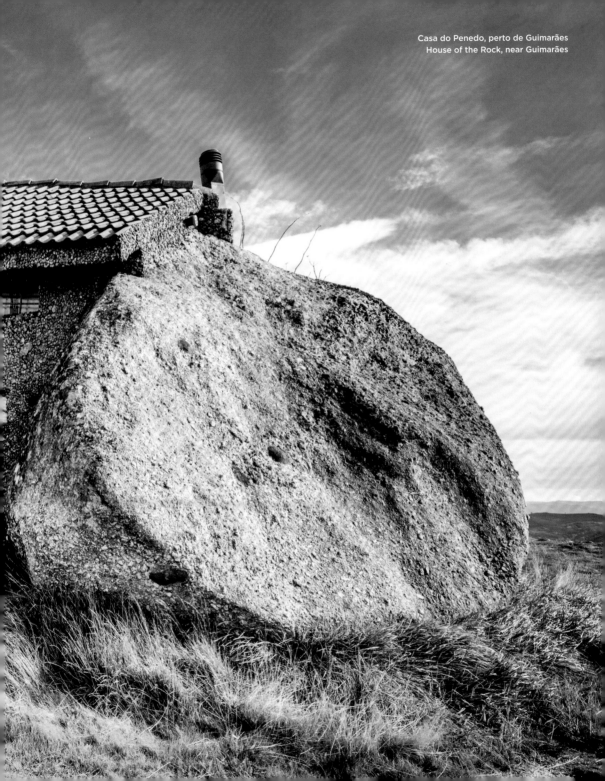

Casa do Penedo, perto de Guimarães
House of the Rock, near Guimarães

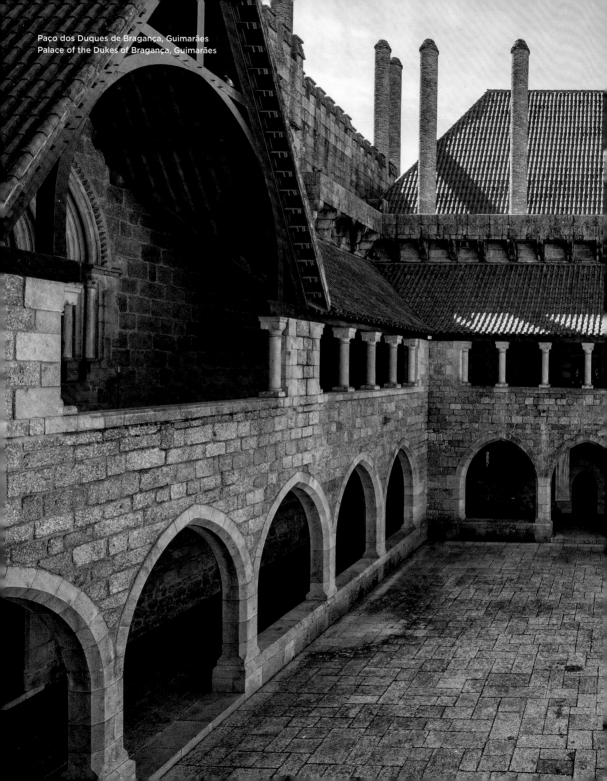

Paço dos Duques de Bragança, Guimarães
Palace of the Dukes of Bragança, Guimarães

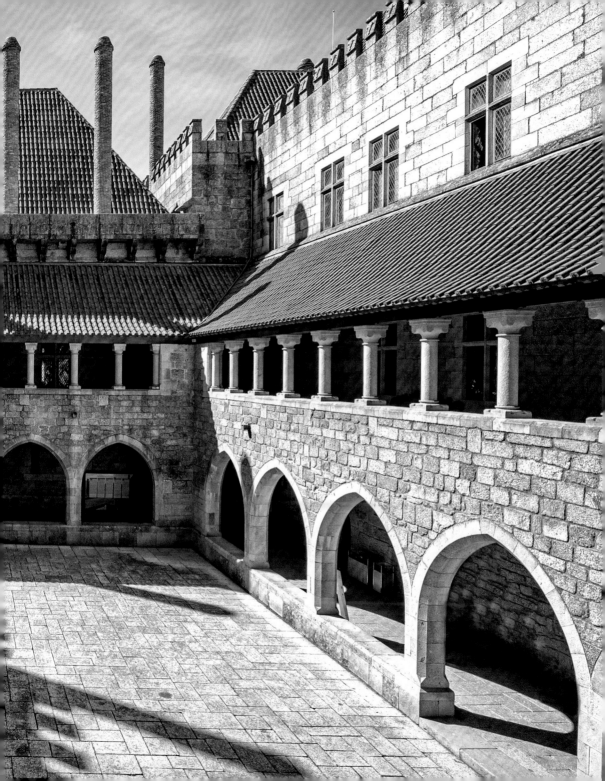

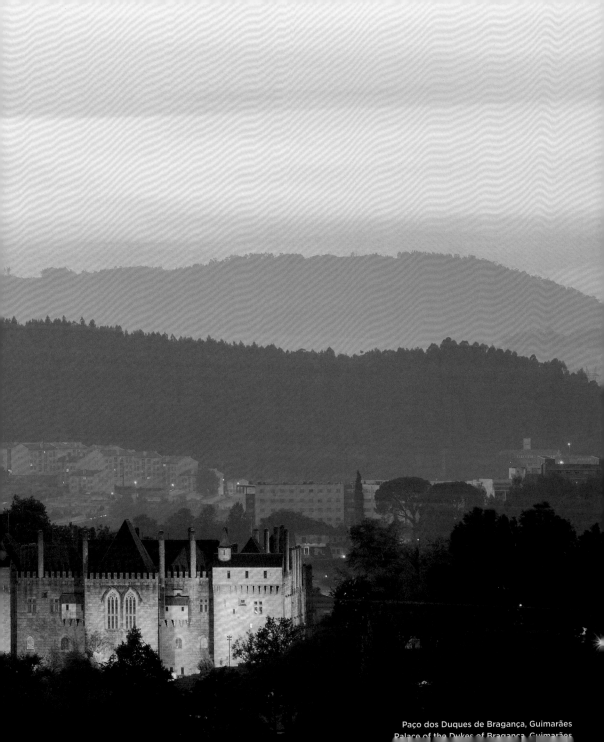

Paço dos Duques de Bragança, Guimarães
Palace of the Dukes of Bragança, Guimarães

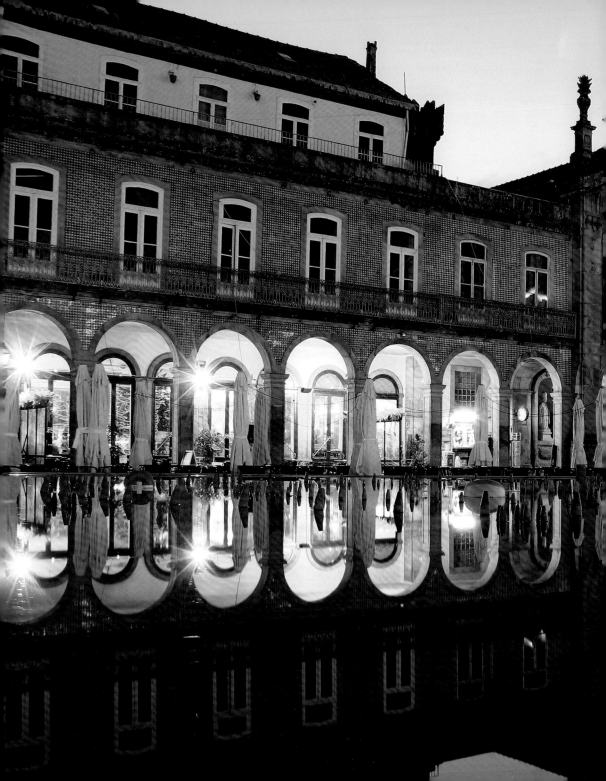

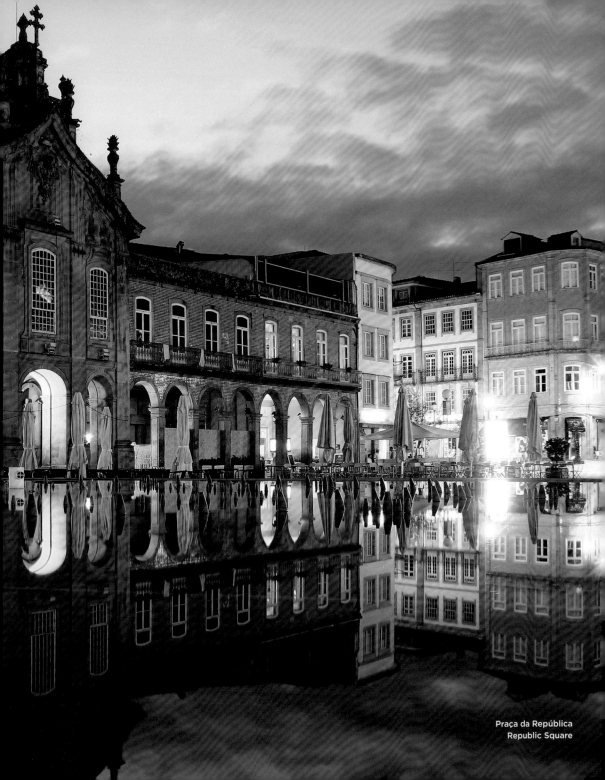

Praça da República
Republic Square

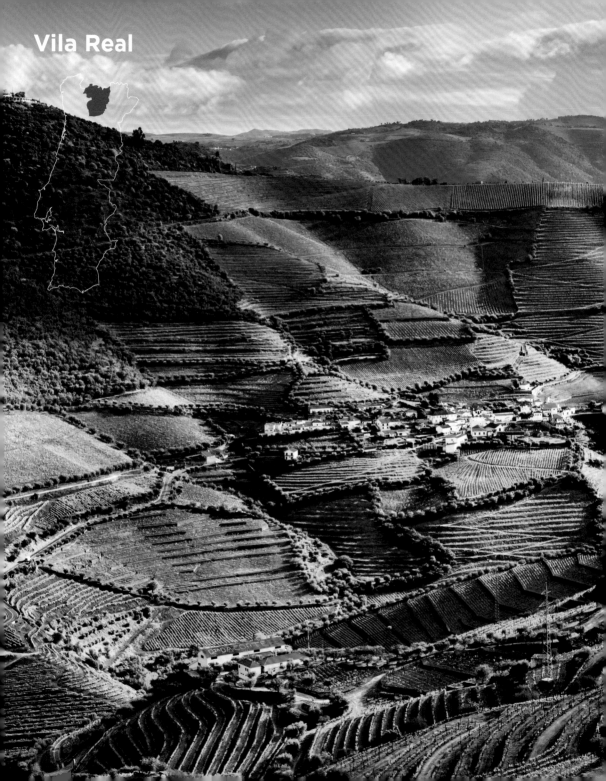

Vila Real

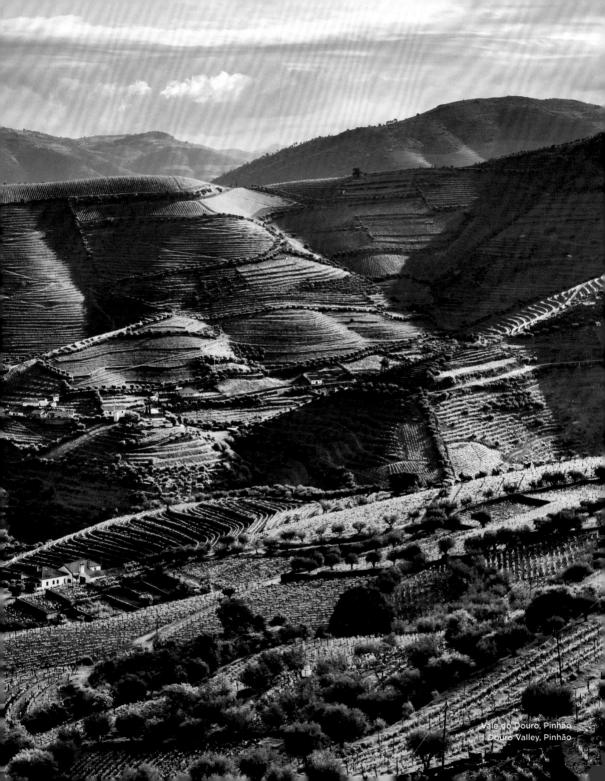

Vale do Douro, Pinhão
Douro Valley, Pinhão

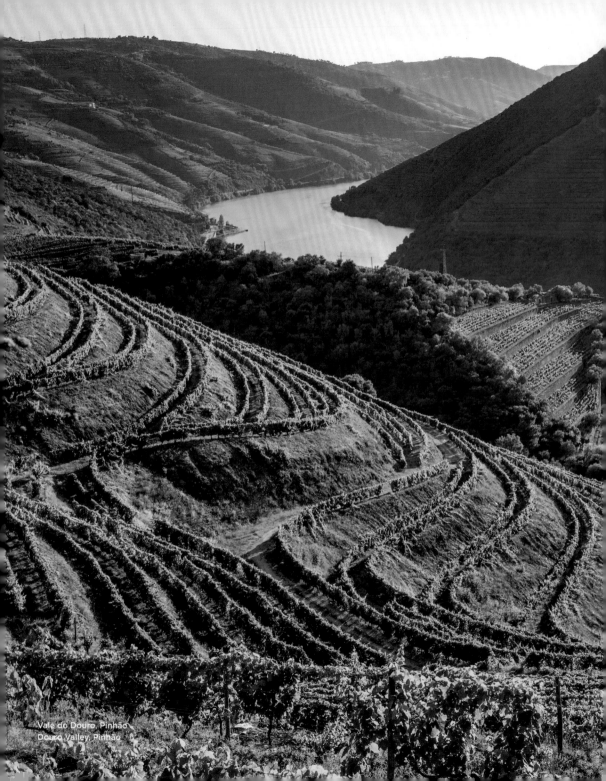

Vale do Douro, Pinhão
Douro Valley, Pinhão

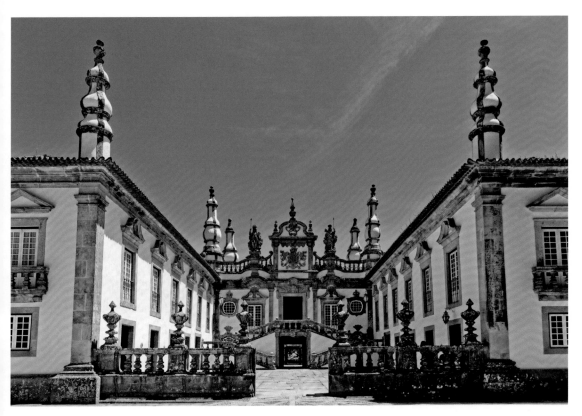

Palácio de Mateus
Mateus Palace

Vila Real

Near Pinhão, the Douro has dug itself a
deep bed, exhibiting a great sense of the
dramatic. However, the inhabitants have
not been deterred from populating these
steep flanks of the mountains with vines
and villages. Further north, the provincial
town of Vila Real boasts a royal heritage,
with palaces from differing epochs
reminding us of past splendours.

Vila Real

Près de Pinhão, le Douro a creusé lui-
même son lit sans ménagement, ce qui
n'a pas dissuadé les habitants de cultiver
des vignes sur les flancs des montagnes
et d'y installer des villages. Plus au
nord, la ville provinciale de Vila Real est
une ancienne ville royale. Les palais de
différentes époques nous rappellent la
splendeur du passé

Vila Real

Bei Pinhão hat sich der Douro mit viel
Sinn für Dramatik ein Bett gegraben.
Die Bewohner lassen sich davon nicht
abschrecken, die Flanken der Berge mit
Rebstöcken und Dörfern zu bebauen.
Weiter nördlich rühmt sich die Provinzstadt
Vila Real königlicher Ursprünge. Paläste
aus verschiedenen Epochen erinnern an
den Glanz der Vergangenheit.

Vila Real

Junto a Pinhão, el Duero ha cavado una
cama con un gran sentido del drama. Pero
esto no evita que los habitantes cultiven
los flancos de las montañas con vides y
construyan pueblos en ellos. Más al norte,
la ciudad provincial de Vila Real presume
de sus orígenes reales con palacios de
diferentes épocas que nos recuerdan el
esplendor del pasado.

Vila Real

Vicino a Pinhão, il Duero si è scavato
un letto con drammatici dislivelli. Ciò
non scoraggia gli abitanti che coltivano
vitigni e costruiscono villaggi sui fianchi
delle montagne. Più a nord, la città di
Vila Real vanta tradizioni reali. Palazzi di
epoche diverse ci ricordano lo splendore
del passato.

Vila Real

In de buurt van Pinhão heeft de Douro
met veel gevoel voor dramatiek een
bedding uitgegraven. Het weerhoudt de
bewoners er niet van de berghellingen
met wijnstokken en dorpen te bebouwen.
Verder naar het noorden kan de
provinciestad Vila Real zich beroemen op
een koninklijke oorsprong. Paleizen uit
verschillende tijdperken herinneren ons aan
de pracht van het verleden.

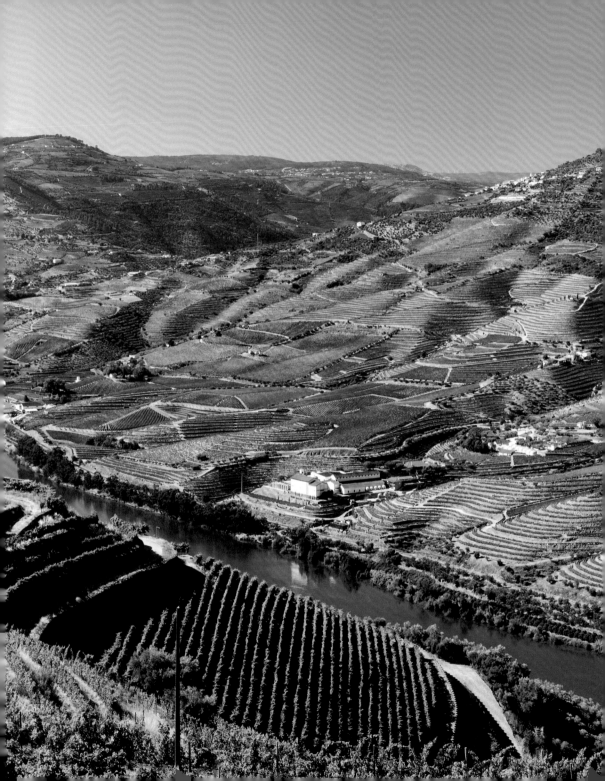

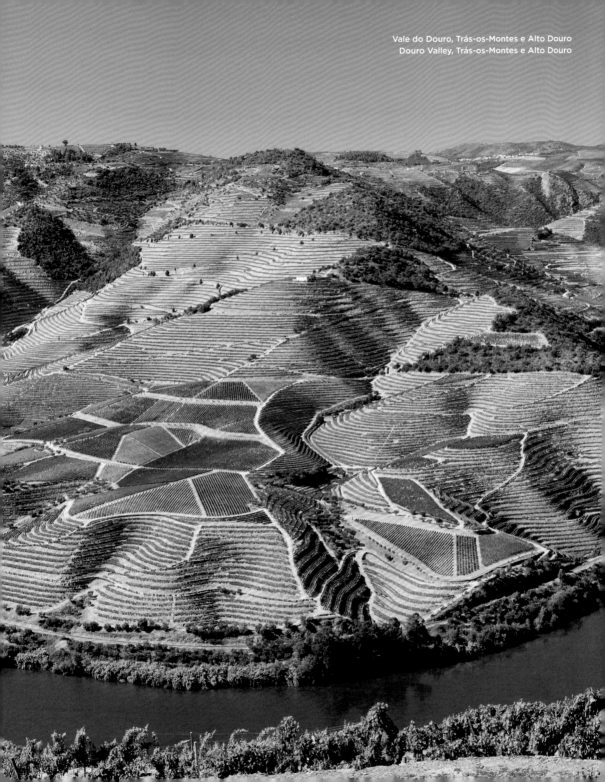

Vale do Douro, Trás-os-Montes e Alto Douro
Douro Valley, Trás-os-Montes e Alto Douro

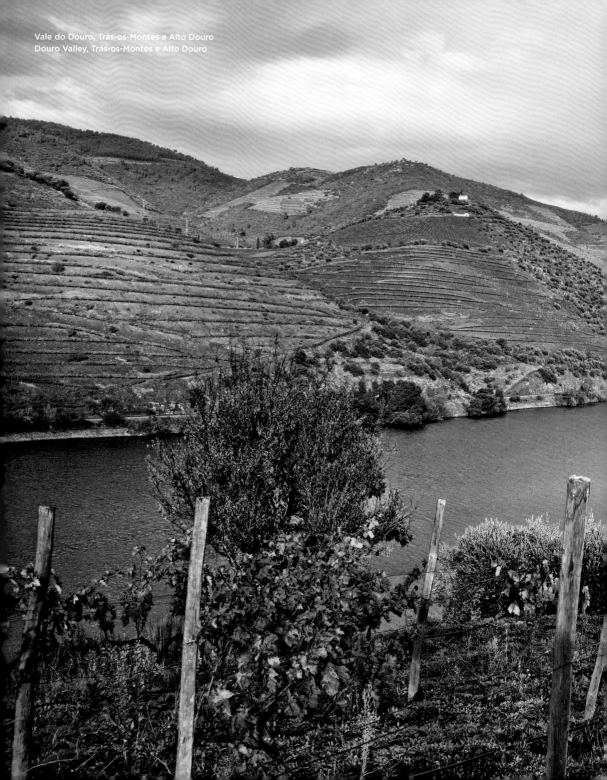

Vale do Douro, Trás-os-Montes e Alto Douro
Douro Valley, Trás-os-Montes e Alto Douro

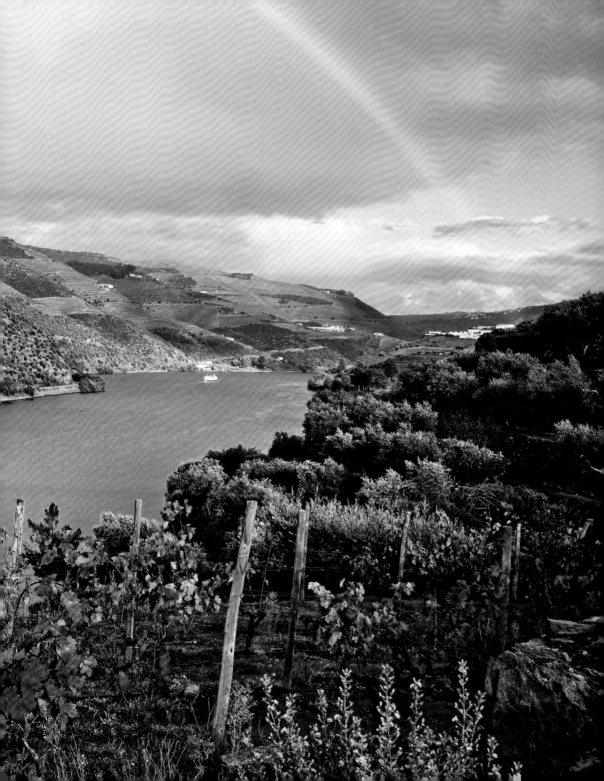

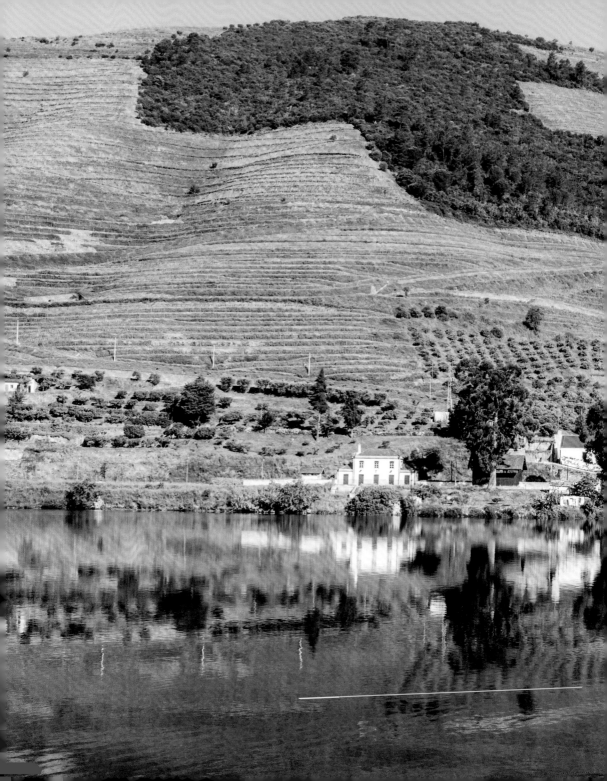

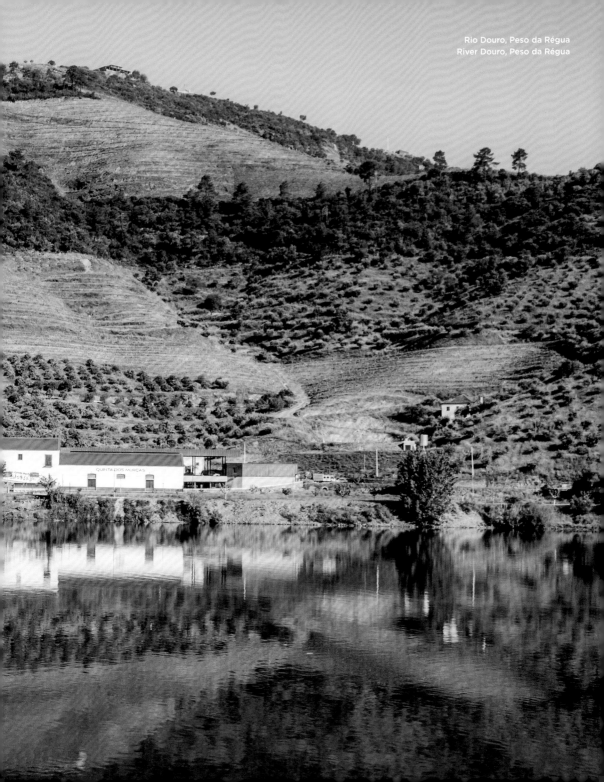

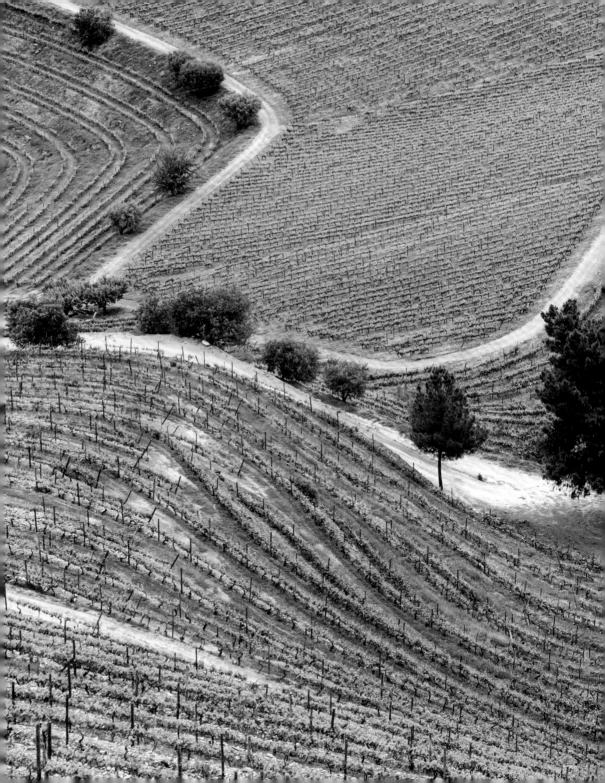

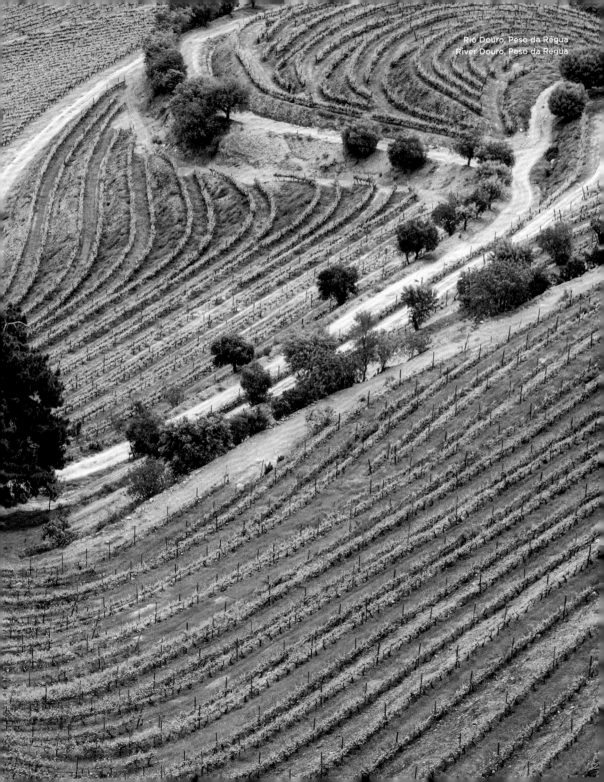

Rio Douro, Peso da Régua
River Douro, Peso da Régua

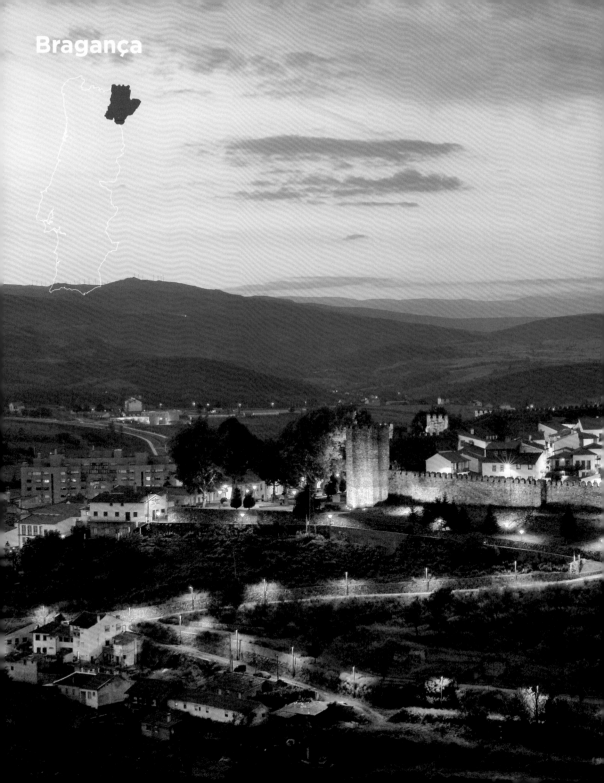

Bragança

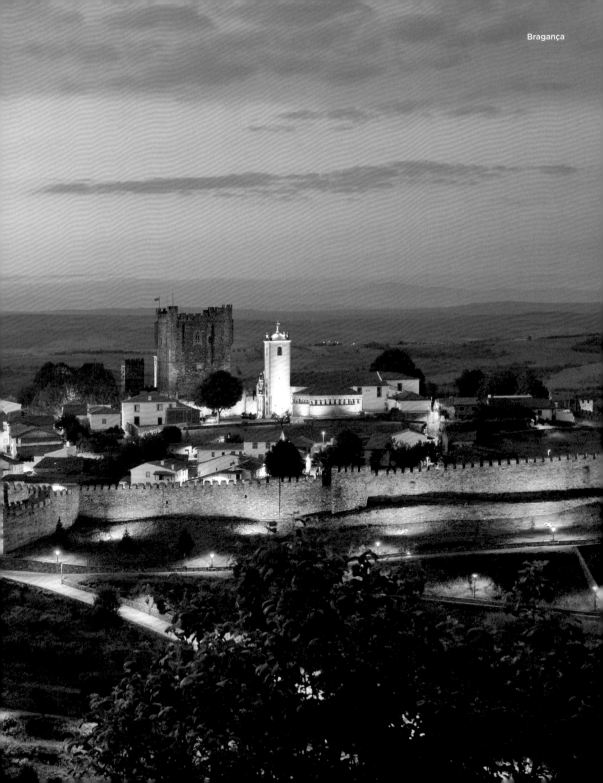

Bragança

Barragem de Aldeiadávila, Parque Natural do Douro Internacional
Aldeiadávila Dam, International Douro Natural Park

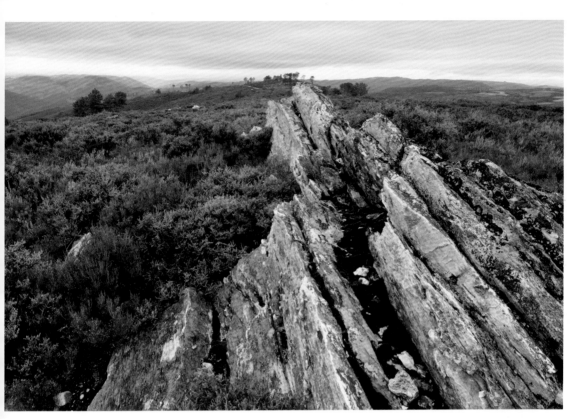

Parque Natural de Montesinho
Montesinho Natural Park

Bragança

Rugged rocky landscapes and rolling hills go hand in hand in the extreme northeast of Portugal, with the region around the bishopric of Bragança being considered deeply religious and traditional. The remote Montesinho Natural Park seems to want to continue this line. It is the home of gnarled trees, with many a chestnut tree here having been around for up to 1000 years.

Bragança

Dans l'extrême nord-est du Portugal, les paysages rocailleux vont de pair avec les collines vallonnées. La région autour de l'évêché de Bragança est considérée comme profondément religieuse et traditionnelle. Le parc naturel éloigné de Montesinho participe également de cette impression. C'est le domaine des arbres noueux – beaucoup de ses châtaigniers existent depuis plus de 1000 ans.

Bragança

Schroffe Felslandschaften und sanftes Hügelland gehen im äußersten Nordosten Portugals Hand in Hand. Die Region um den Bischofssitz Bragança gilt als tief religiös und traditionsverhaftet. Der abgelegene Naturpark Montesinho scheint diese Linie fortsetzen zu wollen. Er ist die Heimat knorriger Bäume – so manche Kastanie hat bis zu 1000 Jahre auf dem Buckel.

Bragança

Los escarpados paisajes rocosos y las colinas onduladas van de la mano en el extremo noreste de Portugal. La región situada en torno a la sede episcopal de Bragança es considerada profundamente religiosa y tradicional. El remoto Parque Natural de Montesinho parece querer continuar en esta línea. Alberga árboles con formas retorcidas; muchos castaños cuentan ya con más de 1000 años.

Braganza

Aspri paesaggi rocciosi e dolci colline vanno a braccetto nell'estremo nord-est del Portogallo. La regione intorno al vescovato di Bragança è considerata profondamente religiosa e tradizionale. Il remoto Parco Naturale di Montesinho sembra voler continuare su questa linea. È la patria degli alberi nodosi – molti castagni hanno fino a 1000 anni.

Bragança

In het uiterste noordoosten van Portugal gaan steile rotslandschappen en glooiende heuvels hand in hand. Het gebied rond het bisdom Bragança wordt beschouwd als uiterst religieus en traditioneel. Het afgelegen natuurgebied Montesinho lijkt deze lijn te willen voortzetten. Het is de geboortegrond van knoestige bomen – sommige kastanjes hebben er al 1000 jaar opzitten.

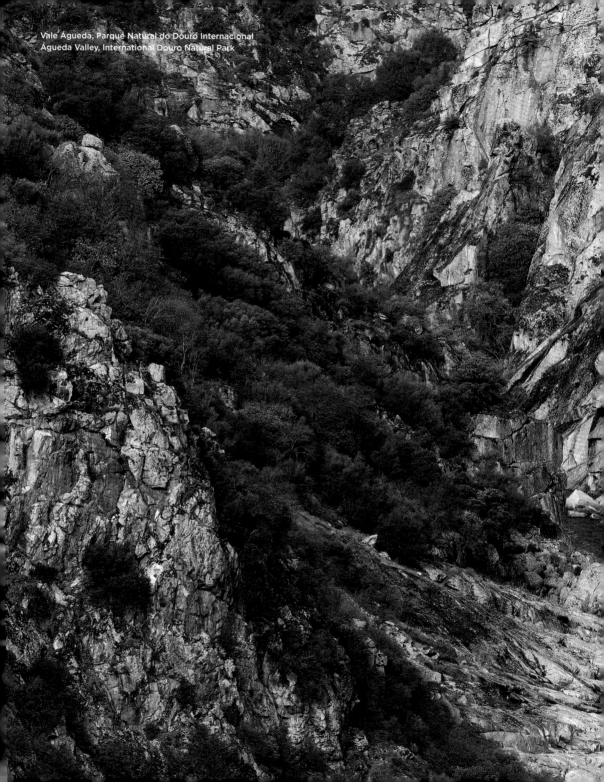

Vale Águeda, Parque Natural do Douro Internacional
Águeda Valley, International Douro Natural Park

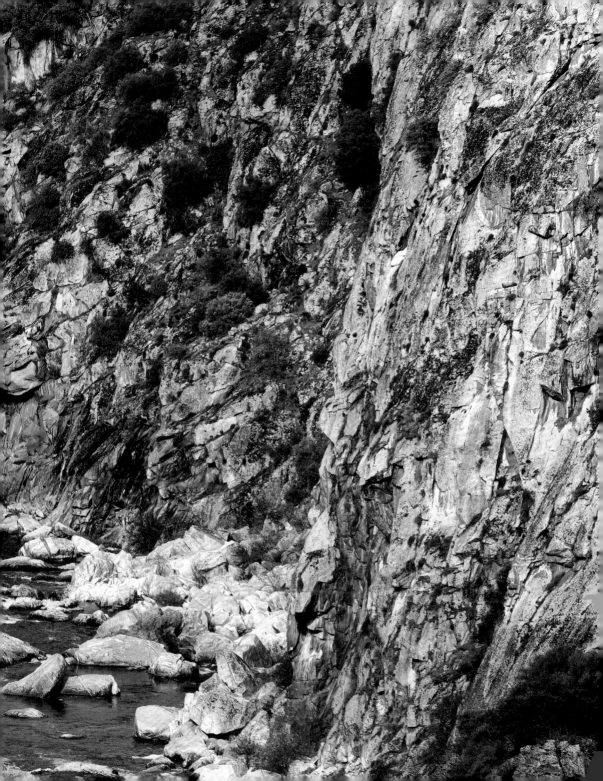

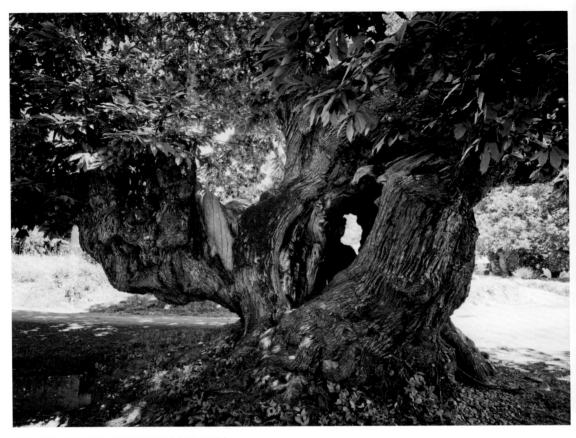

Castanheiro, Lagarelhos, Parque Natural de Montesinho
Chestnut tree, Montesinho Natural Park

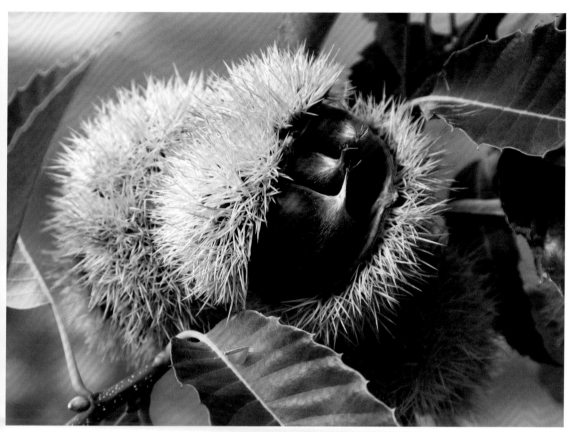

Castanha
Chestnut

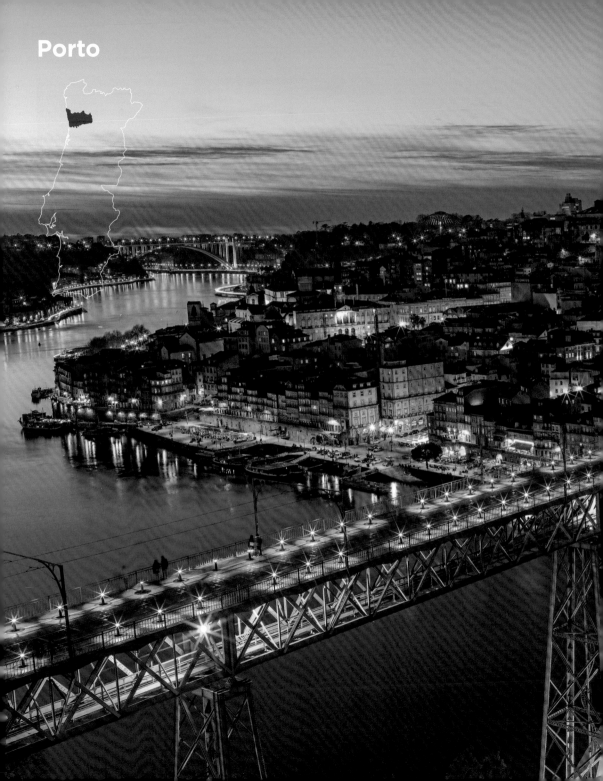

Porto

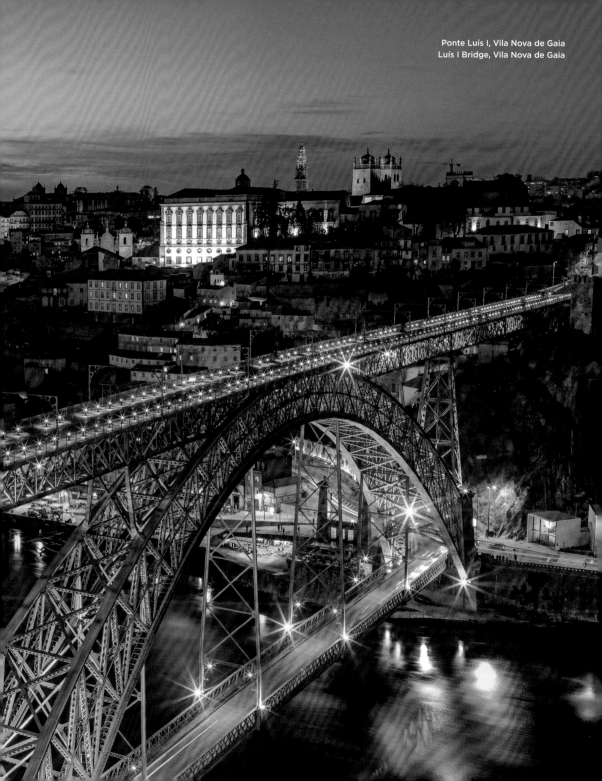

Ribeira, Porto

Porto

Colourful houses, steep hills and winding alleys characterize Porto, in addition to the magnificent buildings decorated with the coloured and glazed tiles known as azulejos. The landmark remains the Ponte Dom Luís I, which spans the Douro river on two levels. Having long resigned itself to its status as Portugal's number two, Porto is now experiencing an unprecedented renaissance.

Porto

Les maisons colorées, les collines abruptes, les ruelles sinueuses et les magnifiques bâtiments décorés d'azulejos sont autant d'éléments caractéristiques de la ville de Porto. L'architecture la plus emblématique reste le Ponte Dom Luís I, qui enjambe le Douro sur deux niveaux. Après s'être longtemps résignée à son statut de numéro deux au Portugal, Porto connaît aujourd'hui une renaissance sans précédent.

Porto

Bunte Häuser, steile Hügel und verwinkelte Gassen prägen Porto genauso wie mit Azulejos geschmückte Prunkbauten. Wahrzeichen bleibt der Ponte Dom Luís I., der den Douro auf zwei Ebenen überspannt. Nachdem sich die Stadt lange mit ihrem Status als Nummer zwei Portugals abgefunden zu haben schien, erlebt Porto nun eine beispiellose Renaissance.

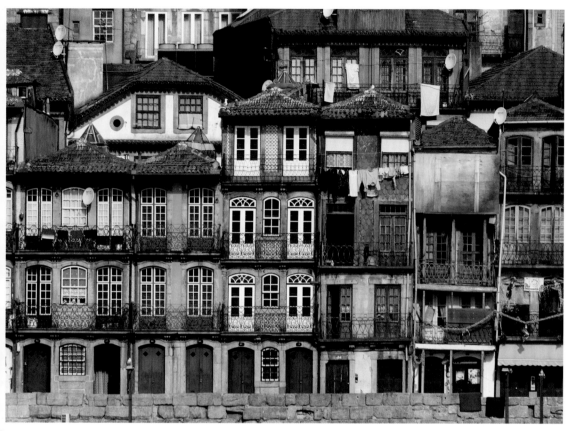

Ribeira, Porto

Oporto

Casas coloridas, colinas empinadas y callejones sinuosos caracterizan Oporto, así como ostentosos edificios decorados con azulejos. El punto más emblemático de la ciudad sigue siendo el Ponte Dom Luís I, formado por dos plataformas que cruzan el Duero. Tras llevar mucho tiempo conformándose con ser el número dos de Portugal, Oporto está experimentando en la actualidad un renacimiento sin precedentes.

Porto

Case colorate, colline scoscese e vicoli tortuosi caratterizzano Porto così come magnifici edifici decorati con azulejo. Il punto di riferimento rimane il Ponte Dom Luís I, che attraversa il Duero su due livelli. Dopo essersi a lungo rassegnata a essere la seconda città del Portogallo, Porto sta vivendo una rinascita senza precedenti.

Porto

Kakelbonte huizen, steile heuvels en kronkelende steegjes kenmerken Porto, net als de prachtige, met azulejos versierde gebouwen. Het herkenningspunt blijft de Ponte Dom Luís I, die de Douro op twee niveaus overspant. Nadat de stad zich lange tijd tevreden lijkt te hebben gesteld met zijn status van tweede stad van Portugal, beleeft Porto nu een ongekende wedergeboorte.

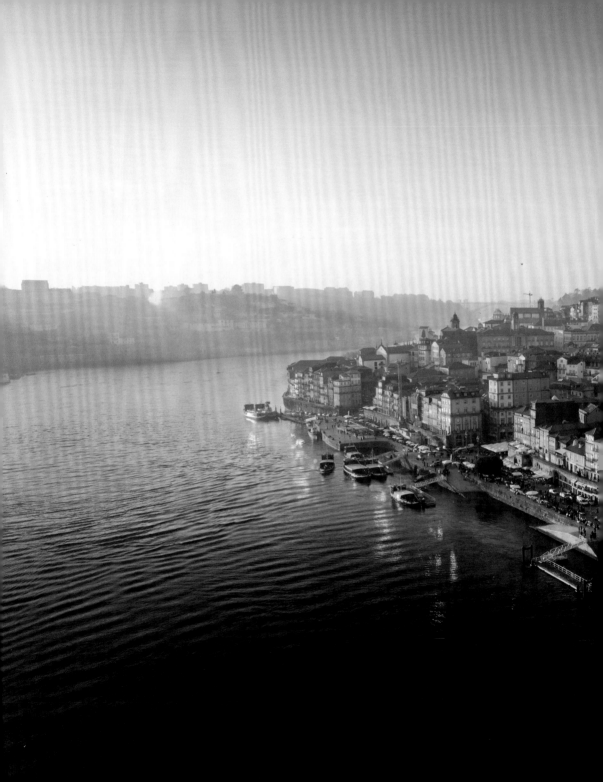

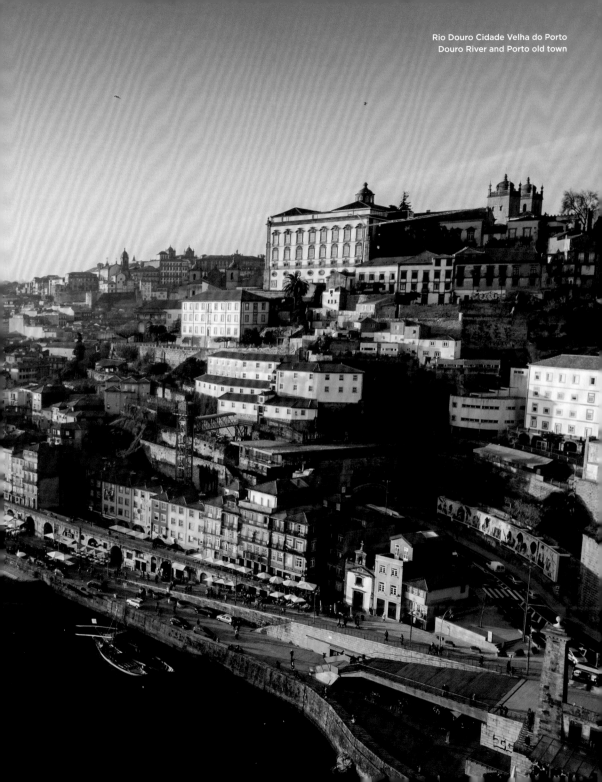

Rio Douro Cidade Velha do Porto
Douro River and Porto old town

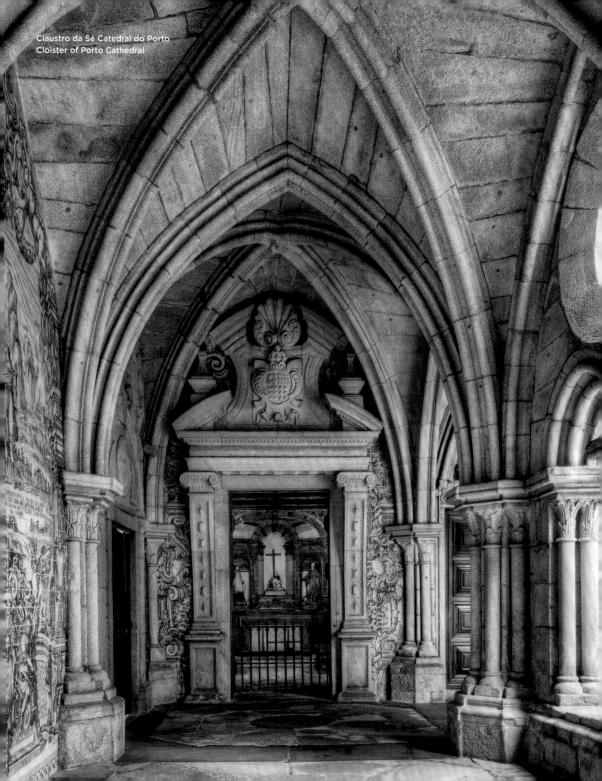

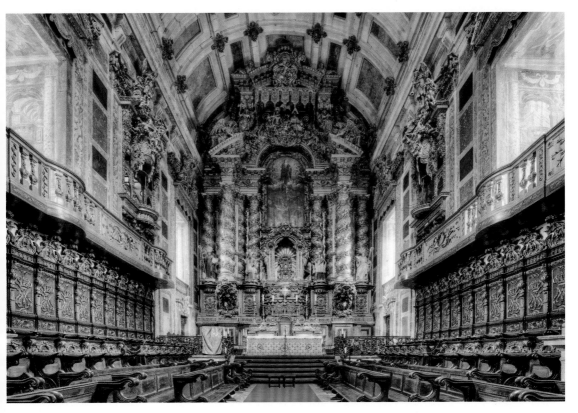

Sé Catedral do Porto
Porto Cathedral

Porto Cathedral (Sé do Porto)
The writer Joanne K. Rowling lived in Porto in the 1990s as an English teacher. She gave the city an unexpected boost by using the time-honoured *Livraria Lello* (Lello Bookshop) as an inspiration for scenes in the *Harry Potter* novels. The view from Porto's sister city of Vila Nova de Gaia, south of the river, is also poetic.

Cathédrale Se do Porto
L'écrivain Joanne K. Rowling a vécu à Porto dans les années 1990 en tant que professeur d'anglais. Elle a donné un coup de pouce inattendu à la ville en utilisant la librairie Lello comme inspiration pour les scènes des romans *Harry Potter*. La vue de la ville jumelle Vila Nova de Gaia est tout aussi poétique.

Kathedrale von Porto (Sé do Porto)
Die Schriftstellerin Joanne K. Rowling hat in den 1990ern als Englischlehrerin in Porto gelebt. Sie hat der Stadt einen unerwarteten Schub gegeben, weil sie die altehrwürdige Livraria Lello als Blaupause für die Schauplätze der *Harry-Potter*-Romane verwendet hat. Poetisch aber ist auch der Blick hinüber von der Schwesterstadt Vila Nova de Gaia.

Catedral Sé
La escritora Joanne K. Rowling, que vivió en Oporto en los años 90 mientras ejercía de profesora de inglés, dio a la ciudad un impulso inesperado inspirarse en la histórica Livraria Lello para los escenarios de las novelas de *Harry Potter*. Y no menos poética es la vista desde la ciudad hermana de Vila Nova de Gaia.

Cattedrale di Porto (Sé do Porto)
La scrittrice Joanne K. Rowling ha vissuto a Porto negli anni '90 come insegnante di inglese. Ha dato alla città un impulso inaspettato utilizzando l'antico Livraria Lello come progetto per le scene dei romanzi di *Harry Potter*. Poetica è anche la vicina città Vila Nova de Gaia.

Sé do Porto
De schrijfster J.K. Rowling woonde in de jaren negentig als lerares Engels in Porto. Ze zette de stad onverwachts op de kaart door de eerbiedwaardige Livraria Lello te gebruiken als blauwdruk voor het toneel waar de romans van *Harry Potter* zich afspelen. Maar het uitzicht vanuit de zusterstad Vila Nova de Gaia is ook poëtisch.

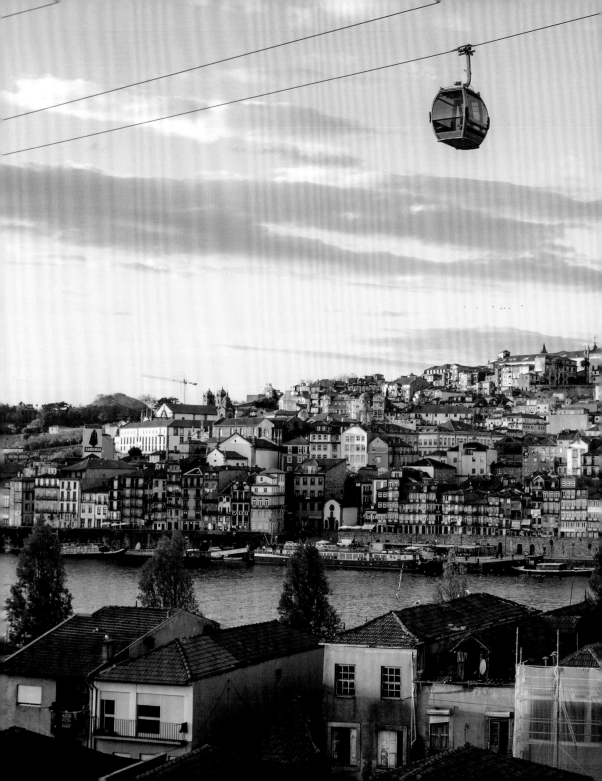

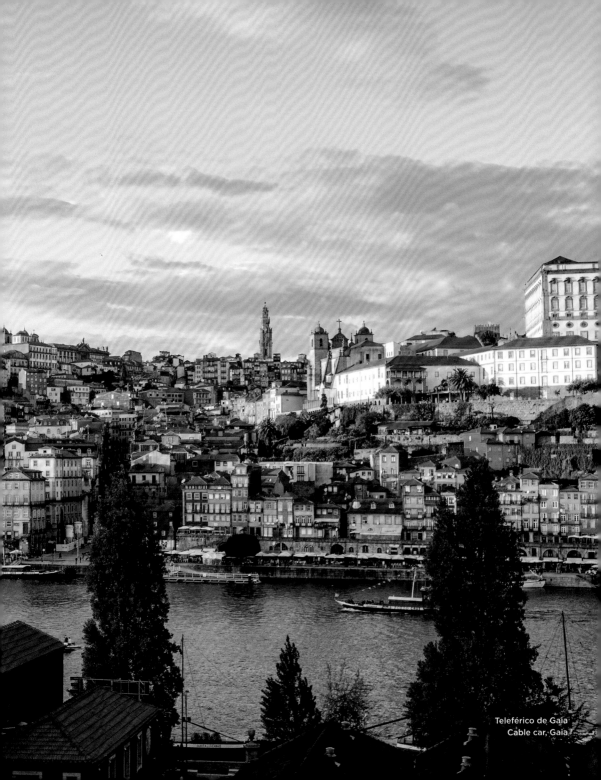

Teleférico de Gaia
Cable car, Gaia

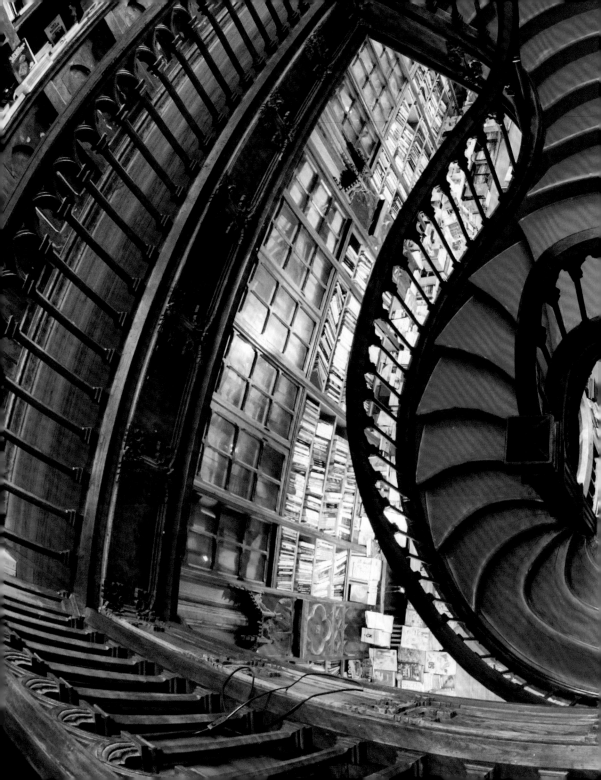

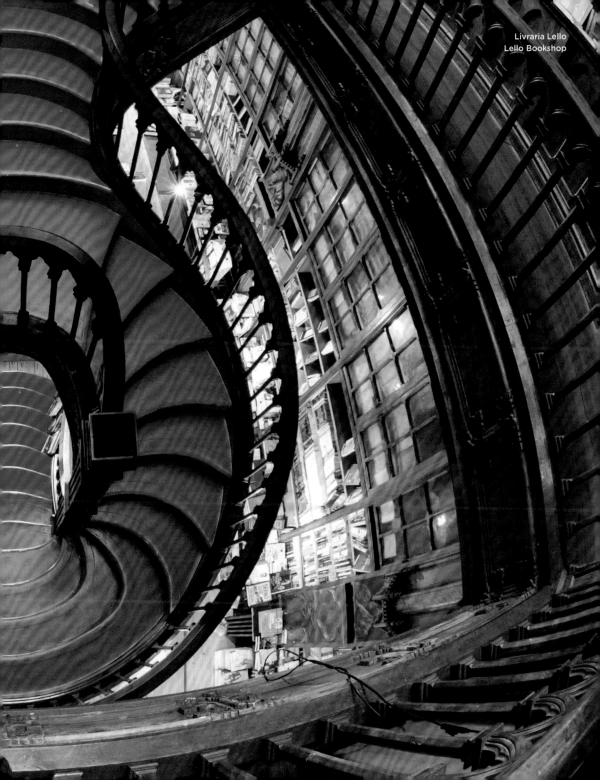

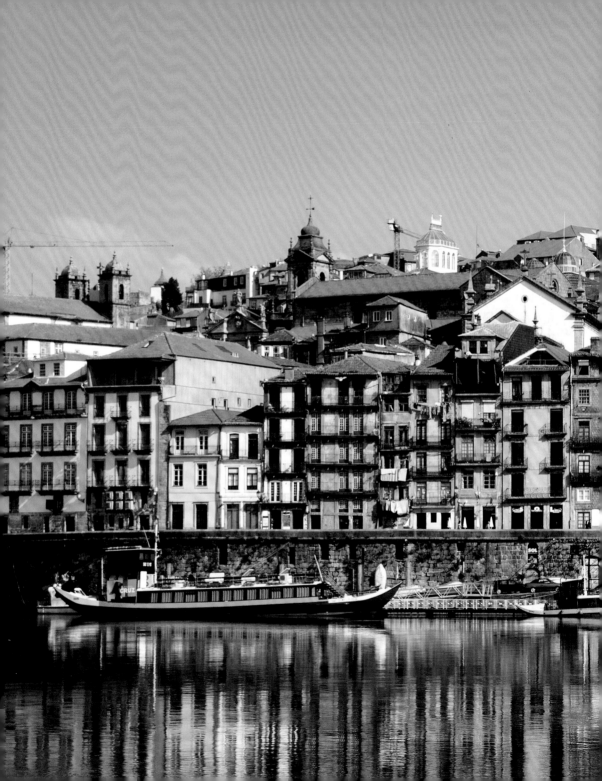

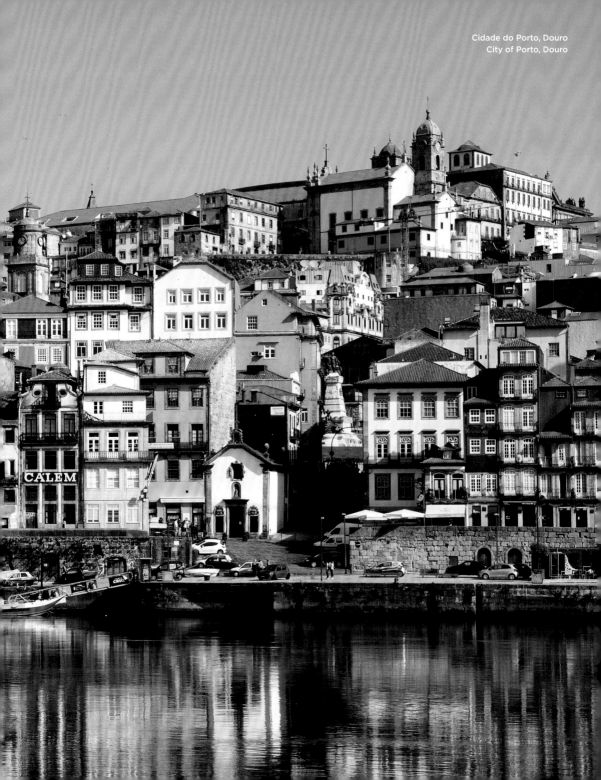

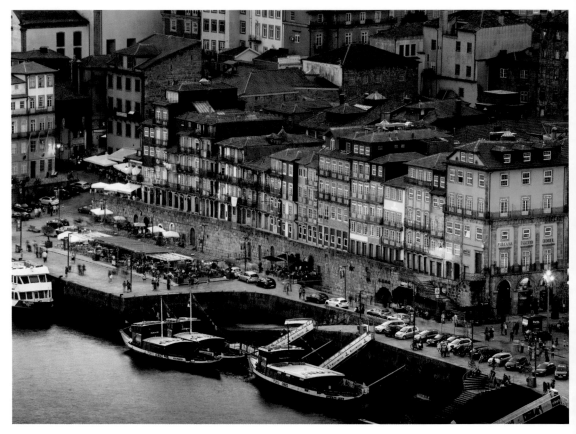

Porto

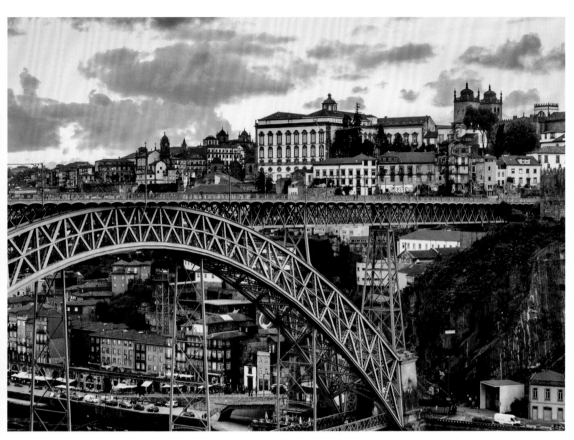

Ponte Luís I, Vila Nova de Gaia
Luís I Bridge, Vila Nova de Gaia

Farol do Porto
Lighthouse, Porto

Port wine

Port wine has become a world-famous symbol of the Douro region. All of the important wineries offer their products for tasting in Vila Nova de Gaia. The traditional Rabelo boats rock unperturbed on the ebb and flow of the tide, giving a very photogenic motif, especially in the light of dusk.

Porto

Le porto est devenu l'emblème mondialement connu de la région du Douro. Tous les vignobles importants organisent des dégustations de vin à Vila Nova de Gaia. Les bateaux traditionnels Rabelo se balancent, imperturbables, sur les vagues de la rivière, donnant à la scène un caractère très photogénique, surtout à la lumière du crépuscule.

Porto

Der Portwein ist zu einem weltweit bekannten Aushängeschild der Douro-Region geworden. Alle wichtigen Kellereien bieten den aufgespriteten Wein in Vila Nova de Gaia zur Verkostung an. Die traditionellen Rabelo-Boote schaukeln davon unbeirrt in den Wogen des Flusses, wobei sie insbesondere im Licht der Dämmerung ein sehr fotogenes Motiv abgeben.

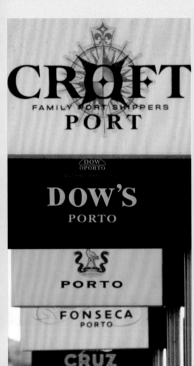

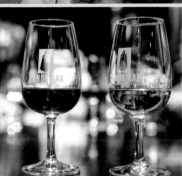

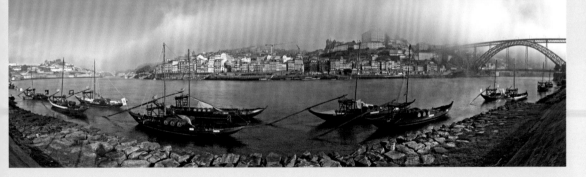

Oporto

El vino de Oporto se ha convertido en una figura mundialmente conocida de la región del Duero. Todas las bodegas importantes de Vila Nova de Gaia ofrecen este vino fortificado para su degustación. Las tradicionales embarcaciones Rabelo se mecen impertérritas a las olas del río, regalándonos una escena muy fotogénica, sobre todo a la luz del atardecer.

Porto

Il vino Porto è diventato una polena di fama mondiale della regione del Duero. Tutte le cantine importanti offrono la degustazione di vinoa Vila Nova de Gaia. Le tradizionali barche di Rabelo dondolano sulle onde del fiume, regalando un pittoresco accento, soprattutto alla luce del tramonto.

Porto

Port is een wereldwijd bekend uithangbord geworden van de Douro-regio. Alle belangrijke wijnkelders in Vila Nova de Gaia organiseren proeverijen voor deze verrijkte wijnsoort. De traditionele Rabelo-boten liggen onverstoorbaar te deinen in de golven van de rivier, waarbij ze vooral in het schemerlicht een zeer fotogeniek beeld opleveren.

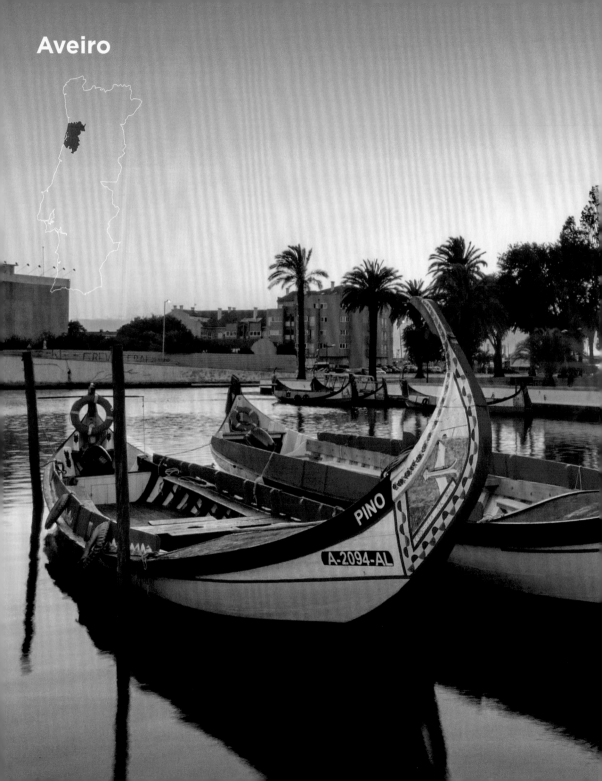

Aveiro

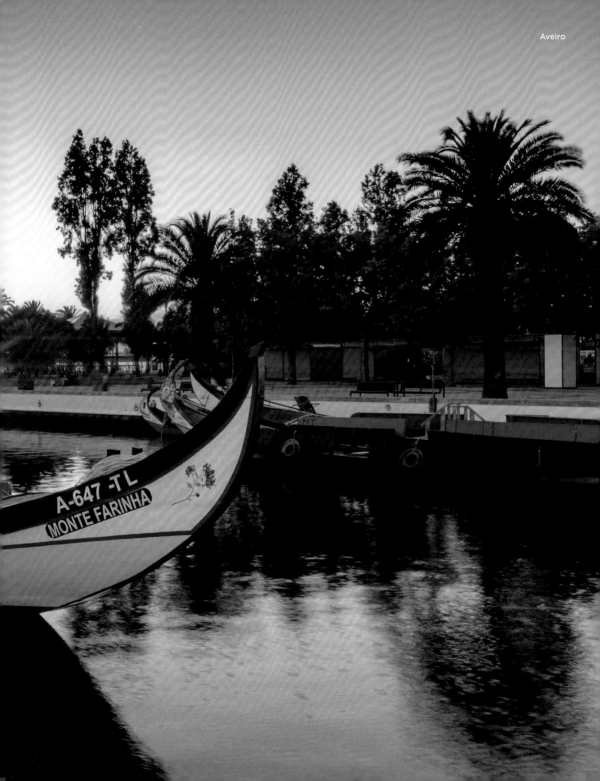

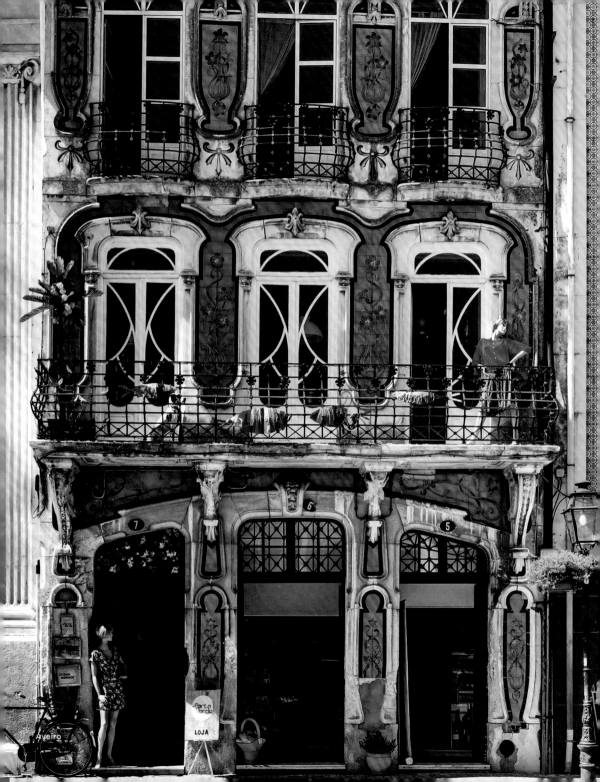

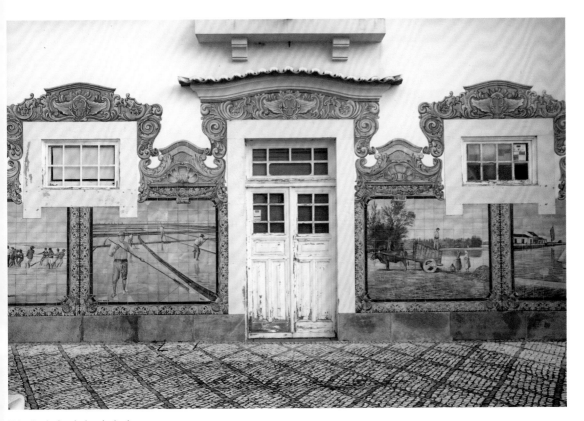

Estação de Comboios de Aveiro
Aveiro Railway Station

Aveiro

The facades of Portuguese houses are unique. Sometimes the characteristic *azulejos* serve just as cheerful ornaments, but in other cases may tell whole stories. The railway station in the provincial town of Aveiro is a particularly gossipy example of this, where countless scenes from the region's past are recreated on the outer walls.

Aveiro

Les façades des maisons portugaises sont uniques. Parfois, les azulejos typiques servent d'ornements joyeux, parfois ils racontent même des histoires entières. La gare de la ville provinciale d'Aveiro en est un exemple particulièrement frappant : d'innombrables scènes du passé de la région sont recréées sur ses murs extérieurs.

Aveiro

Die Fassaden portugiesischer Häuser sind einzigartig. Mal dienen die charakteristischen Azulejos als fröhliche Ornamente, dann wieder erzählen sie ganze Geschichten. Der Bahnhof der Provinzstadt Aveiro ist ein besonders geschwätziges Beispiel hierfür: An den Außenwänden sind unzählige Szenen aus der Vergangenheit der Region nachgestellt.

Aveiro

Las fachadas de las casas portuguesas son únicas. A veces los característicos azulejos sirven como alegre decoración, pero también nos cuentan historias enteras. La estación de ferrocarril de la ciudad de Aveiro es un ejemplo particularmente locuaz de ello: en las paredes exteriores se recrean innumerables escenas del pasado de la región.

Aveiro

Le facciate delle case portoghesi sono uniche. A volte i caratteristici azulejos fungono da allegri ornamenti, poi di nuovo raccontano storie. La stazione ferroviaria della città provinciale di Aveiro ne è un esempio particolarmente calzante: sulle pareti esterne sono ricreate innumerevoli scene del passato della regione.

Aveiro

De gevels van Portugese huizen zijn uniek. Soms dienen de karakteristieke tegels, de *azulejos*, als vrolijke ornamenten, dan weer vertellen ze hele verhalen. Het station in de provinciestad Aveiro is daar een bijzonder praatlustig voorbeeld van: op de buitenmuren zijn talloze scènes uit het verleden van de regio nagemaakt.

Aveiro

60 kilometres south of Porto, the water of the ocean penetrates deep into the interior of the country. On the banks of the lagoon lies Aveiro, whose fishermen benefit from the biodiversity of the brackish water. For this purpose they have developed the typical Moliceiros, the boats which rock on the canals and may remind the observer of a certain Italian lagoon city.

Aveiro

À 60 kilomètres au sud de Porto, l'eau de l'océan pénètre profondément à l'intérieur du pays. Sur les rives de cette lagune se trouve Aveiro, dont les pêcheurs bénéficient de la biodiversité des eaux saumâtres. Pour cela, ils ont développé les emblématiques Moliceiros, qui se balancent sur les canaux – et qui rappellent aux observateurs une célèbre ville lagunaire italienne.

Aveiro

60 Kilometer südlich von Porto dringt das Wasser des Ozeans tief ins Landesinnere ein. An den Ufern der Lagune liegt Aveiro, dessen Fischer von der biologischen Vielfalt des Brackwassers profitieren. Hierzu haben sie die typischen Moliceiros entwickelt, die auf den Kanälen schaukeln – und die Beobachter an eine italienische Lagunenstadt erinnern.

Aveiro

A 60 kilómetros al sur de Oporto, el agua del océano penetra profundamente en el interior del país. A orillas de la laguna se encuentra Aveiro, cuyos pescadores se benefician de la biodiversidad de las aguas salobres. Para ello han desarrollado los típicos moliceiros, que se mueven bamboleantes en los canales y recuerdan a los observadores a las ciudades italianas de canales.

Aveiro

A 60 chilometri a sud di Porto, l'acqua dell'oceano penetra in profondità nell'interno del paese. Sulle rive della laguna si trova Aveiro, i cui pescatori approfittano della biodiversità delle acque salmastre. A questo scopo hanno sviluppato i tipici moliceiros, che ondeggiano sui canali e ricordano una città lagunare italiana.

Aveiro

60 kilometer ten zuiden van Porto dringt het water van de oceaan diep door in het binnenland. Aan de oevers van de lagune ligt Aveiro. De vissers uit deze stad profiteren van de biologische verscheidenheid van het brakke water. Voor dit doel hebben ze de moliceiros ontwikkeld die op de grachten deinen – waardoor toeristen zich in een Italiaanse lagunestad wanen.

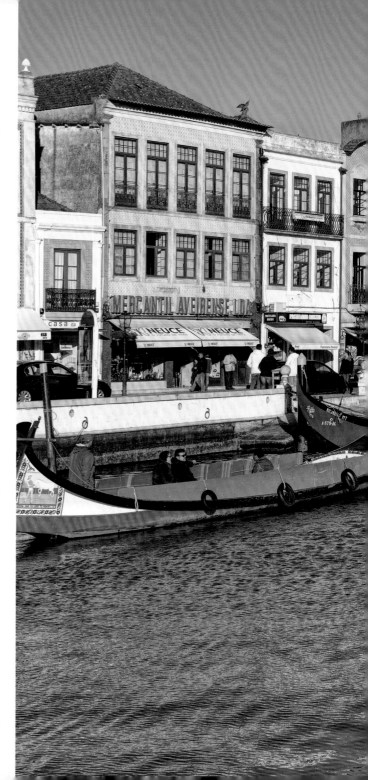

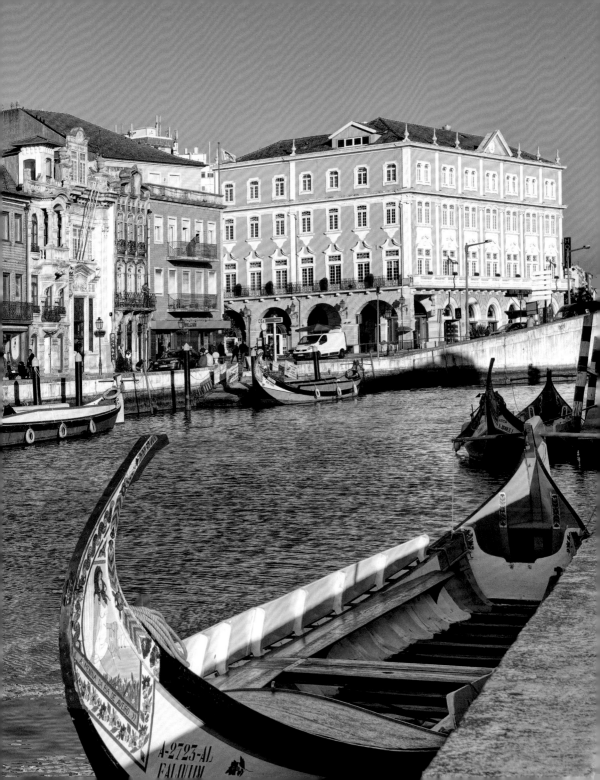

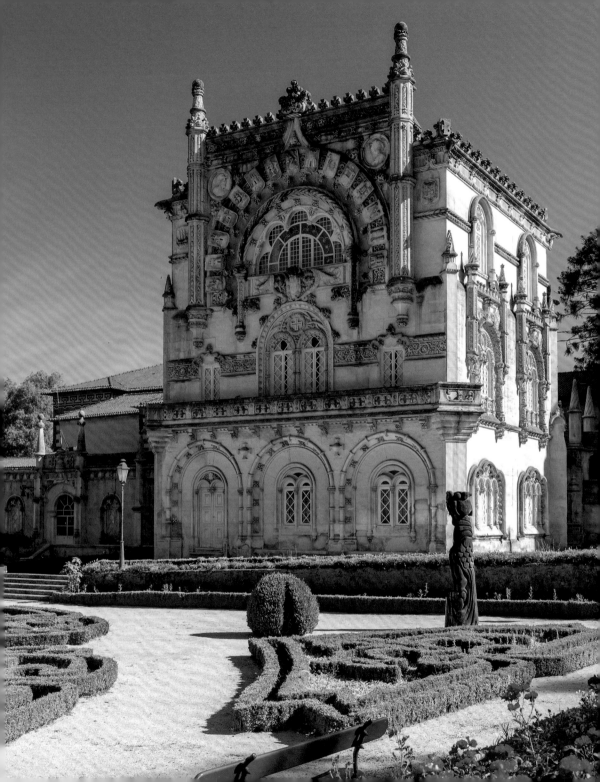

Palácio Hotel do Buçaco, Luso
Bussaco Palace Hotel, Luso

Palácio Hotel do Buçaco, Luso
Bussaco Palace Hotel, Luso

Reserva Natural das Dunas de São Jacinto
São Jacinto Dunes Natural Reserve

São Jacinto

On the peninsula of São Jacinto, nature is largely left to itself. Surrounded by ocean and lagoon, between beach and swamp, and washed by salt, brackish and fresh water, the São Jacinto Dunes Natural Reserve is a valuable habitat for animals and plants. Humans are also permitted to bathe here.

São Jacinto

Sur la péninsule de São Jacinto, la nature est en grande partie livrée à elle-même. Entourée par l'océan et la lagune, entre plage et marais, et lavée par l'eau salée, saumâtre et douce, la Reserva Natural das Dunas de São Jacinto est un habitat précieux pour les animaux et les plantes, mais les visiteurs peuvent également s'y baigner.

São Jacinto

Auf der Halbinsel von São Jacinto ist die Natur weitgehend sich selbst überlassen. Eingerahmt von Ozean und Lagune, zwischen Strand und Sumpf gelegen, und von Salz-, Brack- und Süßwasser umspült, bildet die Reserva Natural das Dunas de São Jacinto einen wertvollen Lebensraum für Tiere und Pflanzen. Auch dem Menschen ist ein Bad ausdrücklich gestattet.

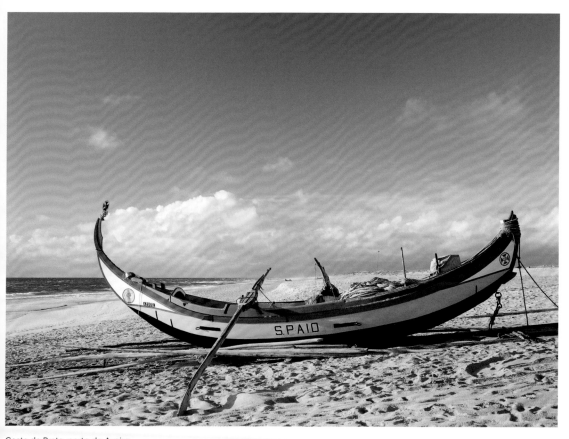

Costa de Prata, perto de Aveiro
Silver Coast, near Aveiro

São Jacinto

En la península de São Jacinto, la naturaleza prospera en gran parte a por sí sola. Rodeada de océano y laguna, entre playa y pantano, y bañada por agua salada, salobre y dulce, la Reserva Natural das Dunas de São Jacinto es un valioso hábitat de animales y plantas. A las personas también les está permitido bañarse.

São Jacinto

Nella penisola di São Jacinto, la natura è in gran parte lasciata a se stessa. Circondata da oceani e lagune, tra spiagge e paludi, bagnata da acque salate, salmastre e dolci, la Reserva Naturale das Dunas de São Jacinto è un prezioso habitat per la flora e la fauna ed è anche balneabile.

São Jacinto

Op het schiereiland São Jacinto wordt de natuur grotendeels aan zichzelf overgelaten. Omgeven door oceaan en lagune, gelegen tussen strand en moeras, en overspoeld door zout, brak en zoet water, vormt de Reserva Natural das Dunas de São Jacinto een waardevolle leefomgeving voor dieren en planten. Ook mensen is het uitdrukkelijk toegestaan een bad te nemen.

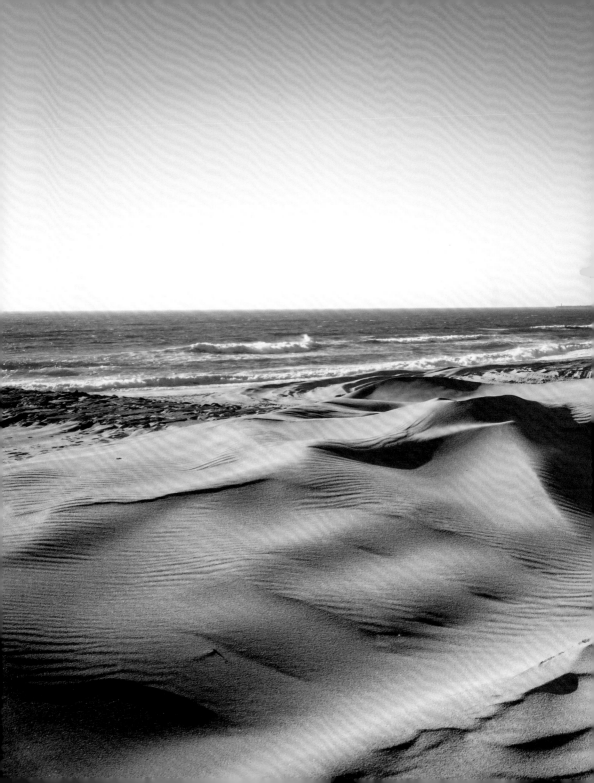

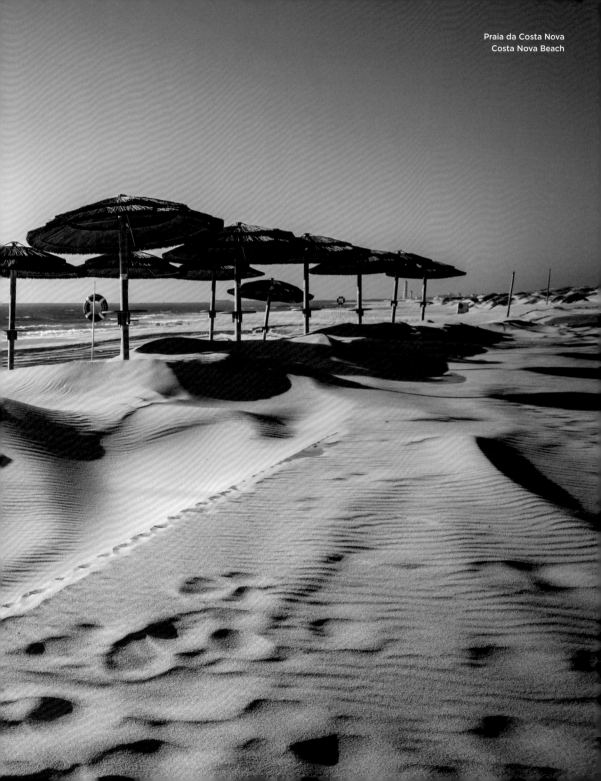

Praia da Costa Nova
Costa Nova Beach

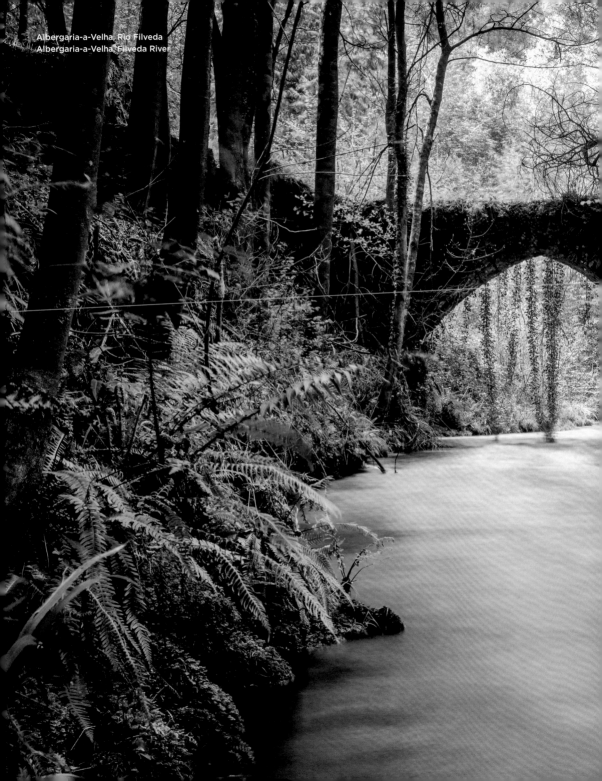
Albergaria-a-Velha, Rio Filveda
Albergaria-a-Velha, Filveda River

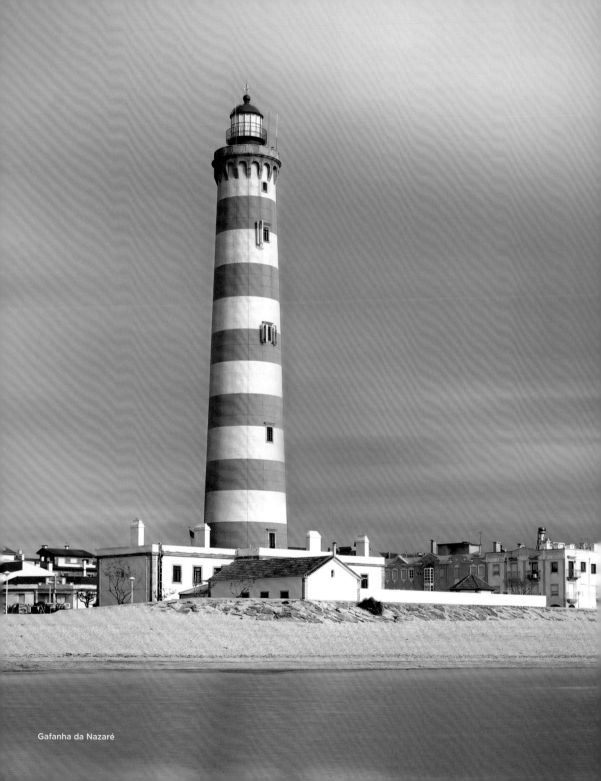

Gafanha da Nazaré

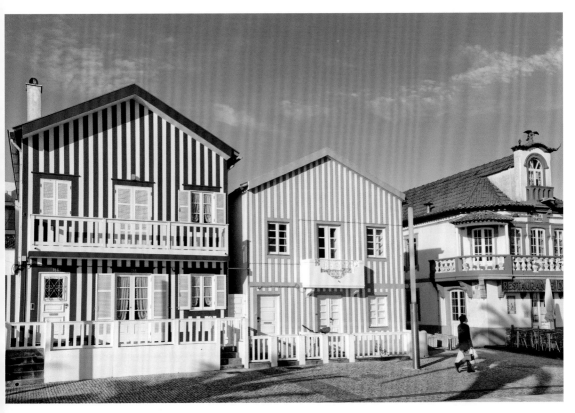

Costa Nova

Costa Nova

Sometimes hoops, sometimes stripes, but always with contrasting colours: the Portuguese like the eye-catching. The maintenance, however, requires some effort, as the untiring Atlantic winds and the salty air quickly degrade the paintwork. A little patina is therefore just as little of a rarity as the proliferating opulence of nature.

Costa Nova

Unies, rayées, de couleurs contrastées : les Portugais aiment attirer l'attention avec les façades des bâtiments. L'entretien, cependant, exige un certain effort, parce que les vents infatigables de l'Atlantique et l'air salé obstruent la peinture. Il est donc courant d'observer une légère patine sur ces façades, tout autant que d'opulentes proliférations de végétation qui les recouvrent parfois entièrement.

Costa Nova

Mal geringelt, mal gestreift und dann wieder farblich abgesetzt: die Portugiesen mögen auffällige Hingucker. Die Pflege allerdings erfordert einigen Einsatz, denn die unermüdlichen Atlantikwinde und die salzhaltige Luft setzen den Anstrichen zu. Ein wenig Patina ist daher ebenso wenig eine Seltenheit, wie die wuchernde Opulenz der Natur.

Costa Nova

Rizado, rayado y para contrastar, de nuevo en color: a los portugueses les gusta lo llamativo. El cuidado, sin embargo, requiere cierto esfuerzo, porque los incansables vientos del Atlántico y el aire salado afectan a la pintura. Un poco de pátina resulta, por lo tanto, tan común, como la proliferación de la opulencia de la naturaleza.

Costa Nova

A volte ad anelli, a volte striati e poi di nuovo con colori contrastanti: i portoghesi amano la vistosità. La cura, tuttavia, richiede un certo sforzo, perché i venti instancabili dell'Atlantico e l'aria salata corrodono la vernice. Una piccola patina è quindi una rarità, quanto l'opulenza proliferante della natura.

Costa Nova

Soms met horizontale lijnen, soms gestreept en dan weer met contrasterende kleuren: de Portugezen houden van blikvangers. Het onderhoud vergt echter enige inspanning, want de onvermoeibare Atlantische wind en de zoute lucht tasten de verf aan. Een beetje patina is dus evenmin een zeldzaamheid als de woekerende weelde van de natuur.

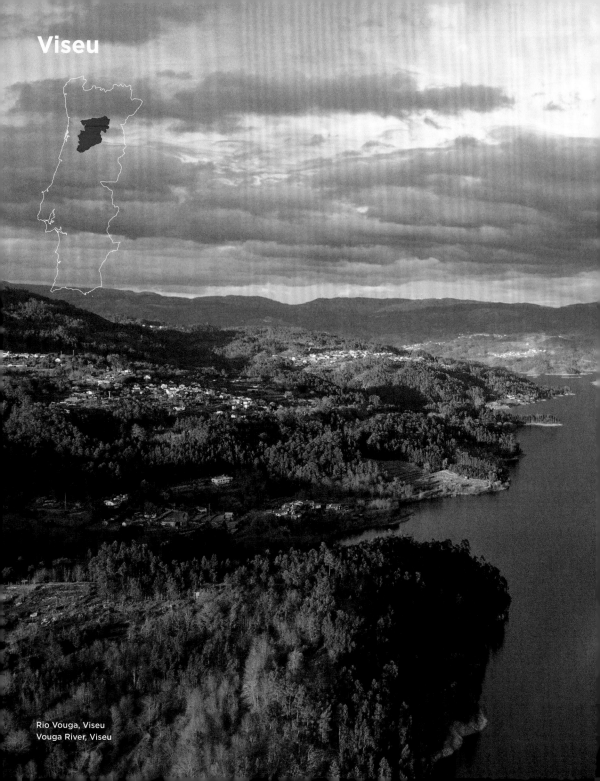

Viseu

Rio Vouga, Viseu
Vouga River, Viseu

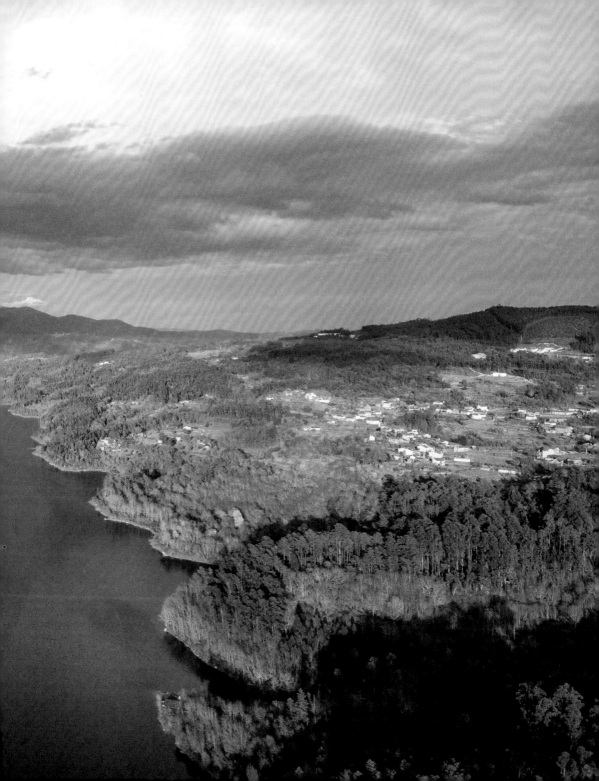

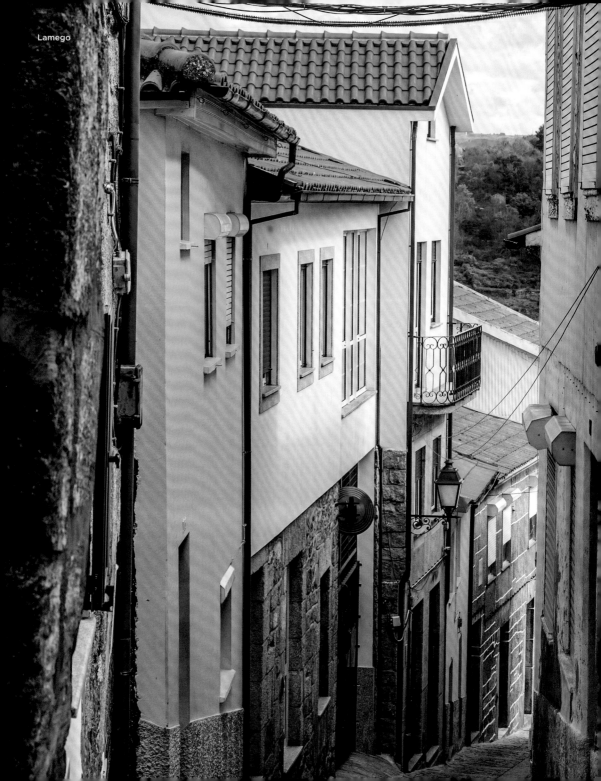
Lamego

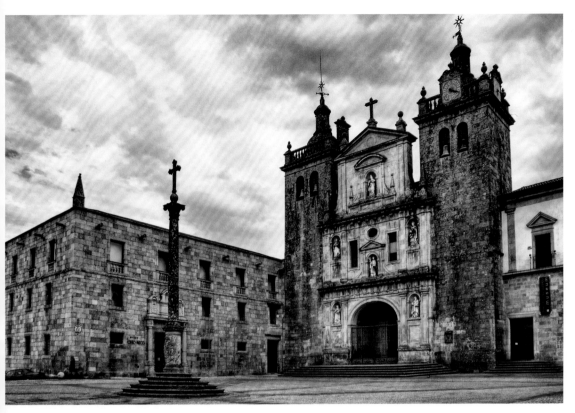

Sé Catedral de Viseu
Viseu Cathedral

Viseu

The sacral buildings of Viseu reflect a history that stretches back to the Middle Ages. The core of the city, founded with the royal approval of a foral in 1123, is not a car friendly zone! The countryside surrounding Viseu is fertile, with the Dão Valley being the second most important wine growing region. Full-bodied red wines thrive on the granite soils, with many formidable old castle overseeing the region.

Viseu

Les bâtiments sacrés de Viseu reflètent une histoire qui remonte au Moyen Âge. Le cœur de la ville, fondée en 1123, n'est plus adapté à l'automobile. Mais la campagne environnante est fertile : la vallée du Dão est la deuxième région viticole la plus importante. Les vins rouges corsés s'épanouissent sur les sols granitiques. sous la surveillance de nombreux châteaux forts.

Viseu

Die Sakralbauten von Viseu sind der Spiegel einer Historie, die weit ins Mittelalter zurückreicht. Autofreundlich wird der Kern der 1123 gegründeten Stadt nicht mehr. Dafür ist das Umland fruchtbar: Das Dão-Tal ist das zweitwichtigste Anbaugebiet für Wein. Auf den Granitböden gedeihen körperreiche Rotweine. Manch trutziges Kastell dient der Überwachung.

Viseu

Los edificios sacros de Viseu reflejan una historia que se remonta a la Edad Media. El centro de esta ciudad, que se fundó en 1123, ya no es un buen lugar para ir en coche, pero el campo circundante es fértil: el valle del Dão es la segunda región vitivinícola más importante. En los suelos graníticos prosperan vinos tintos con cuerpo. Algunos impresionantes fuertes se usan para la vigilancia.

Viseu

Gli edifici sacri di Viseu rispecchiano una storia che risale al Medioevo. Il cuore della città fondata nel 1123 non è aperto al traffico. La campagna circostante è fertile: la Valle del Dão è la seconda regione vinicola più importante. Sui terreni di granito prosperano vigneti per vini rossi corposi. Alcuni imponenti castelli sorvegliano il paesaggio.

Viseu

De sacrale gebouwen van Viseu weerspiegelen een geschiedenis die teruggaat tot ver in de middeleeuwen. De kern van de in 112 gestichte stad zal nooit meer autovriendelijk worden. Maar het omringende landschap is vruchtbaar: de Dão-vallei is het op één na belangrijkste wijnbouwgebied. Op de granieten bodem gedijen volle rode wijnen. Menig machtig kasteel houdt toezicht.

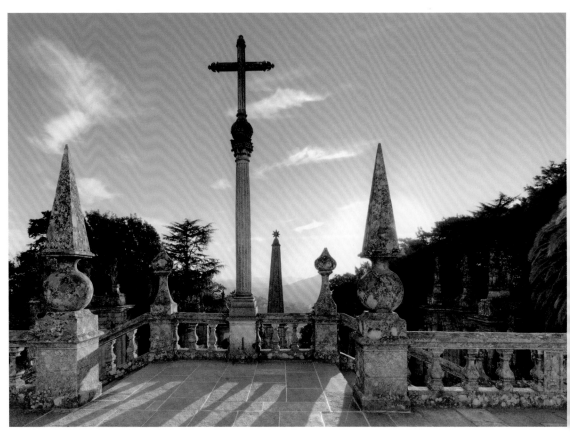

Santuário de Nossa Senhora dos Remédios, Lamego
Nossa Senhora dos Remédios Sanctuary, Lamego

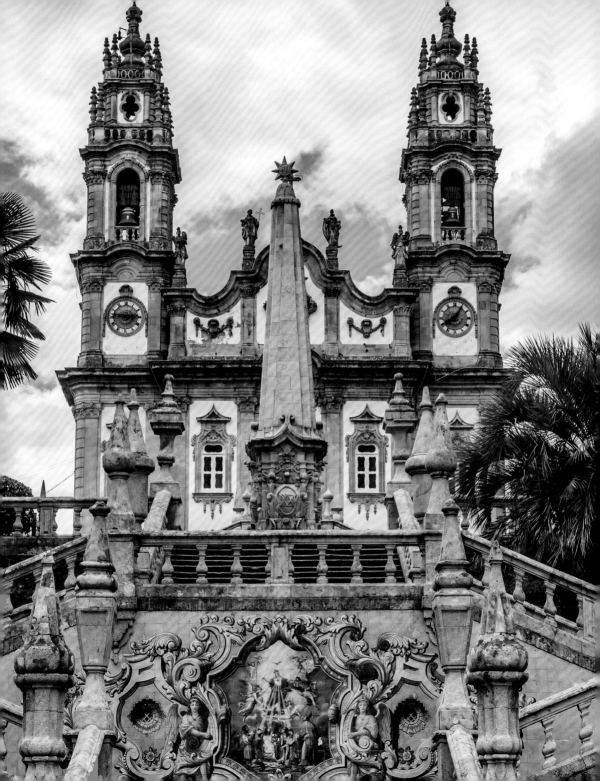

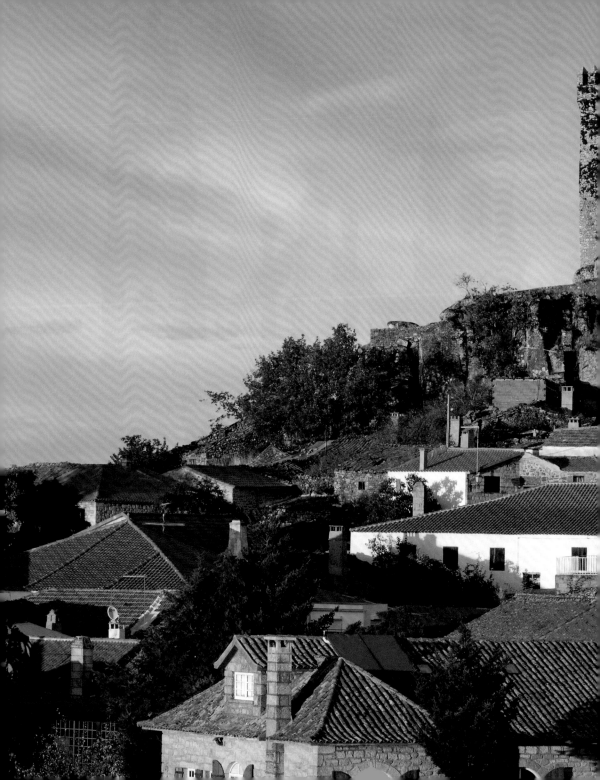

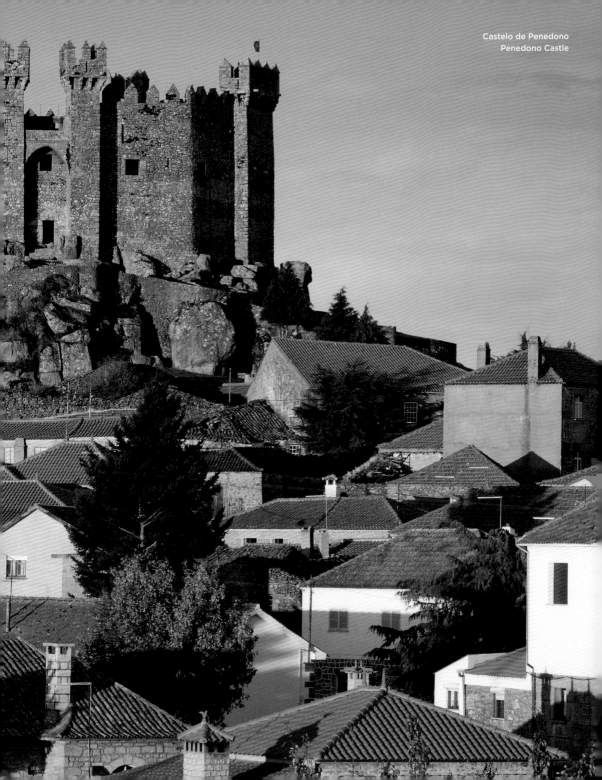

Castelo de Penedono
Penedono Castle

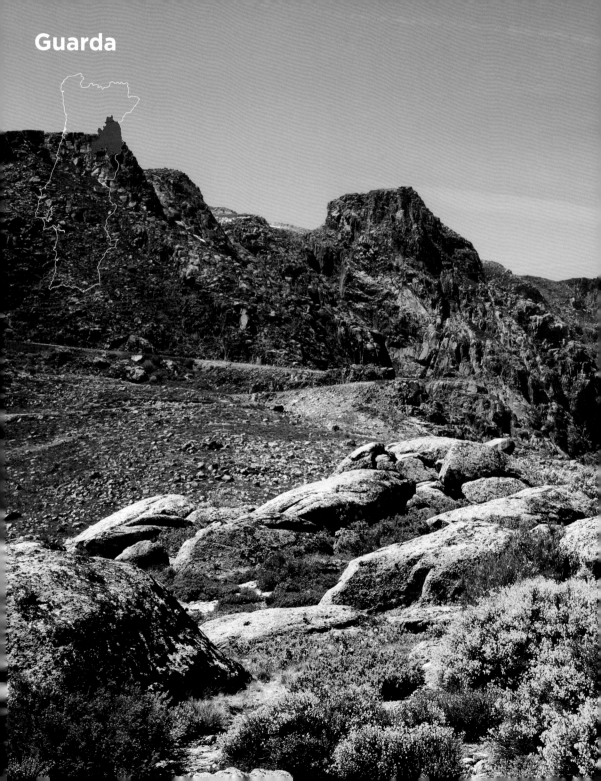

Guarda

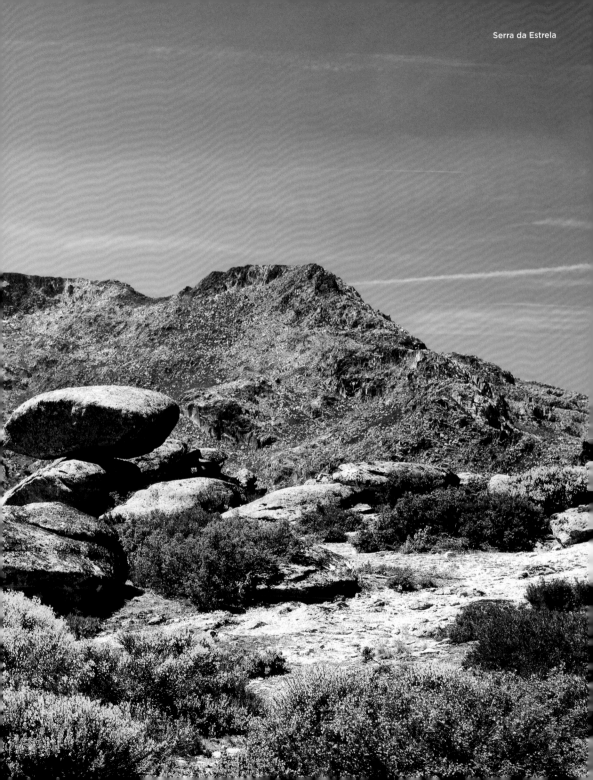

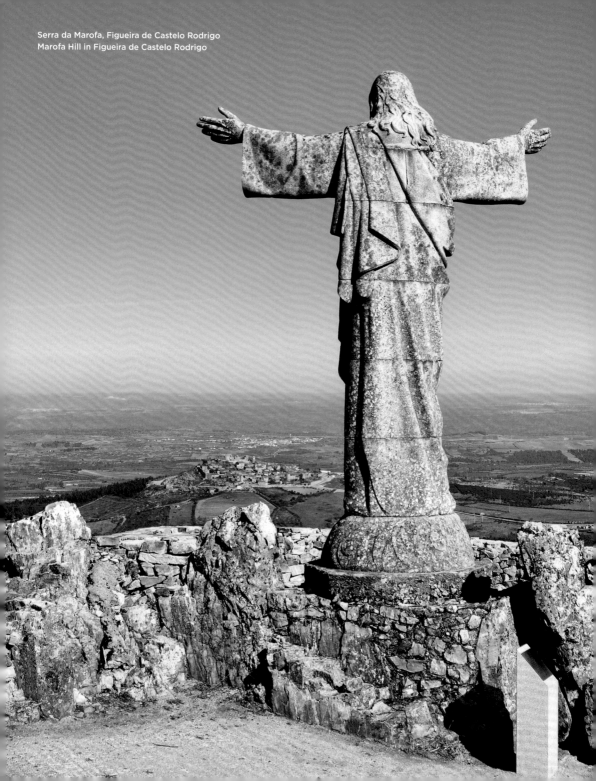

Parque Natural do Douro Internacional, Figueira de Castelo Rodrigo
International Douro Natural Park, Figueira de Castelo Rodrigo

Guarda
In the east, Portugal shows its forbidding side, where the cross-border International Douro Natural Park is home to high plateaus, and whose inhabitants protect themselves from the high winds by building walls. At 1056 metres above sea level, Guarda is the highest town on the Portuguese mainland. Further south, the mountains of the Serra da Estrela reach up to the two thousand meter mark.

Guarda
Im Osten zeigt sich Portugal von seiner spröden Seite: Der grenzübergreifende Naturpark Douro beherbergt Hochplateaus, deren Bewohner sich durch den Bau von Mauern vor dem Wind schützen. Mit 1056 Metern über dem Meeresspiegel ist Guarda die höchstgelegene Stadt des Landes. Weiter südlich kratzt die Serra da Estrela gar an der Zweitausendmetermarke.

Guarda
A est, il Portogallo mostra il suo lato brusco: il parco naturale transfrontaliero del Duero ospita altipiani i cui abitanti si proteggono dal vento costruendo muri. A 1056 metri sopra il livello del mare, Guarda è la città più alta del paese. Più a sud, la Serra da Estrela raggiunge i duemila metri.

Guarda
À l'est, le Portugal montre son côté fragile : le parc naturel transfrontalier du Douro abrite de hauts plateaux sur lesquels les habitants se protègent du vent en construisant des murs. À 1056 mètres au-dessus du niveau de la mer, Guarda est la ville la plus élevée du pays. Plus au sud, la Serra da Estrela s'approche même de la barre des deux mille mètres.

Guarda
En el este, Portugal muestra su lado frágil: el parque natural transfronterizo del Duero alberga altiplanos cuyos habitantes se protegen del viento construyendo muros. A 1056 metros sobre el nivel del mar, Guarda es la ciudad más alta del país. Más al sur, la Serra da Estrela está incluso rayando la marca de los dos mil metros.

Guarda
In het oosten laat Portugal zijn droge kant zien: het grensoverschrijdende natuurgebied Douro herbergt hoogvlakten waar de bewoners zich door de bouw van muren tegen de wind beschermen. Met 1056 meter boven de zeespiegel is Guarda de hoogstgelegen stad van het land. Verder naar het zuiden haalt de Serra da Estrela zelfs bijna de 2000 meter.

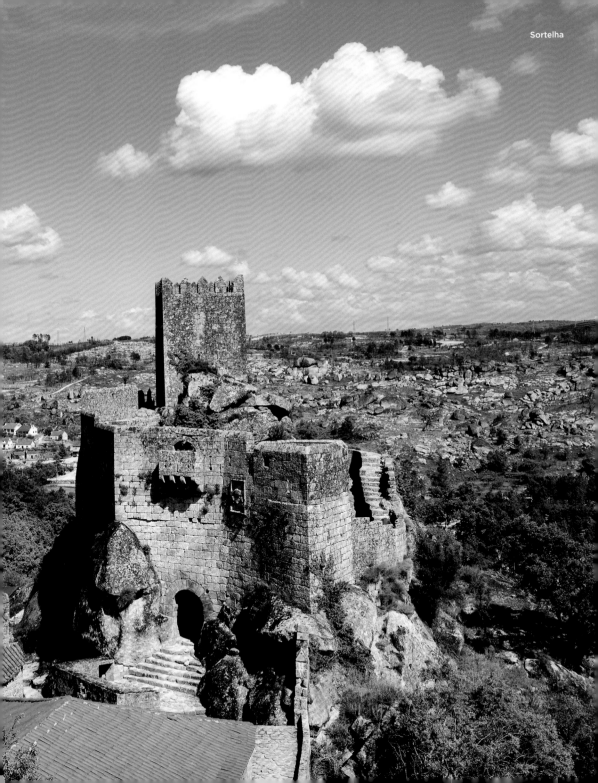

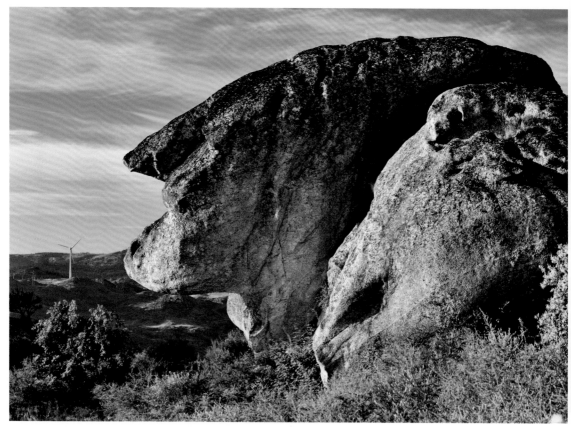

Cabeça da Velha, formação granítica, Serra da Estrela
Granite rock with profile of an old woman, Serra da Estrela

Vale do Côa

The villages around the town of Guarda
have an almost ancient aura. Compared
to the rock paintings in the Vale do Côa
Archaeological Park, however, they seem to
have sprung up yesterday. Archaeologists
estimate the petroglyphs to be more than
25,000 years old.

Vale do Côa

Les villages autour de la ville de Guarda
dégagent une atmosphère surannée.
Pourtant, en comparaison avec les
peintures rupestres du parc archéologique
de Vale do Côa, elles sont assez récentes :
les scientifiques estiment en effet l'âge des
pétroglyphes à plus de 25 000 ans.

Vale do Côa

Die Dörfer rund um das Städtchen Guarda
besitzen eine fast schon altertümliche
Aura. Im Vergleich zu den Felsmalereien
im Archäologischen Park Vale do Côa aber
mutet das nur wie ein Wimpernschlag
an: Das Alter der Petroglyphen schätzen
Wissenschaftler auf mehr als 25 000 Jahre.

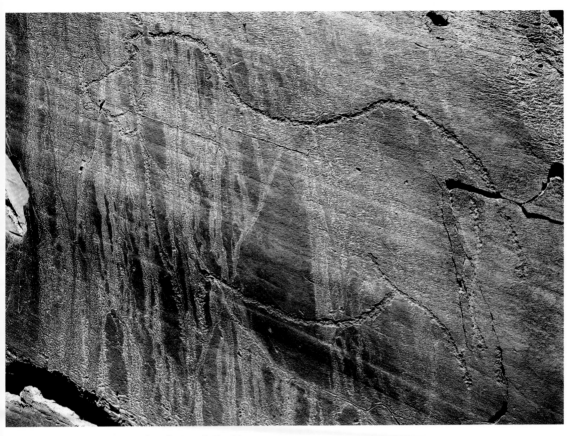

Parque Arqueológico do Vale do Côa, Vila Nova de Foz Côa
Côa Valley Archaeological Park, Vila Nova de Foz Côa

Vale do Côa

Los pueblos que rodean la ciudad de Guarda tienen un aura casi remota. Sin embargo, en comparación con las pinturas rupestres del Parque Arqueológico del Vale do Côa, sólo parece un parpadeo: Los científicos estiman que los petroglifos tienen más de 25 000 años.

Valle do Côa

I villaggi intorno alla città di Guarda hanno un'essenza quasi antica. Rispetto alle incisioni rupestri del Parco Archeologico delle Vale do Côa, tuttavia, questo sembra solo un battito di ciglia: gli studiosi stimano l'età dei petroglifi a più di 25 000 anni.

Vale do Côa

De dorpen rond het stadje Guarda hebben een bijna antieke uitstraling. Vergeleken met de rotstekeningen in het archeologisch park van Vale do Côa lijkt dat echter nog maar een ogenblik geleden: wetenschappers schatten de leeftijd van deze petrogliefen op meer dan 25 000 jaar.

Sortelha

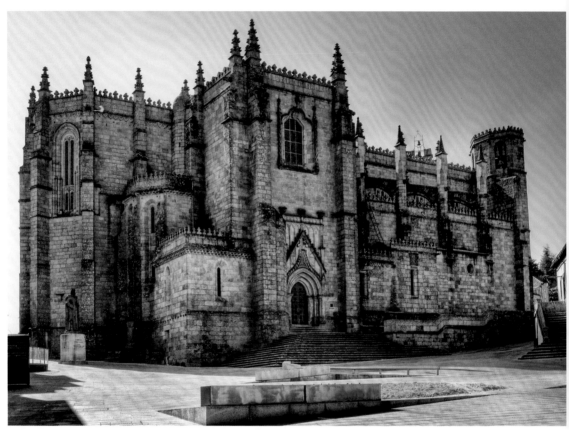

Sé Catedral da Guarda
Guarda Cathedral

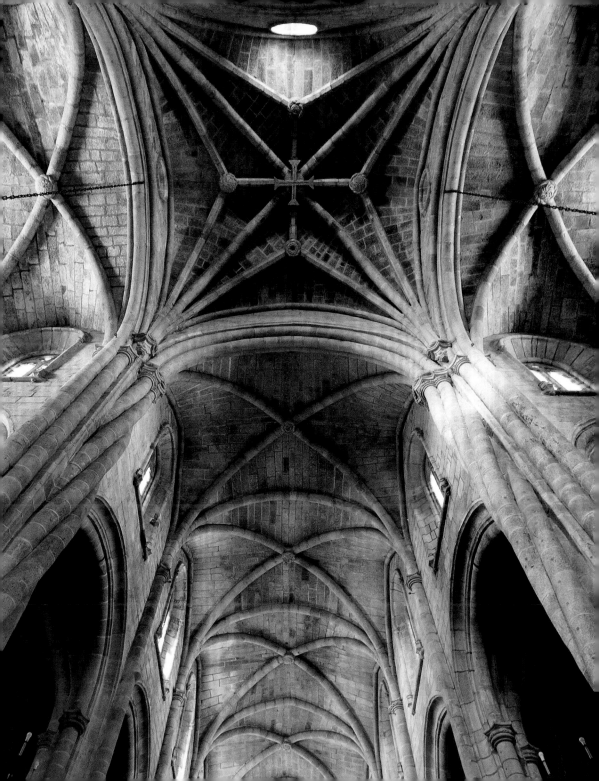

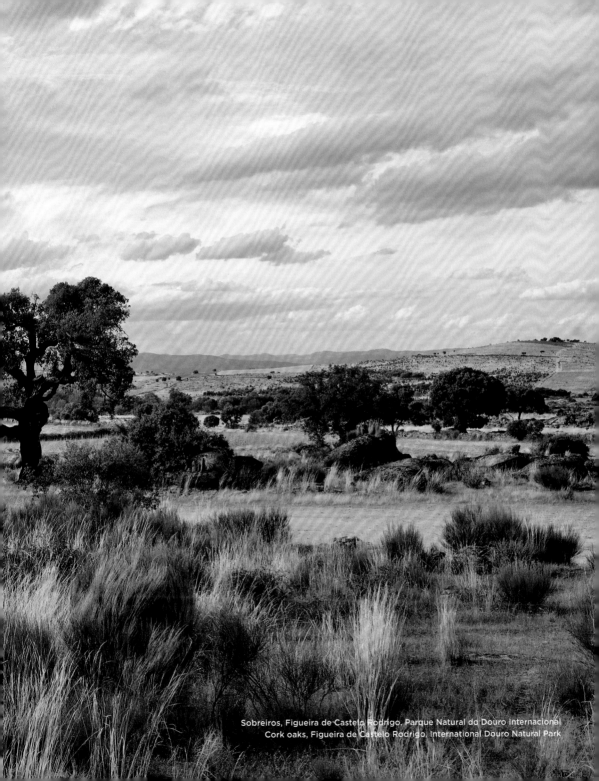

Sobreiros, Figueira de Castelo Rodrigo. Parque Natural do Douro Internacional
Cork oaks, Figueira de Castelo Rodrigo. International Douro Natural Park

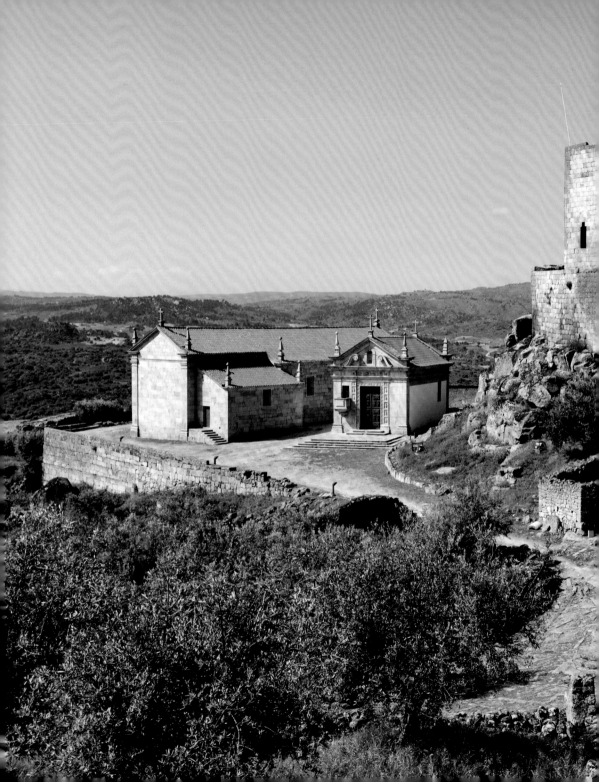

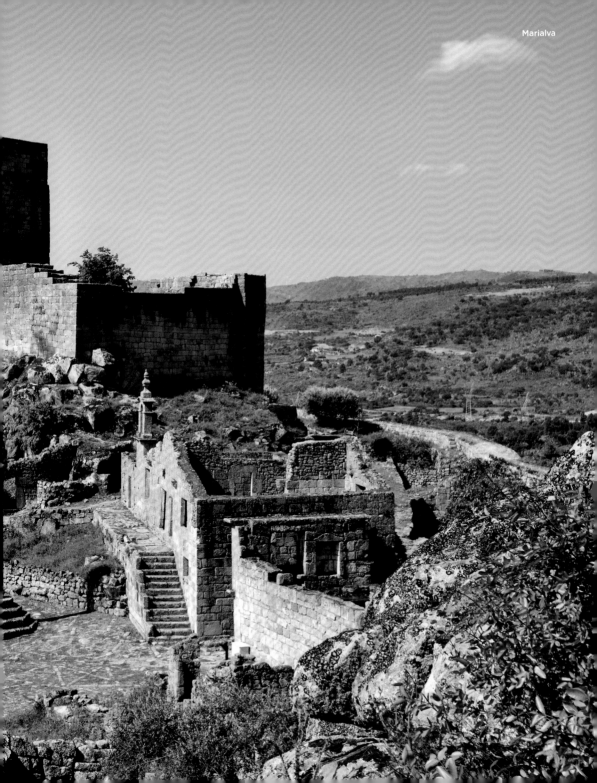

Marialva

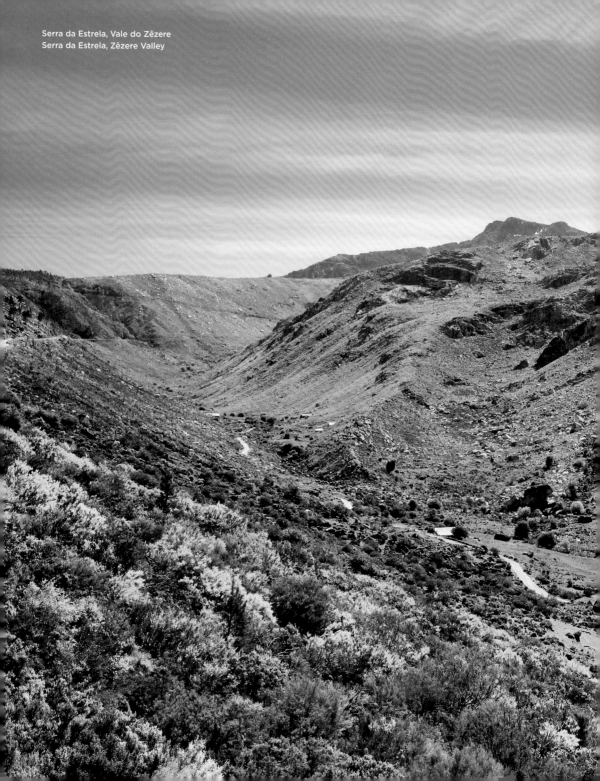

Serra da Estrela, Vale do Zêzere
Serra da Estrela, Zêzere Valley

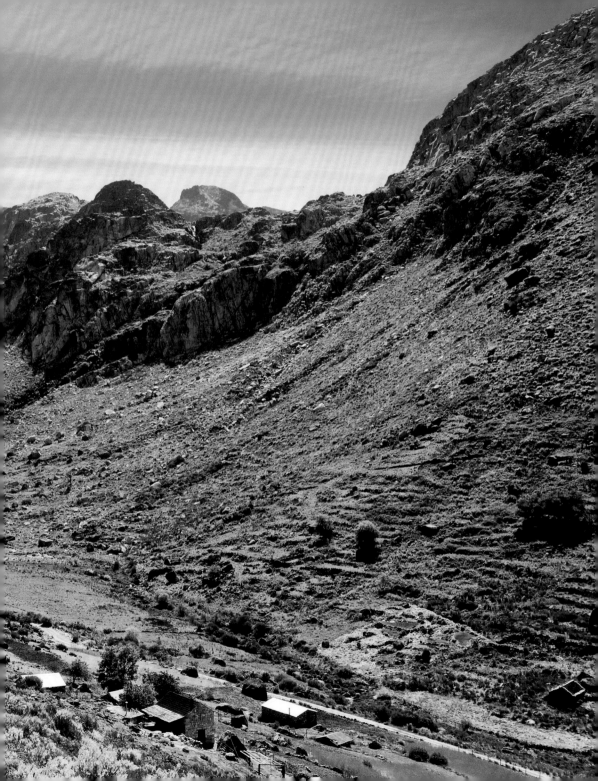

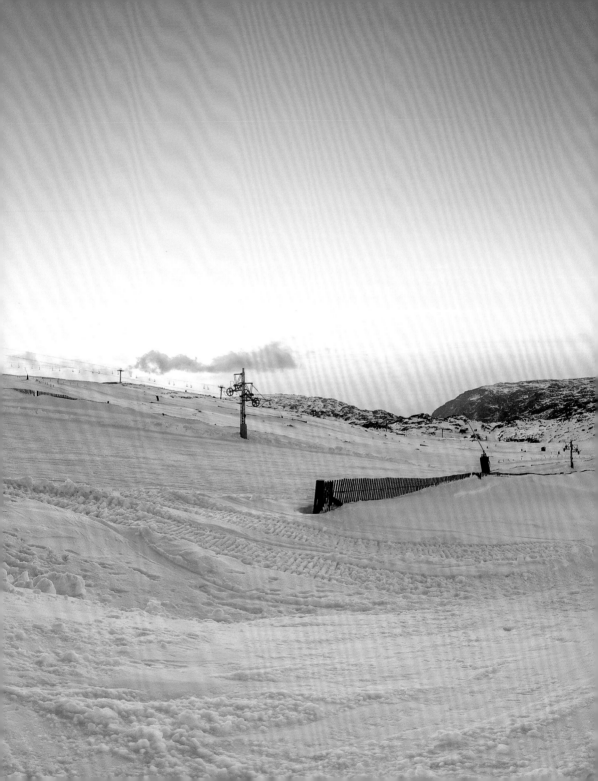

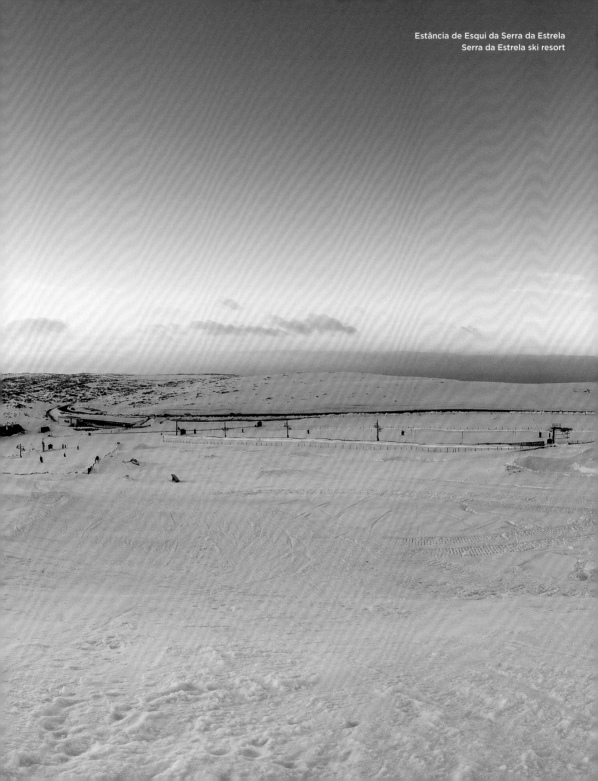

Estância de Esqui da Serra da Estrela
Serra da Estrela ski resort

Coimbra

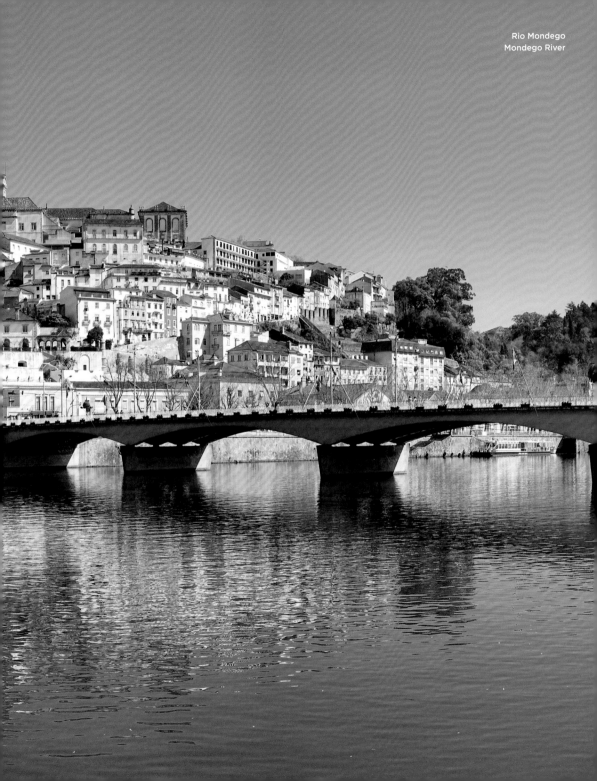

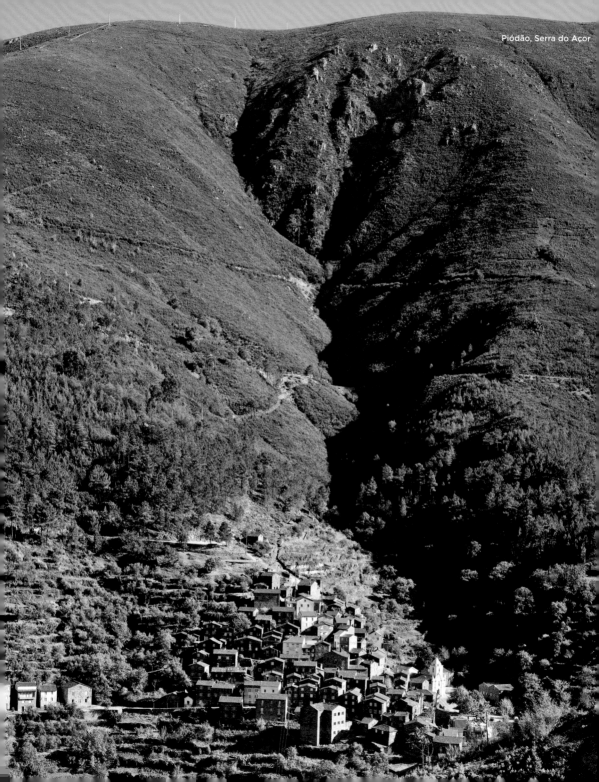
Piódão, Serra do Açor

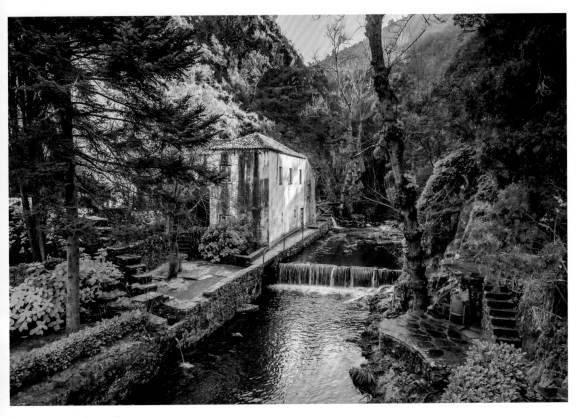

Casa Velha, perto da Lousã
Old house near Lousã

Coimbra

The former capital is picturesquely situated on the Rio Mondego. Since the oldest university was moved here from Lisbon in 1308, the history of the city has been closely linked to science and academic advancement.

Coimbra

L'ancienne capitale pittoresque est située sur le Rio Mondego. Depuis que la plus ancienne université y a été déplacée depuis Lisbonne, l'histoire de la ville a été étroitement liée à la science et au progrès académique.

Coimbra

Mit seinen weiß getünchten Häusern ist Coimbra ein Blickfang. Die ehemalige Hauptstadt liegt malerisch am Rio Mondego. Seit die älteste Universität 1308 von Lissabon hierher verlegt wurde, ist die Geschichte der Stadt eng verknüpft mit Wissenschaft und Fortschritt.

Coimbra

Con sus casas encaladas, Coimbra es un punto de atracción. La antigua capital está situada en el Río Mondego, lo que le da un aspecto muy pintoresco. Desde que en 1308 se trasladó la universidad más antigua de Lisboa aquí, la historia de la ciudad ha estado estrechamente ligada a la ciencia y al progreso.

Coimbra

Coimbra è una città che attira gli sguardi con le sue case imbiancate. L'ex capitale è situata in una posizione pittoresca sul Rio Mondego. Dal momento che la più antica università è stata trasferita qui da Lisbona nel 1308, la storia della città è stata strettamente legata alla scienza e al progresso.

Coimbra

Coimbra is een blikvanger met zijn witgekalkte huizen. De voormalige hoofdstad is schilderachtig gelegen aan de Rio Mondego. Sinds de oudste universiteit hier in 1308 uit Lissabon werd verhuisd, is de geschiedenis van de stad nauw verbonden met wetenschap en vooruitgang.

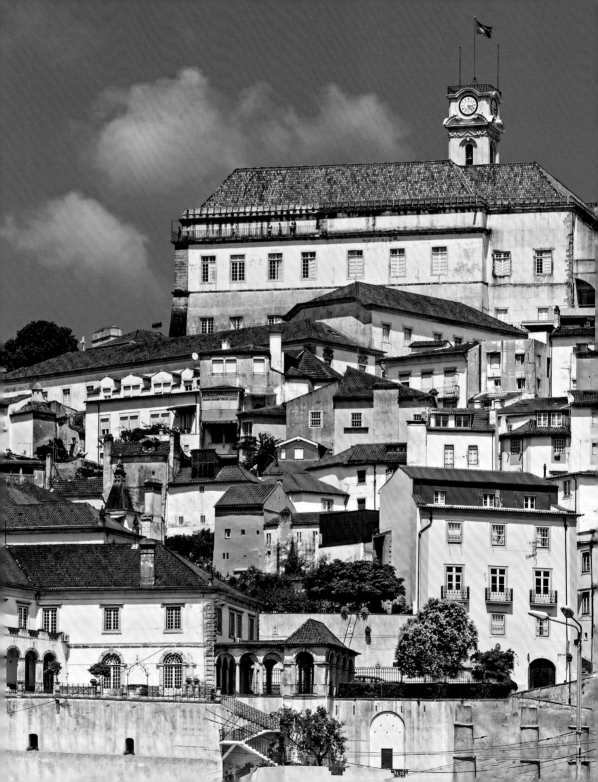

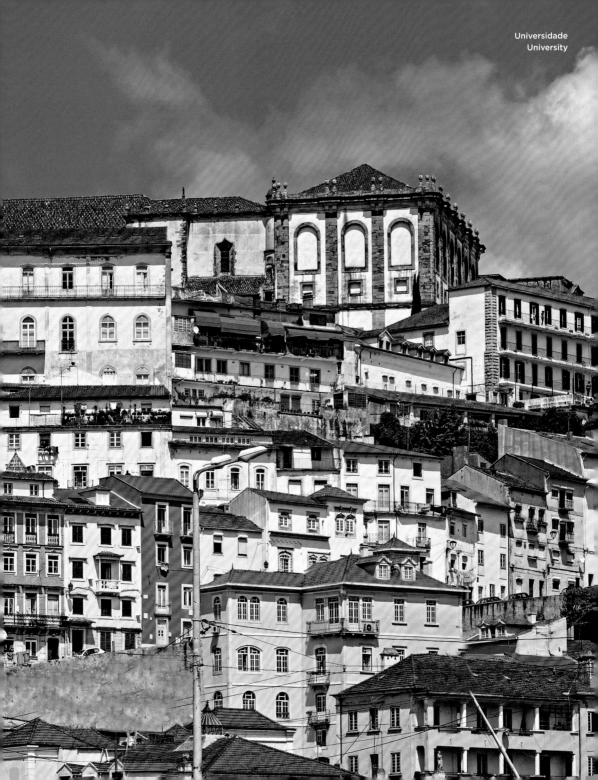

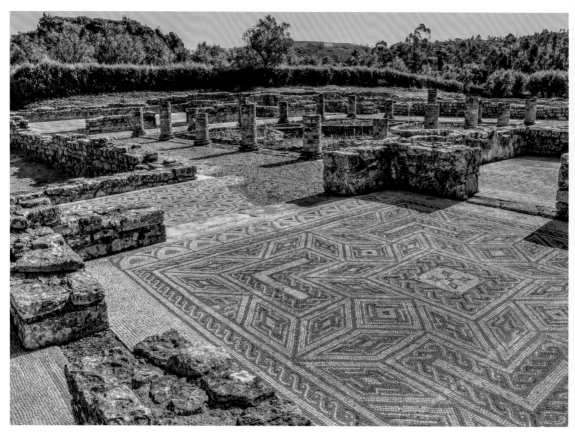

Conímbriga

Conímbriga

Situated on an old trade route between Olissipo (Lisbon) and Bracara Augusta (Braga), Conímbriga was an important Roman transit point. Situated to the southwest of Coimbra, some of its landmarks have been saved to the present day, and are among the most impressive remains of their kind on the Iberian Peninsula.

Conimbriga

Située sur une ancienne route commerciale entre Olissipo (Lisbonne) et Bracara Augusta (Braga), Conimbriga (Coimbra) fut très tôt un important point de transit. Au sud-ouest de la ville, certains vestiges ont été préservés jusqu'à aujourd'hui. Ces ruines romaines sont parmi les plus impressionnantes dans leur genre de toute la péninsule ibérique.

Conímbriga

An einer alten Handelsstraße zwischen Olissipo (Lissabon) und Bracara Augusta (Braga) gelegen, war Conímbriga (Coimbra) schon früh eine wichtige Durchgangsstation. Südwestlich der Stadt konnten einige ihrer Landmarken in die Gegenwart gerettet werden. Sie gehören zu den imposantesten ihrer Art auf der iberischen Halbinsel.

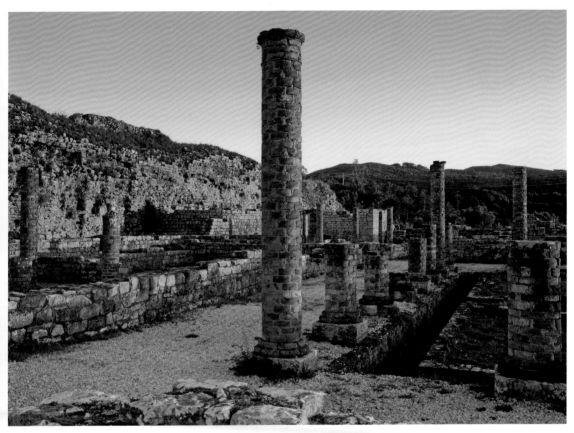

Conímbriga

Conímbriga

Situada en una antigua ruta comercial entre Olissipo (Lisboa) y Bracara Augusta (Braga), Conímbriga (Coimbra) fue desde muy pronto un importante punto de tránsito. Al suroeste de la ciudad, algunos de sus hitos han sido salvados hasta el día de hoy. Se encuentran entre los más impresionantes de su clase en la Península Ibérica.

Conímbriga

Situata su un'antica via commerciale tra Olissipo (Lisbona) e Bracara Augusta (Braga), Conímbriga (Coimbra) era un importante punto di transito iniziale. A sud-ovest della città, alcuni dei suoi punti di riferimento sono arrivati fino ai giorni nostri. Sono tra i più imponenti del loro genere nella penisola iberica.

Conímbriga

Conímbriga (Coimbra), gelegen aan een oude handelsroute tussen Olissipo (Lissabon) en Bracara Augusta (Braga), was al vroeg een belangrijk doorgangsstation. Ten zuidwesten van de stad zijn enkele bezienswaardigheden tot op heden bewaard gebleven. Ze behoren tot de indrukwekkendste in hun soort op het Iberisch schiereiland.

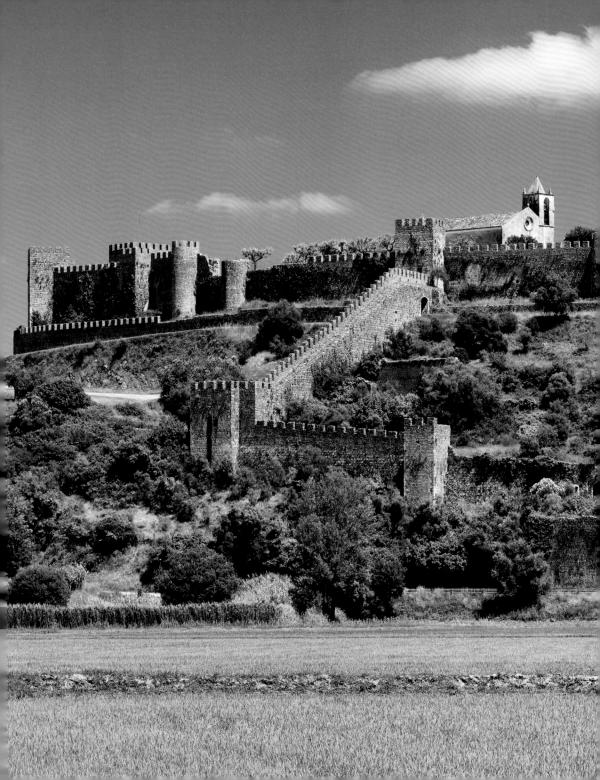

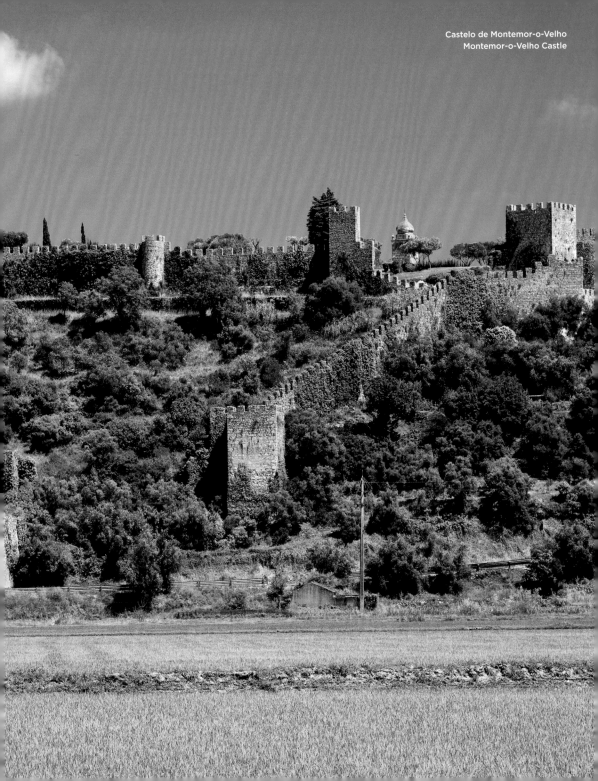

Praia da Figueira da Foz
Figueira da Foz Beach

Montemor-o-Velho

On the way from Coimbra to its mouth at Figueira da Foz, the Mondego River passes the pretty village of Montemor-o-Velho. A spacious 12th century castle watches over the fields of rice below. Finally, the river reaches the sea, with its flowery shifting dunes seemingly untouchable—at least as long as the ocean keeps its temperament under control.

Montemor-o-Velho

Sur le chemin de Coimbra, à l'embouchure de Figueira da Foz, le Rio Mondego passe par le joli village de Montemor-o-Velho. Un spacieux château du XIIᵉ siècle veille sur les champs plantés de riz, et la plage aux dunes fleuries semble intouchable – du moins tant que l'océan reste calme.

Montemor-o-Velho

Auf dem Weg von Coimbra zur Mündung bei Figueira da Foz passiert der Rio Mondego das hübsche Dorf Montemor-o-Velho. Über den mit Reis bepflanzten Feldern wacht ein weitläufiges Schloss aus dem 12. Jh. Auch der Strand mit seinen blumenreichen Wanderdünen scheint unantastbar – zumindest solange, wie der Ozean sein Temperament zügelt.

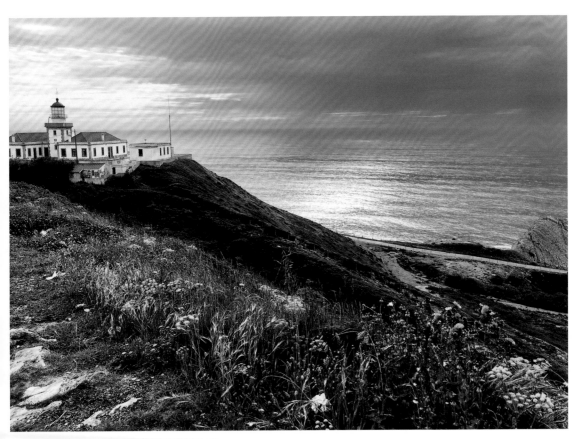

Figueira da Foz

Montemor-o-Velho

En el camino de Coimbra a la desembocadura de Figueira da Foz, el Río Mondego pasa por el bonito pueblo de Montemor-o-Velho. Un espacioso castillo del siglo XII vigila los campos de arroz, y la playa, con sus florecientes dunas movedizas, también parece intocable, al menos mientras el océano mantenga su temperamento bajo control.

Montemor-o-Velho

Sulla strada che da Coimbra porta alla foce di Figueira da Foz, il Rio Mondego passa per il grazioso villaggio di Montemor-o-Velho. Un ampio castello del XII secolo sorveglia i campi coltivati a riso, e anche la spiaggia con le sue dune fiorite sembra intoccabile – almeno finché l'oceano manterrà sotto controllo la sua indole.

Montemor-o-Velho

Op weg van Coimbra naar de monding bij Figueira da Foz passeert de Rio Mondego het mooie dorpje Montemor-o-Velho. Een uitgestrekt kasteel uit de 12e eeuw waakt over de met rijst beplante velden. Ook het strand met zijn stuifduinen vol bloemen lijkt onaantastbaar – in elk geval zolang de oceaan zijn temperament onder controle heeft.

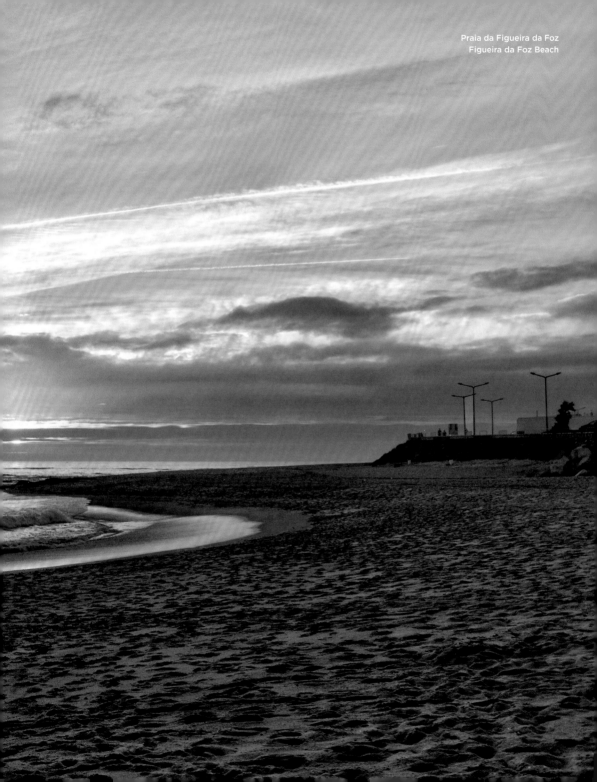

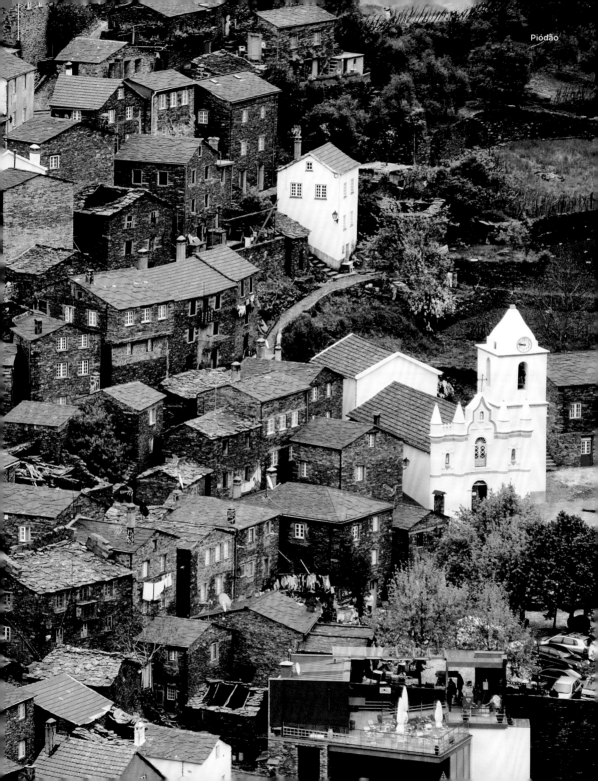

Piódão

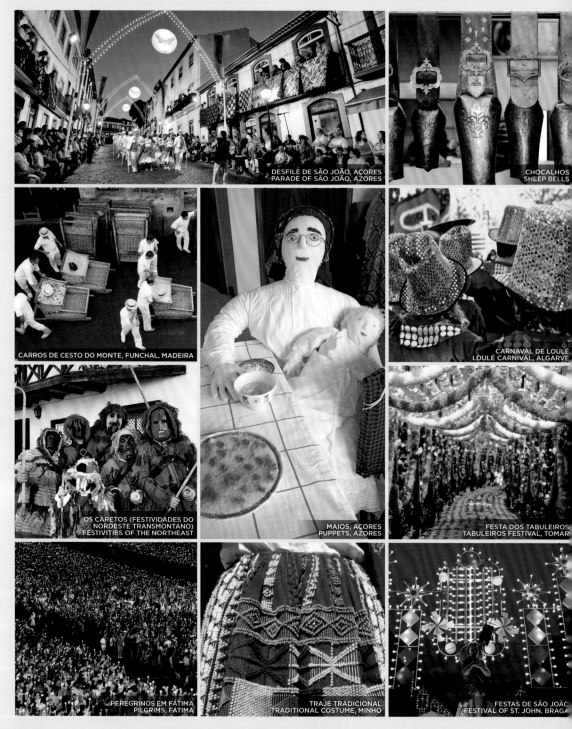

DESFILE DE SÃO JOÃO, AÇORES
PARADE OF SÃO JOÃO, AZORES

CHOCALHOS
SHEEP BELLS

CARROS DE CESTO DO MONTE, FUNCHAL, MADEIRA

CARNAVAL DE LOULÉ
LOULÉ CARNIVAL, ALGARVE

OS CARETOS (FESTIVIDADES DO
NORDESTE TRANSMONTANO)
FESTIVITIES OF THE NORTHEAST

MAIOS, AÇORES
PUPPETS, AZORES

FESTA DOS TABULEIROS
TABULEIROS FESTIVAL, TOMAR

PEREGRINOS EM FÁTIMA
PILGRIMS, FATIMA

TRAJE TRADICIONAL
TRADITIONAL COSTUME, MINHO

FESTAS DE SÃO JOÃO
FESTIVAL OF ST. JOHN, BRAGA

148

ESCOLA PORTUGUESA DE ARTE EQUESTRE LISBOA
PORTUGUESE SCHOOL OF EQUESTRIAN ART

VIANA DO CASTELO

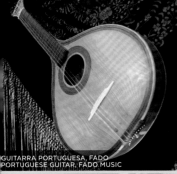

GUITARRA PORTUGUESA, FADO
PORTUGUESE GUITAR, FADO MUSIC

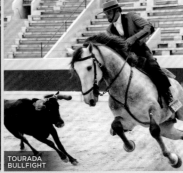

TOURADA
BULLFIGHT

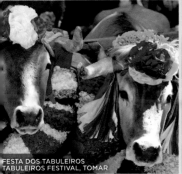

FESTA DOS TABULEIROS
TABULEIROS FESTIVAL, TOMAR

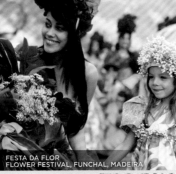

FESTA DA FLOR
FLOWER FESTIVAL, FUNCHAL, MADEIRA

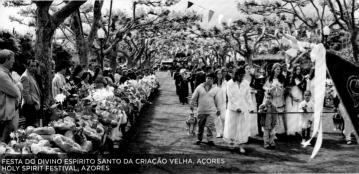

FESTA DO DIVINO ESPÍRITO SANTO DA CRIAÇÃO VELHA, AÇORES
HOLY SPIRIT FESTIVAL, AZORES

Traditions

The Portuguese are proud of their traditions. The inhabitants of Loulé follow their carnival traditions and the people of Viana do Castelo take care of their traditional costumes . Religious processions and folkloric festivals are a large part of the annual cycle. Melancholy, which finds its perfect expression in *fado* music, enjoys particular significance.

Traditions

Les Portugais sont fiers de leurs traditions. Ainsi, les habitants de Loulé s'occupent du carnaval et des costumes de Viana do Castelo. Les processions religieuses et les fêtes folkloriques font également partie du cycle annuel. Une importance particulière est attachée à la mélancolie qui trouve son expression parfaite dans le fado.

Traditionen

Die Portugiesen sind stolz auf ihre Traditionen. Die Bewohner von Loulé pflegen den Karneval und die von Viana do Castelo ihre Trachten. Religiöse Prozessionen und Volksfeste strukturieren den Jahreszyklus. Besonderen Stellenwert genießt die Melancholie, die im Fado ihren formvollendeten Ausdruck findet.

Tradiciones

Los portugueses están orgullosos de sus tradiciones. Por eso los habitantes de Loulé cuidan el carnaval y los trajes regionales de Viana do Castelo. Las procesiones religiosas y los festivales folclóricos también forman parte del ciclo anual. La melancolía, que encuentra su perfecta expresión en el fado, tiene un significado especial.

Tradizioni

I portoghesi sono orgogliosi delle loro tradizioni. Gli abitanti di Loulé portano avanti quelle del carnevale e dei costumi popolari di Viana do Castelo. Anche le processioni religiose e le feste folcloristiche fanno parte del ciclo annuale di festeggiamenti. La malinconia, che trova la sua perfetta espressione nel fado, ha un significato particolare.

Tradities

De Portugezen zijn trots op hun tradities. De inwoners van Loulé koesteren dan ook hun carnaval en die van Viana do Castelo hun klederdracht. Religieuze processies en folkloristische feesten maken eveneens deel uit van de jaarcyclus. Melancholie, een gevoel dat in de fado perfect tot uitdrukking komt, heeft een bijzondere betekenis.

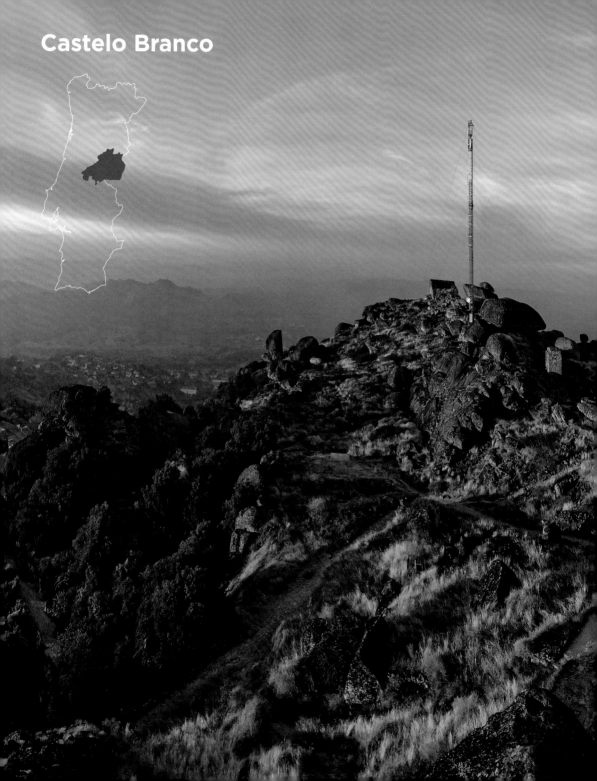
Castelo Branco

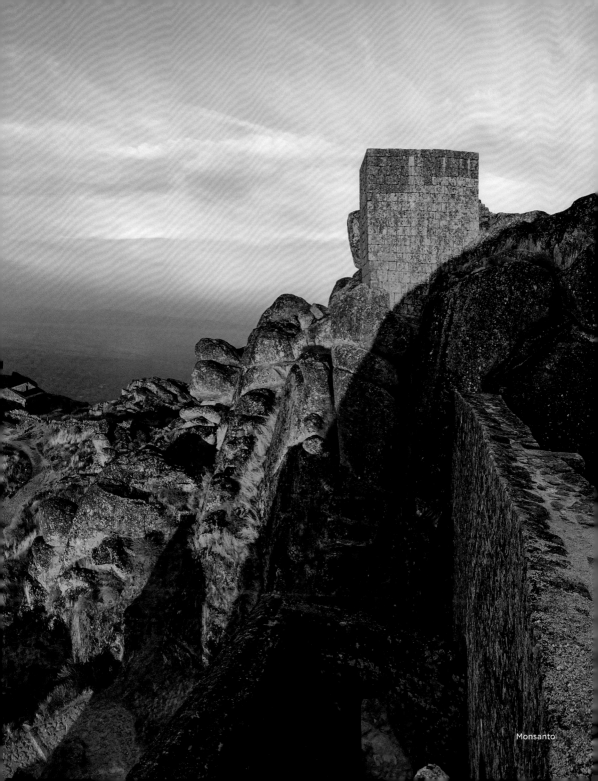

Monsanto

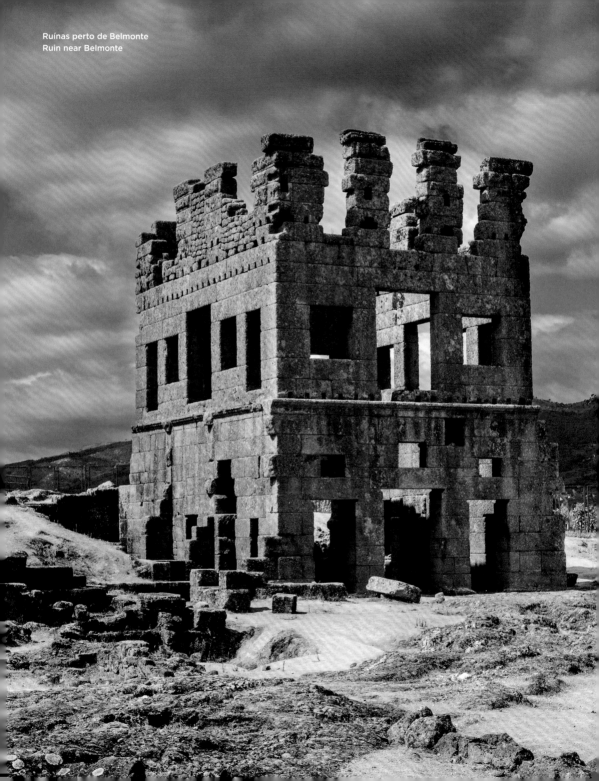

Ruínas perto de Belmonte
Ruin near Belmonte

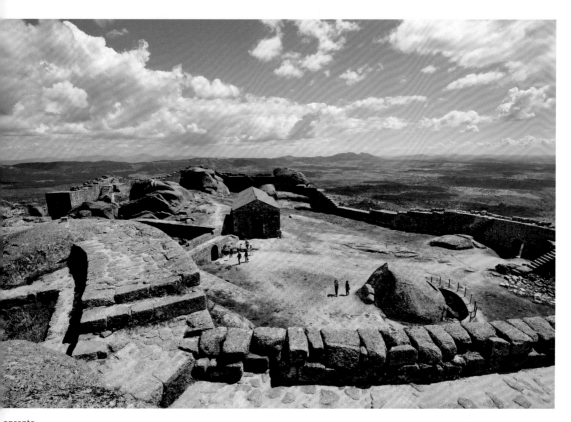

onsanto

Castelo Branco

he Romans scaled the heights of eastern
ortugal, and the ruins of the tower
Centum Cellas from the 1st century
ear witness to this. However, the rock
wellings in the historic mountain village of
onsanto are even bolder. Here they built
to, and sometimes under, boulders of
ften enormous dimensions, thus making
e buildings a complete architectural
uriosity and an amazing sight to behold.

Castelo Branco

es Romains ont escaladé les hauteurs de
est du Portugal, comme en témoignent
s ruines de la tour de Centum Cellas,
atant du Ier siècle. Cependant, ce sont les
abitations en pierre du village historique
e Monsanto qui sont la marque la plus
appante de leur audace : encastrées
ans des rochers aux dimensions
npressionnantes, elles sont une véritable
uriosité architecturale et offrent un
ectacle étonnant.

Castelo Branco

Hoch hinaus wollten die Römer im Osten
Portugals. Davon kündet die Ruine des
Turmes von Centum Cellas aus dem 1. Jh.
Noch kühner allerdings erscheinen die
Felswohnungen im historischen Bergdorf
Monsanto: Eingebettet in Findlinge
von teils enormen Ausmaßen, sind die
Bauten architektonisches Kuriosum und
Sehenswürdigkeit in einem.

Castelo Branco

Los romanos querían llegar a lo más alto en
el este de Portugal. Las ruinas de la torre
de Centum Cellas del siglo I lo atestiguan,
pero los apartamentos de piedra en el
histórico pueblo montañoso de Monsanto
parecen aún más atrevidos: incrustados en
rocas de dimensiones a veces enormes, los
edificios son una curiosidad arquitectónica
y, a la vez, todo un espectáculo.

Castelo Branco

I romani volevano risalire il Portogallo
orientale. Lo testimoniano i resti della torre
di Centum Cellas del I secolo, ma le case
in pietra dello storico villaggio montano
di Monsanto appaiono ancora più audaci:
incastonati in massi di dimensioni talvolta
enormi, gli edifici sono al contempo
una curiosità architettonica e un luogo
da visitare.

Castelo Branco

De Romeinen wilden in Oost-Portugal
de hoogte in gaan. De ruïne van de
toren van Centum Cellas uit de 1e eeuw
getuigt hiervan. Nog stoutmoediger
komen de grotwoningen in het historische
bergdorp Monsanto over: ingebed tussen
zwerfstenen van soms enorme afmetingen
zijn de bouwsels een architectonische
curiositeit en bezienswaardigheid in een.

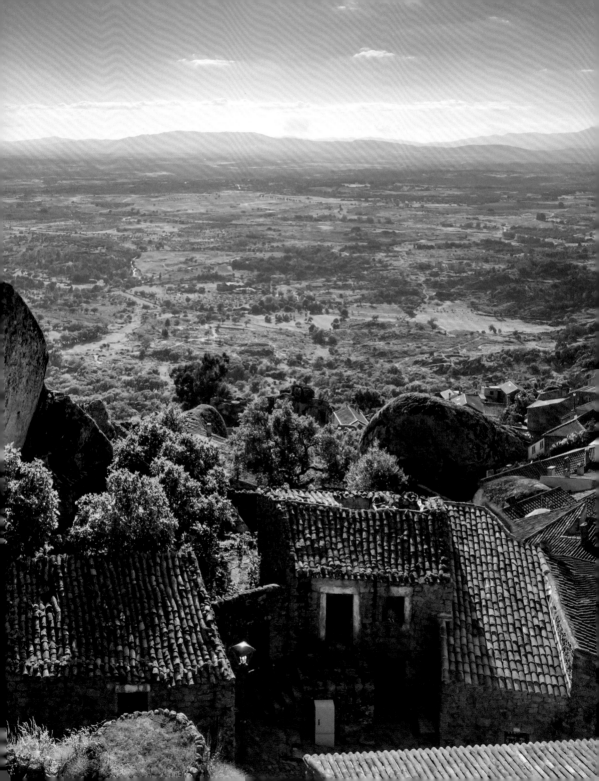

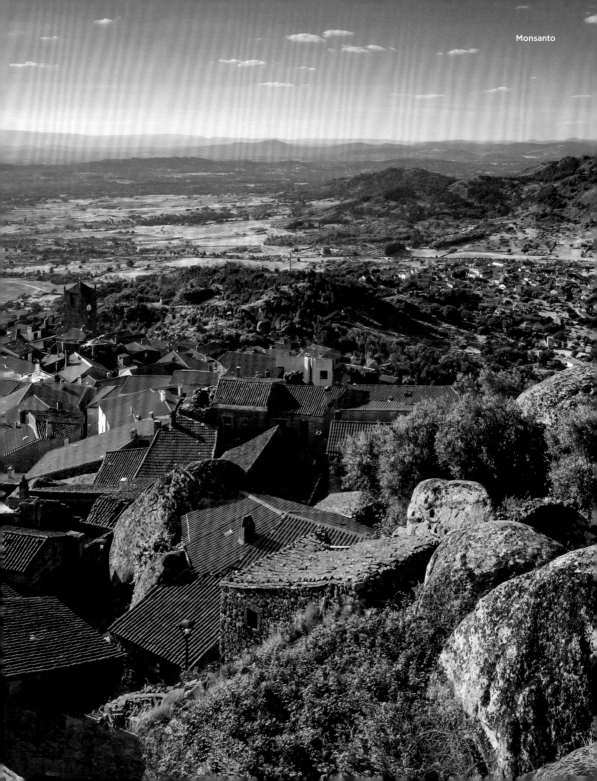

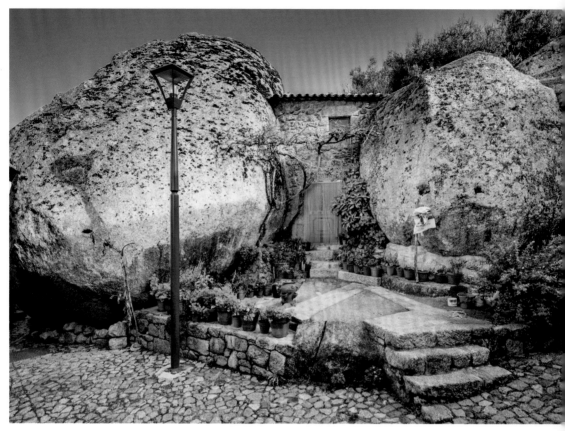

Monsanto

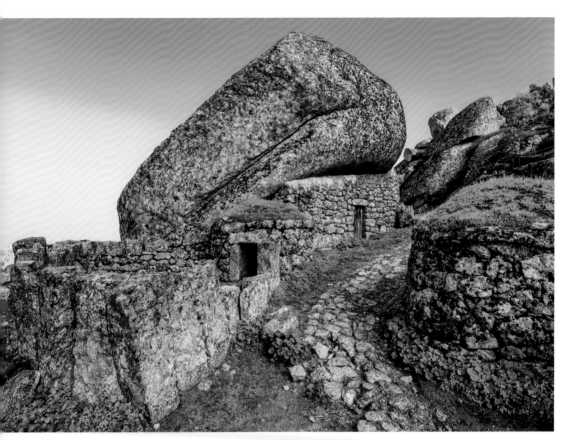

onsanto

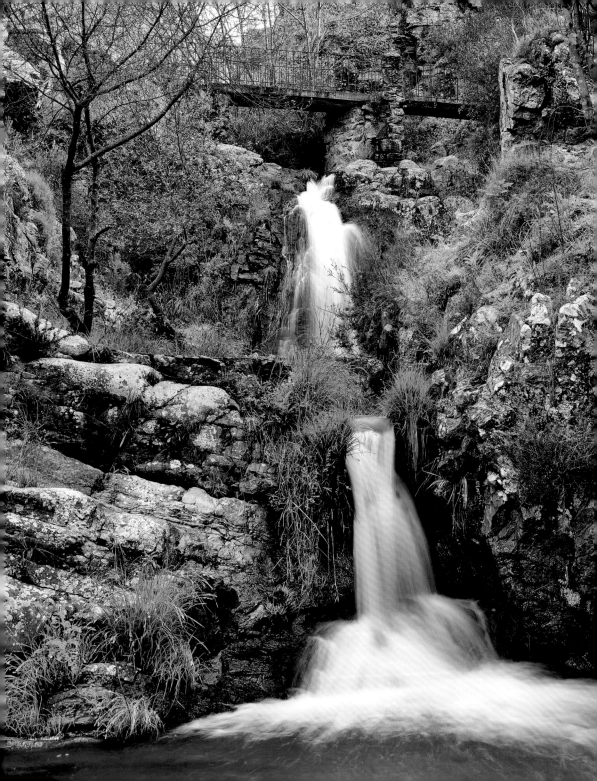

Vila de Rei, Cascata do Penedo Furado
Vila de Rei, Penedo Furado Waterfall

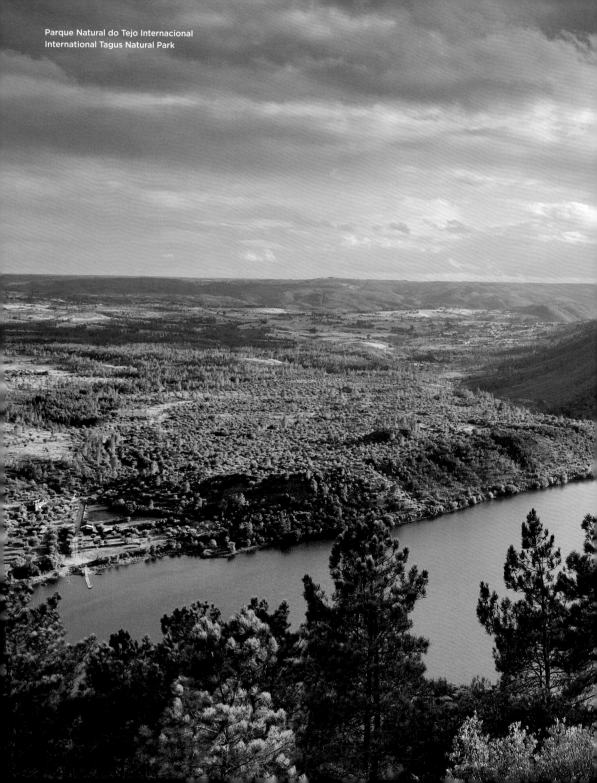

Parque Natural do Tejo Internacional
International Tagus Natural Park

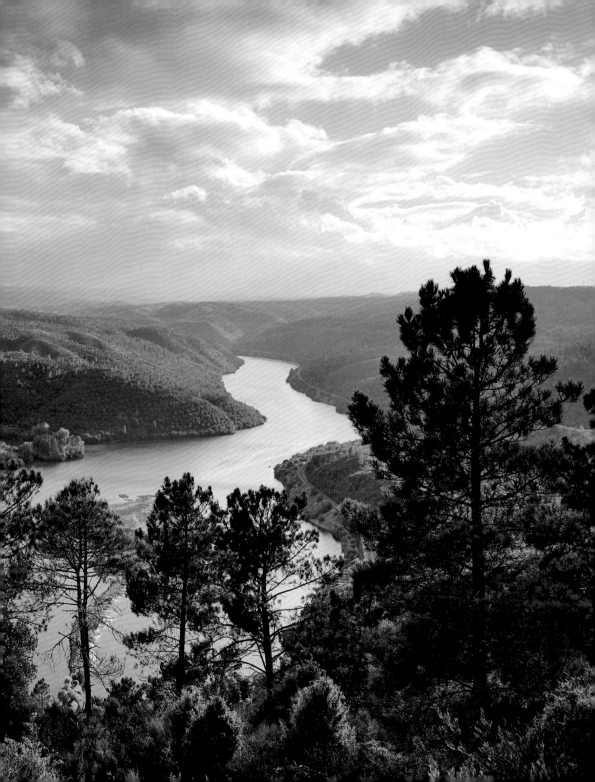

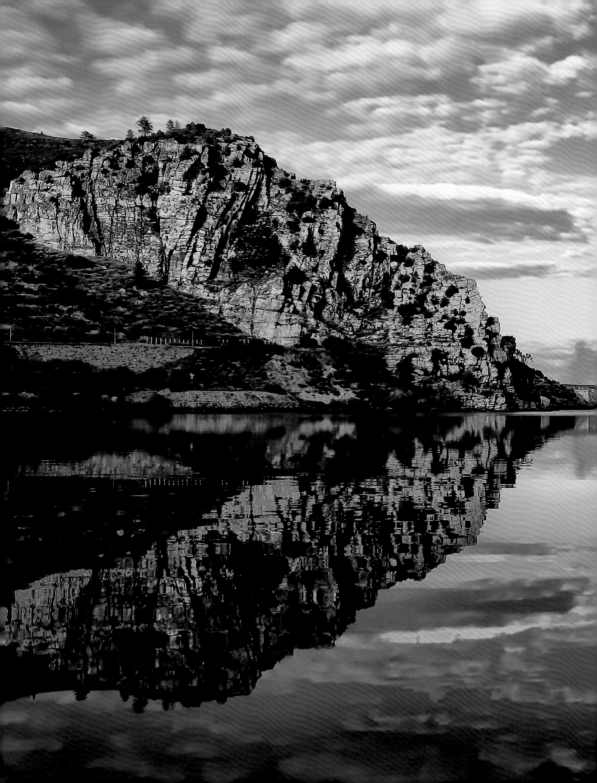

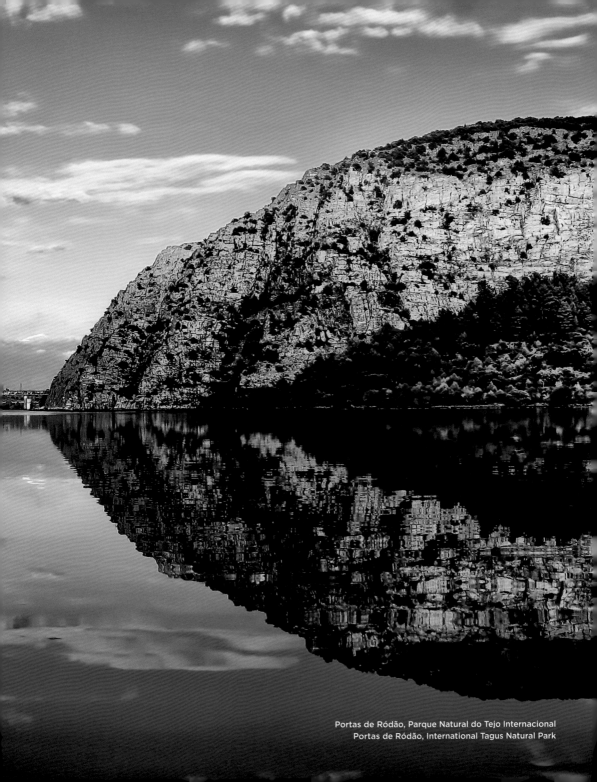

Portas de Ródão, Parque Natural do Tejo Internacional
Portas de Ródão, International Tagus Natural Park

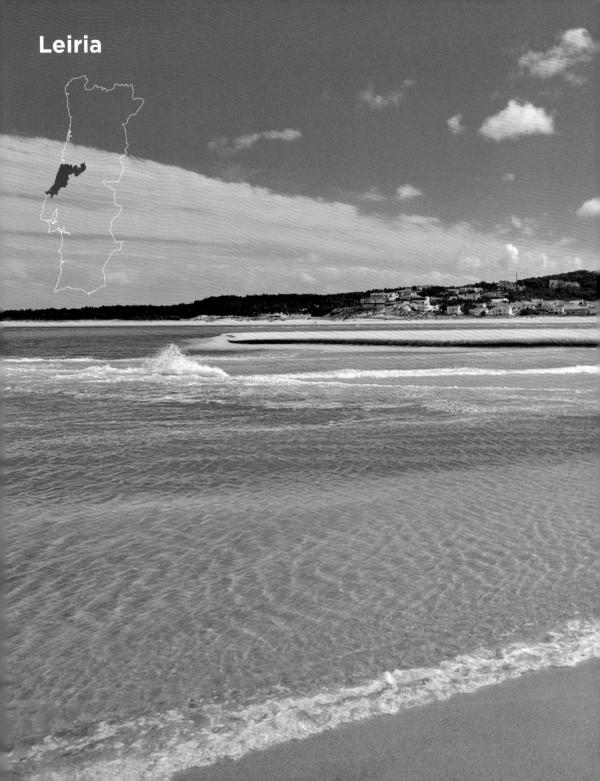

Leiria

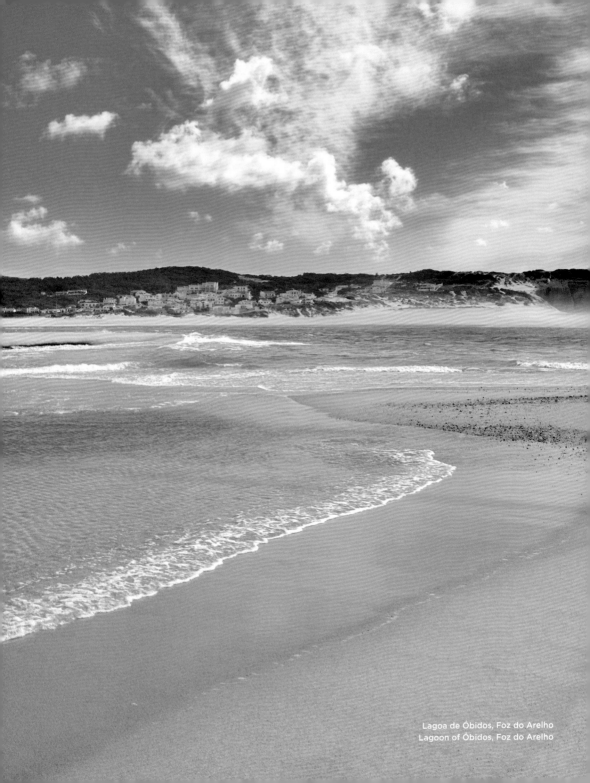

Lagoa de Óbidos, Foz do Arelho
Lagoon of Óbidos, Foz do Arelho

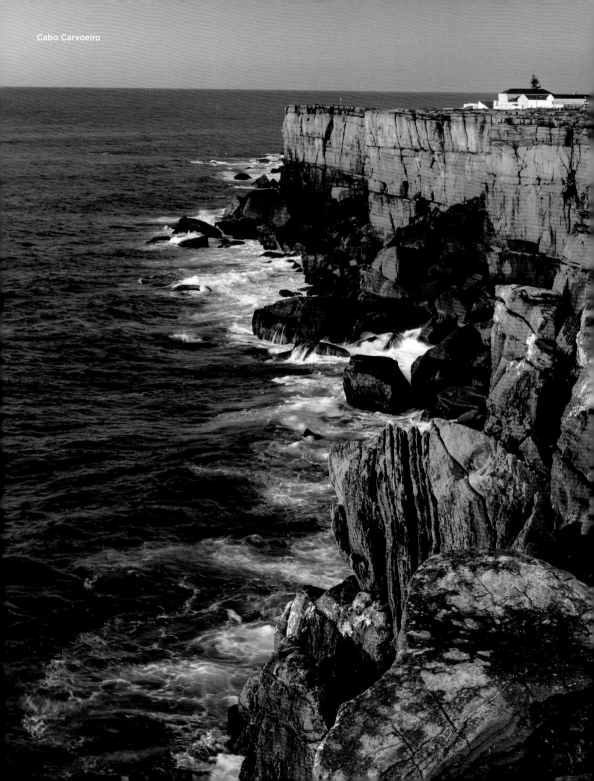

Cabo Carvoeiro

Reserva Natural das Berlengas
Berlengas Natural Reserve

Leiria

North of Lisbon, the dunes slowly give way to a rockier coastline. On the small, craggy Peniche peninsula one may be view nature's creative side, where the cliffs glow in melodramatic red shades in the evening sun. Meanwhile, the waters around the offshore islands of the Berlengas archipelago shimmer with a greenish shade.

Leiria

Au nord de Lisbonne, les dunes cèdent lentement la place à une côte rocheuse. Sur la petite péninsule de Peniche, la nature semble s'être surpassée : les falaises y brillent d'un rouge mélodramatique au soleil du soir, tandis que l'eau de l'archipel de Berlengas, au large, est émeraude.

Leiria

Nördlich von Lissabon weichen die Dünen langsam einer felsigen Küste. Ihre ganzen gestalterischen Fähigkeiten hat die Natur auf der kleinen Halbinsel Peniche unter Beweis gestellt, wo die Klippen in der Abendsonne in melodramatischem Rot leuchten. Grünlich schimmert unterdessen das Wasser beim vorgelagerten Archipel Berlengas.

Leiria

Al norte de Lisboa, las dunas dan paso lentamente a una costa rocosa. La naturaleza ha demostrado todas sus habilidades artísticas en la pequeña península de Peniche, donde los acantilados brillan en un rojo melodramático bajo el sol del atardecer. Mientras tanto, el agua del archipiélago de las Berlengas aguas arriba brilla verdosa.

Leiria

A nord di Lisbona le dune cedono lentamente il passo a una costa rocciosa. La natura nella piccola Penisola ha dimostrato tutte le sue capacità creative, dove le scogliere si illuminano di rosso melodrammatico al tramonto. Nel frattempo, l'acqua a monte dell'arcipelago delle Berlenghe brilla di verde.

Leiria

Ten noorden van Lissabon maken de duinen langzaam plaats voor een rotsachtige kust. De natuur heeft op het kleine schiereiland, waar de kliffen melodramatisch rood oplichten in de avondzon, al zijn vormgevende vaardigheden laten zien. Ondertussen schittert het water van de ervoor gelegen eilandengroep Berlengas prachtig blauwgroen.

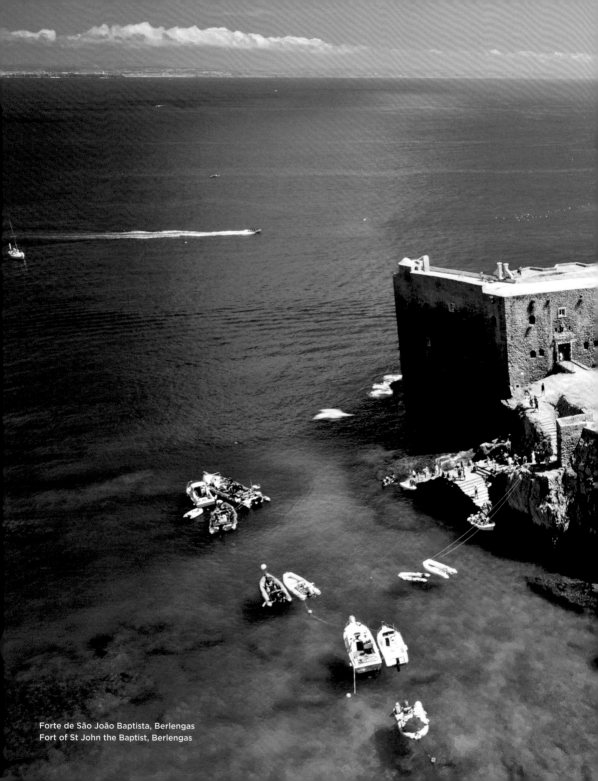

Forte de São João Baptista, Berlengas
Fort of St John the Baptist, Berlengas

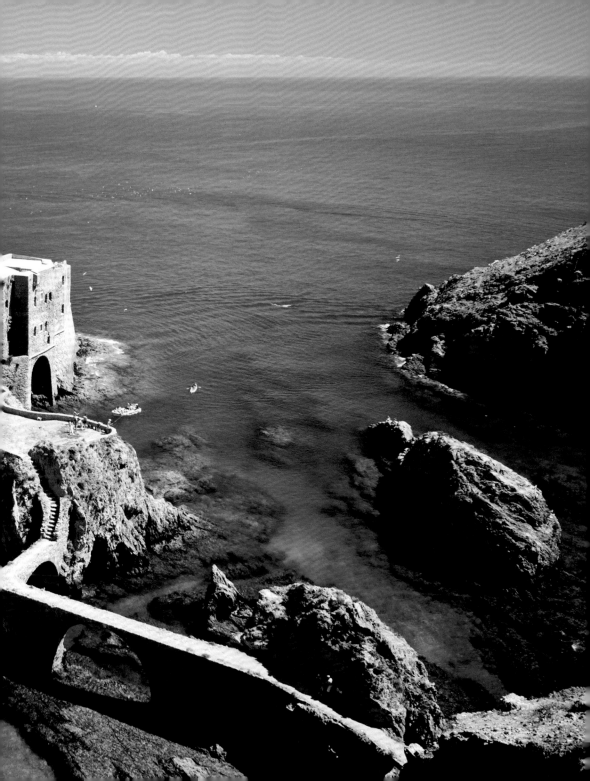

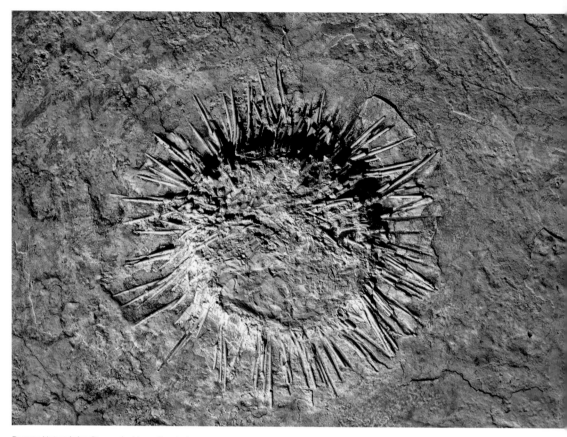

Parque Natural das Serras de Aire e Candeeiros
Serras de Aire e Candeeiros Natural Park

Serras de Aire e Candeeiros

The Fort São João Baptista (Fort of
St John the Baptist), built in the 17th
century, served as a defence against North
African corsairs. Today, the fortress on
the main island of the Berlengas Group
is a popular destination for boat owners.
The attractions in the Serras de Aire e
Candeeiros Natural Park are significantly
older, as the fossils found here show the
inhabitants of the sea from 170 million
years ago.

Serras de Aire et Candeeiros

Le fort São João Baptista, construit au
XVIIᵉ siècle, servait de défense contre les
corsaires nord-africains. Aujourd'hui, la
forteresse, sur l'île principale de l'archipel
des Berlengas, est une destination
populaire pour les marins de plaisance.
Mais l'attrait pour la Serras de Aire e
Candeeiros est beaucoup plus ancien :
certains fossiles prouvent que la vie s'y
développe depuis 170 millions d'années.

Serras de Aire e Candeeiros

Der Abwehr nordafrikanischer Korsaren
diente das 17. Jh. errichtete Fort São João
Baptista. Heute ist die auf der Hauptinsel
der Berlengas-Gruppe gelegene Festung
ein beliebtes Ausflugsziel für Bootsbesitzer
Deutlich älter sind die Attraktionen in den
Serras de Aire e Candeeiros: Die Fossilien
zeigen die Meeresbewohner von vor 170
Millionen Jahren.

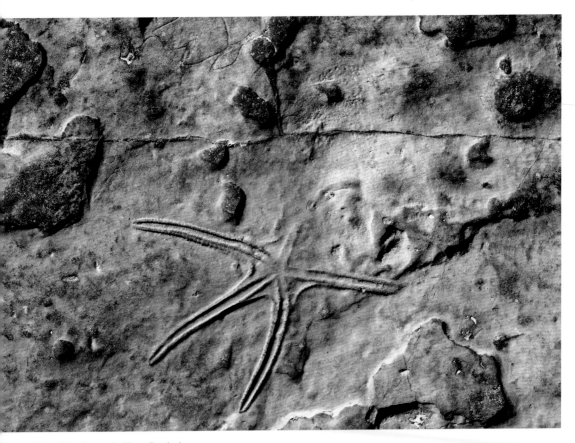

Parque Natural das Serras de Aire e Candeeiros
Serras de Aire e Candeeiros Natural Park

Serras de Aire y Candeeiros

El Fuerte São João Baptista, construido en el siglo XVII, sirvió como defensa contra los corsarios norteafricanos. Hoy en día, la fortaleza en la isla principal del Grupo Berlengas es un destino popular para los propietarios de barcos. Los atractivos de las Serras de Aire e Candeeiros son bastante más antiguos: los fósiles muestran cómo eran los habitantes del mar de hace 170 millones de años.

Serras de Aire e Candeeiros

Il Forte São João Baptista, costruito nel XVII secolo, serviva come difesa contro i corsari nordafricani. Oggi, la fortezza sull'isola principale dell'Arcipelago di Berlengas è una destinazione amata dai proprietari di barche. Le attrazioni dei Serras de Aire e Candeeiros sono molto più antiche: i fossili mostrano gli abitanti del mare di 170 milioni di anni fa.

Serras de Aire e Candeeiros

Fort São João Baptista, gebouwd in de 17e eeuw, diende als verdediging tegen Noord-Afrikaanse zeerovers. Tegenwoordig is de op het hoofdeiland van de Berlengas Archipelago gelegen vesting een populaire bestemming voor mensen met een boot. De attracties in de Serras de Aire e Candeeiros zijn beduidend ouder: de fossielen tonen de zeebewoners van 170 miljoen jaar geleden.

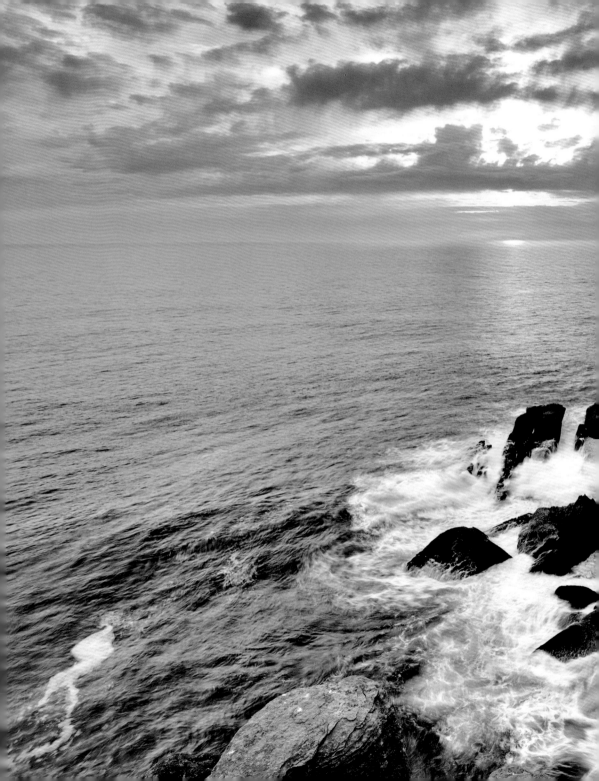

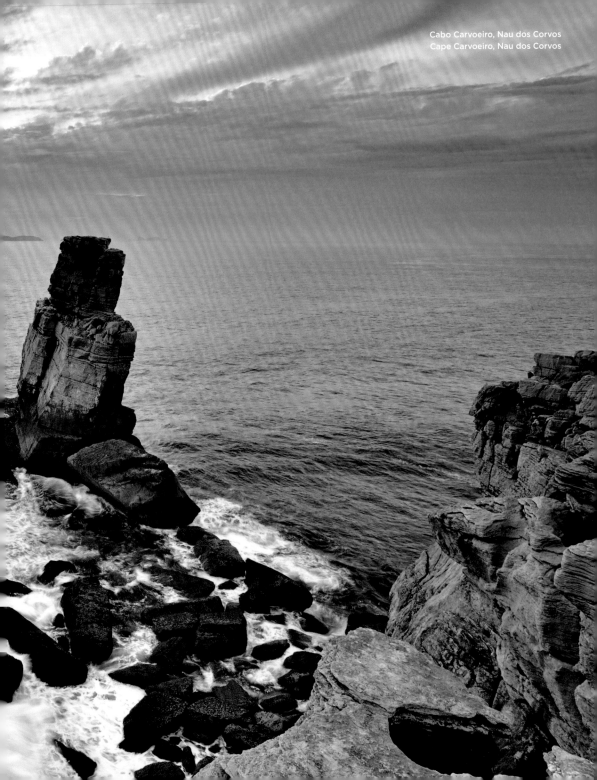

Cabo Carvoeiro, Nau dos Corvos
Cape Carvoeiro, Nau dos Corvos

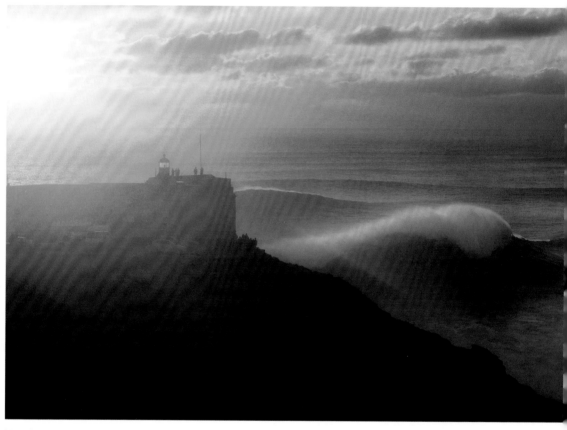

Nazaré

Nazaré

The coastal town of Nazaré regularly comes into the news due to its huge waves. The largest specimens can tower up to 25 meters, but even these monster rollers can't dissuade surfers from trying to ride them. On the contrary, the adrenalin-addicted wave riders consider mastering them to be the greatest and most beautiful challenge.

Nazaré

La ville côtière de Nazaré est régulièrement sous les feux de la rampe en raison de la hauteur de ses vagues, pouvant atteindre jusqu'à 25 mètres. Mais cette houle n'empêche pas les surfeurs de se jeter à l'eau. Au contraire : les amateurs considèrent la maîtrise de ces vagues monstrueuses comme le plus grand et le plus beau des défis.

Nazaré

Der Küstenort Nazaré rückt regelmäßig wegen seiner hohen Wellen ins Rampenlicht. Die größten Exemplare sollen sich bis zu 25 Meter auftürmen. Auch die Monsterwellen können Surfer nicht davon abhalten, sich in die Fluten zu stürzen. Im Gegenteil: ihre Bewältigung gilt den Hasardeuren auf dem Brett als größte und schönste Herausforderung.

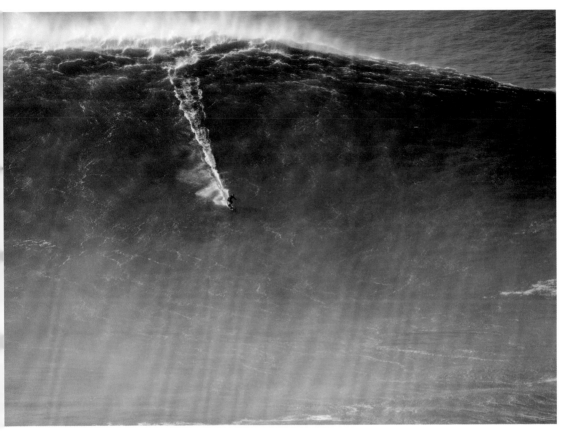

Nazaré

Nazaré

La ciudad costera de Nazaré se convierte a menudo en el centro de atención debido a sus grandes olas. Se estima que las más grandes alcanzan los 25 metros, pero ni las monstruosas olas pueden impedir que los surfistas se lancen al mar. Al contrario: dominarlas es el mayor y más hermoso desafío para los amantes de la tabla.

Nazaré

La città costiera di Nazaré è sempre sotto le luci della ribalta grazie alle sue alte onde. Alcune arrivano persino fino a 25 metri. Nemmeno le onde giganteche impediscono ai surfisti di cavalcare le acquee. Al contrario: i più audaci le considerano come la sfida più grande e più bella.

Nazaré

De kustplaats Nazaré staat regelmatig in de schijnwerpers vanwege de hoge golven. De grootste golven zouden een hoogte van 25 meter kunnen bereiken. Zelfs deze monstergolven kunnen surfers er niet van weerhouden zich in het water te wagen. Integendeel: de overmeestering ervan is voor de waaghalzen op de plank de grootste en mooiste uitdaging.

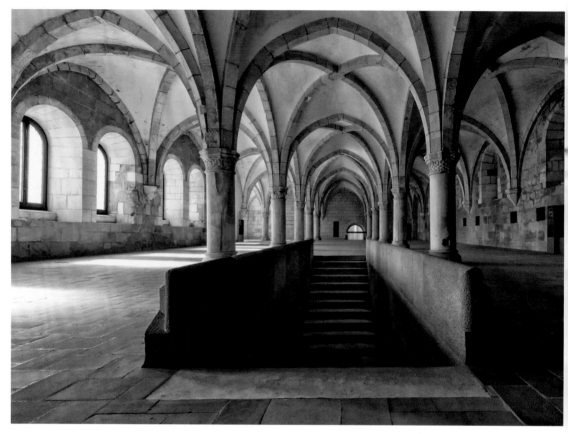

Mosteiro de Alcobaça
Alcobaça Monastery

Alcobaça

The quietest possible antidote to the roar of the ocean is the Alcobaça Monastery, only twelve kilometres from Nazaré, in the hinterland. The former Cistercian monastery is closely linked to the founding of the state of Portugal and has long been one of the spiritual centres of the country. Today it is a UNESCO World Heritage Site.

Alcobaçaça

Le monastère d'Alcobaça, à seulement douze kilomètres de Nazaré, dans l'arrière-pays, est, à l'opposé, un refuge particulièrement silencieux face au rugissement de l'océan. L'ancien monastère cistercien est étroitement lié à la fondation de l'État du Portugal et a longtemps été l'un des centres spirituels du pays. Aujourd'hui, c'est un site du patrimoine mondial de l'UNESCO.

Alcobaça

Der denkbar ruhigste Gegenpol zum Getöse des Ozeans ist das nur zwölf Kilometer von Nazaré im Hinterland gelegene Kloster von Alcobaça. Das ehemalige Zisterzienserkloster ist eng mit der Gründung des Staates Portugals verbunden und zählte lange zu den geistigen Zentren des Landes. Heute gehört es zum Weltkulturerbe der Unesco.

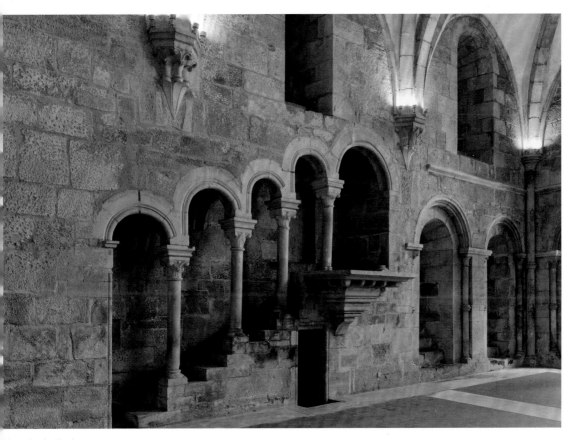

Mosteiro de Alcobaça
Alcobaça Monastery

Alcobaça

El polo opuesto al rugido del océano es, por su extremada calma, el Monasterio de Alcobaça, situado a sólo doce kilómetros de Nazaré, en el interior del país. El antiguo monasterio cisterciense está estrechamente ligado a la fundación del estado de Portugal y ha sido uno de los centros espirituales del país durante mucho tiempo. En la actualidad es Patrimonio de la Humanidad de la UNESCO.

Alcobaça

L'antitesi più tranquilla al fragore dell'oceano è il Monastero di Alcobaça, a soli dodici chilometri da Nazaré, nell'entroterra. L'ex monastero cistercense è strettamente legato alla fondazione dello stato del Portogallo ed è stato a lungo uno dei centri spirituali del paese. Oggi è patrimonio dell'umanità dell'UNESCO.

Alcobaça

De rustigst denkbare tegenpool van de bulderende oceaan is het klooster van Alcobaça, dat in het achterland staat, op slechts 12 kilometer van Nazaré. Het voormalige cisterciënzer klooster is nauw verbonden met de oprichting van staat Portugal en is allang een van de spirituele centra van het land. Het staat tegenwoordig op de werelderfgoedlijst van de Unesco.

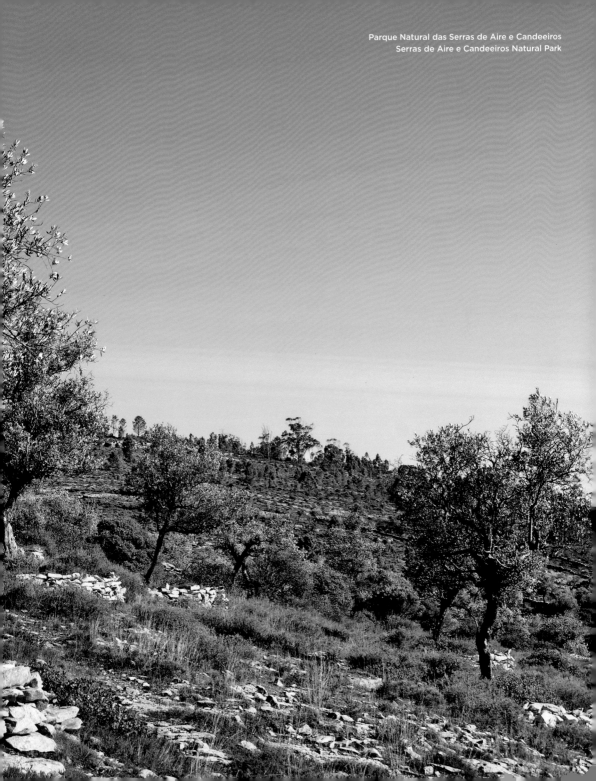

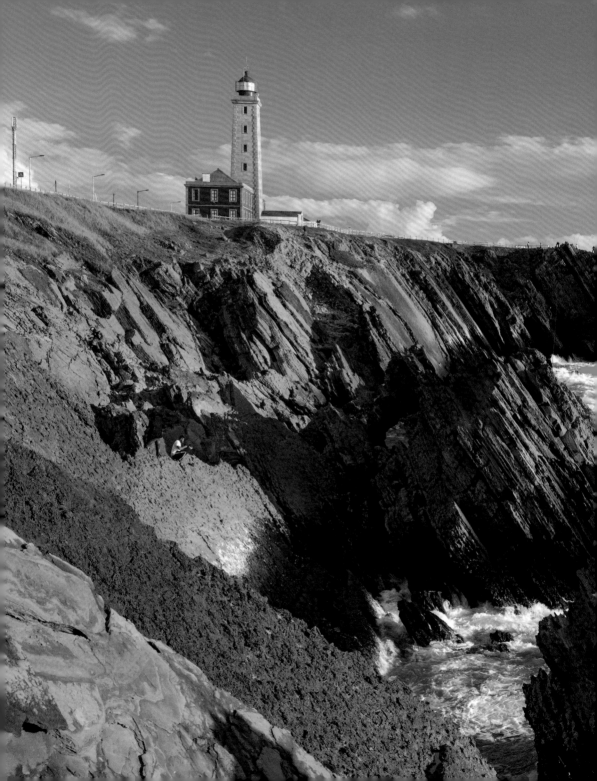

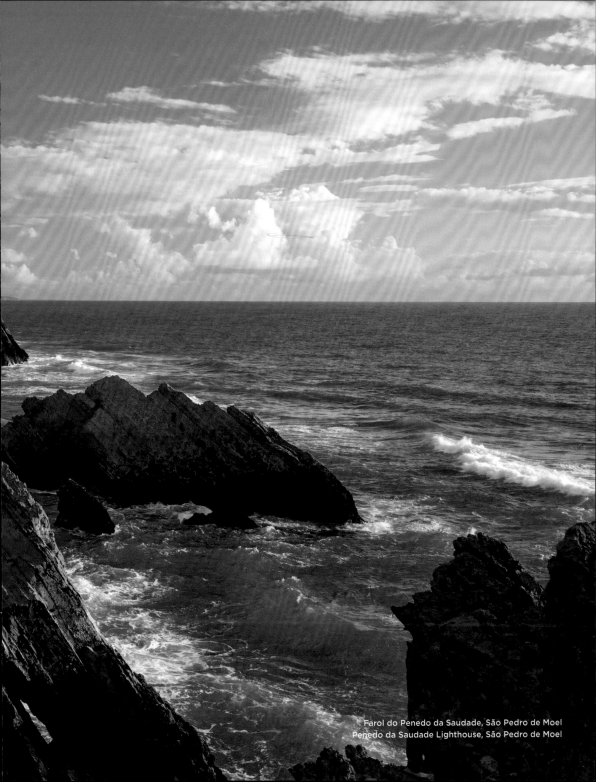

Farol do Penedo da Saudade, São Pedro de Moel
Penedo da Saudade Lighthouse, São Pedro de Moel

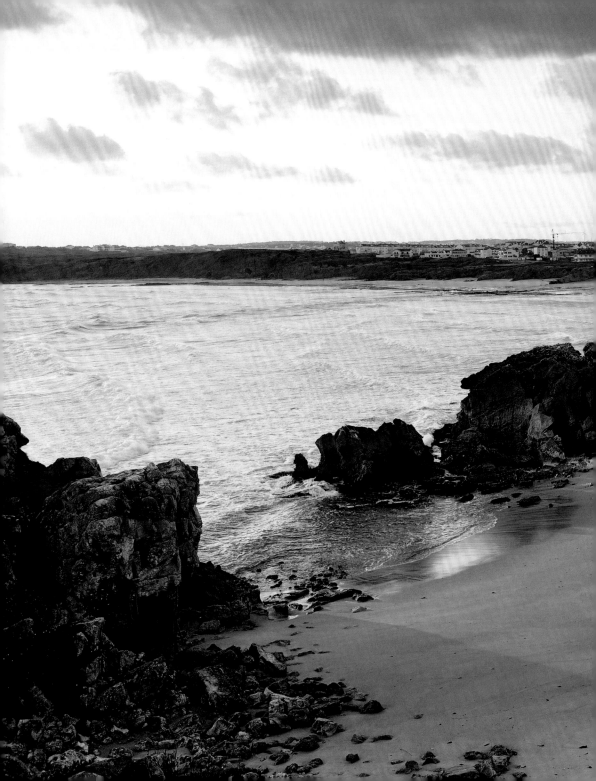

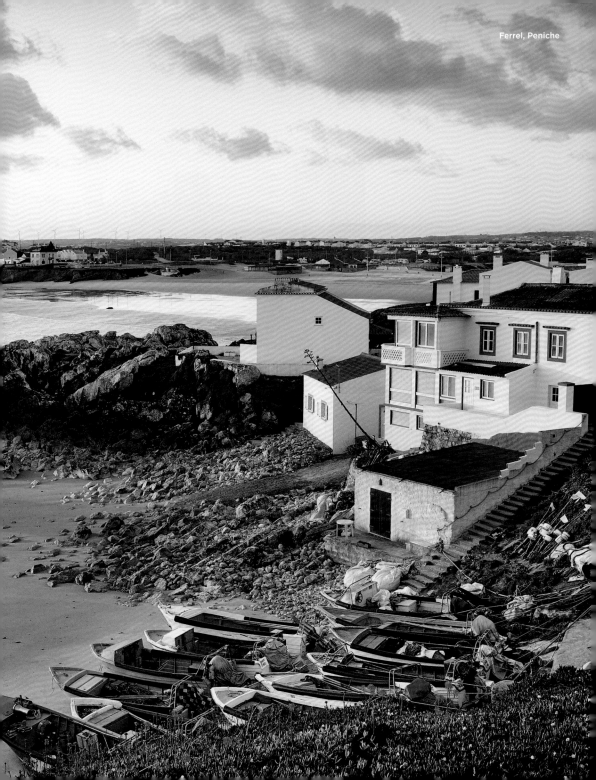
Ferrel, Peniche

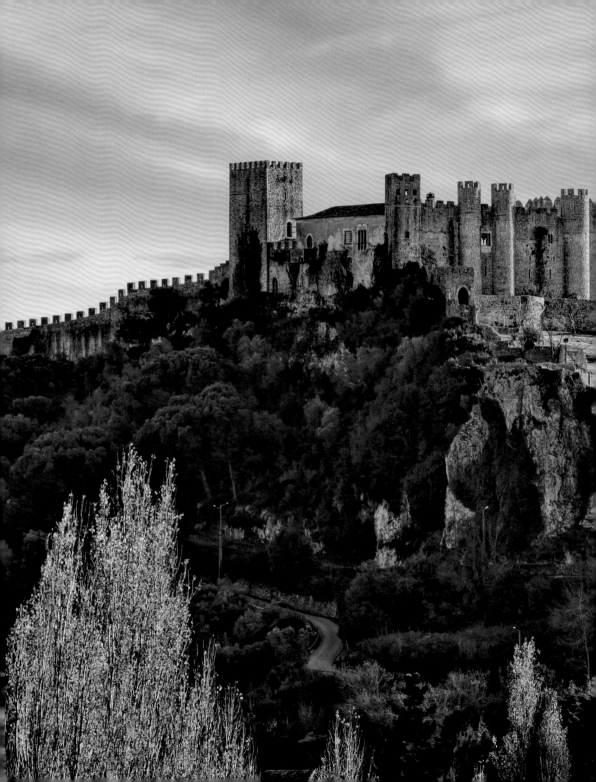

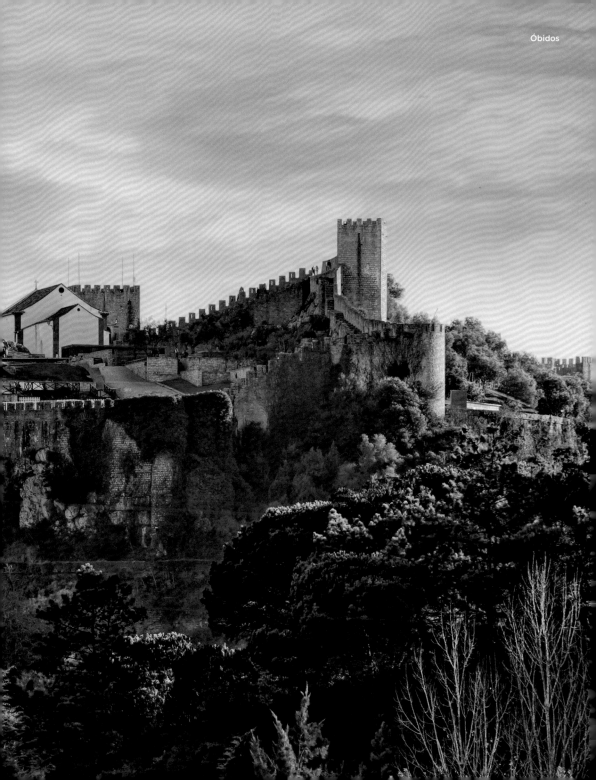

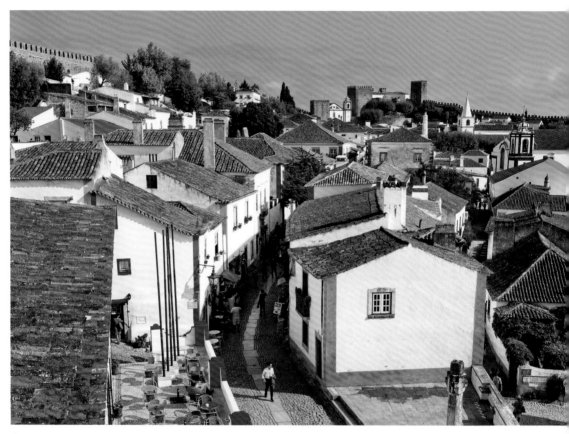

Óbidos

Leiria

In Leiria, it is considered good taste to add cheerful colours to the corners of houses and window frames. A stately castle with impressive and still-intact protective walls watches over the provincial town. Meanwhile, the tiny natural harbour of Baleal is protected by treacherous cliffs, which can quickly determine the fate of untrained sea captains.

Leiria

À Leiria, il est de bon ton de décorer les coins des maisons et les encadrements de fenêtres de couleurs vives. Un imposant château aux murailles impressionnantes et intactes veille sur la ville de province. Le minuscule port naturel de Baleal, quant à lui, est protégé par de dangereuses falaises, très dangereuses pour les marins inexpérimentés.

Leiria

In Leiria gehört es zum guten Ton, Häuserecken und Fensterrahmen mit fröhlichen Farben zu versehen. Über das Provinzstädtchen wacht eine stattliche Burg mit ebenso imposanten wie intakten Schutzmauern. Der winzige Naturhafen von Baleal wird unterdessen von tückischen Klippen geschützt, die ungeübten Kapitänen schnell zum Verhängnis werden können.

Nazaré

Leiria

En Leiria, está muy bien visto decorar las esquinas de las casas y los marcos de las ventanas con colores alegres. Un majestuoso castillo con impresionantes e intactas murallas de protección vigila a ciudad de provincias. Mientras tanto, el pequeño puerto natural de Baleal está protegido por acantilados traicioneros, que pueden convertirse rápidamente en la perdición de los capitanes no entrenados.

Leiria

A Leiria, è considerato di buon gusto decorare con colori allegri gli angoli delle case e delle finestre. Un maestoso castello con imponenti e intatte mura di protezione veglia sulla città di provincia. Il piccolo porto naturale di Baleal, invece, è protetto da scogliere insidiose, che possono rapidamente diventare una fatalità per capitani non addestrati.

Leiria

In Leiria is het bon ton om vrolijke kleuren aan te brengen op de hoeken en kozijnen van huizen. Een statig kasteel met indrukwekkende en intacte dikke muren waakt over de provinciestad. Ondertussen wordt de kleine natuurlijke haven van Baleal beschermd door verraderlijke kliffen, die onervaren kapiteins snel noodlottig kunnen worden.

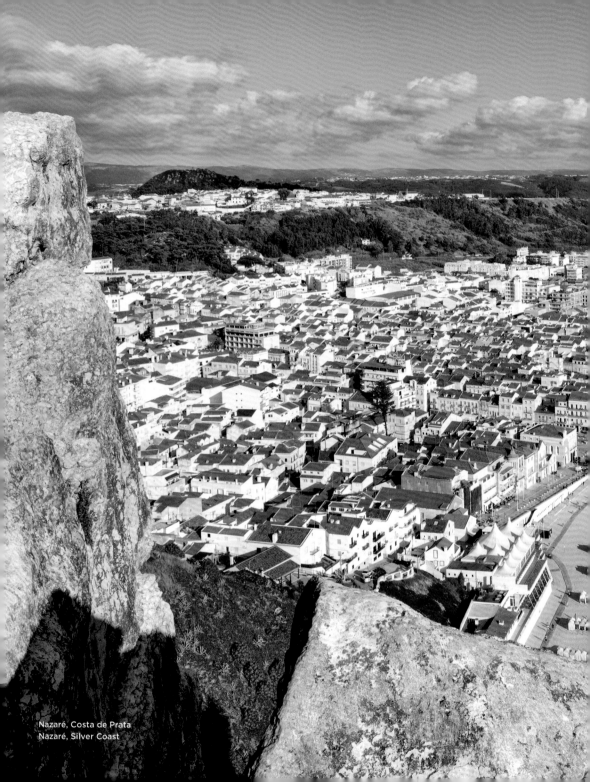

Nazaré, Costa de Prata
Nazaré, Silver Coast

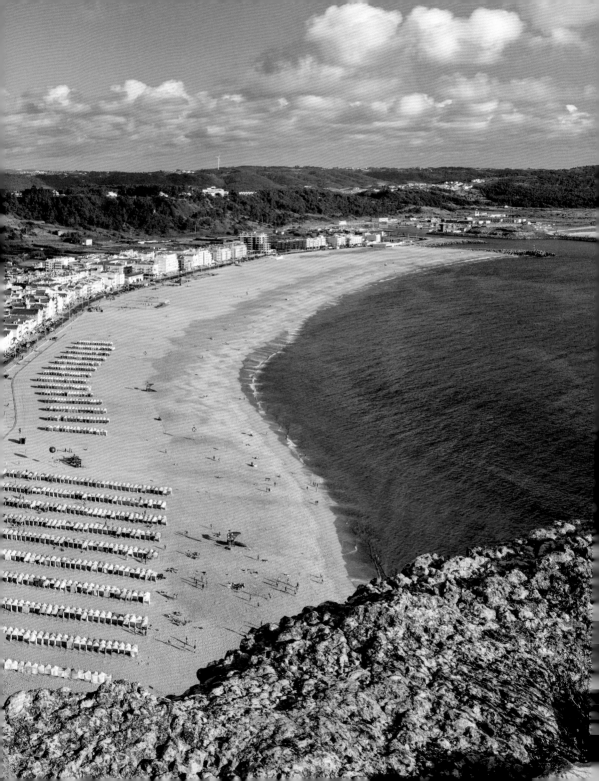

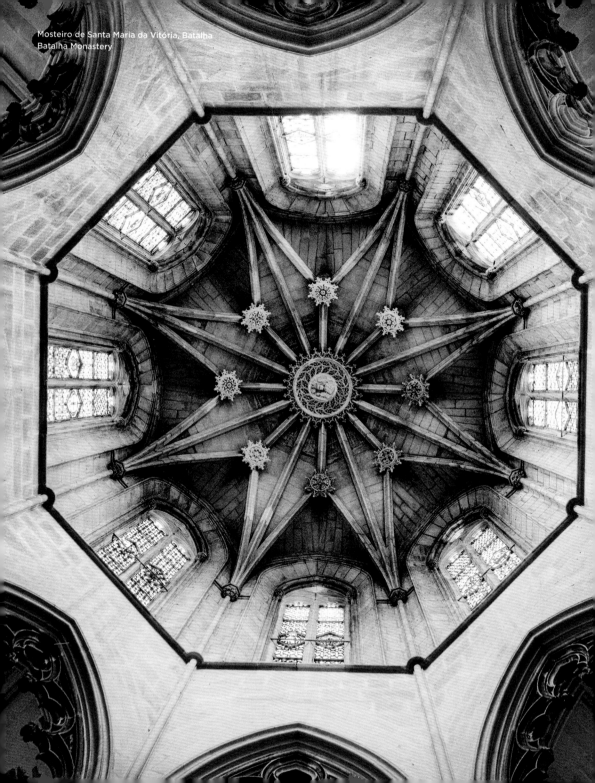

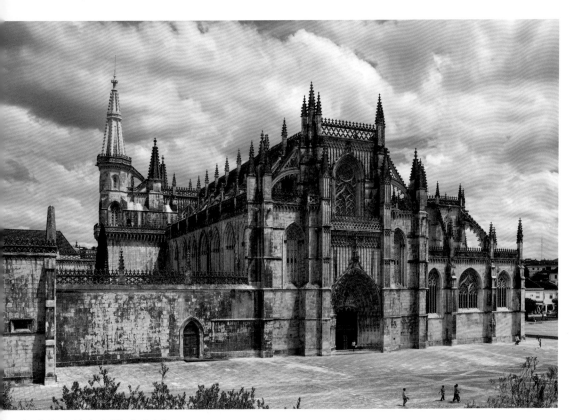

Mosteiro de Santa Maria da Vitoria, Batalha
Batalha Monastery

Batalha Monastery

Nazaré is a place of pilgrimage for adventurous surfers, but the popular seaside resort also has its gentler sides. A real retreat, however, is the Batalha Monastery, which the Portuguese royal family had built to celebrate their victory, in 1385, over the Kingdom of Castile. It was later presented to the Dominican Order.

Monastère de Batalha

Nazaré est une destination de rêve pour les surfeurs aventuriers. Mais la populaire station balnéaire a aussi une dimension plus apaisante. Le plus important des lieux de retraites de la région est effectivement le monastère de Batalha, construit par la famille royale portugaise à partir de 1385 pour célébrer la victoire sur le royaume de Castille, et qui a plus tard été offert à l'Ordre Dominicain.

Kloster von Batalha

Nazaré ist ein Sehnsuchtsziel für abenteuerlustige Wellenreiter. Doch das beliebte Seebad hat auch sanfte Seiten. Ein echter Rückzugsort ist hingegen das Kloster von Batalha, welches der portugiesische Königshaus ab 1385 aus Freude über den Sieg über das Königreich Kastilien hat errichten lassen. Später wurde es dem Dominikanerorden übergeben.

Monasterio de Batalha

Nazaré es un destino de anhelo para los surfistas aventureros. Pero su popular balneario también tiene otra cara más suave. Un verdadero lugar de retiro, sin embargo, es el monasterio de Batalha, que la familia real portuguesa mandó construir a partir de 1385 para celebrar la victoria sobre el Reino de Castilla. Más tarde fue entregado a la Orden Dominicana.

Monastero di Batalha

Nazaré è una meta ambita dai surfisti avventurosi. Ma la famosa località balneare ha anche i suoi lati mansueti. Un vero e proprio ritiro, però, è il Monastero di Batalha, che la famiglia reale portoghese aveva costruito a partire dal 1385 per la gioia della vittoria sul Regno di Castiglia. In seguito, fu donato all'Ordine Domenicano.

Klooster van Batalha

Nazaré is een droombestemming voor avontuurlijke surfers. De populaire badplaats heeft echter ook zijn vriendelijke kanten. Een echt toevluchtsoord is het klooster van Batalha, dat de Portugese koninklijke familie vanaf 1385 had laten bouwen uit vreugde over de overwinning op het koninkrijk Castilië. Later werd het overgedragen aan de dominicaanse orde.

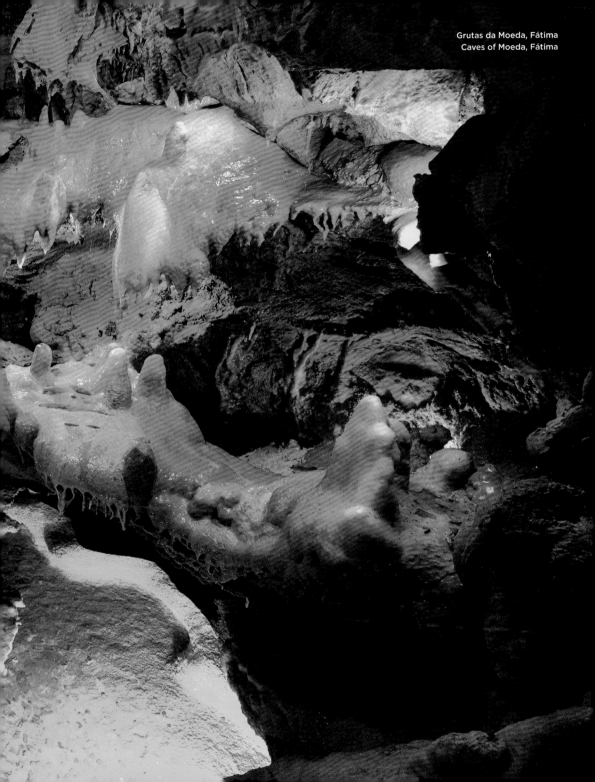

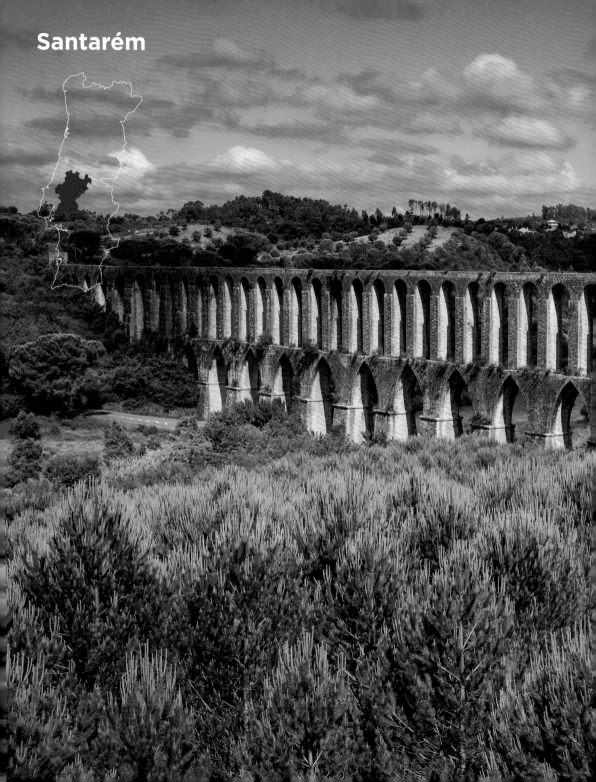

Santarém

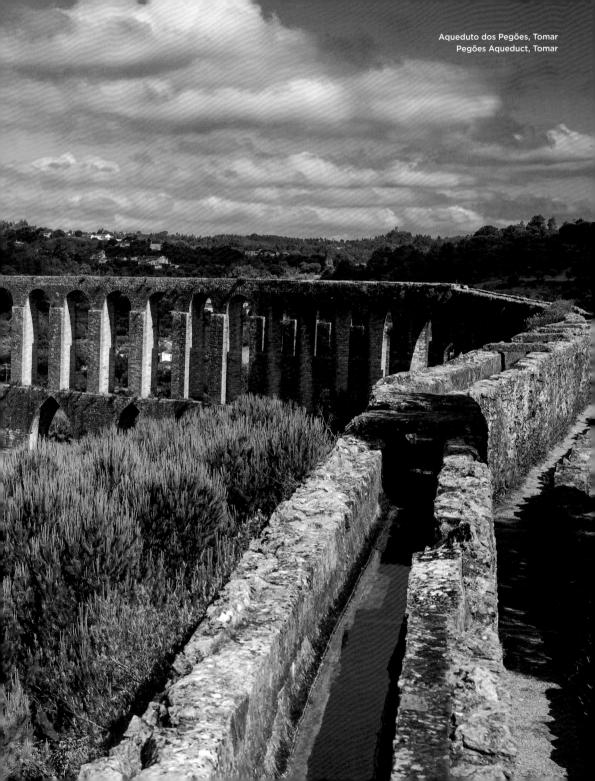

Aqueduto dos Pegões, Tomar
Pegões Aqueduct, Tomar

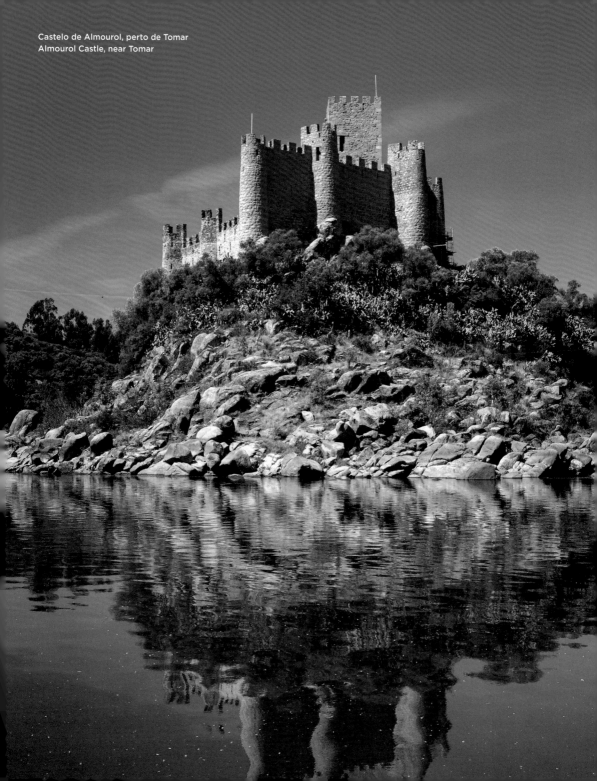

Castelo de Almourol, perto de Tomar
Almourol Castle, near Tomar

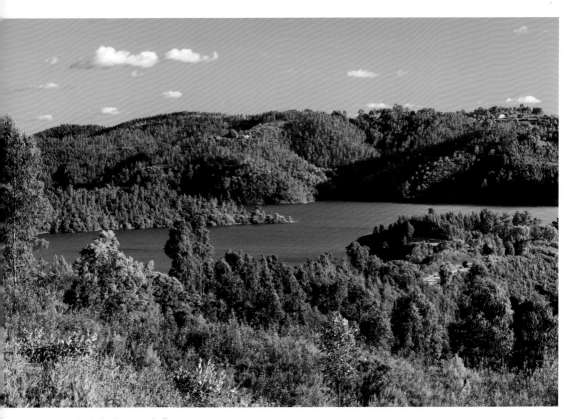

Barragem de Castelo de Bode, perto de Tomar
Castelo de Bode Dam, near Tomar

Santarém

With its 180 arches and a length of six kilometres, the aqueduct of Pegões, near Tomar, is one of the most important Portuguese constructions of the 17th century. The water held by the Castelo do Bode Dam constitutes the largest freshwater reservoir in the country and is the venue for many nautical activities, in addition to supplying the Lisbon region with water.

Santarem

Avec ses 180 arches et ses 6 kilomètres de long, l'aqueduc de Pegões est l'un des bâtiments les plus importants du XVIIᵉ siècle. Castelo do Bode est le plus grand réservoir d'eau douce du pays. Il approvisionne également la région de Lisbonne.

Santarém

Mit seinen 180 Bögen und einer Länge von sechs Kilometern zählt das Aquädukt von Pegões zu den bedeutendsten Bauwerken des 17. Jh. Mittlerweile wird die Wasserversorgung der Region um Tomar über Talsperren reguliert. Der Stausee bei Castelo do Bode ist das größte Süßwasserreservoir des Landes. Es dient auch der Versorgung der Region Lissabons.

Santarém

Con sus 180 arcos y una longitud de seis kilómetros, el acueducto de Pegões es uno de los edificios más importantes del siglo XVII. Actualmente el suministro de agua de la región de Tomar se regula mediante embalses, y el Castelo do Bode es el mayor embalse de agua dulce del país. También sirve para abastecer a la región de Lisboa.

Santarém

Con i suoi 180 archi e i suoi sei chilometri di lunghezza, l'acquedotto di Pegões è uno degli edifici più importanti del XVII secolo. Il serbatoio di Castelo do Bode è il più grande serbatoio di acqua dolce del paese. Serve anche per rifornire la regione di Lisbona.

Santarém

Met 180 bogen en een lengte van 6 kilometer behoort het aquaduct van Pegões tot een van de belangrijkste bouwwerken van de 17e eeuw. Inmiddels wordt de watervoorziening van de regio rond Tomar gereguleerd door stuwdammen. Het stuwmeer van Castelo do Bode is het grootste zoetwaterreservoir van het land. Het voorziet ook de regio Lissabon van water.

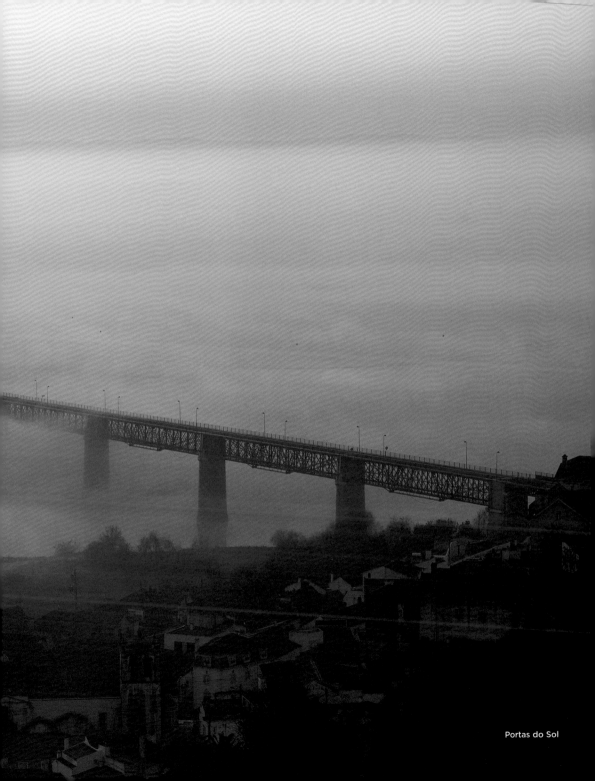

Portas do Sol

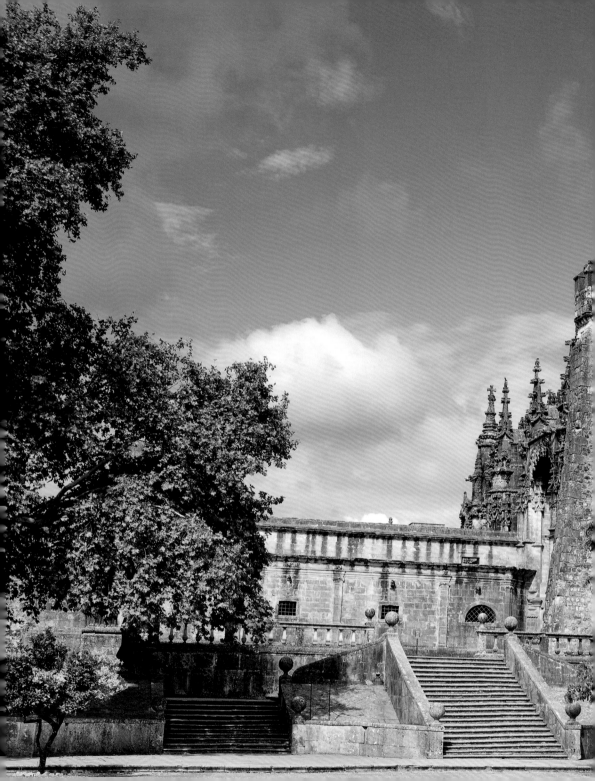

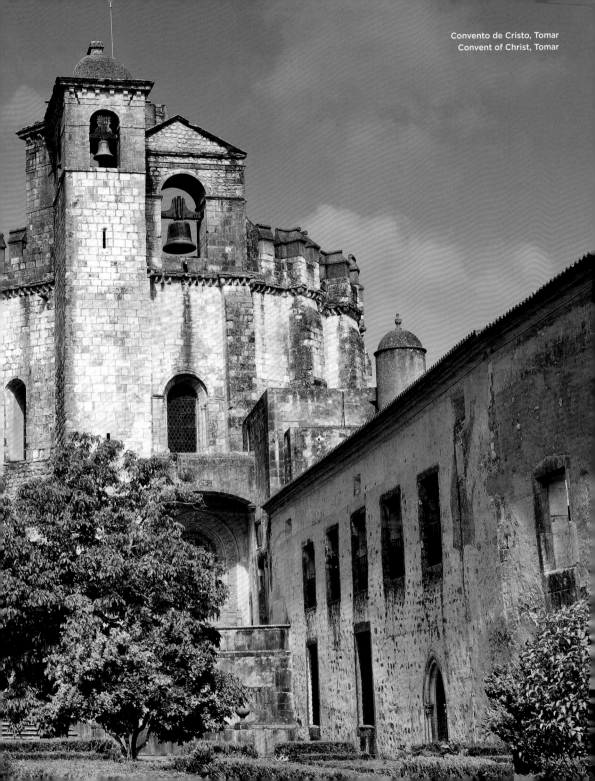

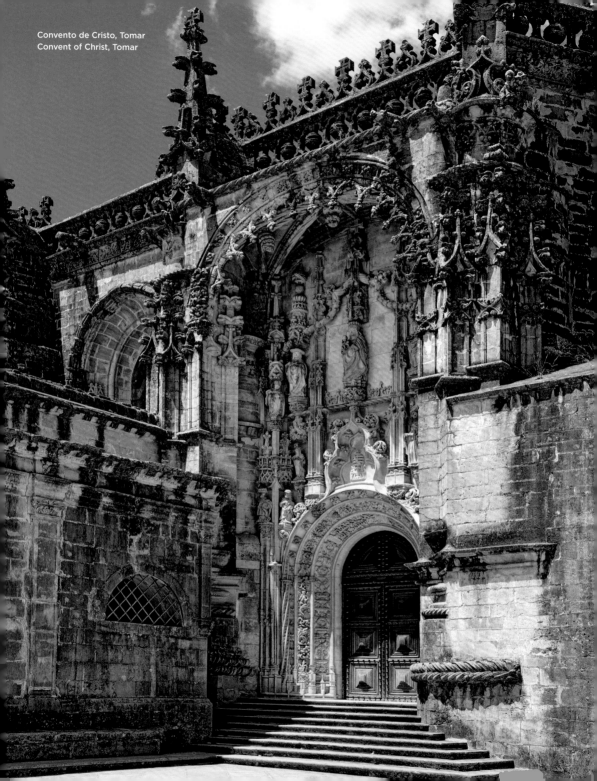

Convento de Cristo, Tomar
Convent of Christ, Tomar

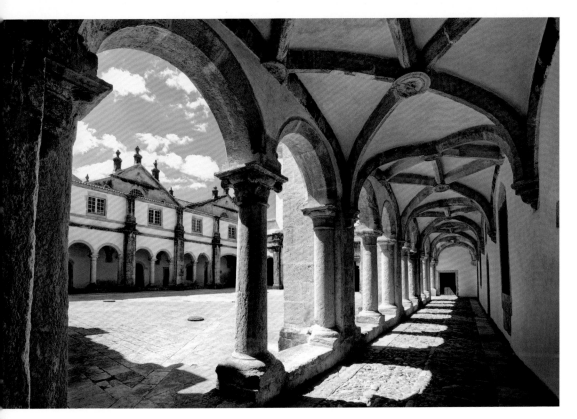

Convento de Cristo, Tomar
Convent of Christ, Tomar

Santarém

Boldly engineered constructions can be found in many places in mountainous Portugal. Some seem to lead—at least when swathed by fog—into nothingness, others reach skywards, like the Convent of Christ in Tomar, with its characteristic round church, which had been built in 1162 by Knights Templar as a fortified monastery. Here, they did not stint on religious ornamentation.

Santarem

Il n'est pas rare de croiser d'ambitieux édifices dans les montagnes portugaises. Certains semblent – du moins dans le brouillard – ne mener nulle part, tandis que d'autres semblent vouloir entrer en contact avec le ciel : le Convento de Cristo, avec son église ronde caractéristique, est un ancien monastère fortifié érigé en 1162 par les Templiers. Ils n'ont pas lésiné sur les ornements sacrés.

Santarém

Kühne Konstruktionen sind im bergigen Portugal vielerorts zu finden. Einige scheinen – zumindest im Nebel – ins Nichts zu führen, andere sind um den Kontakt nach oben bemüht: Der Convento de Cristo mit seiner charakteristischen Rundkirche wurde schon 1162 als Wehrkloster von Tempelrittern errichtet. An sakralen Ornamenten haben sie nicht gespart.

Santarém

Las construcciones atrevidas se pueden encontrar en muchos lugares del montañoso Portugal. Algunos parecen llevar a la nada, al menos en la niebla; sin embargo, otros están ansiosos por hacia arriba: el Convento de Cristo, con su característica iglesia redonda, ya fue construido en 1162 como monasterio fortificado por los Caballeros Templarios. No perdonaban los adornos sacrales.

Santarém

In molti luoghi del Portogallo montuoso si possono trovare costruzioni ardite. Alcune sembrano condurre – almeno nella nebbia – verso il nulla, altre invece verso l'alto: il Convento de Cristo con la sua caratteristica chiesa rotonda fu costruito già nel 1162 dai Cavalieri Templari come monastero fortificato decorato con numerosi ornamenti sacrali.

Santarém

In het bergachtige Portugal zijn op veel plaatsen gewaagde constructies te vinden. Sommige lijken – althans in de mist – nergens heen te leiden, andere doen hun best contact met boven te leggen: het Convento de Cristo met zijn karakteristieke ronde kerk werd in 1162 al door tempeliers gebouwd als versterkt klooster. Zij hebben niet bezuinigd op sacrale ornamenten.

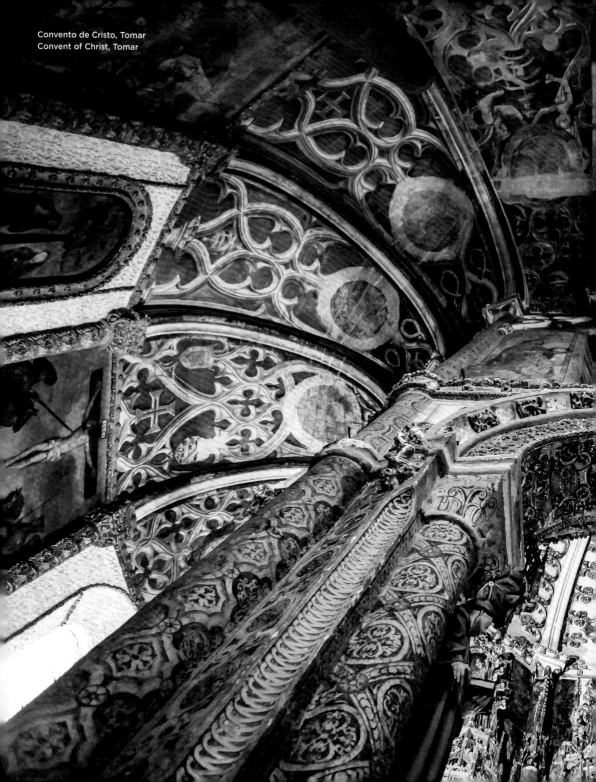

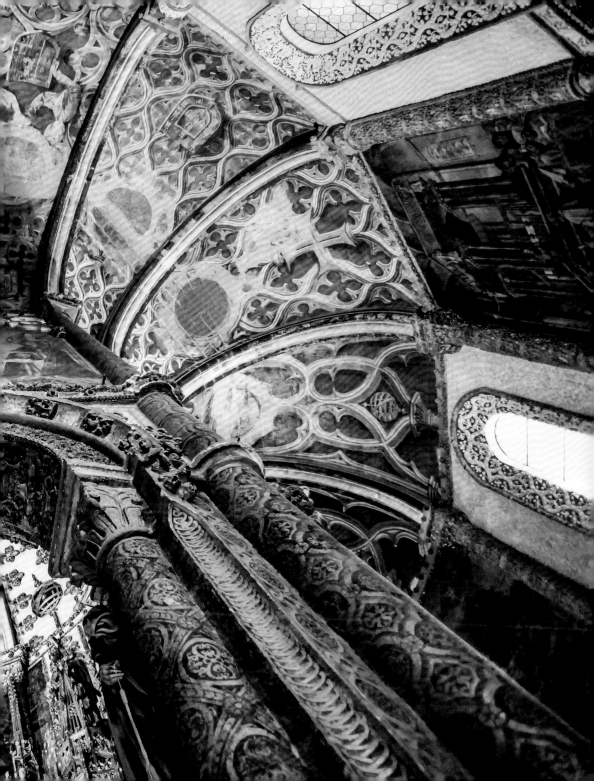

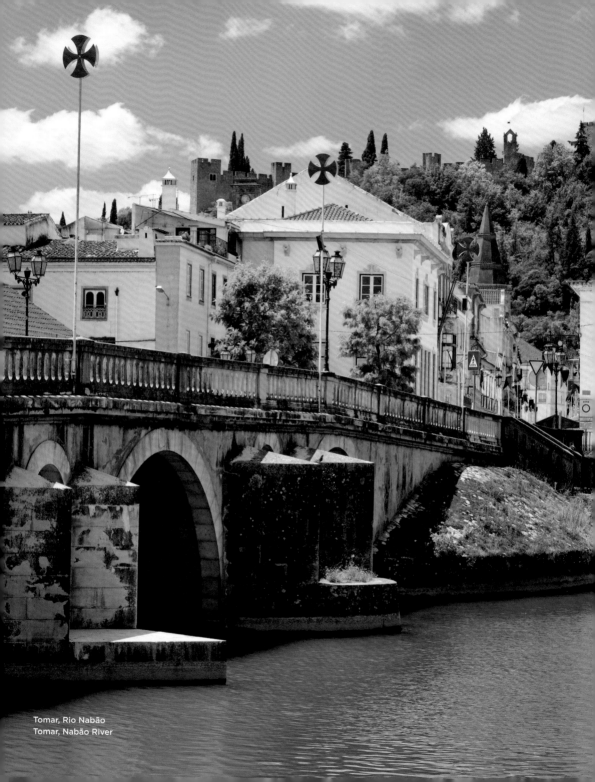

Tomar, Rio Nabão
Tomar, Nabão River

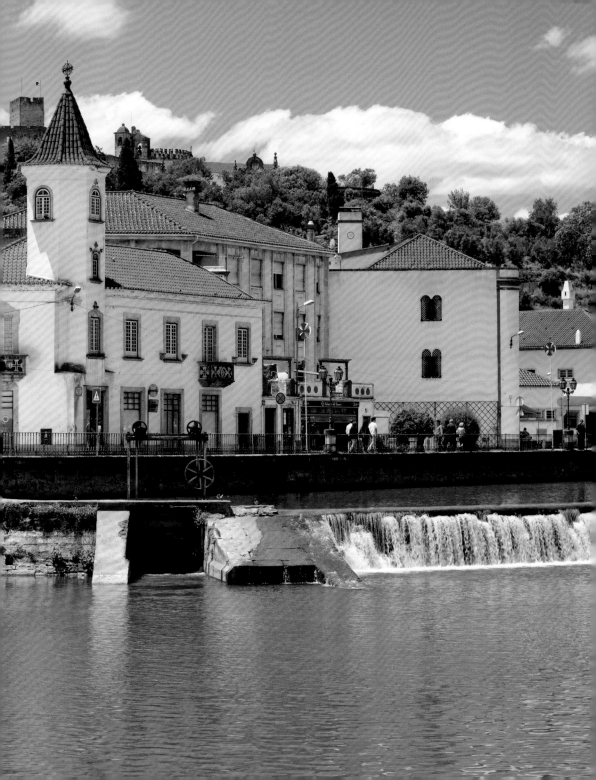

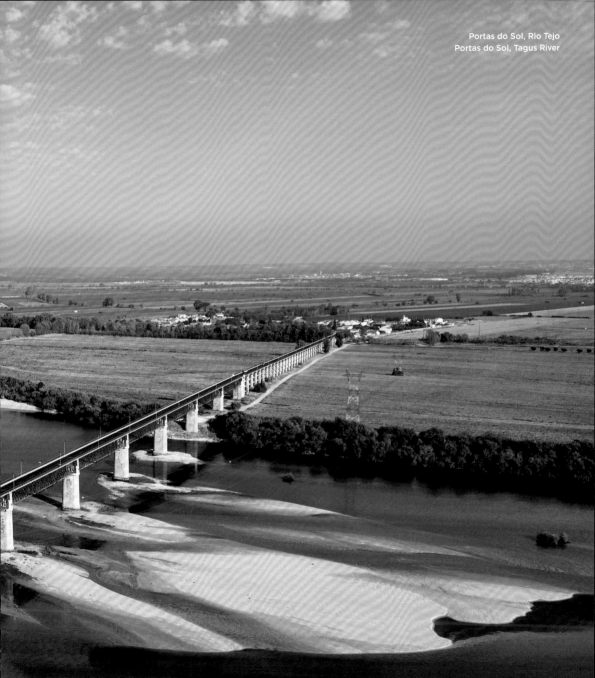

Portas do Sol, Rio Tejo
Portas do Sol, Tagus River

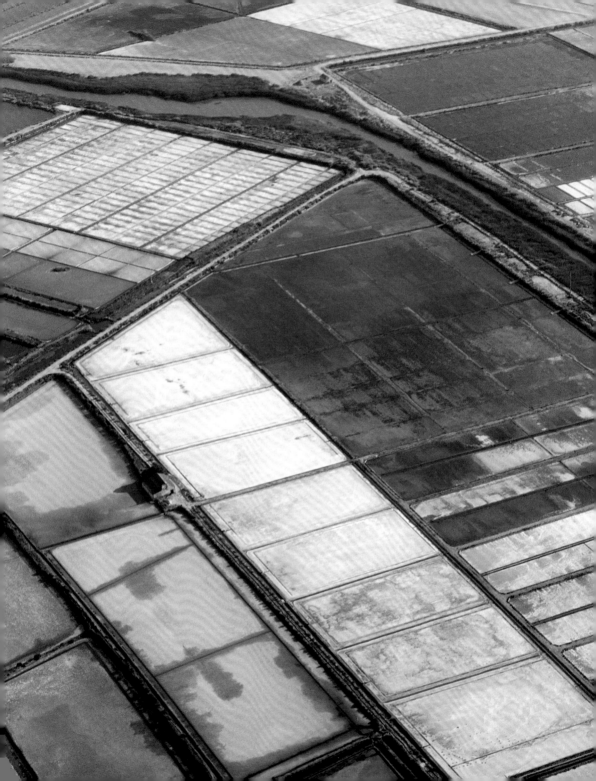

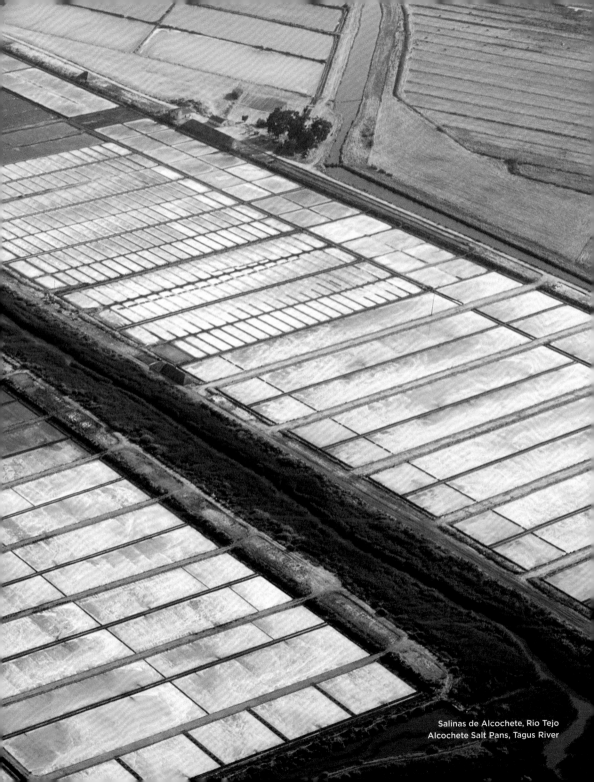

Salinas de Alcochete, Rio Tejo
Alcochete Salt Pans, Tagus River

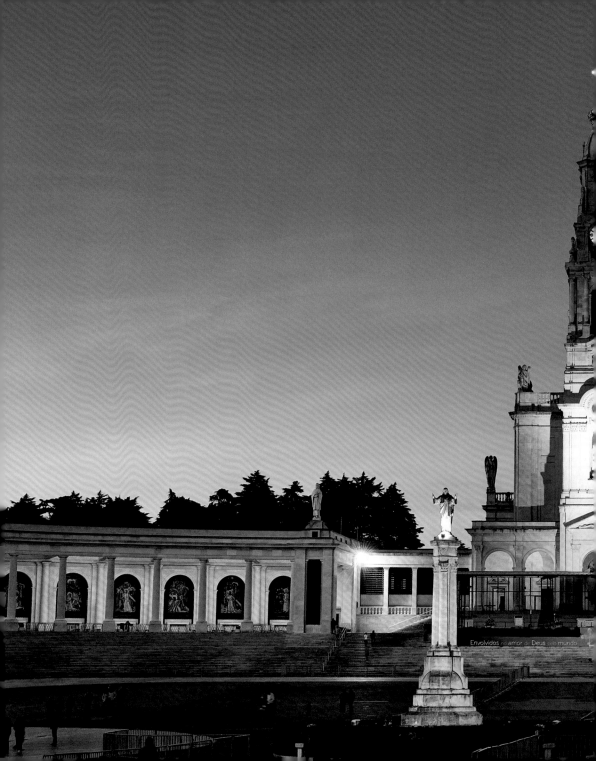

Envolvidos no amor de Deus pelo mundo

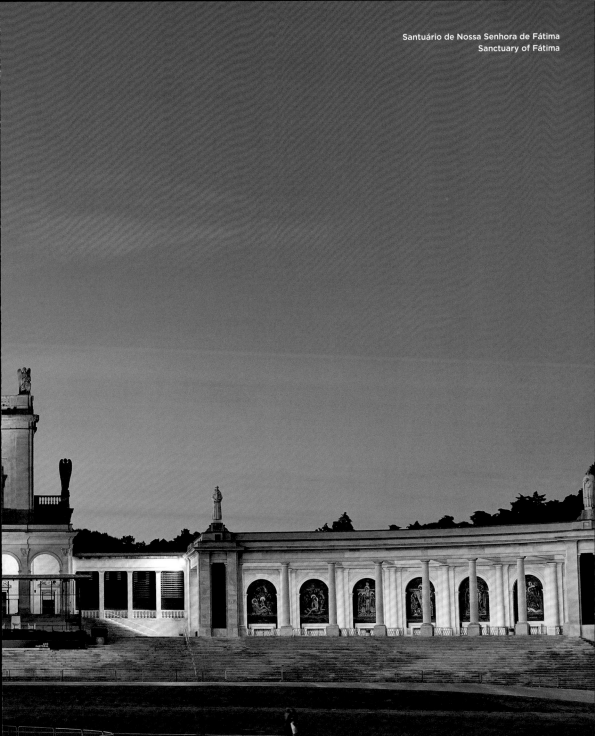

Santuário de Nossa Senhora de Fátima
Sanctuary of Fátima

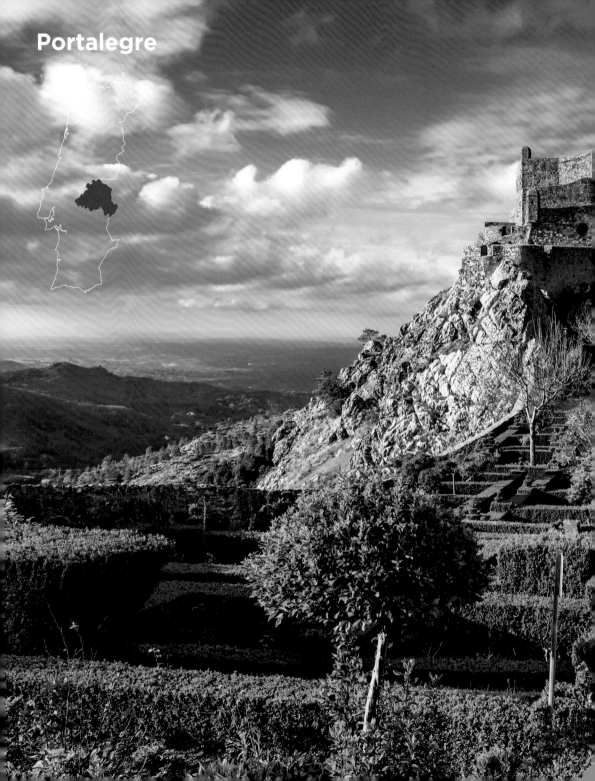

Portalegre

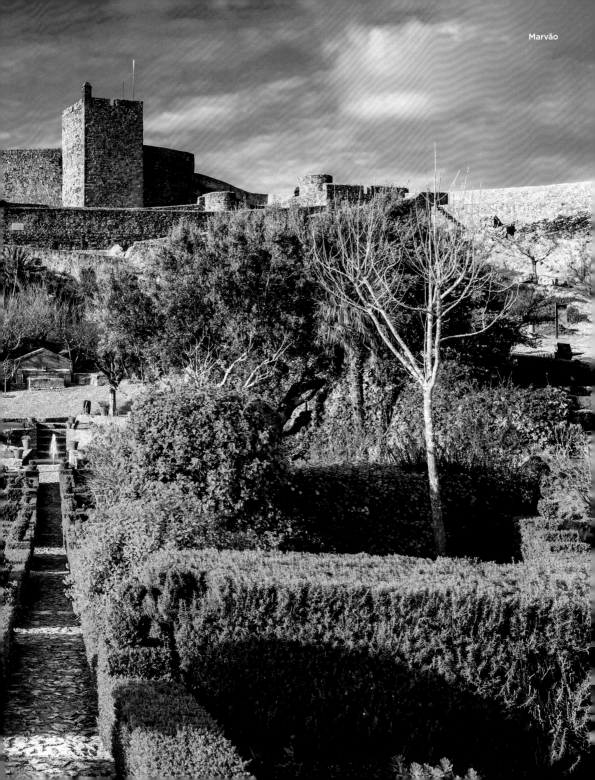

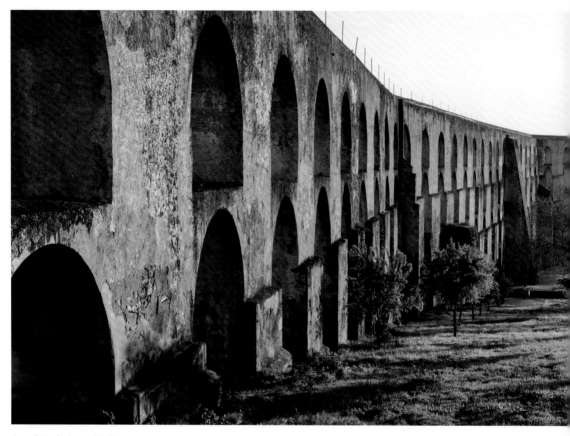

Aqueduto da Amoreira, Elvas
Amoreira Aqueduct, Elvas

Portalegre

The Tagus, or Tejo, River divides Portugal into a northern and a southern half. The latter is called Alentejo, meaning "beyond the Tagus". In the Serra de São Mamede the region shows a rather atypical face: extensive hills and coniferous forests, which are more reminiscent of Tuscany. The panorama from the castle of Marvão, dating from the 9th century, offers one of Portugal's finest views.

Portalegre

Le Tage divise le Portugal en une moitié nord et une moitié sud, appelée Alentejo – « au-delà du Tage ». Dans la Serra de São Mamede, la région présente un visage plutôt atypique : de vastes collines et des forêts de conifères rappellent davantage la Toscane. Le château de Marvão offre, depuis le IXe siècle, un beau point de vue sur le lieu.

Portalegre

Der Tejo teilt Portugal in eine Nord- und eine Südhälfte. Letztere trägt den Namen Alentejo, was übersetzt „jenseits des Tejo" bedeutet. In der Serra de São Mamede zeigt die Region ein eher untypisches Gesicht: weitläufige Hügel und Nadelwälder erinnern eher an die Toskana. Die Burg von Marvão bietet schon seit dem 9. Jh. einen sicheren Überblick.

Parque Natural da Serra de São Mamede
Serra de São Mamede Natural Park

Portalegre

El Tajo divide Portugal en una mitad norte y una mitad sur. Esta última se llama Alentejo, que, traducido, significa "más allá del Tajo". En la Serra de São Mamede, la región muestra una cara más bien atípica: sus extensas colinas y sus bosques de coníferas nos recuerdan más bien a la Toscana. El castillo de Marvão ofrece desde el siglo IX un paisaje que, sin duda, merece la pena ser visto.

Portalegre

Il Tago divide il nord e il sud del Portogallo. Quest'ultimo è chiamato Alentejo, che significa "oltre il Tago". Nella Serra de São Mamede la regione presenta un volto piuttosto atipico: ampie colline e boschi di conifere ricordano di più la Toscana. Il castello di Marvão offre dal IX secolo un bel panorama.

Portalegre

De Taag (Tejo) verdeelt Portugal in een noordelijke en een zuidelijke helft. Die laatste draagt de naam Alentejo, wat 'aan de overkant van de Taag' betekent. In de Serra de São Mamede vertoont de regio een nogal atypisch gezicht: uitgestrekte heuvels en naaldbossen doen meer denken aan Toscane. De burcht van Marvão biedt al sinds de 9e eeuw een veilig overzicht.

217

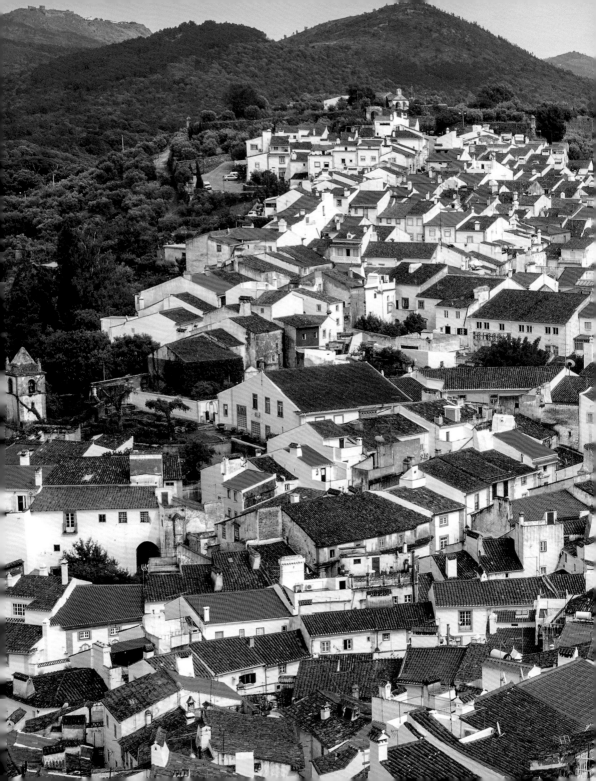

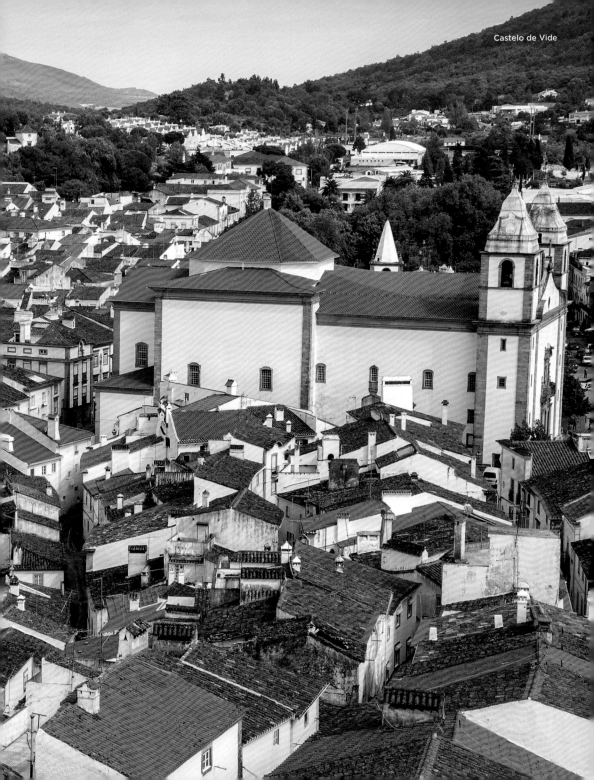

Castelo de Vide

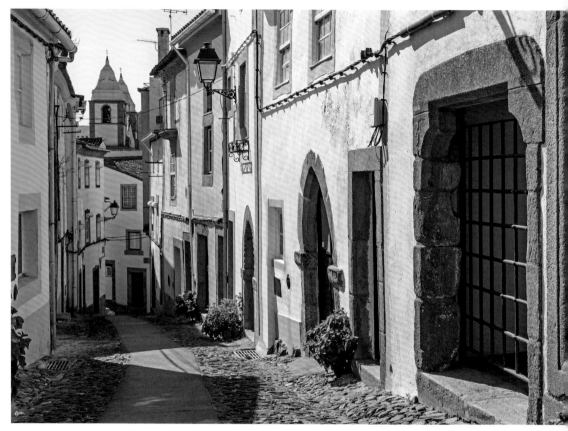

Castelo de Vide

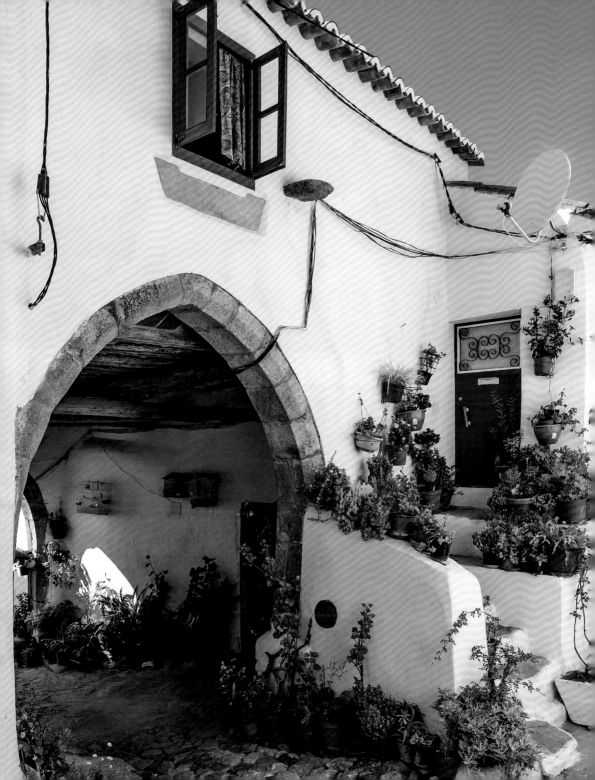

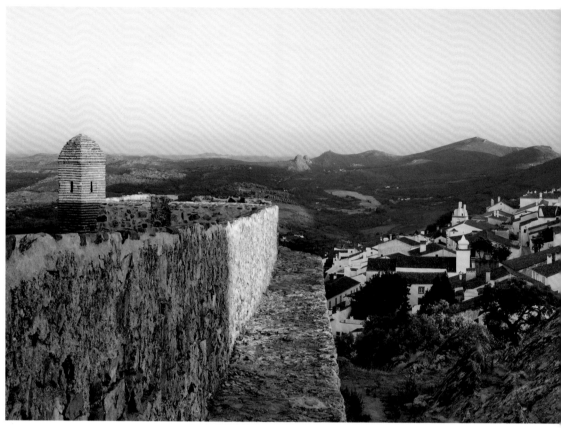

Marvão

Castelo de Vide

With its white houses and their orange-tiled roofs, the medieval village of Castelo de Vide appeals to the poetically inclined. Together, they form a mosaic which seems to fit perfectly into the surrounding green environment. Only on a tour through the alleyways do other colours emerge, in addition to a delightful variety of archways.

Castelo de Vide

Avec ses maisons blanches et ses toits pourpres, le village médiéval de Castelo de Vide fait appel à la fibre poétique des visiteurs : ces couleurs contrastées forment une mosaïque qui semble s'intégrer miraculeusement dans le vert de l'environnement. Au détour des allées, on y découvre encore de nouvelles nuances – en même temps que l'on y admire une importante variété d'arcades.

Castelo de Vide

Mit weißen Häusern und karmesinroten Dächern spricht das mittelalterliche Dorf Castelo de Vide poetische Adern an. Gemeinsam bilden sie ein Mosaik, das sich auf wundersame Weise in die grüne Umgebung einzupassen scheint. Erst bei einem Rundgang durch die Gassen zeigen sich auch andere Farbtöne – und eine entzückende Vielfalt an Torbögen.

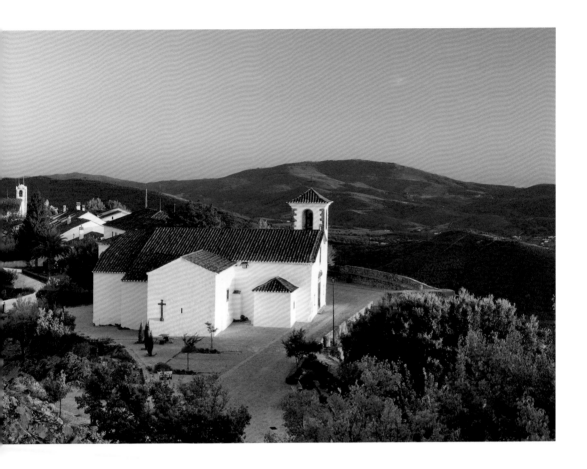

astelo de Vide

on casas blancas y tejados de color
armesí, el pueblo medieval de Castelo
e Vide apela a las vetas poéticas. Juntos
orman un mosaico que parece encajar
ilagrosamente en el entorno verde. Sólo
n un recorrido por los callejones aparecen
tros colores...– y una increíble variedad
e arcos.

Castelo de Video

Con le sue case bianche e i suoi tetti
cremisi, il borgo medievale di Castelo de
Vide fa appello alle vene poetiche. Insieme
formano un mosaico che sembra inserirsi
miracolosamente nel verde dell'ambiente.
Solo durante un giro turistico tra i vicoli
appaiono altri colori – e una deliziosa
varietà di arcate.

Castelo de Video

Het middeleeuwse dorp Castelo de
Vide spreekt met zijn witte huizen en
karmozijnrode daken dichtaders aan.
Samen vormen ze een mozaïek dat
wonderbaarlijk goed lijkt te passen in
de groene omgeving. Pas tijdens een
rondgang door de steegjes komen andere
kleuren tevoorschijn – en een betoverende
verscheidenheid aan poortbogen.

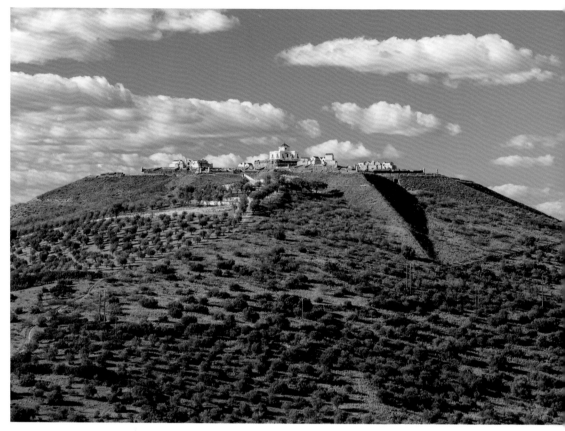

Forte de Nossa Senhora da Graça, Elvas
Nossa Senhora da Graça Fort, Elvas

Elvas

A border town and garrison town, Elvas has been a Unesco World Heritage Site since 2012 due to the presence of its 'star fort' fortifications, which were built to protect against the invading Spanish. The inhabitants of the mighty Nossa Senhora da Graça Fort lived in Moorish houses.

Elvas

Ancienne ville frontière et ville de garnison, Elvas a été inscrite dans ce cadre sur la liste du patrimoine mondial de l'UNESCO. On y trouve notamment la plus grande fortification conservée au monde, qui a été construite pour se protéger des Espagnols. Les habitants du puissant Fort Nossa Senhora da Graça vivaient dans des maisons mauresques.

Elvas

Als Grenz- und Garnisonsstadt hat Elvas Aufnahme in die Liste des Unesco-Weltkulturerbes gefunden. Zentraler Bestandteil sind die weltweit größten erhaltenen Bollwerk-Befestigungen, die einst zur Absicherung gegen die Spanier errichtet wurden. Die Bewohner des mächtigen Fort Nossa Senhora da Graça lebten in maurisch geprägten Häusern.

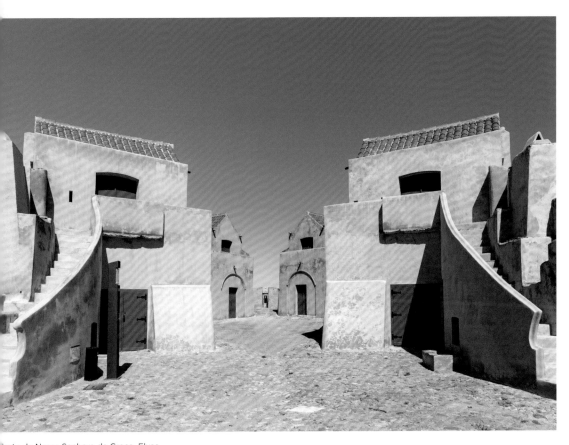

Forte de Nossa Senhora da Graça, Elvas
Nossa Senhora da Graça Fort, Elvas

Elvas

Como ciudad fronteriza y ciudad de guarnición, Elvas está incluida en la Lista del Patrimonio Mundial de la UNESCO. Su componente central son las fortificaciones de baluarte preservadas más grandes del mundo, que una vez fueron construidas para ofrecer protección frente a los españoles. Los habitantes del poderoso Fuerte Nossa Senhora da Graça vivían en casas moriscas.

Elvas

In quanto città di confine e di guarnigione, Elvas è stata inserita nella lista del patrimonio mondiale dell'Unesco. La parte centrale è la più grande barriera fortificata conservata al mondo, un tempo costruito per difendersi dagli spagnoli. Gli abitanti del possente Forte Nossa Senhora da Graça vivevano in case moresche.

Elvas

Als grens- en garnizoensstad is Elvas opgenomen op de werelderfgoedlijst van de Unesco. Het belangrijkst zijn 's werelds grootste bewaard gebleven bastionfortificaties, die ooit werden gebouwd als bescherming tegen de Spanjaarden. De bewoners van het machtige fort Nossa Senhora da Graça woonden in Moors aandoende huizen.

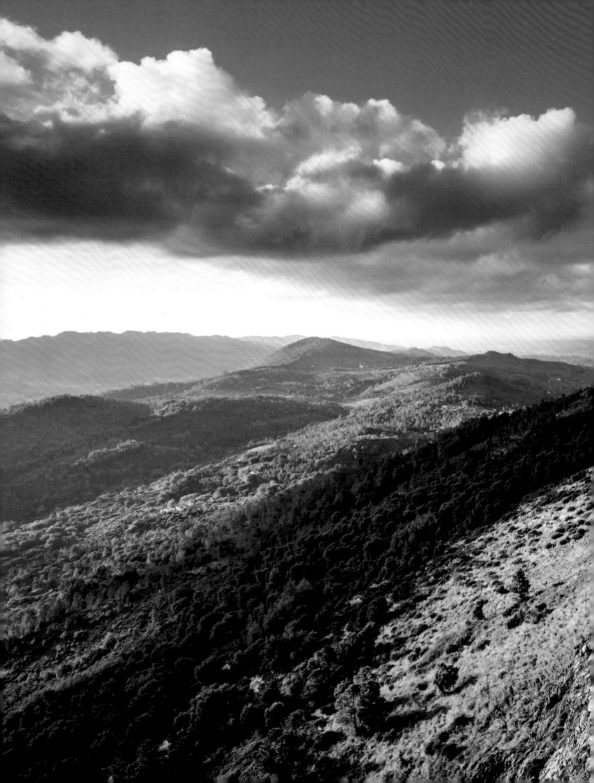

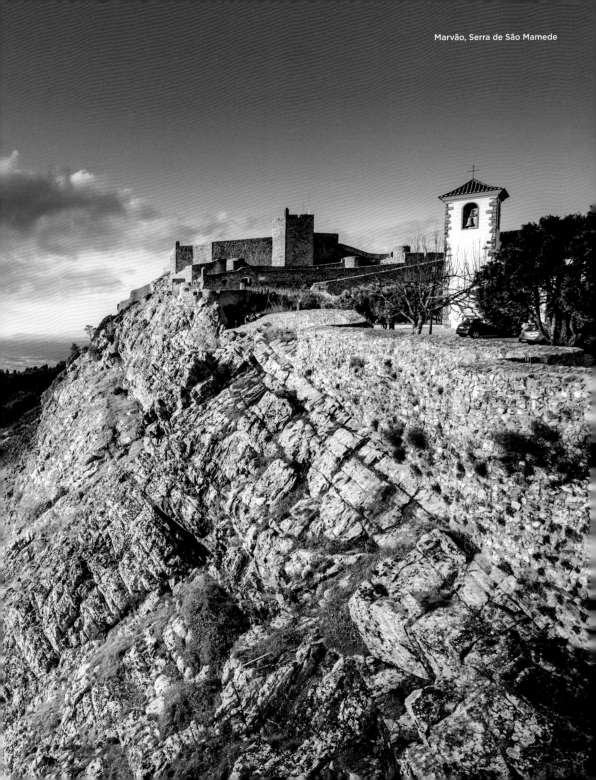

Marvão, Serra de São Mamede

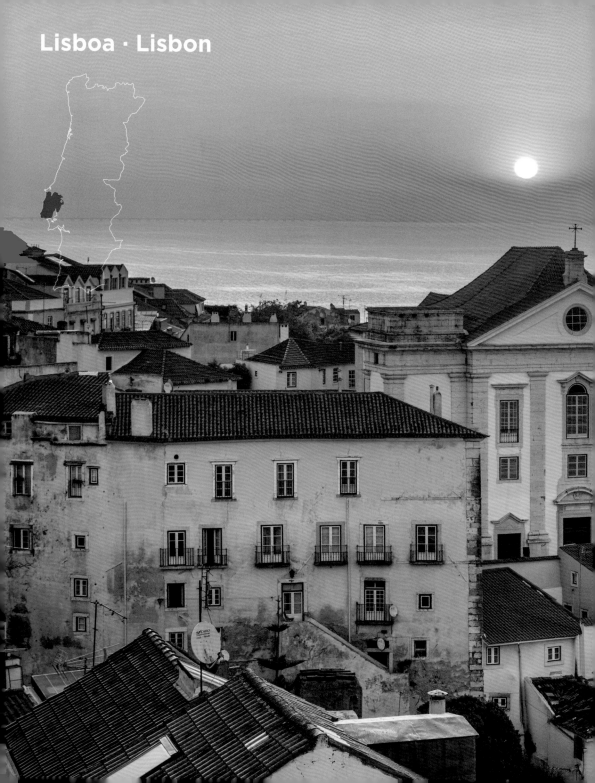

Lisboa · Lisbon

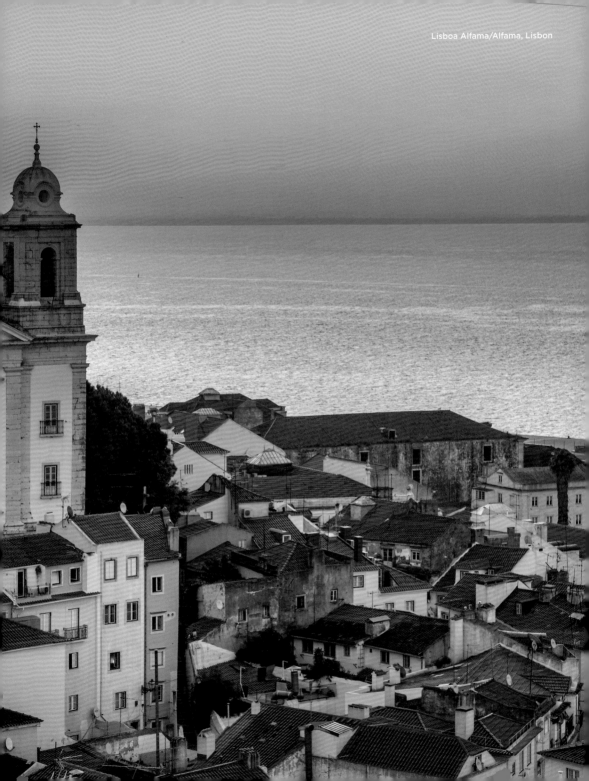

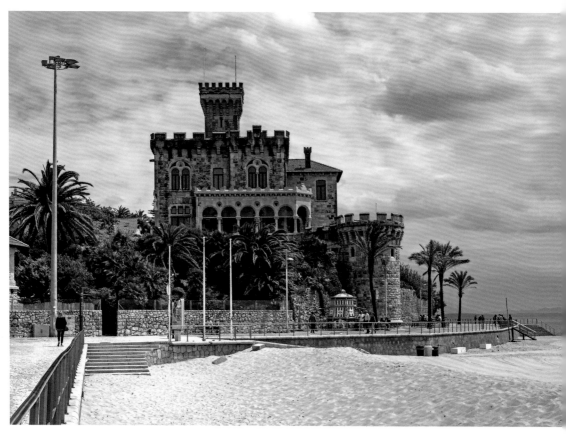

Forte da Cruz, Praia do Tamariz
Da Cruz Fort, Tamariz Beach

Lisbon

Estoril is the fashionable seaside resort just outside Lisbon. The Forte da Cruz beach house offers direct access to Tamariz Beach. A few kilometres further west, Cascais is an equally attractive beach town. The Farol de Santa Marta is just one of three lighthouses which have given ship captains orientation in the often stormy waters.

Lisbonne

À la périphérie de Lisbonne, Estoril est la station balnéaire à la mode. Le Forte da Cruz y est idéalement situé, au pied de la Praia da Tamariz. Quelques kilomètres plus à l'ouest sur la côte, la ville de Cascais est tout aussi attrayante. Le Farol de Santa Marta est l'un des trois phares qui guident les navires dans les eaux souvent tumultueuses.

Lissabon

Estoril ist das mondäne Seebad vor den Toren Lissabons. Das Forte da Cruz bietet direkten Zugang zur Praia da Tamariz. Ein paar Kilometer weiter gen Westen lockt mi Cascais ein ebenso attraktiver Strandort. Der Farol de Santa Marta ist nur einer von drei Leuchttürmen, die Schiffskapitänen Orientierung in den oftmals stürmischen Gewässern geboten haben.

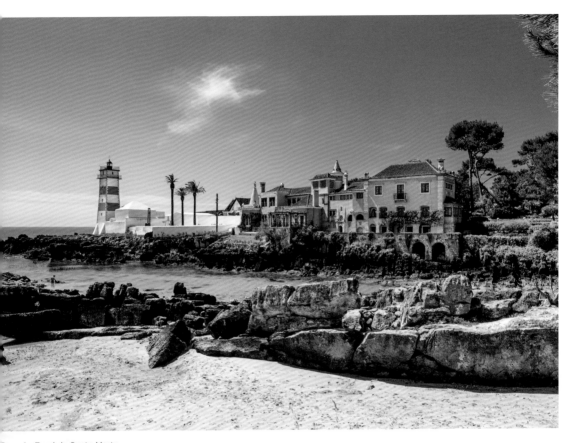

Cascais, Farol de Santa Marta
Santa Marta Lighthouse, Cascais

Lisboa

Estoril es la elegante estación balnearia situada a las afueras de Lisboa. El Forte da Cruz ofrece acceso directo a la Praia da Tamariz. Unos kilómetros más al oeste, Cascais es una ciudad de playa igualmente atractiva. El Farol de Santa Marta es sólo uno de los tres faros que han orientado a los capitanes de los barcos en las aguas a menudo tormentosas.

Lisbona

Estoril è la località balneare alla moda appena fuori Lisbona. Il Forte da Cruz offre un accesso diretto a Praia da Tamariz. A pochi chilometri più a ovest, Cascais è una città balneare altrettanto affascinante. Il Farol de Santa Marta è solo uno dei tre fari che hanno orientato i capitani nelle acque spesso tempestose.

Lissabon

Estoril is de mondaine badplaats net buiten de poorten van Lissabon. Het Forte da Cruz biedt directe toegang tot het Praia da Tamariz. Een paar kilometer verder naar het westen is Cascais een even aantrekkelijke badplaats. De Farol de Santa Marta is slechts een van de drie vuurtorens die scheepskapiteins ter oriëntatie hebben gediend in de vaak stormachtige wateren.

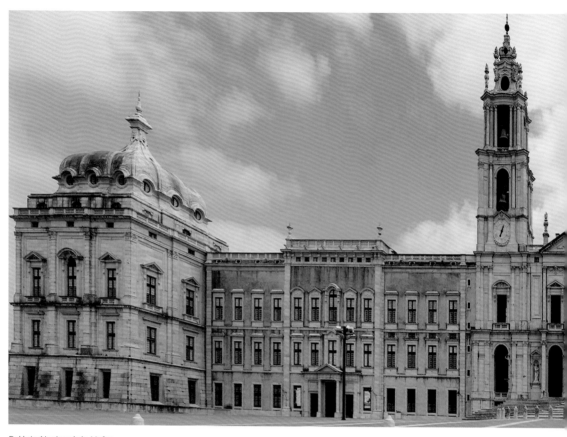

Palácio Nacional de Mafra
National Palace of Mafra

National Palace of Mafra

In the 17th and 18th centuries Portugal was a rich colonial power. During this period the largest castle and monastery complex in the country was built, the Palácio Nacional de Mafra. Situated 50 kilometres north of Lisbon, it is no coincidence that the building is reminiscent of German baroque castles, since the architect was named Johann Friedrich Ludwig, although he was known to the locals as João Frederico Ludovice.

Palais national de Mafra

Aux XVIIᵉ et XVIIIᵉ siècles, le Portugal était une riche puissance coloniale. C'est à cette époque qu'a été construit le plus grand château et monastère du pays : le Palácio Nacional de Mafra. Situé à 50 kilomètres au nord de Lisbonne, le bâtiment rappelle les châteaux baroques allemands ; ce n'est pas une coïncidence, car il a été conçu par un architecte du nom de Johann Friedrich Ludwig.

Palácio Nacional de Mafra

Im 17. und 18. Jh. war Portugal eine reiche Kolonialmacht. In dieser Epoche entstand auch die größte Schloss- und Klosteranlage des Landes: der Palácio Nacional de Mafra. Das 50 Kilometer nördlich von Lissabon gelegene Bauwerk erinnert nicht zufällig an deutsche Barockschlösser, denn der Architekt hörte auf den Namen Johann Friedrich Ludwig.

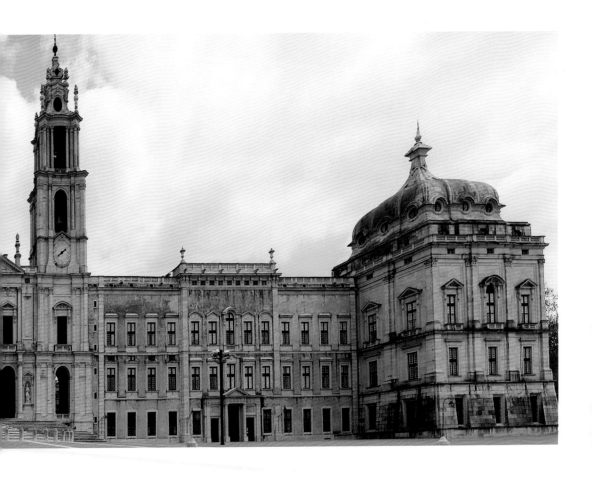

Palácio Nacional de Mafra

En los siglos XVII y XVIII Portugal fue
una rica potencia colonial. Durante este
período se construyó el mayor complejo de
castillos y monasterios del país: el Palácio
Nacional de Mafra, situado a 50 kilómetros
al norte de Lisboa. No es casualidad
que la construcción nos recuerde a los
castillos barrocos alemanes; y es que el
arquitecto respondía al nombre de Johann
Friedrich Ludwig.

Palazzo Nazionale di Mafra

Nei secoli XVII e XVIII il Portogallo era
una ricca potenza coloniale. Durante
questo periodo fu costruito il più grande
complesso di castelli e di monasteri del
paese: il Palácio Nacional de Mafra. Situato
a 50 chilometri a nord di Lisbona, l'edificio
ricorda i castelli barocchi tedeschi, e non è
una coincidenza, poiché l'architetto porta il
nome di Johann Friedrich Ludwig.

Palácio Nacional de Mafra

In de 17e en 18e eeuw was Portugal een
rijke koloniale macht. In deze periode werd
het grootste kasteel- en kloostercomplex
van het land gebouwd: het Palácio
Nacional de Mafra. Het gebouwencomplex,
dat 50 kilometer ten noorden van
Lissabon staat, doet niet toevallig denken
aan Duitse barokke kastelen, want de
architect luisterde naar de naam Johann
Friedrich Ludwig.

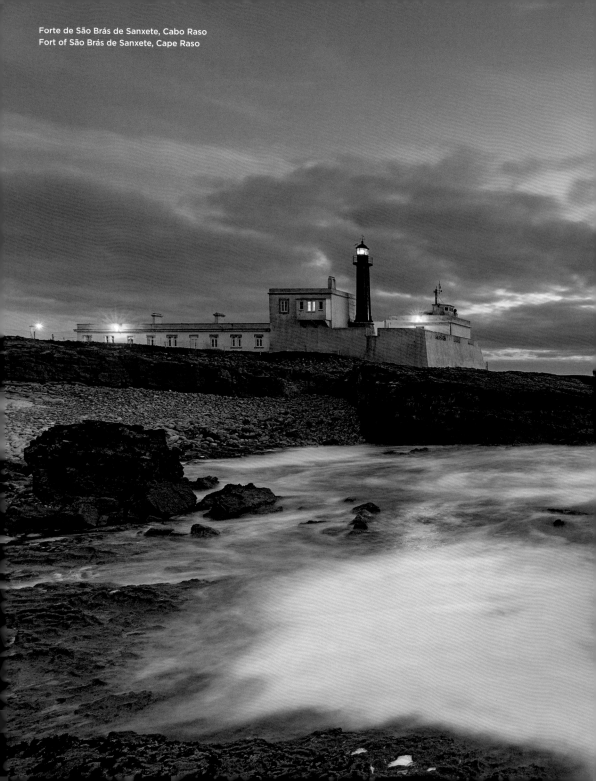

Forte de São Brás de Sanxete, Cabo Raso
Fort of São Brás de Sanxete, Cape Raso

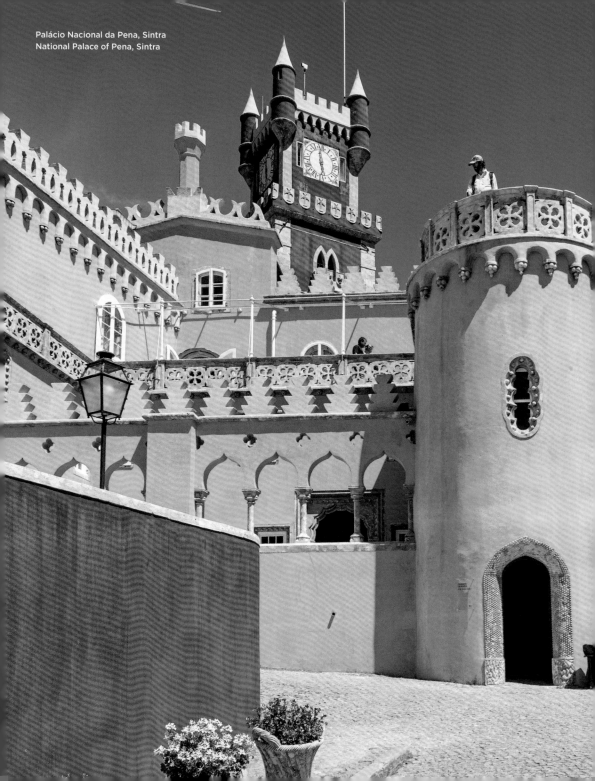

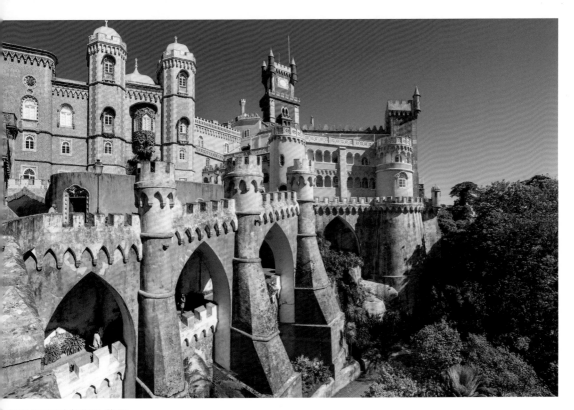

Palácio Nacional da Pena, Sintra
National Palace of Pena, Sintra

Sintra

A fairytale castle? Maybe. What is certain is that the Palácio Nacional da Pena quotes a variety of architectural styles. Historians could show that the complex, built in the middle of the 19th century, inspired the Bavarian King Ludwig II to build Neuschwanstein. Reason enough to take a look at the melodramatic confection mounted on a rock near Sintra.

Sintra

Est-ce un château de contes de fées ? Peut-être. Ce qui est certain, c'est que le Palácio Nacional da Pena présente une variété de styles architecturaux. Les historiens ont pu prouver que le complexe, construit au milieu du XIXᵉ siècle, a inspiré le roi bavarois Louis II dans la construction de Neuschwanstein. Une raison suffisante pour jeter un coup d'œil à cette architecture, construite de façon mélodramatique sur un rocher près de Sintra.

Sintra

Ein Märchenschloss? Vielleicht. Fest steht, dass der Palácio Nacional da Pena eine Vielzahl von Baustilen zitiert. Historiker konnten belegen, dass die Mitte des 19. Jh. entstandene Anlage den bayrischen König Ludwig II. zum Bau von Neuschwanstein inspiriert hat. Grund genug, die melodramatisch auf einem Felsen bei Sintra gelegene Vorlage in Augenschein zu nehmen.

Sintra

¿Un castillo de hadas? Tal vez. Lo que es seguro es que el Palácio Nacional da Pena posee una variedad de estilos arquitectónicos. Los historiadores pudieron comprobar que el complejo, construido a mediados del siglo XIX, inspiró al rey bávaro Luis II a construir el castillo de Neuschwanstein; razón más que suficiente para echar un vistazo al melodramático patrón de una roca cerca de Sintra.

Sintra

Un castello delle fate? Forse. Ciò che è certo è che il Palácio Nacional da Pena ricorda una varietà di stili architettonici. Gli storici hanno potuto dimostrare che il complesso, costruito a metà del XIX secolo, ha ispirato il re bavarese Ludwig II per costruire Neuschwanstein. Motivo sufficiente per dare un'occhiata al modello melodrammatico su una roccia vicino a Sintra.

Sintra

Een sprookjeskasteel? Misschien. Zeker is dat het Palácio Nacional da Pena een veelvoud aan architectonische stijlen citeert. Historici konden bewijzen dat het halverwege de 19e eeuw gebouwde complex de Beierse koning Lodewijk II inspireerde tot de bouw van Neuschwanstein. Reden genoeg om een kijkje te nemen in het melodramatisch op een rots gelegen voorbeeld bij Sintra.

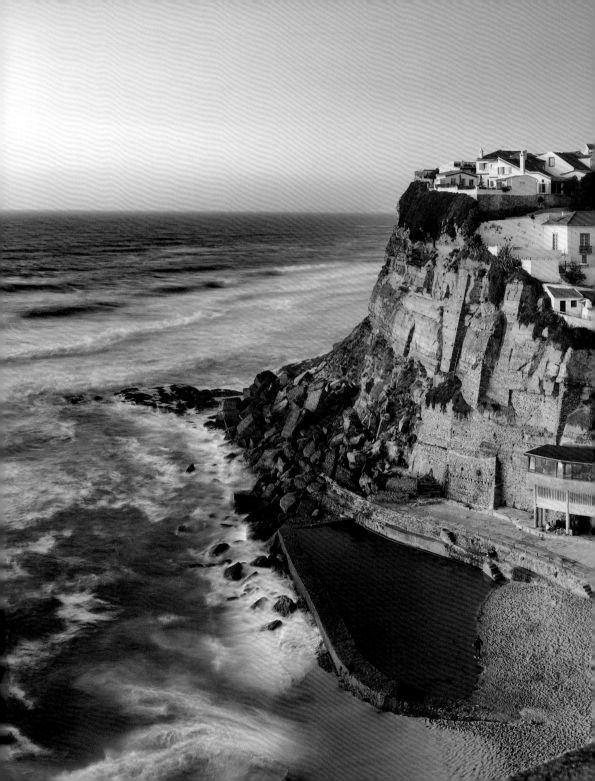

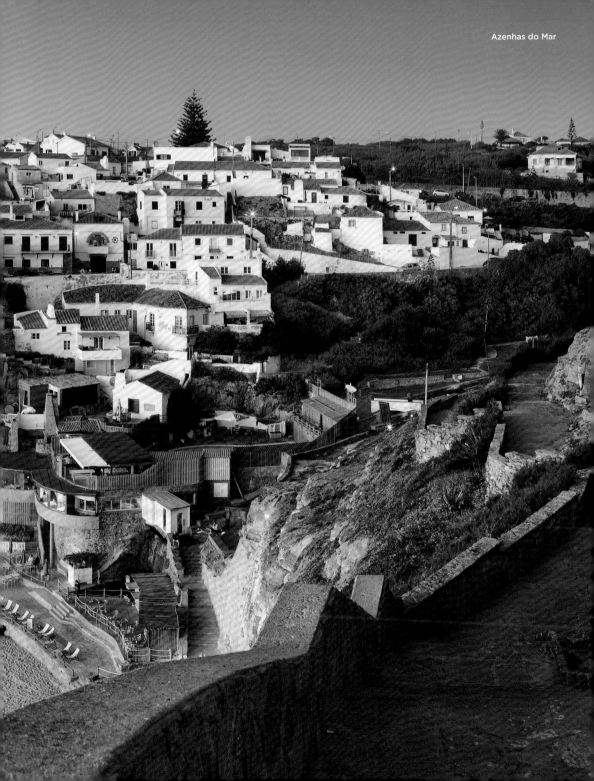

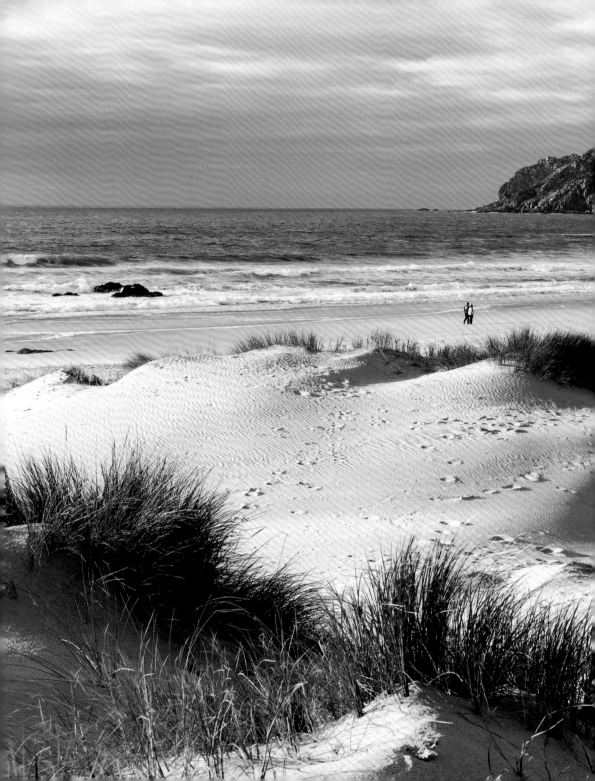

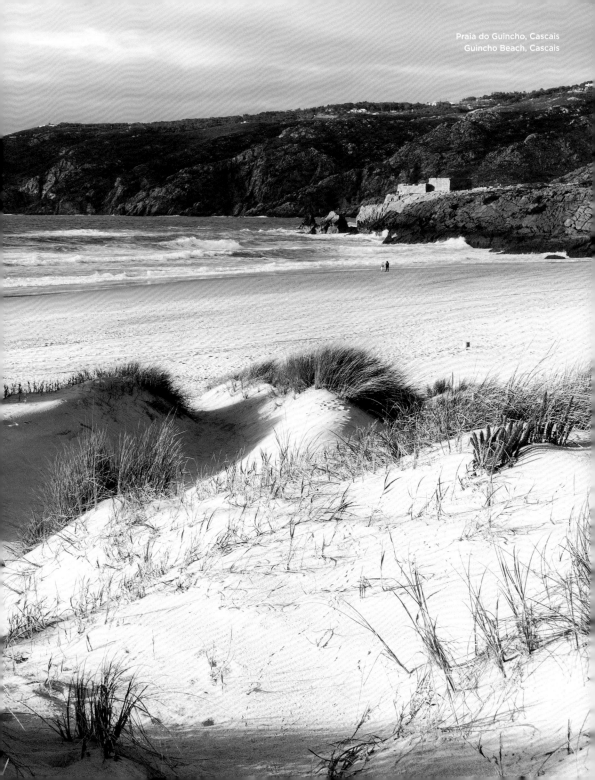

Cabo da Roca
Cape Roca

Cabo da Roca

The small village of Azenhas do Mar elegantly nestles upon a cliff. The 'initiation wells' in the Quinta da Regaleira in Sintra seem even bolder. Meanwhile, the lighthouse at Cabo da Roca radiates a cool confidence—as if it knows that it has the honour of being allowed to watch over the westernmost point of the European mainland.

Cabo da Roca

Le petit village d'Azenhas do Mar est élégamment blotti contre une falaise. La fontaine de la Quinta da Regaleira, dans la même région de Sintra, est un véritable bijou architectural. Pendant ce temps, le phare de Cabo da Roca rayonne d'une souveraineté froide – comme s'il savait l'honneur de surveiller le point le plus à l'ouest du continent européen.

Cabo da Roca

Das kleine Dorf Azenhas do Mar schmiegt sich elegant an eine Felsenklippe. Noch kühner scheint die Brunnenanlage in der Quinta da Regaleira in Sintra. Der Leuchtturm am Cabo da Roca strahlt derweil eine kühle Souveränität aus – als wüsste er um die Ehre, über den westlichsten Punkt des europäischen Festlands wachen zu dürfen.

Cabo da Roca

El pequeño pueblo de Azenhas do Mar se encuentra elegantemente enclavado en un acantilado. La fuente de la Quinta da Regaleira de Sintra parece aún más atrevida. Mientras tanto, el faro de Cabo da Roca irradia una fría soberanía, como si fuese conocedor de que tiene el honor de poder vigilar el punto más occidental del continente europeo.

Cabo da Roca

Il piccolo villaggio di Azenhas do Mar si adagia elegantemente su una scogliera. La fontana della Quinta da Regaleira a Sintra sembra ancora più ardita. Il faro di Cabo da Roca invece irradia una fredda sovranità, come se sapesse di avere l'onore di sorvegliare il punto più occidentale della terraferma europea.

Cabo da Roca

Het kleine dorpje Azenhas do Mar vlijt zich elegant tegen een klif. Het brongebouw in de Quinta da Regaleira in Sintra lijkt nog stoutmoediger. Ondertussen straalt de vuurtoren op de Cabo da Roca een koele soevereiniteit uit – alsof hij wist dat hem de eer te beurt viel over het westelijkste punt van het Europese vasteland te mogen waken.

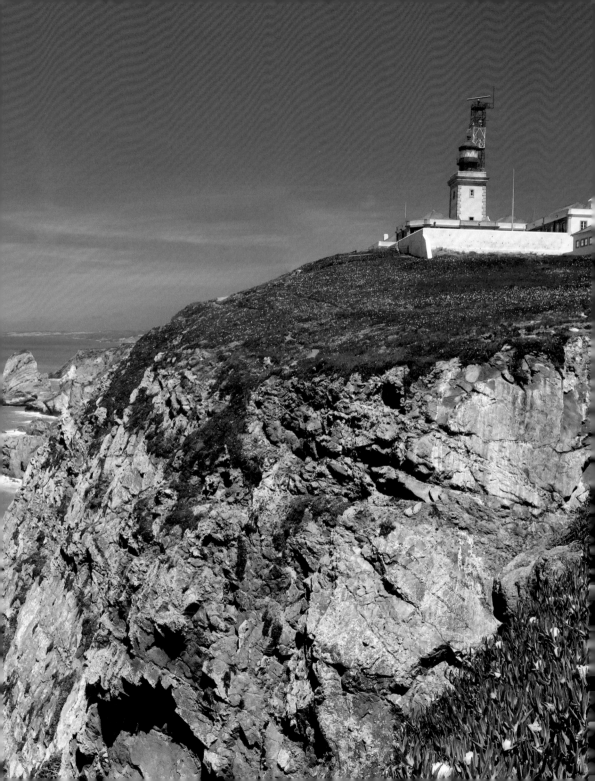

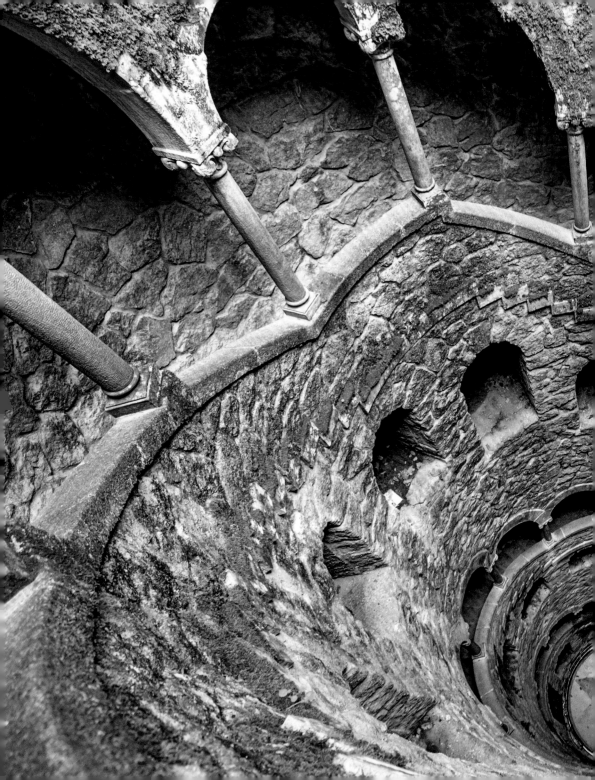

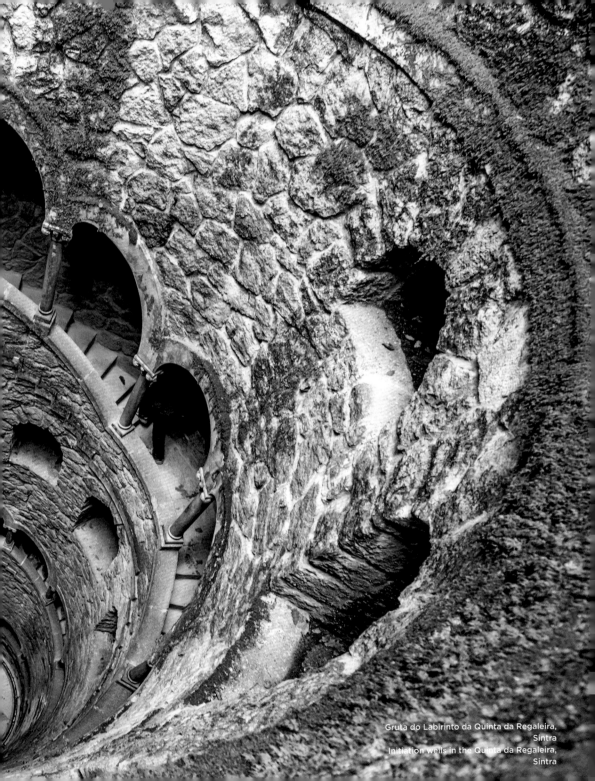

Gruta do Labirinto da Quinta da Regaleira,
Sintra
Initiation Wells in the Quinta da Regaleira,
Sintra

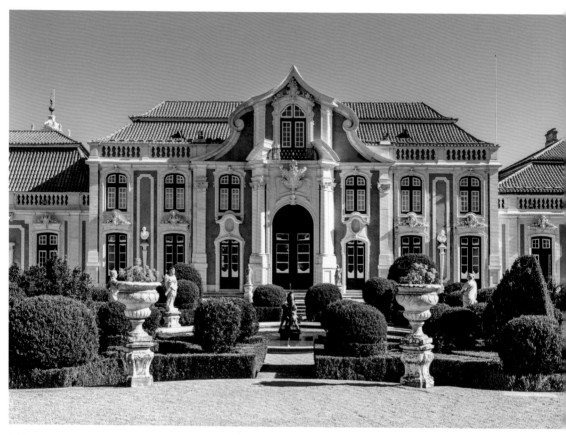

Palácio Nacional de Queluz
National Palace of Queluz

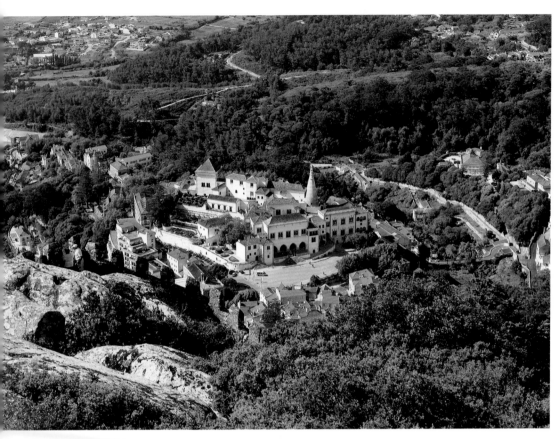

Palácio Nacional de Sintra
National Palace of Sintra

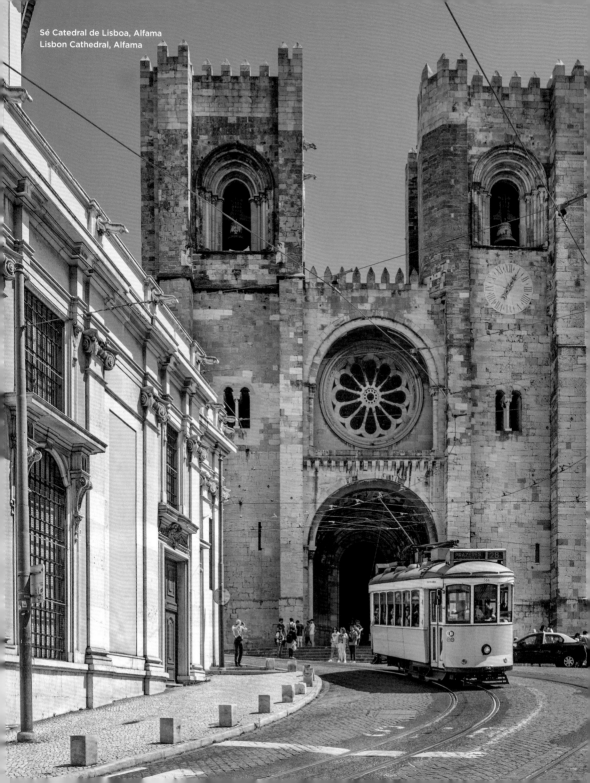

Sé Catedral de Lisboa, Alfama
Lisbon Cathedral, Alfama

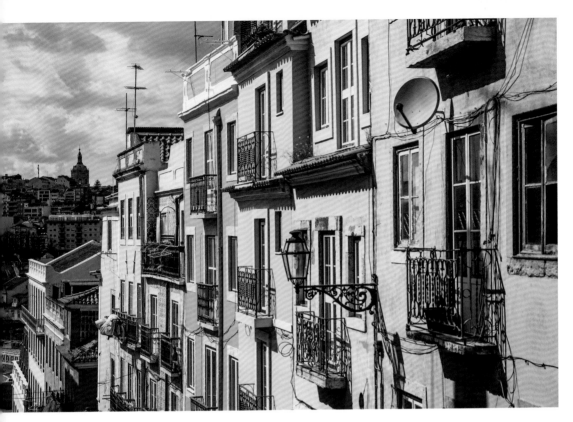

Bairro Alto

Lisbon
The Portuguese capital is colourful, a little melancholic and sublimely old-fashioned. Line 28 has become a symbol of Lisbon's cityscape, where the trams have been rumbling through the narrow alleys of the Alfama for decades. Visitors like to use the archaic means of transport for a leisurely round trip.

Lisbonne
La capitale portugaise est colorée, un peu mélancolique et sublimement surannée. La ligne 28 est devenue un symbole du paysage urbain de Lisbonne : depuis des décennies, le tramway gronde dans les ruelles étroites de l'Alfama. Les visiteurs aiment utiliser ces moyens de transport désuets pour une visite au ralenti.

Lissabon
Die portugiesische Hauptstadt ist farbenfroh, ein bisschen melancholisch auf erhabene Weise altmodisch. Die Linie 28 ist zu einem Symbol für das Stadtbild Lissabons geworden: Die Tram rumpelt seit Dekaden unbeirrt durch die engen Gassen der Alfama. Besucher nutzen das archaische Verkehrsmittel gerne für eine entschleunigte Rundfahrt.

Lisboa
La capital portuguesa es colorida, un poco melancólica y extraordinariamente anticuada. La línea 28 se ha convertido en un símbolo del paisaje urbano de Lisboa: el tranvía lleva décadas circulando por las estrechas callejuelas de la Alfama. A los visitantes les gusta utilizar el arcaico medio de transporte para un viaje de ida y vuelta desacelerado.

Lisbona
La capitale portoghese è colorata, un po' malinconica e sublime. La linea 28 è diventata un simbolo del paesaggio urbano di Lisbona: da decenni il tram attraversa gli stretti vicoli dell'Alfama. Ai visitatori piace utilizzare il vecchio mezzo di trasporto per un viaggio di andata e ritorno senza fretta.

Lissabon
De Portugese hoofdstad is kleurrijk, een beetje melancholiek en op een sublieme manier ouderwets. Lijn 28 is een symbool geworden van het stadsbeeld van Lissabon: de tram hobbelt al tientallen jaren voort door de smalle steegjes van de Alfama. Bezoekers gebruiken het archaïsche vervoermiddel graag voor een onthaastende rondrit.

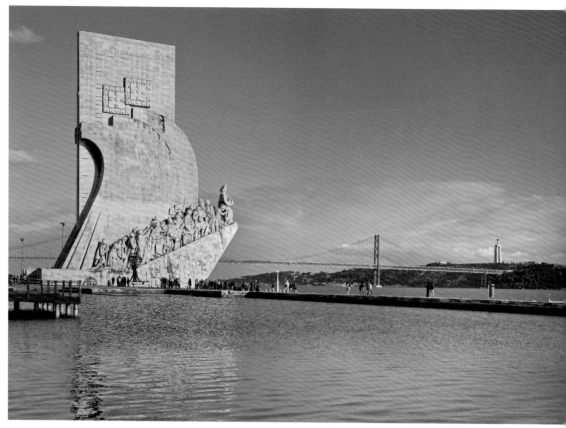

Padrão dos Descobrimentos, Belém, Tejo
Padrão dos Descobrimentos, Belém, Tagus

Tagus River

The Tagus, or Tejo, has always provided Lisbon with access to the Atlantic Ocean which is as generous as it is safe. Near the mouth of the river in Belém, the Padrão dos Descobrimentos (Monument of Discovery) reminds us of the great Portuguese sailors, while on the other side of the river, in Almada, stands the 75 meter high Cristo Rei—one of the world's largest statues of Christ.

Tage

Le Tage a toujours donné à Lisbonne un accès pratique et sans risque à l'océan. Près de l'embouchure du fleuve à Belém, le Padrão dos Descobrimentos (monument de la Découverte) commémore les grands marins portugais. De l'autre côté de la rivière à Almada, le Cristo Rei, haut de 75 m, abrite l'une des plus grandes statues du Christ.

Tejo

Der Tejo bietet Lissabon seit jeher einen ebenso großzügigen wie sicheren Zugang zum Atlantik. Nahe der Mündung in Belém erinnert das Padrão dos Descobrimentos (Denkmal der Entdeckungen) an die großen portugiesischen Seefahrer. Auf der anderen Seite des Flusses in Almada wacht der 75 Meter hohe Cristo Rei – eine der größten Christusstatuen.

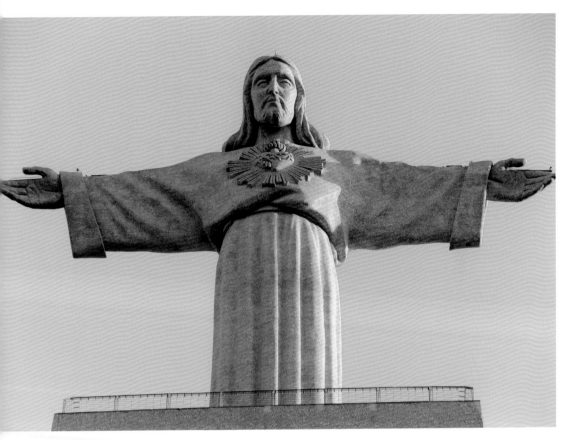

Cristo Rei

Tajo

El Tajo siempre ha proporcionado a Lisboa un acceso al Océano Atlántico tan generoso como seguro. Cerca de la desembocadura del río en Belém, el Padrão dos Descobrimentos (Monumento de los Descubrimientos) nos recuerda a los grandes marineros portugueses. Al otro lado del río, en Almada, se encuentra, con sus 75 metros de altura, el Cristo Rei, (una de las estatuas más grandes de Cristo).

Tago

Il Tago ha offerto sempre a Lisbona l'accesso all'Oceano Atlantico in modo tanto generoso quanto sicuro. Vicino alla foce del fiume a Belém, il Padrão dos Descobrimentos (Monumento alle Scoperte) ci ricorda i grandi navigatori portoghesi. Dall'altra parte del fiume, ad Almada, si trova il Cristo Rei alto 75 metri, una delle statue più grandi del Cristo.

Tejo

De Taag heeft Lissabon altijd een even veilige als genereuze toegang verschaft tot de Atlantische Oceaan. Vlak bij de monding van de rivier in Belém herinnert de Padrão dos Descobrimentos (Monument van de ontdekkingen) ons aan de grote Portugese ontdekkingsreizigers. Aan de overkant van de rivier, in Almada, waakt de 75 meter hoge Cristo Rei – een van de grootste Christusbeelden.

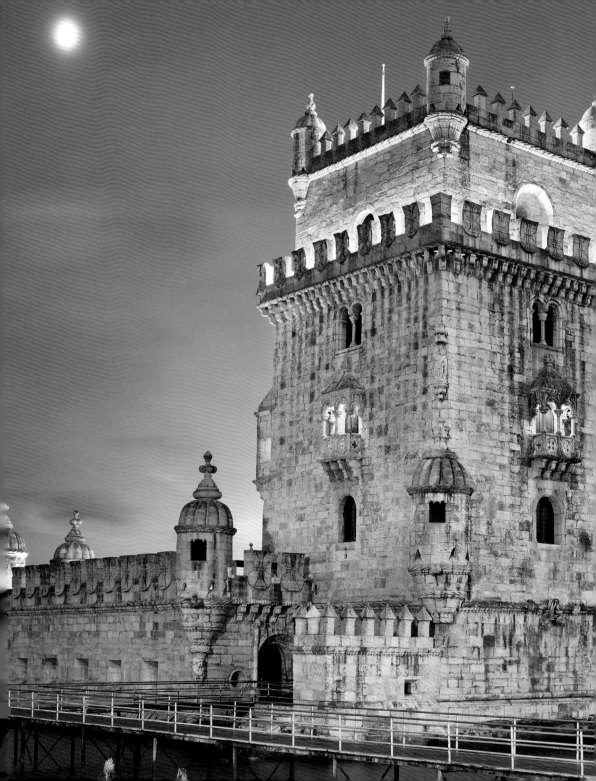

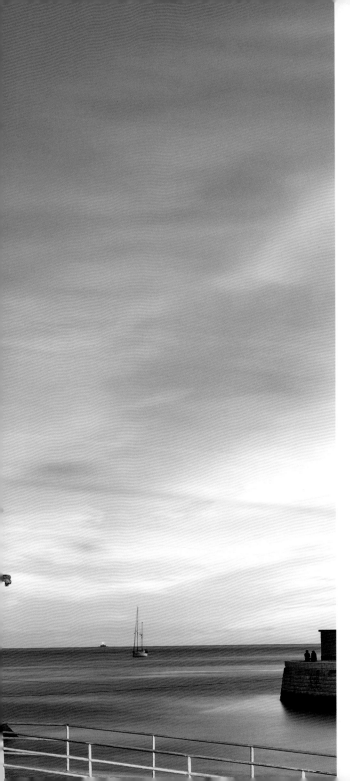

Torre de Belém
Belém Tower

Torre de Belém

It was King Manuel I who ordered the construction of the Torre de Belém (Belem Tower) in 1515. To this day, a long cultivated architectural style is named after him. The tower, located on the banks of the Tagus, had the task of welcoming returning seafarers, with Vasco da Gama being probably the best known of them. The bridge over the Tagus, completed in 1998, bears his name.

Torre de Belém

C'est le roi Manuel I qui ordonna la construction de la Torre de Belém en 1515 : aujourd'hui encore, un style architectural porte d'ailleurs son nom. La tour, située sur les rives du Tage, avait pour mission d'accueillir les marins de retour au pays. Le pont sur le Tage, achevé en 1998, porte d'ailleurs le nom de Vasco da Gama, probablement le plus grand d'entre eux.

Torre de Belém

Es war König Manuel I., der die Torre de Belém 1515 in Auftrag gegeben hat. Bis heute wird ein lange kultivierter Baustil nach ihm benannt. Dem an den Ufern des Tejo gelegenen Turm kam die Aufgabe zu, heimkehrende Seefahrer zu begrüßen. Vasco da Gama war der wohl größte von ihnen. Seinen Namen trägt die 1998 fertiggestellte Brücke über den Tejo.

Torre de Belém

Fue el rey Manuel I quien ordenó a construir la Torre de Belém en 1515. Hasta el día de hoy, un estilo arquitectónico cultivado desde hace mucho tiempo lleva su nombre. La torre, situada a orillas del Tajo, tenía la misión de acoger a los marineros que regresaban. Vasco da Gama fue probablemente el más grande de ellos. El puente sobre el Tajo, terminado en 1998, lleva su nombre.

Torre di Belém

Fu il re Manuel I a dare l'incarico della Torre de Belém nel 1515. A tutt'oggi, un coltivato stile architettonico prende il suo nome. La torre, situata sulle rive del Tago, aveva il compito di accogliere i navigatori al loro ritorno. Vasco da Gama fu probabilmente il più importante. Il ponte sul Tago, completato nel 1998, porta il suo nome.

Torre de Belém

Het was koning Manuel I die in 1515 de Torre de Belém liet bouwen. Er wordt nog altijd een lang gecultiveerde bouwstijl naar hem genoemd. De toren, die op de oever van de Taag staat, had als taak de terugkerende zeevaarders te verwelkomen. Vasco da Gama was waarschijnlijk de grootste onder hen. De in 1998 voltooide brug over de Taag draagt zijn naam.

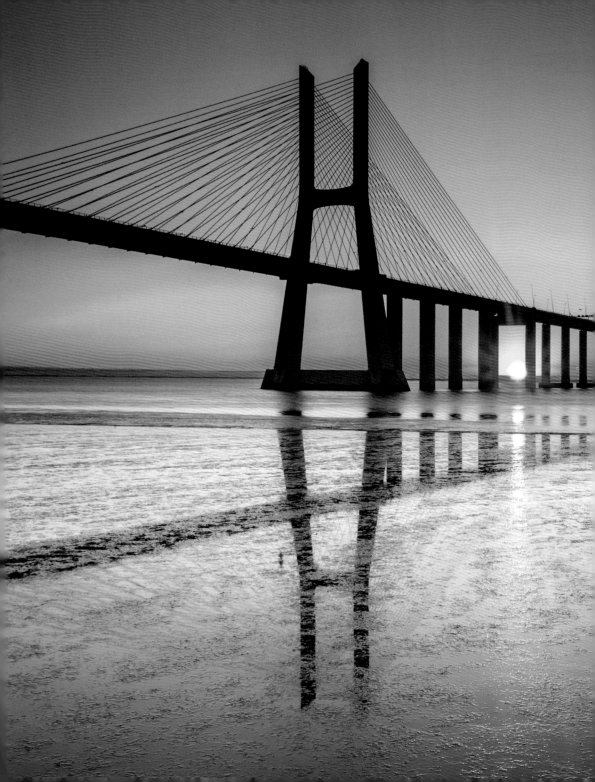

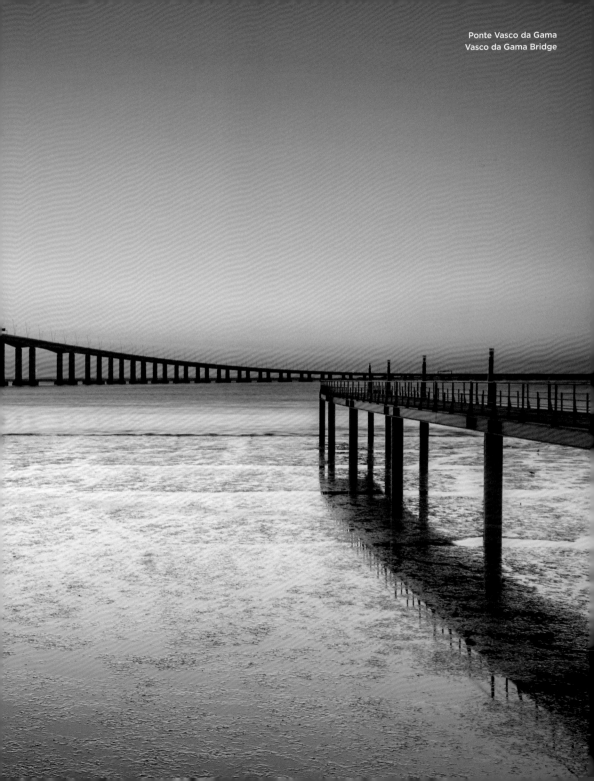

Ponte Vasco da Gama
Vasco da Gama Bridge

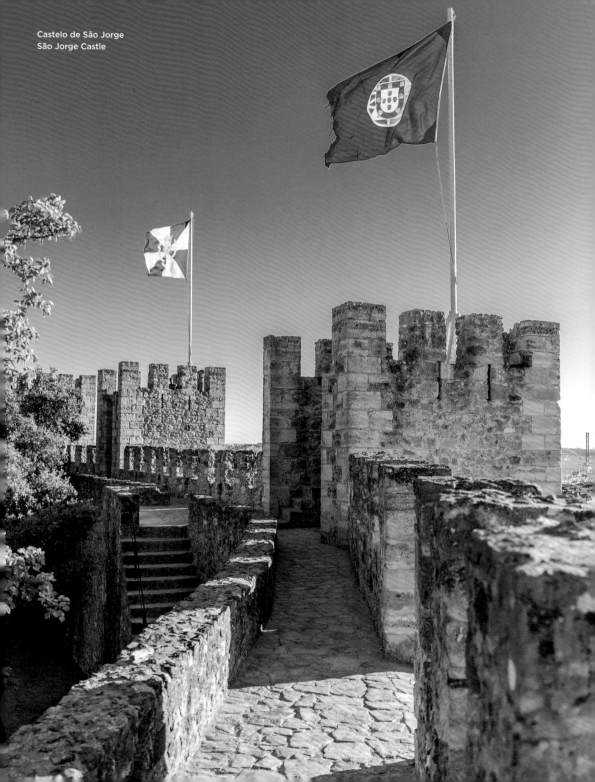

Castelo de São Jorge
São Jorge Castle

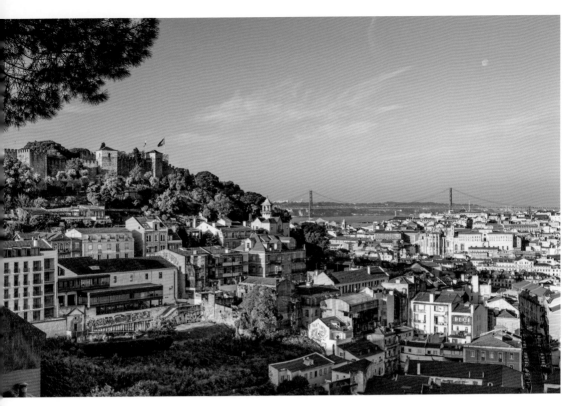

Miradouro da Graça

Baixa

Large parts of the old town were destroyed by the earthquake in 1755, and Lisbon's Baixa district had to be completely rebuilt. Since then, the Praça do Comércio (Commerce Square), complete with equestrian statue, and the Praça do Rossio (Rossio Square) have offered ample civic space. Another landmark is the Elevador de Santa Justa, which raises visitors to the Baixa over 45 metres up into the Chiado district.

Baixa

Une grande partie de la vieille ville a été détruite par un tremblement de terre en 1755. Le quartier de la Baixa, à Lisbonne, a ainsi été entièrement reconstruit. Aujourd'hui, la Praça do Comércio (et sa statue équestre) et la Praça de Rossio offrent de grands espaces ouverts dans la ville. L'Elevador de Santa Justa, qui emmène les visiteurs sur 45 mètres dans le district du Chiado, est également un incontournable de la Baixa.

Baixa

Weite Teile der Altstadt wurden 1755 bei einem Erdbeben zerstört. Lissabons Baixa musste neu aufgebaut werden. Seitdem bieten die Praça do Comércio (mit Reiterstandbild) und die Praça do Rossio großzügig Platz. Ein weiteres Wahrzeichen ist der Elevador de Santa Justa, der Besucher der Baixa über 45 Höhenmeter in den Stadtteil Chiado katapultiert.

Baixa

Gran parte del casco antiguo fue destruido por un terremoto en 1755, y la Baixa de Lisboa tuvo que ser reconstruida. Desde entonces, la Praça do Comércio (con estatua ecuestre) y la Praça do Rossio son plazas muy espaciosas. Otro hito es el Elevador de Santa Justa, que catapulta a los visitantes de la Baixa a más de 45 metros dentro del Chiado.

Baixa

Gran parte della città vecchia fu distrutta da un terremoto nel 1755. La Baixa di Lisbona ha dovuto essere riedificata daccapo. Da allora, la Praça do Comércio (con statua equestre) e la Praça do Rossio sono state ampliate. Un altro punto di riferimento è l'Elevador de Santa Justa, che catapulta i visitatori della Baixa per oltre 45 metri nel quartiere Chiado.

Baixa

Grote delen van de oude stad werden in 1755 verwoest door een aardbeving. De Baixa van Lissabon moest opnieuw worden opgebouwd. Sindsdien bieden het Praça do Comércio (met ruiterstandbeeld) en het Praça do Rossio een overvloed aan ruimte. Een andere mijlpaal is de Elevador de Santa Justa, die de bezoekers van de Baixa meer dan 45 meter de hoogte in schiet naar de wijk Chiado.

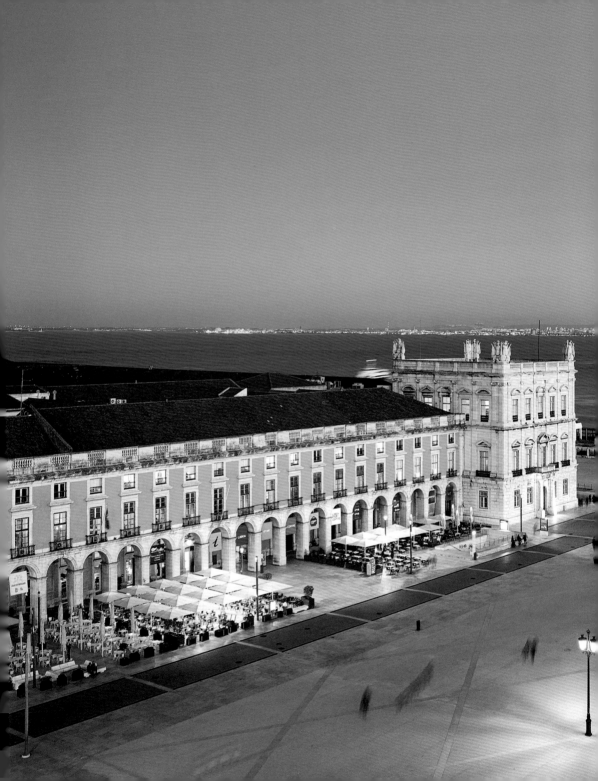

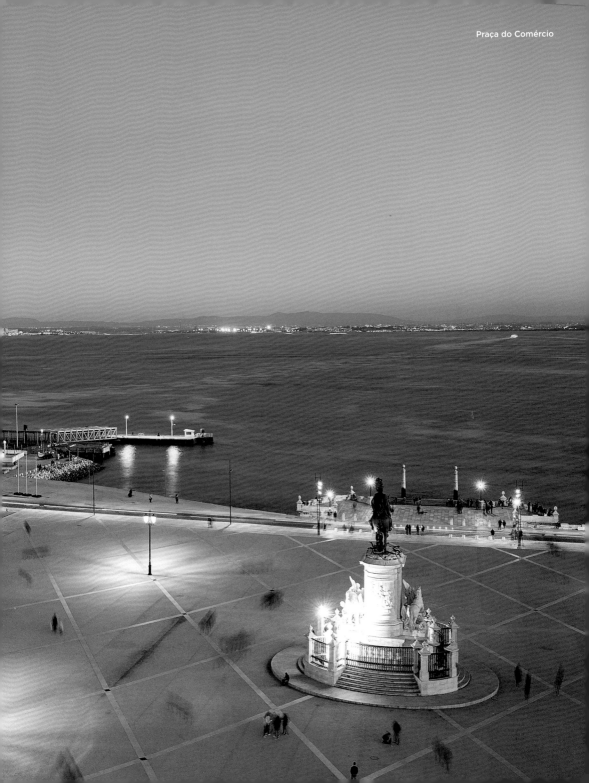

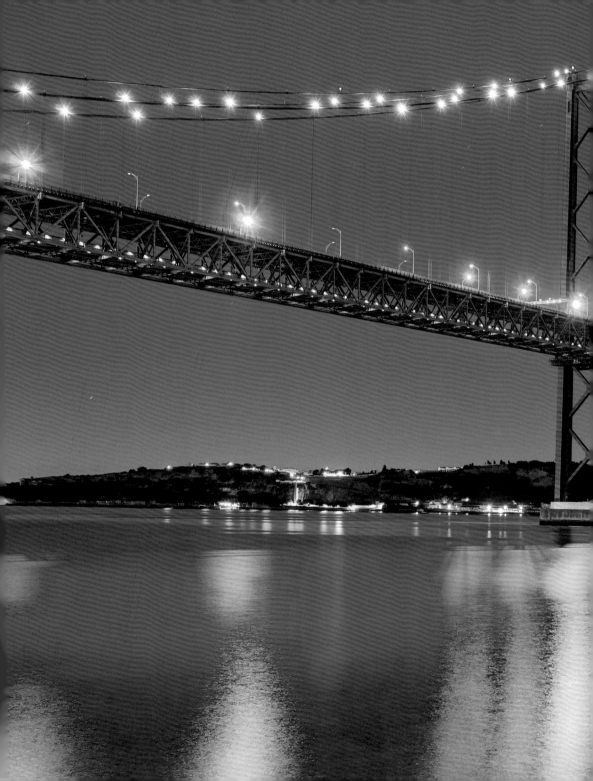

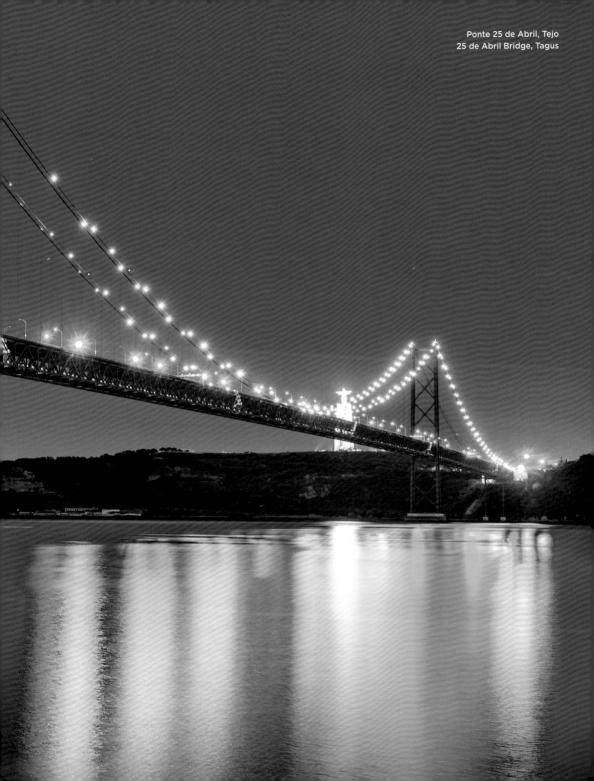

Ponte 25 de Abril, Tejo
25 de Abril Bridge, Tagus

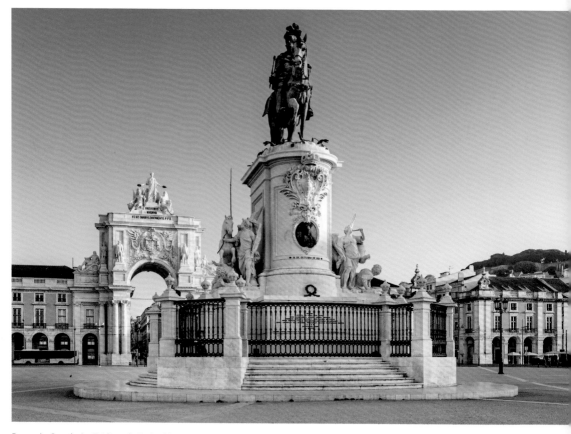

Praça do Comércio, Estátua de D. José I
Praça do Comércio, Statue of King José I

Elevador de Santa Justa, Chiado
Santa Justa Lift, Chiado

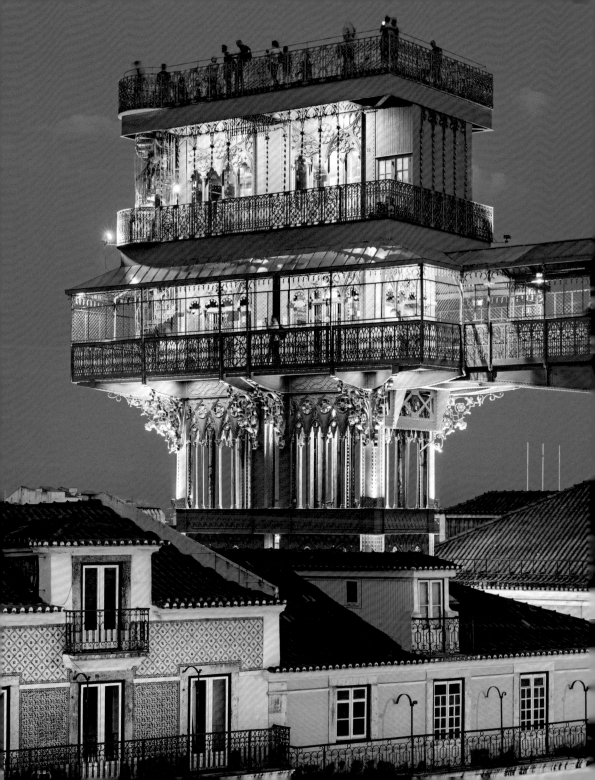

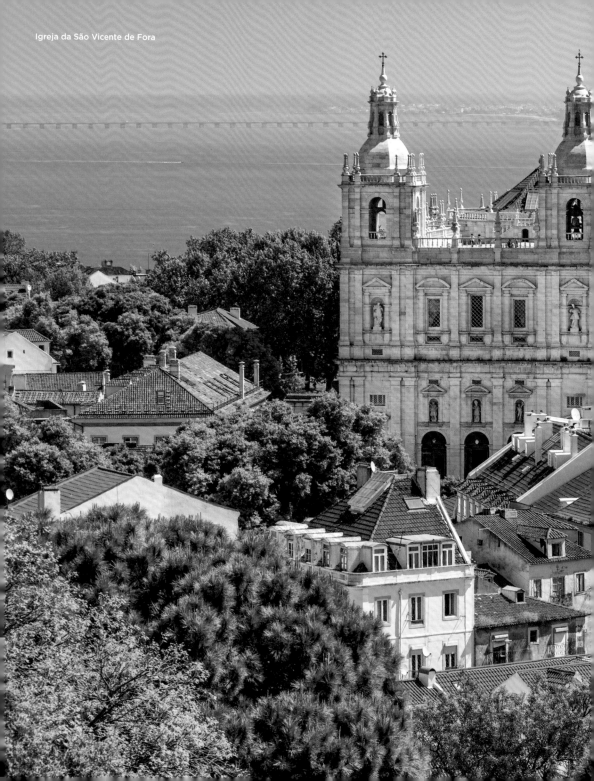
Igreja da São Vicente de Fora

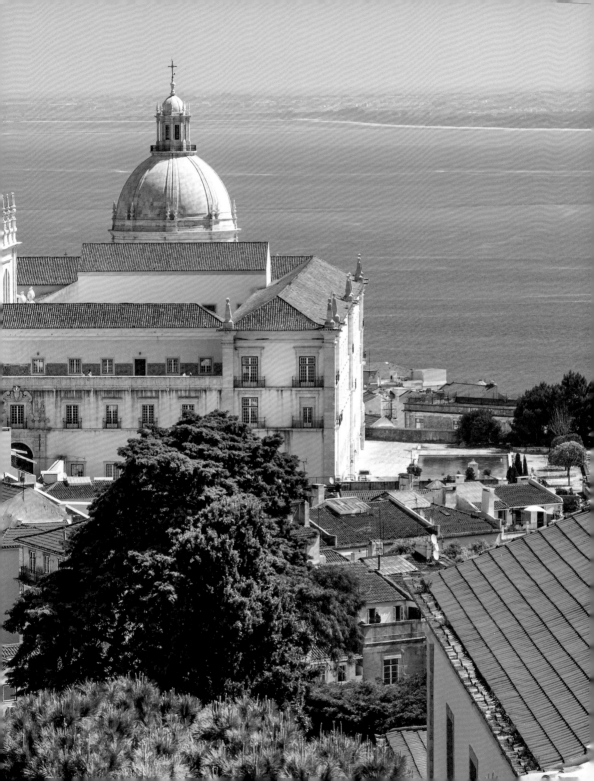

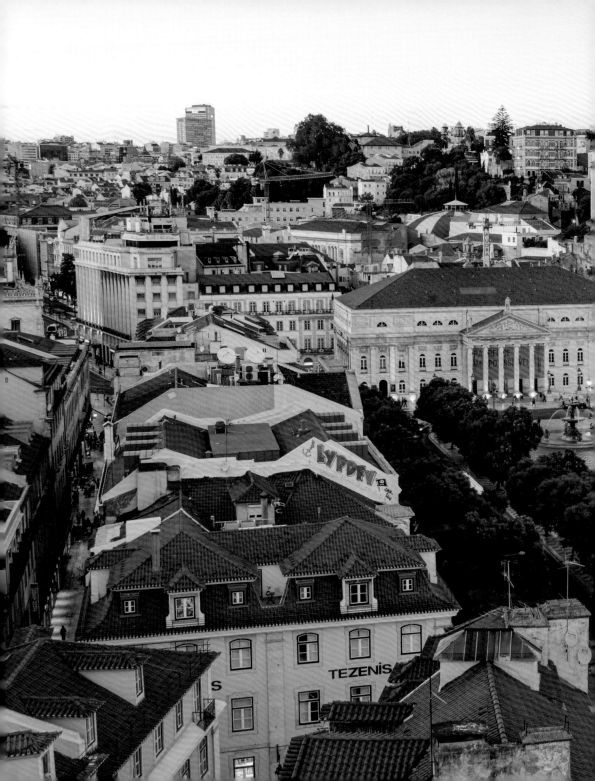

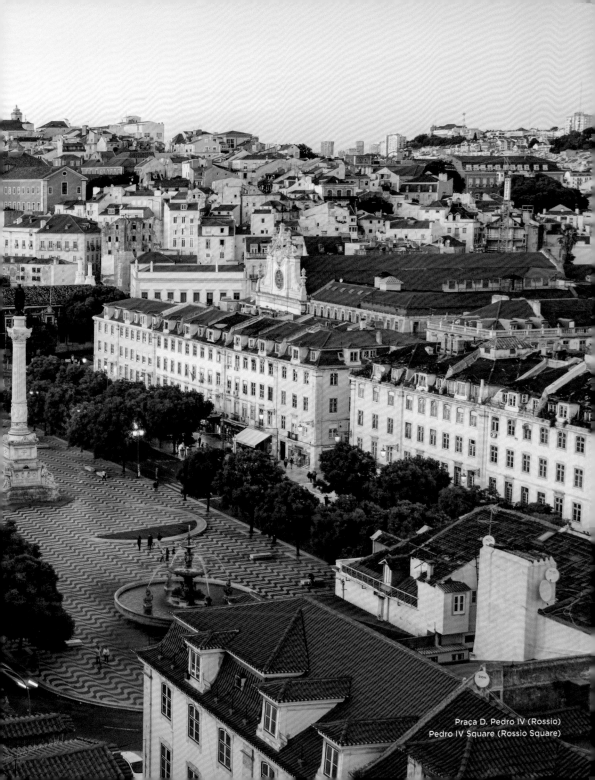

Praça D. Pedro IV (Rossio)
Pedro IV Square (Rossio Square)

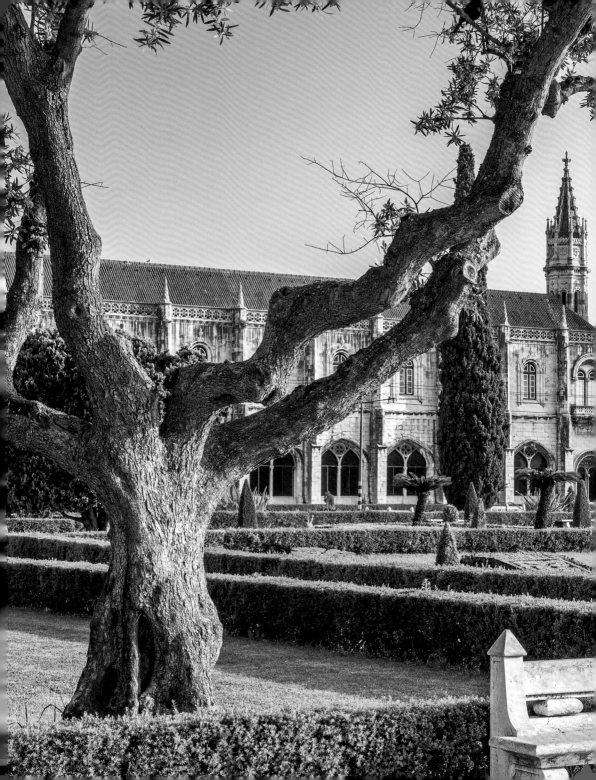

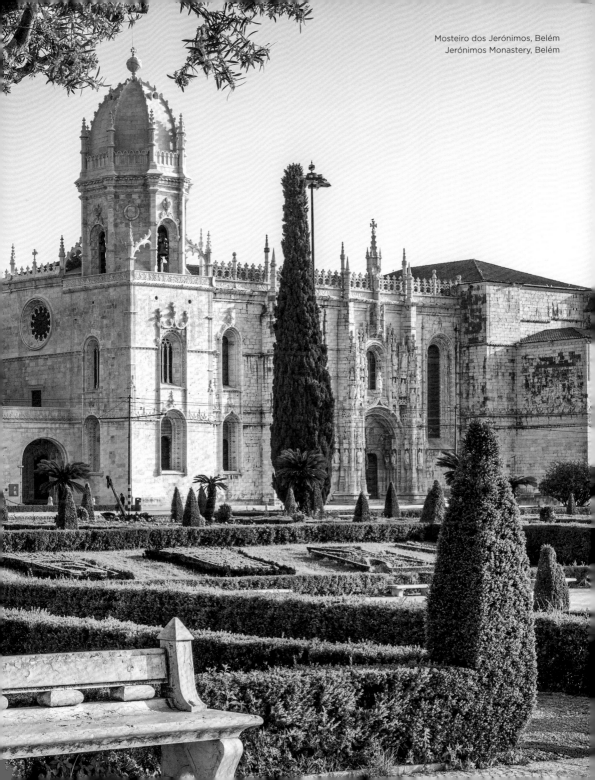

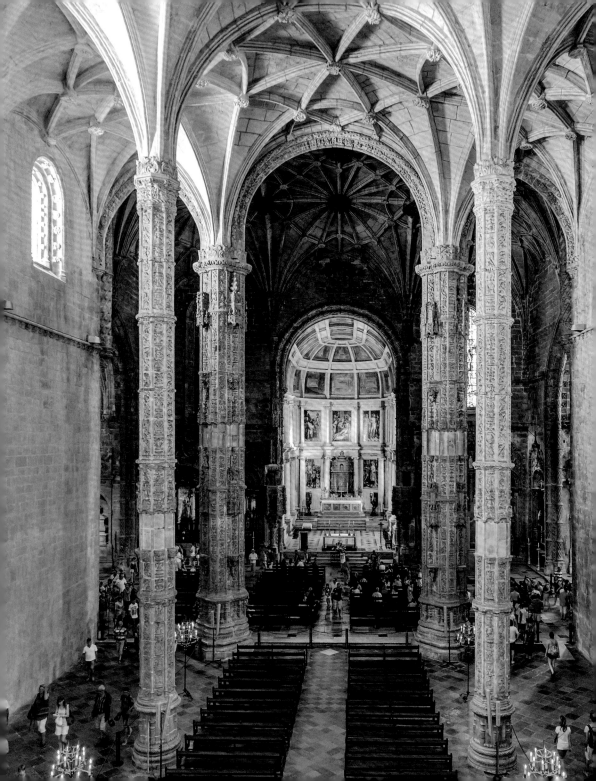

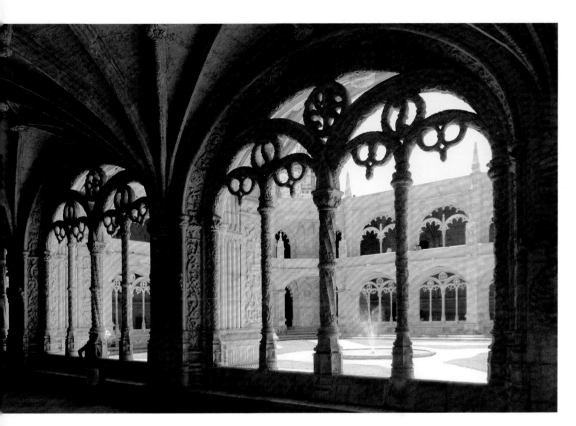

Mosteiro dos Jerónimos, Belém
Jerónimos Monastery, Belém

Mosteiro dos Jerónimos, Belém
Jerónimos Monastery, Belém

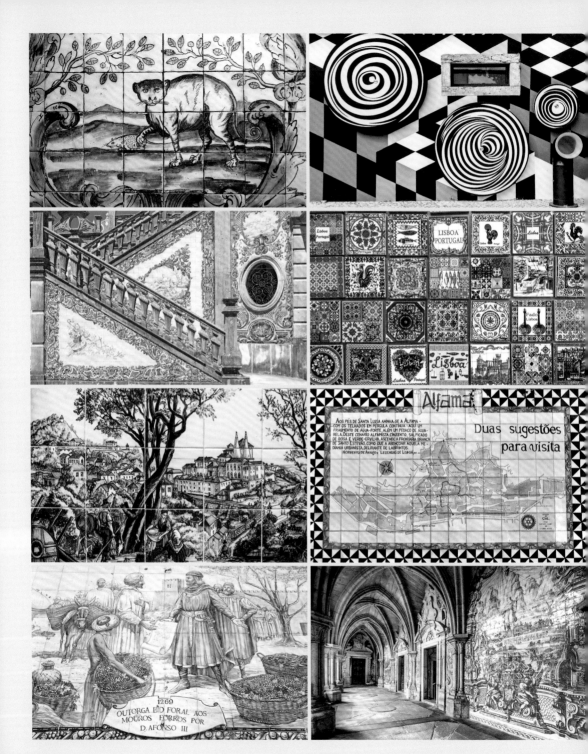

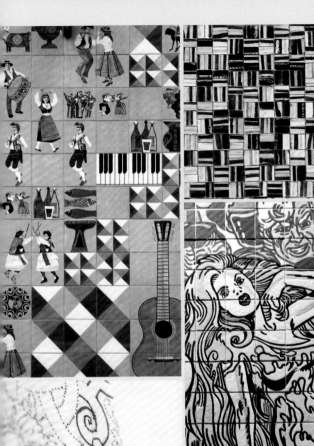

Azulejos

Colourfully painted *azulejos* (tiles) are a Portuguese cultural asset. Sometimes the glazed tiles are purely decorative works of art, however, their importance is often greater, with historical scenes being recreated on the facades or inside railway stations and churches. The National Azulejo Museum in Lisbon offers a great overview.

Les azulejos (carreaux) peints en couleurs sont un atout culturel portugais. Parfois, les carreaux émaillés sont des œuvres d'art purement décoratives. Mais leur importance est souvent plus grande : des scènes historiques sont ainsi parfois recréées sur les façades, ou à l'intérieur des gares et des églises. Le Museu Nacional do Azulejo, à Lisbonne, offre une excellente vue d'ensemble.

Bunt bemalte Azulejos (Fliesen) sind ein portugiesisches Kulturgut. Manchmal sind die glasierten Fliesen rein dekorative Kunstwerke. Häufig aber ist ihre Bedeutung größer: An den Fassaden oder im Innern von Bahnhöfen und Kirchen sind historische Szenen nachgestellt. Einen tollen Überblick gewährt das Museu Nacional do Azulejo in Lissabon.

Los azulejos pintados de colores son un patrimonio cultural portugués. A veces los azulejos vidriados son obras de arte puramente decorativas. Sin embargo, a menudo desempeñan un papel más importante, ya que recrean escenas históricas en las fachadas o en el interior de las estaciones de ferrocarril y las iglesias. El Museu Nacional do Azulejo de Lisboa ofrece una buena visión de esto.

I colorati azulejos (piastrelle) sono un bene culturale portoghese. A volte le piastrelle smaltate sono opere d'arte puramente decorative. Tuttavia, spesso hanno un'importanza maggiore: vengono ricreate scene storiche sulle facciate o all'interno di stazioni ferroviarie e di chiese. Il Museu Nacional do Azulejo di Lisbona offre un'ottima panoramica.

Kleurig beschilderde azulejos (tegels) zijn een Portugees cultuurgoed. Soms zijn de geglazuurde tegels louter decoratieve kunstwerkjes. Ze hebben echter vaak een grotere betekenis: historische taferelen worden ermee afgebeeld op de gevels of binnenruimten van treinstations en kerken. Het Museu Nacional do Azulejo in Lissabon biedt een schitterend overzicht.

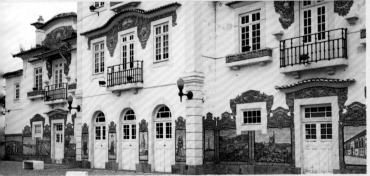

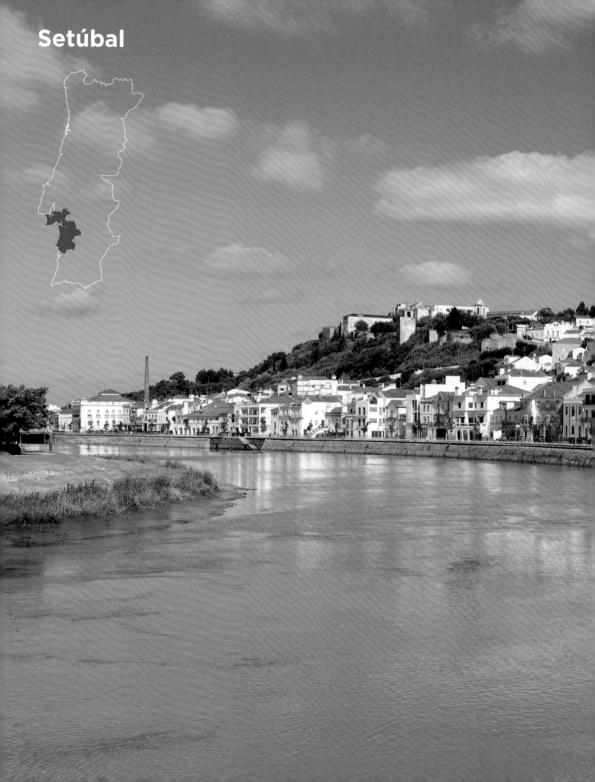

Setúbal

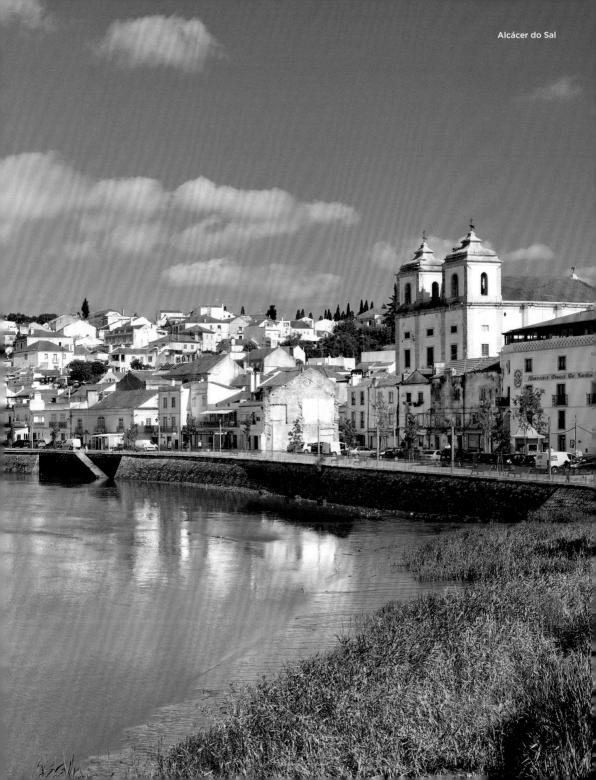

Cabo Espichel

The Nature Park of Arrábida
The Parque Natural de Arrábida spreads out on a headland to the south of Lisbon. Its three beaches are extremely popular with the inhabitants of the capital. The headland of Cabo Espichel is much more lonely, jutting out into the Atlantic Ocean. Since 1790 a lighthouse has assisted with navigation.

Parc naturel d'Arrábida
Au sud de Lisbonne s'étend, sur un promontoire, le parc naturel d'Arrábida. Ses trois plages sont extrêmement populaires auprès des habitants de la capitale. Le Cabo Espichel, beaucoup plus solitaire, se projette à l'Ouest dans l'océan Atlantique. Depuis 1790, un phare aide à la navigation.

Parque Natural de Arrábida
Südlich von Lissabon breitet sich auf einer Landzunge der Parque Natural de Arrábida aus. Die drei Strände sind äußerst beliebt bei den Bewohnern der Hauptstadt. Deutlich einsamer ist das Cab Espichel, das vorwitzig in den Atlantik hinausragt. Seit 1790 hilft ein Leuchtturm bei der Navigation.

Parque Natural de Arrábida

Al sur de Lisboa se extiende en un cabo el Parque Natural de Arrábida. Las tres playas son muy populares entre los habitantes de la capital. El Cabo Espichel, que se proyecta descaradamente hacia el océano Atlántico, es mucho más solitario. Desde 1790 cuenta con un faro que ayuda a la navegación.

Parco Naturale di Arrábida

A sud di Lisbona, su un promontorio, si estende il Parco Naturale di Arrábida. Le tre spiagge sono molto amate dagli abitanti della capitale. Il Cabo Espichel è molto più selvaggio, affacciandosi in modo insolente nell'Oceano Atlantico. Dal 1790 un faro serve come punto di riferimento ai naviganti.

Parque Naturel de Arrábida

Ten zuiden van Lissabon strekt zich op een landtong het Parque Natural de Arrábida uit. De drie stranden zijn erg populair bij de inwoners van de hoofdstad. De Cabo Espichel is aanzienlijk eenzamer en steekt eigenwijs de Atlantische Oceaan in. Sinds 1790 helpt een vuurtoren bij de navigatie.

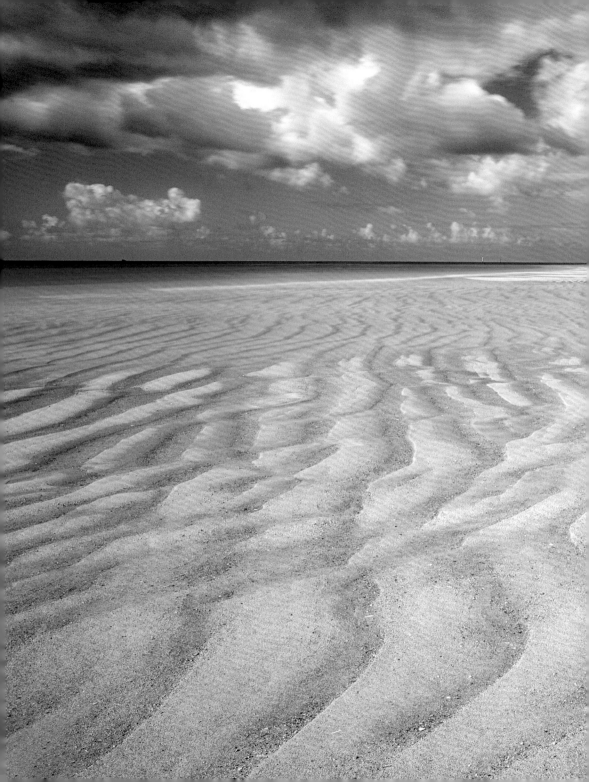

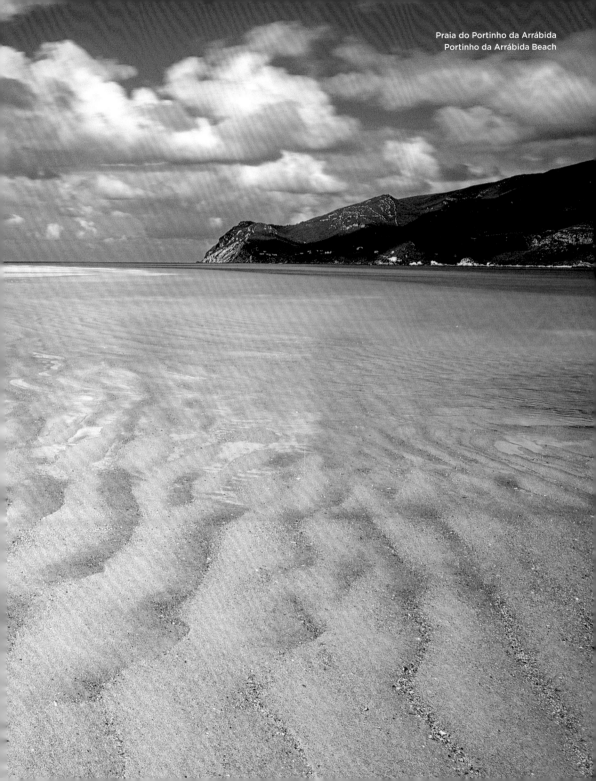

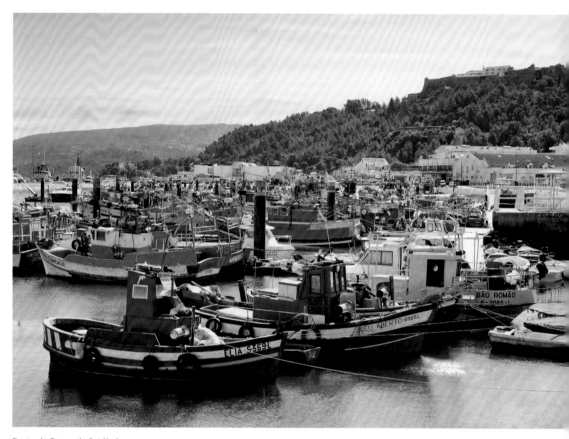

Porto de Pesca de Setúbal
Fishing harbour of Setúbal

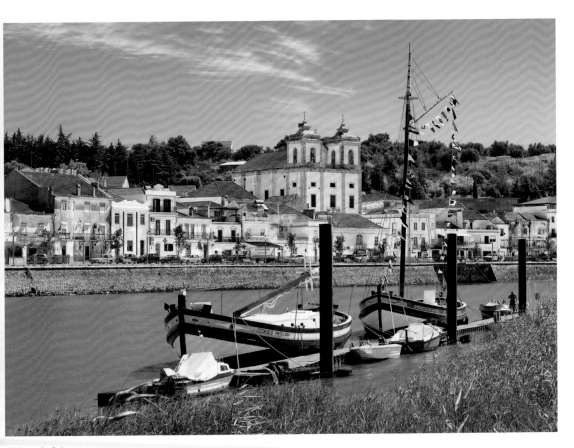

Alcácer do Sal

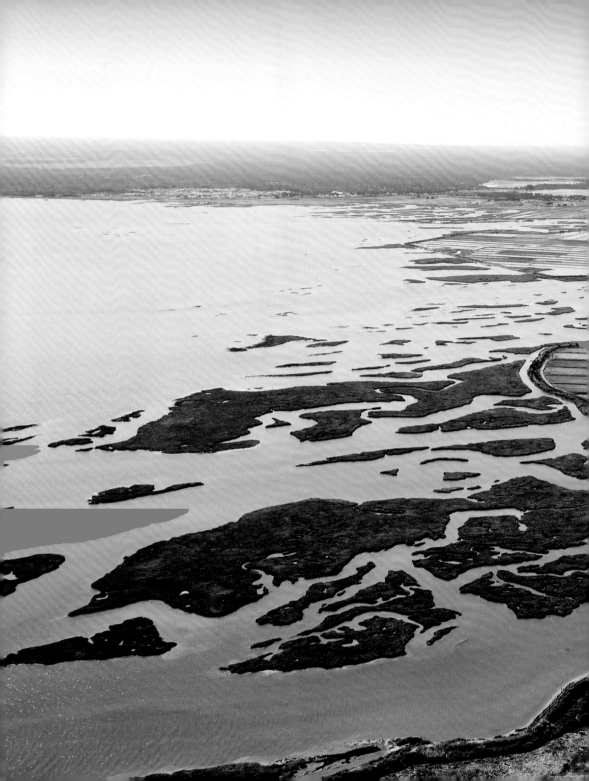

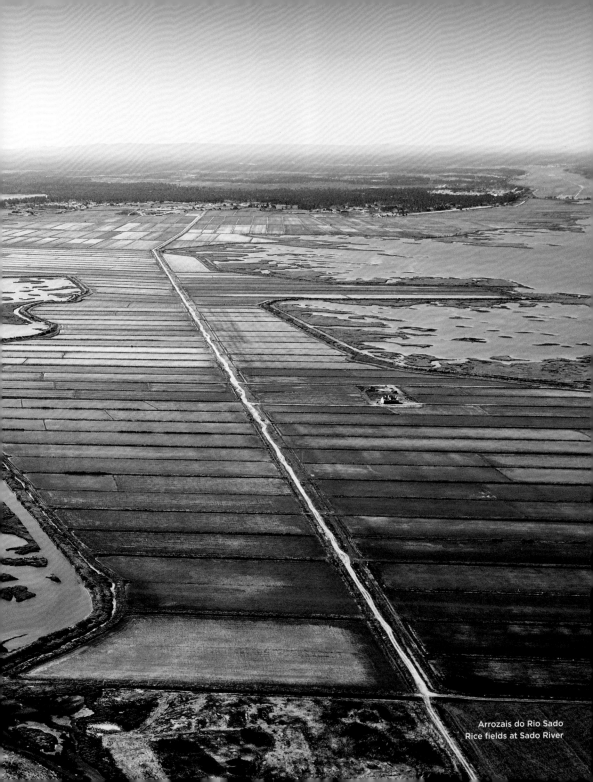

Arrozais do Rio Sado
Rice fields at Sado River

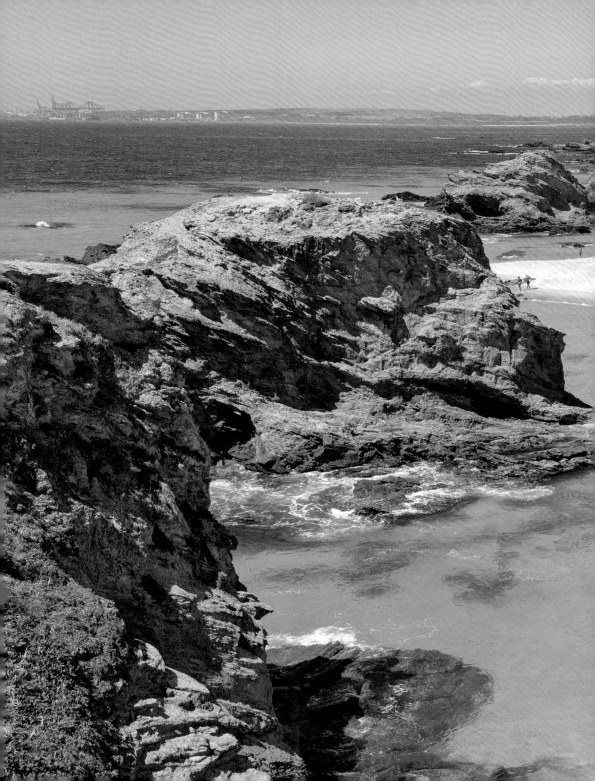

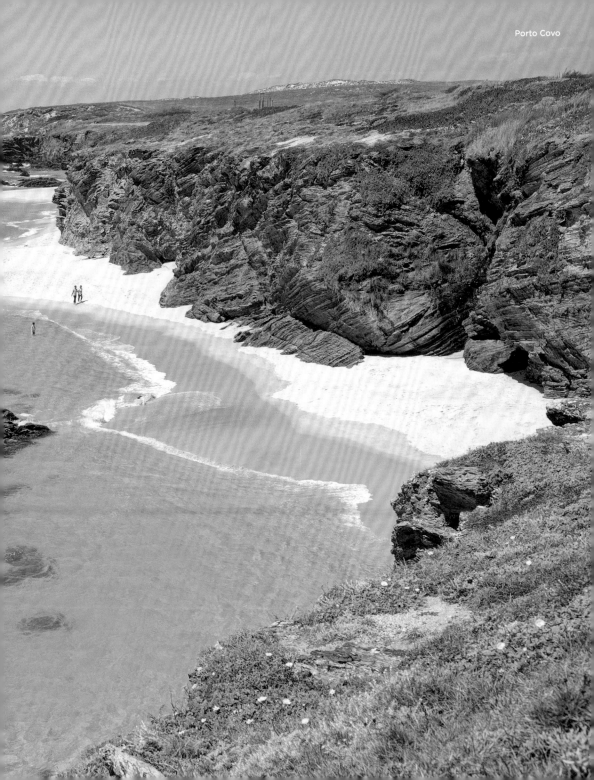

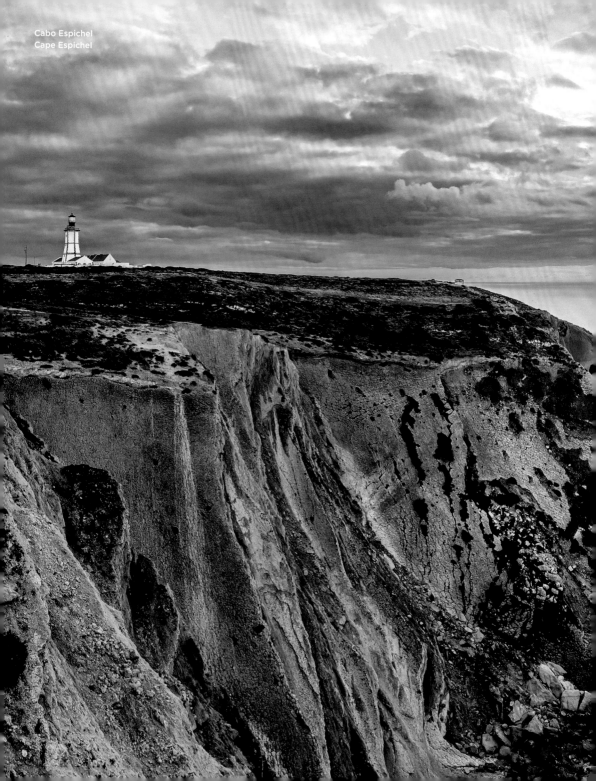

Cabo Espichel
Cape Espichel

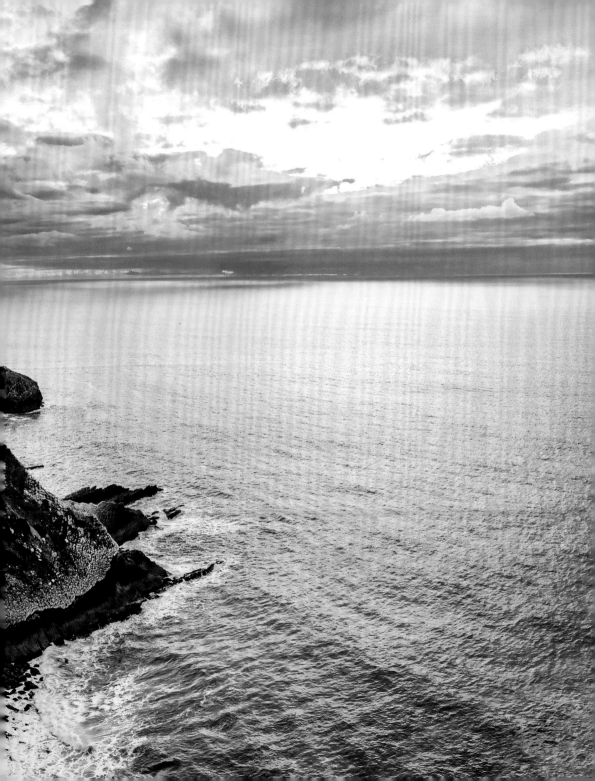

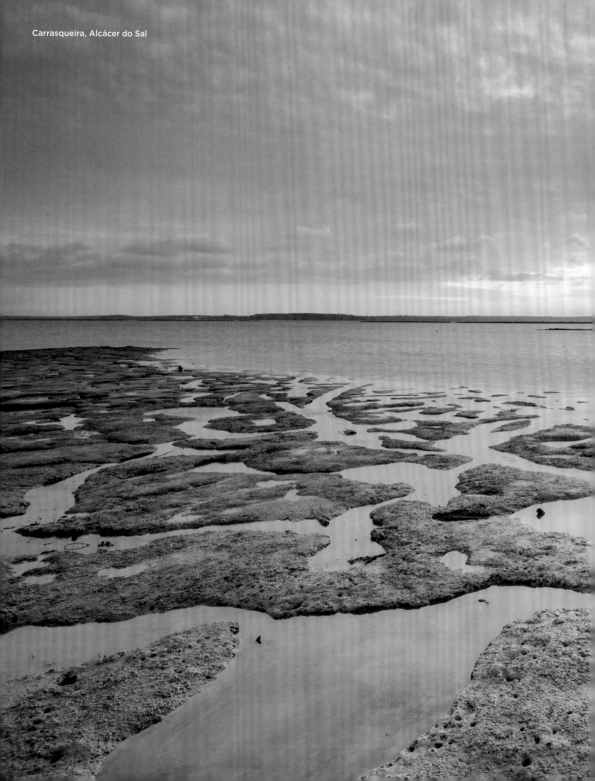

Carrasqueira, Alcácer do Sal

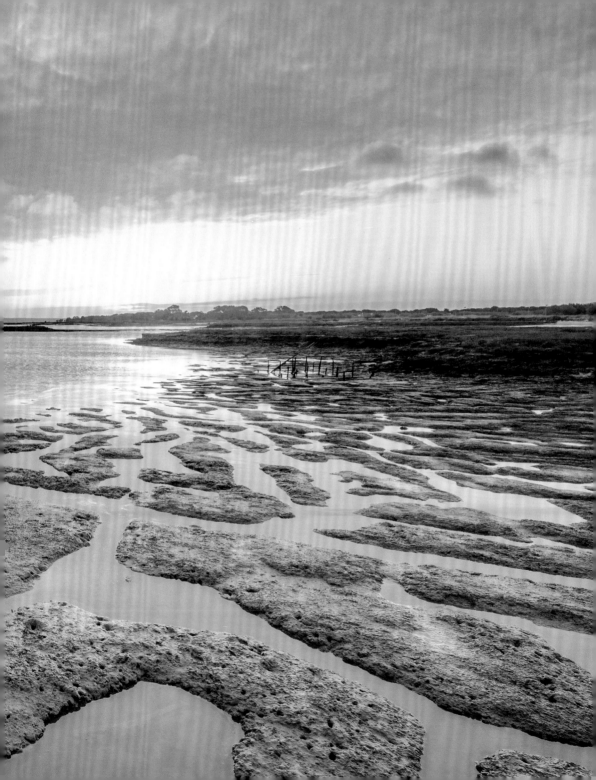

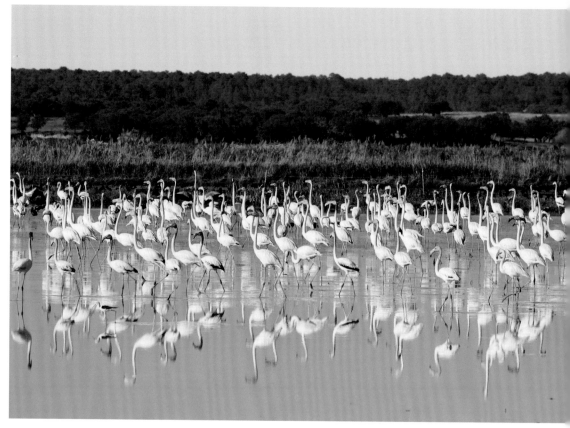

Flamingos (Phoenicopterus roseus), Reserva Natural do Estuário do Sado
Sado Estuary Natural Reserve

Setúbal

Setúbal's fishing harbour and riverside promenade are reminiscent of bygone times. Rice fields spread out further inland in the wetlands. The shallow waters of the Sado estuary are also an important refuge for various bird species, with even flamingos feeling at home here.

Setúbal

Le port de pêche et le front de mer de Setúbal sont de véritables réminiscences des temps anciens. À l'intérieur des terres, dans les marais, se développent des rizières. Les eaux peu profondes de l'estuaire du Sado sont également un refuge important pour diverses espèces d'oiseaux, et même les flamants roses se sentent ici chez eux.

Setúbal

Fischerhafen und Uferpromenade von Setúbal erinnern an vergangene Zeiten. Weiter landeinwärts im Marschland können sich Reisfelder entfalten. Die seichten Gewässer der Sado-Mündung sind außerdem ein wichtiges Rückzugsgebiet für verschiedene Vogelspezies. Sogar Flamingos fühlen sich hier wohl.

Reserva Natural do Estuário do Sado
Sado Estuary Natural Reserve

Setúbal

El puerto pesquero de Setúbal y el paseo marítimo transportan a épocas pasadas. Los campos de arroz pueden desarrollarse más tierra adentro en los pantanos. Además, las aguas poco profundas del estuario del Sado son un importante refugio para varias especies de aves; incluso los flamencos se sienten como en casa aquí.

Setúbal

Il porto peschereccio di Setúbal e la passeggiata lungo il fiume ricordano tempi passati. Risaie si distendono nell'entroterra, nella regione bassa paludosa. Anche le acque poco profonde della foce del Sado costituiscono un importante rifugio per diverse specie di uccelli. Anche per i fenicotteri.

Setúbal

De vissershaven en boulevard van Setúbal roepen vervlogen tijden in herinnering. Verder landinwaarts kunnen rijstvelden in het moeras tot volle wasdom komen. Het ondiepe water in het estuarium van de Sado is ook een belangrijk toevluchtsoord voor allerlei vogelsoorten. Zelfs flamingo's voelen zich hier thuis.

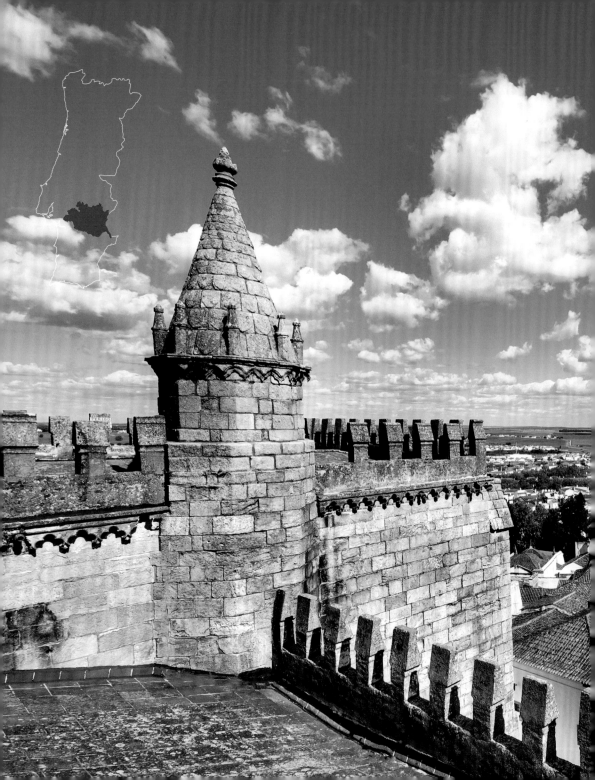

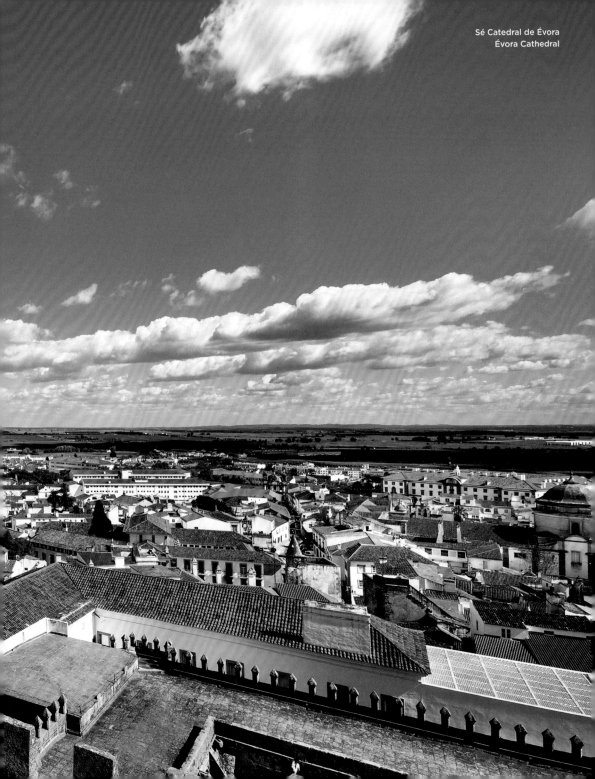

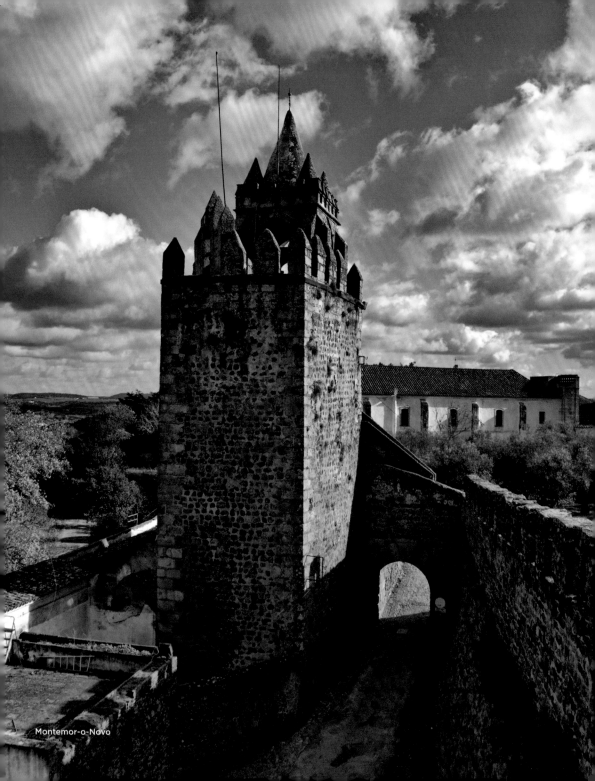

Montemor-o-Novo

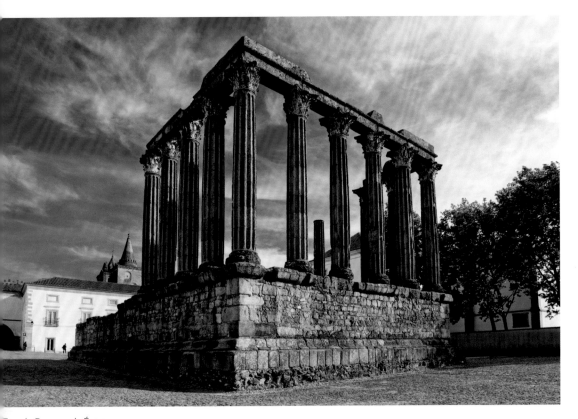

Templo Romano de Évora
Roman Temple of Évora

Évora

The columns of the Roman Temple of Évora constitute the distinctive landmark in Évora. The entire historical centre of the capital of the Alentejo is a UNESCO World Heritage Site. The reason for this is that the cityscape shows traces of many different epochs, including that of the Moorish occupation from the 8th to 11th century.

Évora

Les colonnes du temple romain de Diane sont l'une des attractions principales d'Évora, mais l'ensemble du centre historique de la capitale de l'Alentejo est classé au patrimoine mondial de l'UNESCO. La raison : le paysage urbain donne à voir des vestiges de nombreuses époques différentes – parmi lesquelles l'occupation mauresque, du VIIIᵉ au XIᵉ siècle.

Évora

Die Säulen des römischen Diana-Tempels sind das markante Erkennungszeichen von Évora. Das gesamte historische Zentrum der Hauptstadt des Alentejo gehört zum Weltkulturerbe der Unesco. Der Grund: Das Stadtbild weist Spuren vieler unterschiedlicher Epochen auf – darunter auch aus der maurischen Besatzung vom 8. bis 11. Jahrhundert.

Évora

Las columnas del templo romano de Diana son el hito distintivo de Évora. Todo el centro histórico de la capital del Alentejo es Patrimonio de la Humanidad de la UNESCO. La razón: el paisaje de la ciudad muestra rastros de muchas épocas diferentes, entre ellas también de la ocupación morisca de los siglos VIII al XI.

Évora

Le colonne del tempio romano di Diana sono il simbolo distintivo di Évora. L'intero centro storico della capitale dell'Alentejo è patrimonio dell'umanità dell'UNESCO. Il motivo: Il paesaggio urbano mostra tracce di epoche diverse, tra cui anche l'occupazione moresca dall'VIII all'XI secolo.

Évora

De zuilen van de Romeinse tempel van Diana zijn het markante herkenningspunt van Évora. Het hele historische centrum van de hoofdstad van Alentejo staat op de Unesco-werelderfgoedlijst. De reden: het stadsbeeld vertoont sporen van veel verschillende tijdperken, onder andere van de Moorse bezetting van de 8e tot de 11e eeuw.

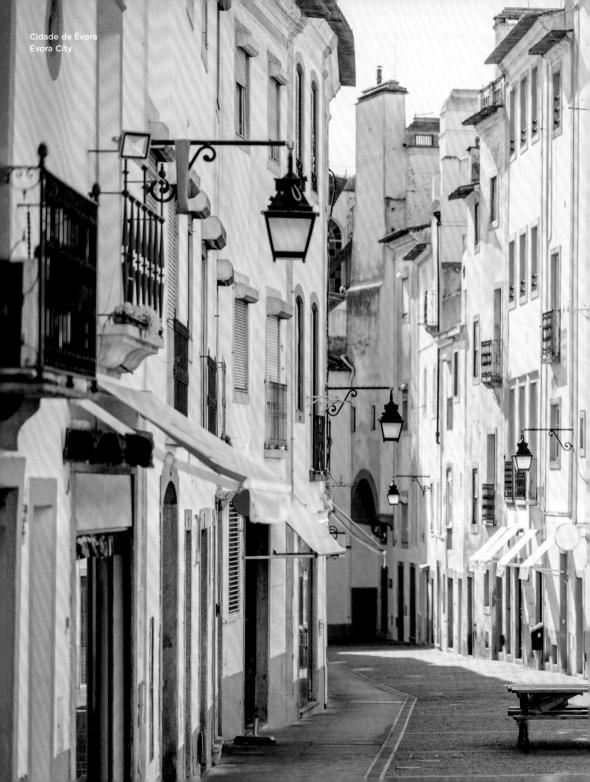

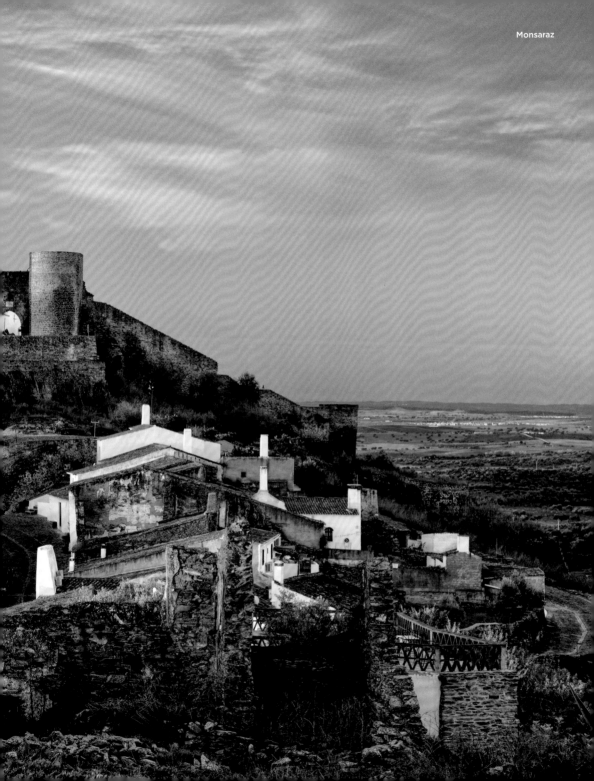

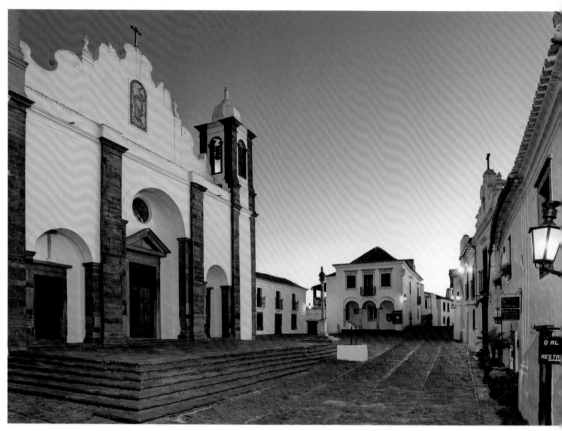

Monsaraz

Évora & Monsaraz

Despite its many treasures, Évora is not a city of museums. The coexistence of historical beauty and the lively atmosphere of the university city make Évora particularly attractive. In the traffic-free medieval town of Monsaraz, on the other hand, things are more leisurely. Narrow alleys and small squares characterize the city which lies at 342 m.

Évora & Monsaraz

Malgré ses nombreux trésors, Évora n'est pas une ville-musée. La coexistence de la beauté historique et l'atmosphère animée de la ville universitaire la rendent même particulièrement attrayante. En revanche, dans la ville médiévale de Monsaraz, où il n'y a aucune circulation, les choses sont plus tranquilles. Construite sur une colline de 342 m, elle est surtout composée de ruelles étroites et de petites places.

Évora & Monsaraz

Trotz der vielen Schätze ist Évora keine museale Stadt. Das Nebeneinander der historischen Schönheit und die lebendige Atmosphäre der Universitätsstadt machen Évoras besonderen Reiz aus. In der verkehrsfreien mittelalterlichen Stadt Monsaraz hingegen geht es gemächlich zu. Schmale Gassen und kleine Plätze prägen die auf 342 m gelegene Stadt.

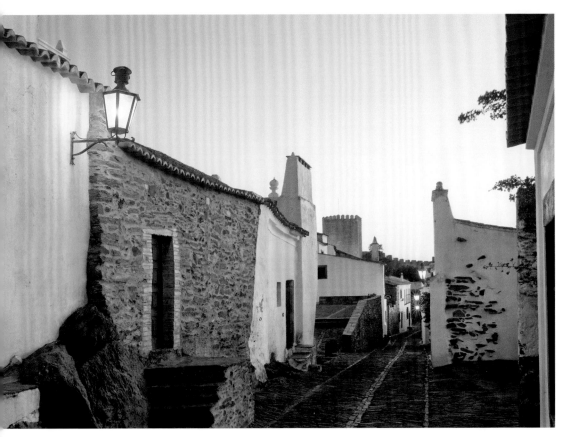

onsaraz

vora y Monsaraz

 pesar de sus numerosos tesoros, Évora
o es una ciudad museo. La coexistencia
e la belleza histórica y el ambiente
nimado de la ciudad universitaria hacen
e Évora una ciudad particularmente
tractiva. Por otro lado, Monsaraz es una
udad medieval sin tráfico, donde todo es
ás tranquilo. La ciudad, situada a 342 m
e altitud, se caracteriza por sus callejones
strechos y por sus plazas pequeñas.

Évora e Monsaraz

Nonostante i suoi numerosi tesori, Évora
non è una città museo. La coesistenza
di bellezze storiche e l'atmosfera vivace
della città universitaria rendono Évora
particolarmente attraente. Nella città
medievale senza traffico di Monsaraz,
d'altra parte, le cose sono più tranquille.
Stretti vicoli e piazzette caratterizzano la
città a 342 m.

Évora & Monsaraz

Ondanks de vele schatten is Évora geen
museumstad. Het naast elkaar bestaan
van historische schoonheid en de
levendige sfeer van de universiteitsstad
maken Évora bijzonder aantrekkelijk. In
het verkeersvrije middeleeuwse stadje
Monsaraz daarentegen is het wat rustiger.
Smalle steegjes en pleintjes karakteriseren
de stad op 342 m.

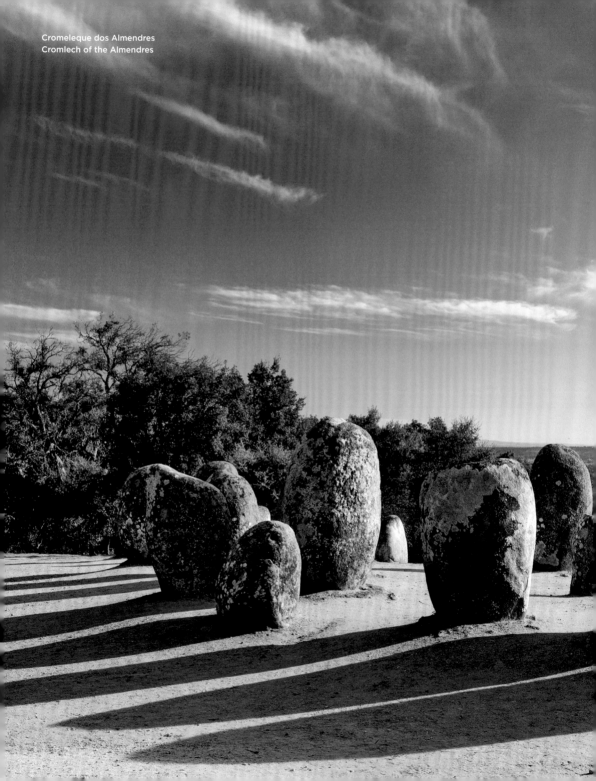

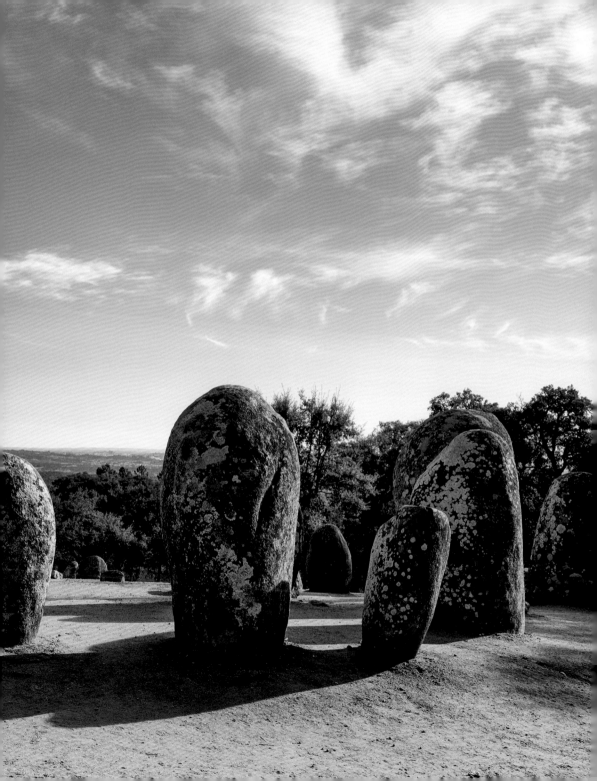

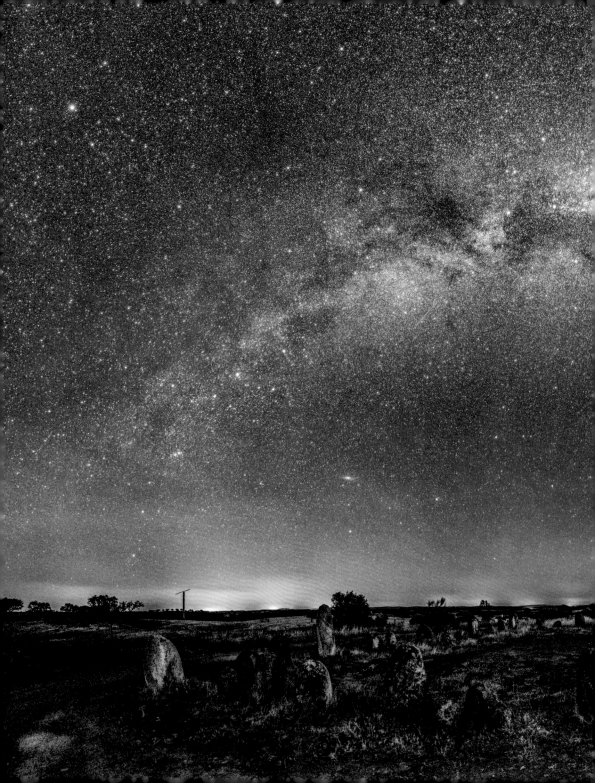

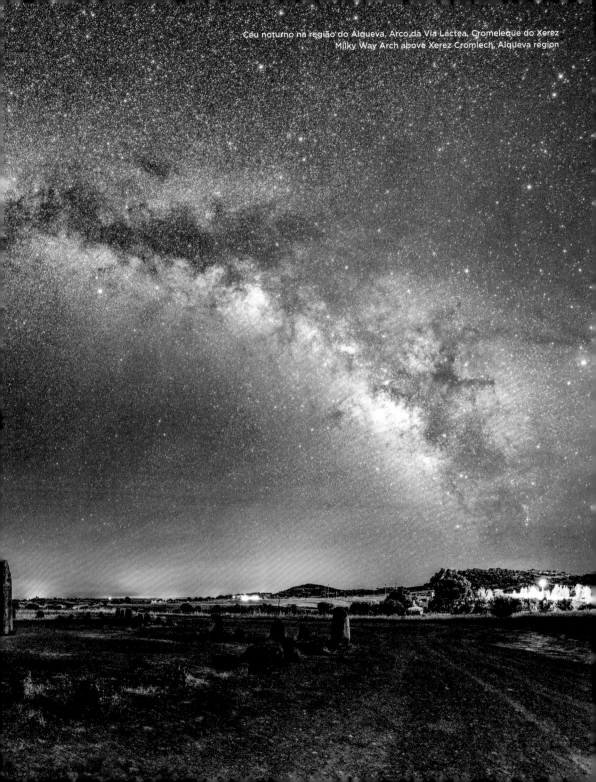

Céu noturno na região do Alqueva, Arco da Via Láctea, Cromeleque do Xerez
Milky Way Arch above Xerez Cromlech, Alqueva region

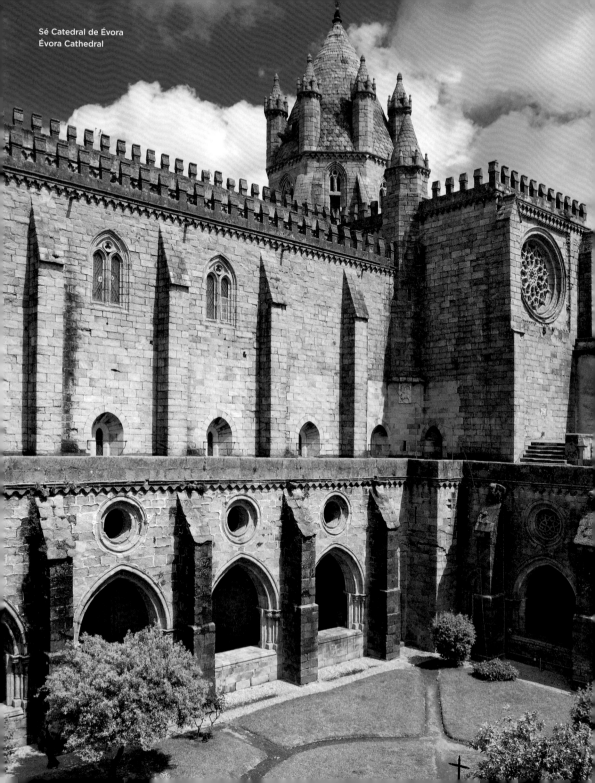

Sé Catedral de Évora
Évora Cathedral

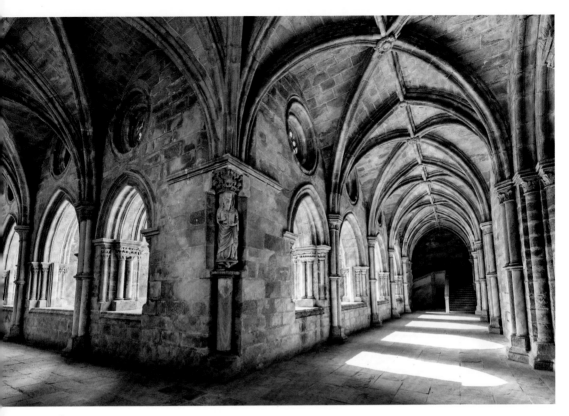

é Catedral de Évora
vora Cathedral

vora

total of 92 menhirs form the Cromlech f the Almendres. Their exact origin is still nclear. Near Alqueva, a similar ensemble astonishing, especially when viewed nder the intense night sky, as this area in e east of the Alentejo has been declared "dark sky" reserve.

vora

e Cromlech d'Almendres est composé e 92 menhirs, dont l'origine exacte 'est pas encore claire. Près d'Alqueva, à est de l'Alentejo, un ensemble similaire uscite l'étonnement – surtout sous son iel nocturne intense, certifié et protégé n tant que réserve « Dark sky » (« ciel ombre ») pour son environnement avorisant l'observation des étoiles.

Évora

Insgesamt 92 Menhire (Hinkelsteine) formen den Cromlech von Almendres. Ihre genaue Herkunft ist bis heute ungeklärt. In der Nähe von Alqueva sorgt ein ähnliches Ensemble für Erstaunen – vor allem unter dem intensiven Nachthimmel, der im Osten des Alentejo zu einem „Dark-Sky"-Schutzgebiet ausgerufen wurde.

Évora

Un total de 92 menhires forman el Cromlech de Almendres, cuyo origen exacto aún se desconoce. Cerca de Alqueva hay un conjunto similar bastante sorprendente, especialmente bajo el intenso cielo nocturno, declarado reserva de "cielo oscuro" al este del Alentejo.

Évora

Il Cromlech di Almendres è composto da 92 menhir. La loro origine esatta non è ancora chiara. Vicino ad Alqueva, si trova un complesso megalitico sorprendente – soprattutto sotto l'intenso cielo notturno, nella parte orientale dell'Alentejo, è stato dichiarato riserva "Dark-Sky".

Évora

In totaal vormen 92 menhirs de cromlech van Almendres. De precieze herkomst van deze neolithische steencirkel is nog onduidelijk. In de buurt van Alqueva wekt een vergelijkbaar ensemble verbazing – vooral onder de pikzwarte nachthemel, die in het oosten van Alentejo is uitgeroepen tot een 'dark sky-park'.

Barragem do Alqueva, Rio Guadiana
Alqueva Dam, Guadiana River

Cavalo Lusitano
Lusitano horse

Sobreiro
Cork oak

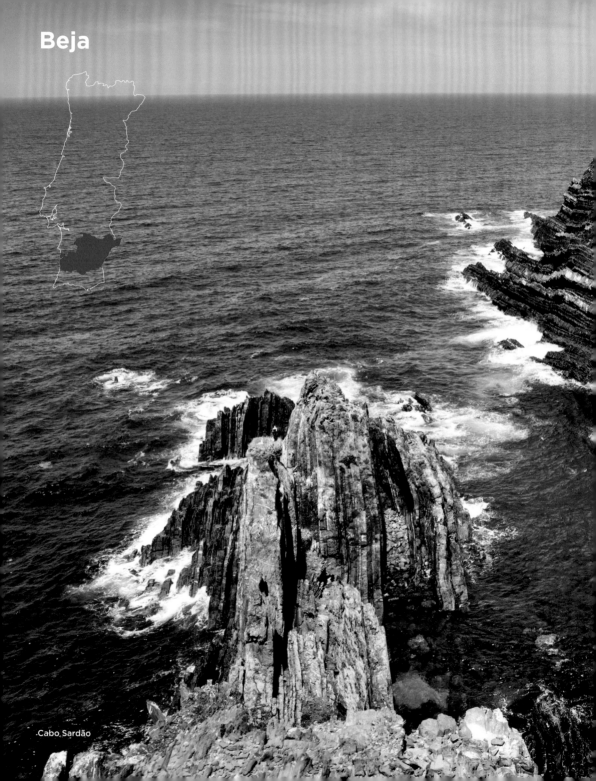

Beja

Cabo Sardão

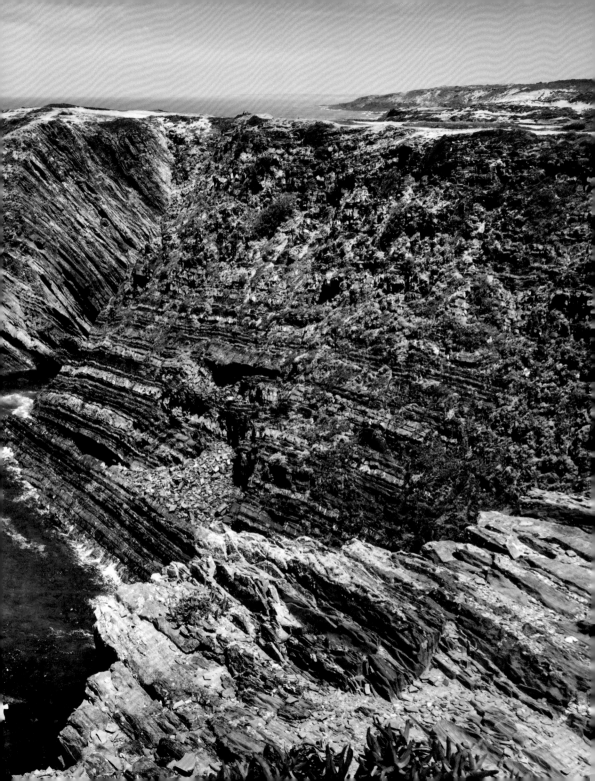

Vila Nova de Milfontes

Beja

The village of Mértola, at the foot of which the waters of the Guadiana River leisurely flow, appears like a painting. The ancient windmills, whose sails were once covered with cloth, also radiate a certain calm. In the Alentejo and the Algarve they were an integral part of the landscape, until their services were no longer needed.

Beja

Le village de Mértola, au pied duquel les eaux de la rivière Guadiana coulent tranquillement, semble sortir d'une toile. Les anciens moulins à vent, dont les ailes étaient autrefois recouvertes de toiles à voile, participent également de cette impression de calme. Dans l'Alentejo et l'Algarve, les moulins faisaient également partie intégrante du paysage, jusqu'à ce que leurs services ne soient plus nécessaires.

Beja

Wie gemalt scheint das Dorf Mértola, zu dessen Füßen das Wasser des Río Guadiana gemächlich dahinfließt. Eine gewisse Ruhe strahlen auch die altertümlichen Windmühlen aus, deren Flügel einst mit Segeltüchern bespannt waren. Im Alentejo und an der Algarve waren sie ein fester Bestandteil der Landschaft, bis ihre Dienste nicht mehr benötigt wurden.

Moinho de Vento
Windmill

Beja

El pueblo de Mértola, a cuyos pies fluyen tranquilamente las aguas del río Guadiana, parece haber sido pintado. Los antiguos molinos de viento, cuyas alas estuvieron un día cubiertas de tela de vela, también transmiten cierta calma. En el Alentejo y el Algarve fueron parte del paisaje hasta que sus servicios dejaron de ser necesarios.

Beja

Il villaggio di Mértola, ai cui piedi scorrono tranquillamente le acque del fiume Guadiana, sembra essere stato dipinto. Anche gli antichi mulini a vento, le cui pale erano un tempo ricoperte di tela, trasmettono una certa calma. Nell'Alentejo e nell'Algarve erano parte integrante del paesaggio fino a loro disuso.

Beja

Het dorp Mértola, aan de voet waarvan het water van de rivier de Guadiana kalmpjes stroomt, lijkt geschilderd te zijn. De oude windmolens, waarvan de wieken ooit bedekt waren met zeildoek, stralen ook een zekere rust uit. In Alentejo en de Algarve waren ze een vast bestanddeel van het landschap tot hun diensten niet meer nodig waren.

Zambujeira do Mar, Parque Natural do Sudoeste Alentejano e Costa Vicentina
Zambujeira do Mar, South West Alentejo and Vicentine Coast Natural Park

Torre de Menagem, Castelo de Beja
Keep, Castle of Beja

Castle of Beja

The castle of Beja was for many centuries an important bulwark for the defence of the Portuguese borders. The 40-metre-high Torre de Menagem made it possible for the defenders to observe invaders movements far into the distance. Today, however, it offers a more peaceful view of the winding streets of the old town.

Château de Beja

Le château de Beja a été pendant des siècles un important bastion pour la défense des frontières portugaises. La Torre de Menagem, d'une hauteur de 40 mètres, permettait de surveiller les alentours – aujourd'hui, elle offre une vue paisible sur la vieille ville sinueuse.

Burg von Beja

Die Burg von Beja war über lange Jahrhunderte eine wichtige Bastion zur Verteidigung der portugiesischen Landesgrenzen. Der 40 Meter hohe Torre de Menagem hat einen kontrollierenden Blick in die Ferne ermöglicht – heute gestattet er in friedlicher Absicht eine schwelgerische Aussicht auf die verwinkelte Altstadt.

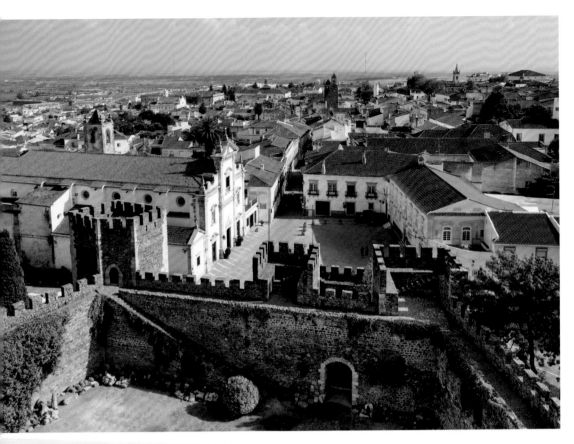

Torre de Menagem, Castelo de Beja
Keep, Castle of Beja

Castillo de Beja

El castillo de Beja fue durante muchos siglos un importante bastión para la defensa de las fronteras portuguesas. La Torre de Menagem, de 40 metros de altura, ha hecho posible una visión controladora de la distancia, que hoy en día ofrece una vista tranquila del serpenteante casco antiguo.

Castello di Beja

Il Castello di Beja è stato per molti secoli un importante bastione per la difesa dei confini portoghesi. La Torre de Menagem, alta 40 metri, che una volta serviva all'avvistamento e offre oggi un fastoso panorama sul serpeggiante centro storico.

Kasteel van Beja

Het kasteel van Beja was eeuwenlang een belangrijk bolwerk voor de verdediging van de Portugese grenzen. De 40 meter hoge Torre de Menagem heeft een controleerbaar zicht in de verte mogelijk gemaakt – vandaag de dag staat hij met een vreedzaam oogmerk een weelderig uitzicht toe op het labyrint van de oude stad.

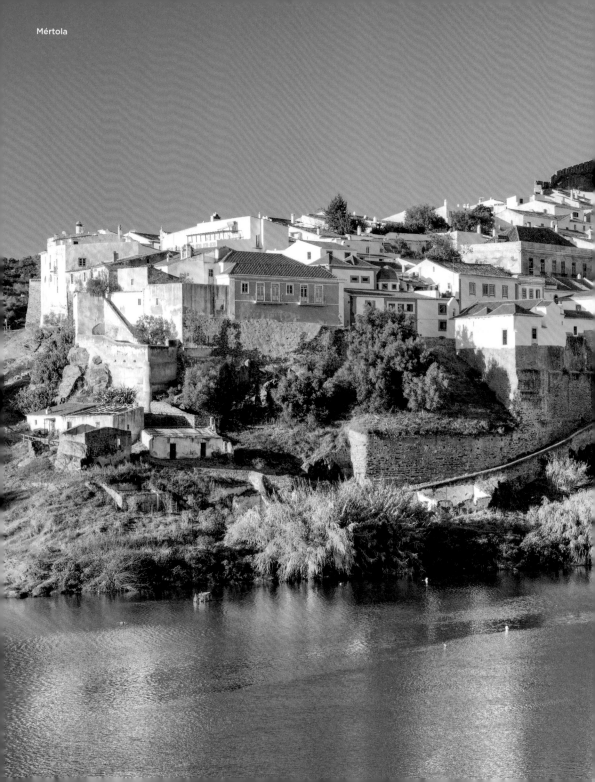

Mértola

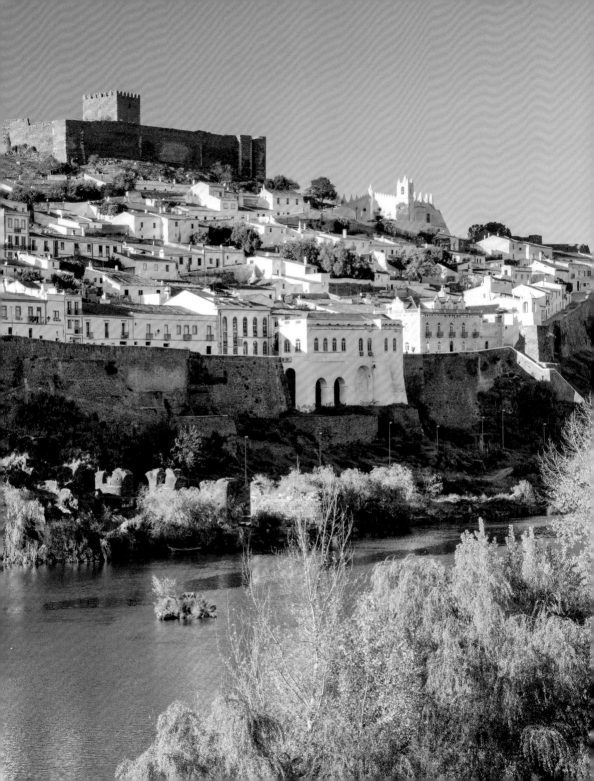

Parque Natural do Vale do Guadiana
Guadiana Valley Natural Park

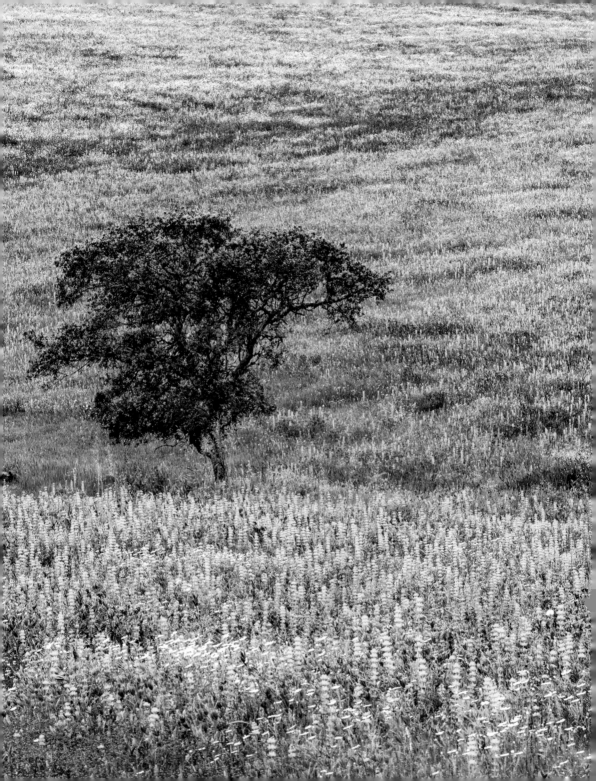

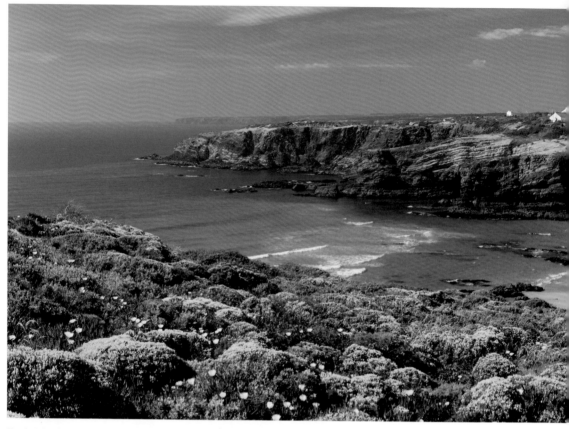

Zambujeira do Mar, Parque Natural do Sudoeste Alentejano e Costa Vicentina
Zambujeira do Mar, South West Alentejo and Vicentine Coast Natural Park

Costa Vicentina

The vegetation on the rugged Costa Vicentina is far from Mediterranean: wind and weather make a carefree life possible only for the most resistant plants. This hardly diminishes the charm of dreamy coastal towns like Zambujeira do Mar. Further inland, flower carpets grouped around a solitary cork oak charm the eye.

Costa Vicentina

La végétation de la Costa Vicentina n'est pas très méditerranéenne : le vent et le temps ne permettent une vie insouciante qu'aux plantes résistantes. Cela ne diminue en rien le charme des villes côtières de rêve, comme Zambujeira do Mar. En avançant à l'intérieur des terres, les prairies de fleurs, groupées autour de chênes-lièges solitaires, sont un régal pour les yeux.

Costa Vicentina

Die Vegetation an der schroffen Costa Vicentina ist wenig mediterran: Wind und Wetter ermöglichen nur widerstandsfähigen Pflanzen ein sorgenfreies Leben. Das mindert den Reiz verträumter Küstenorte wie Zambujeira do Mar kaum. Weiter im Inland schmeicheln Blumenwiesen dem Auge, die sich um eine solitäre Korkeiche gruppieren.

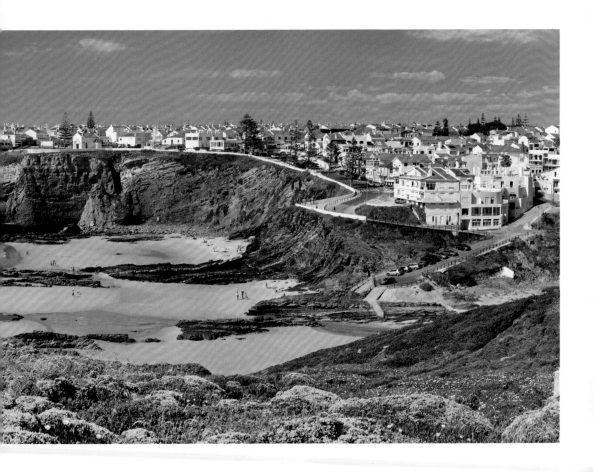

Costa Vicentina

La vegetación en la escarpada Costa Vicentina no es muy mediterránea: el viento y el clima hacen que solo las plantas resistentes puedan vivir sin preocupaciones, pero esto apenas disminuye el encanto de pueblos costeros de ensueño como Zambujeira do Mar. Más hacia el interior, las praderas de flores que se agrupan alrededor de un solitario alcornoque son un todo regalo para la vista.

Costa Vicentina

La vegetazione dell'aspra Costa Vicentina non è molto mediterranea: il vento e le condizioni atmosferiche fanno sopravvivere solo le piante più resistenti. Questo non diminuisce il fascino di incantate città costiere come Zambujeira do Mar. Più nell'entroterra, lo sguardo si allieta con i prati fioriti che si raggruppano intorno a una solitaria quercia da sughero.

Costa Vicentina

De vegetatie aan de ruige Costa Vicentina is niet erg mediterraan: wind en weer staan alleen resistente planten een zorgeloos bestaan toe. Dit doet nauwelijks afbreuk aan de charme van dromerige kustplaatsen als Zambujeira do Mar. Verder landinwaarts strelen bloemenweiden die gegroepeerd zijn rond een eenzame kurkeik het oog.

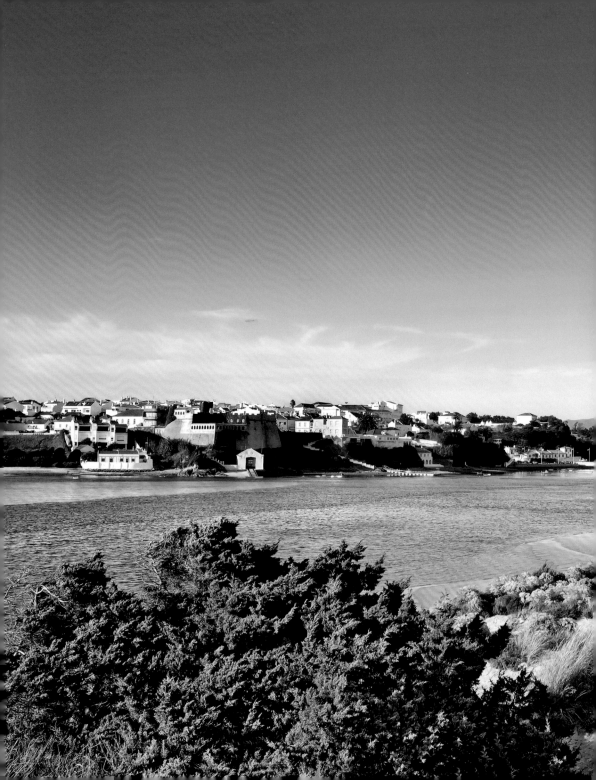

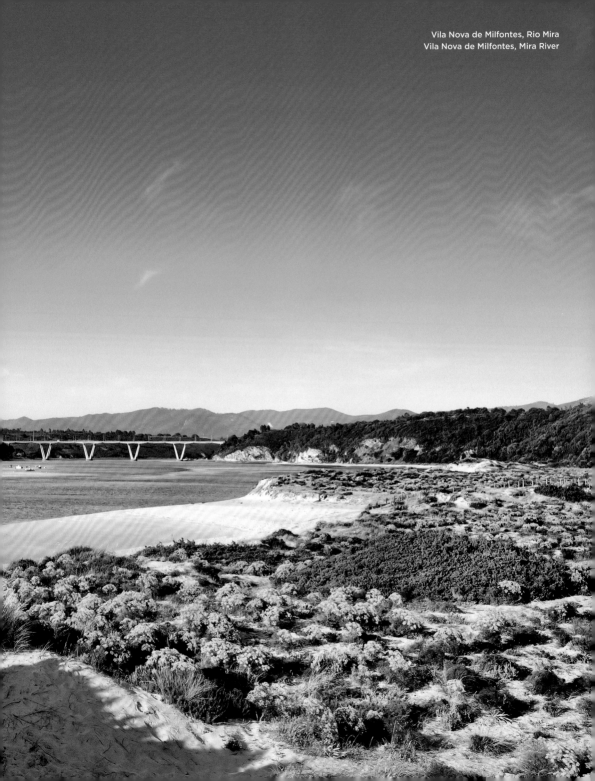

Vila Nova de Milfontes, Rio Mira
Vila Nova de Milfontes, Mira River

Algarve

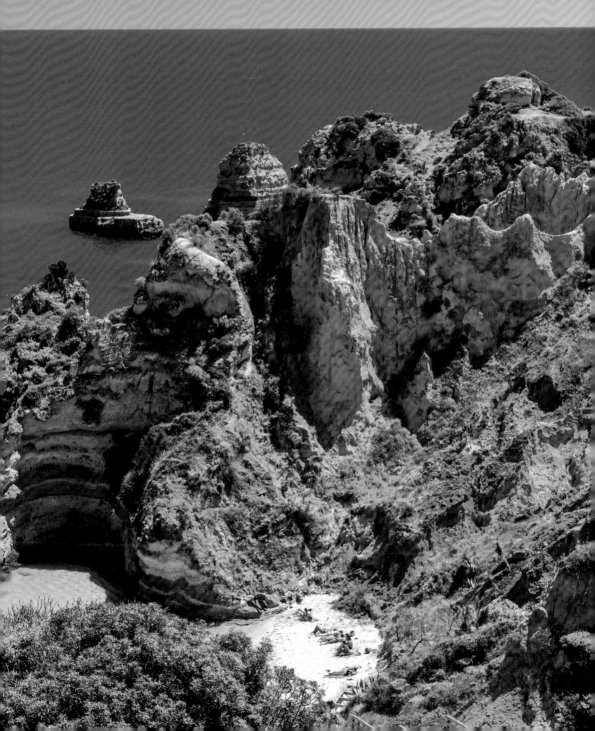

Odeceixe

Algarve

Dramatic rock formations, hidden coves
and azure waters are an irresistible
combination. With their help, the Algarve
has become one of the world's top
holiday destinations in recent years. The
consistently good weather, coupled with
a photogenic hinterland, contribute to the
popularity of southern Portugal.

Algarve

Les formations rocheuses énigmatiques,
les criques dissimulées et l'eau azur sont
une combinaison irrésistible grâce à
laquelle l'Algarve est devenue ces dernières
années l'une des meilleures destinations
de vacances au monde. Le beau temps
constant et un arrière-pays photogénique
contribuent à la popularité du sud
du Portugal.

Algarve

Dramatische Felsformationen, versteckte
Badebuchten und azurblaues Wasser
sind eine unwiderstehliche Kombination.
Mit ihrer Hilfe hat sich die Algarve in den
zurückliegenden Jahren in die Weltspitze
der Urlaubsregionen aufgeschwungen. Das
beständig gute Wetter und ein fotogenes
Hinterland leisten ihren Beitrag zur
Popularität von Portugals Süden.

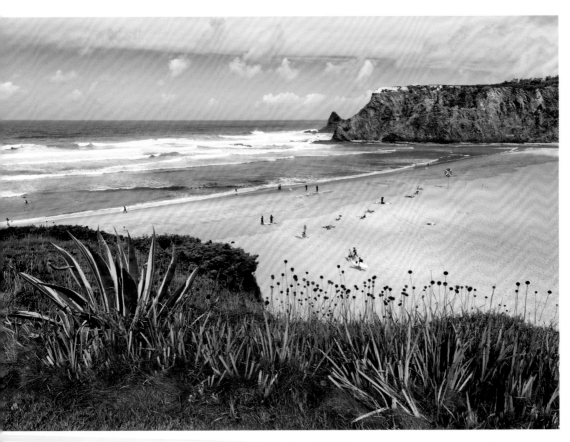

Praia de Odeceixe
Odeceixe Beach

Algarve

Las dramáticas formaciones rocosas, las calas recónditas y las aguas azules son una combinación irresistible. Con su ayuda, el Algarve se ha convertido en los últimos años en uno de los principales destinos vacacionales del mundo. El buen clima constante y un interior fotogénico contribuyen a la popularidad del sur de Portugal.

Algarve

Imponenti formazioni rocciose, insenature nascoste e acque azzurre sono un'irresistibile combinazione. L'Algarve è diventata per questo negli ultimi anni una delle regioni turistiche più belle del mondo. Il clima costantemente mite e un entroterra panoramico contribuiscono alla popolarità del Portogallo meridionale.

Algarve

Dramatische rotsformaties, verborgen baaien en azuurblauw water vormen een onweerstaanbare combinatie. Met de hulp daarvan is de Algarve in de afgelopen jaren uitgegroeid tot een van de beste vakantieregio's ter wereld. Het aanhoudend goede weer en een fotogeniek achterland dragen bij aan de populariteit van Zuid Portugal.

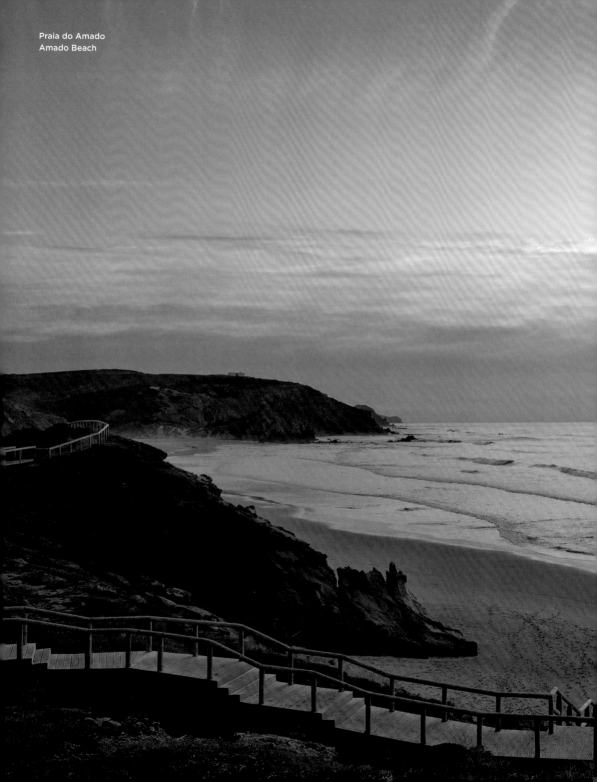

Praia do Amado
Amado Beach

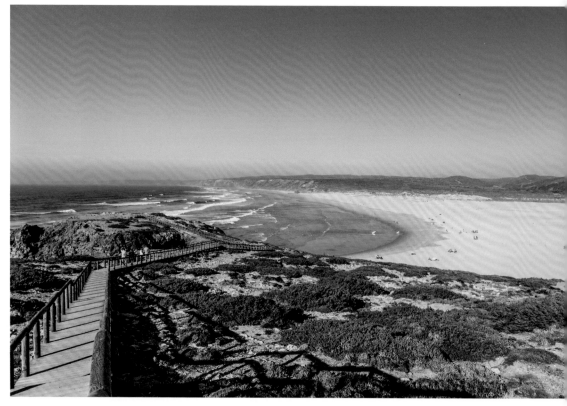

Carrapateira

Faro

The west coast of the Algarve is a place for nature lovers and individualists. Here, agave flowers, natural rock arches and the weathered sails of windmills defy the elements. Meanwhile, the tireless Atlantic entertains surfers from all over the world.

Faro

La côte ouest de l'Algarve est parfaite pour les amoureux de la nature et les personnes qui apprécient le calme et la solitude. Ici, les fleurs d'agave, les ponts naturels et les ailes patinées des moulins à vent défient les éléments, tandis que l'Atlantique, infatigable, divertit les surfeurs du monde entier.

Faro

Die Westküste der Algarve ist ein Fall für Naturliebhaber und Individualisten. Hier trotzen Agavenblüten, Naturbrücken und die verwitterten Flügel von Windmühlen den Elementen. Der nimmermüde Atlantik lässt es sich unterdessen nicht nehmen, die aus allen Teilen der Welt angereisten Surfer zu unterhalten.

Faro

La costa oeste del Algarve es un buen destino para los amantes de la naturaleza y los individualistas. Aquí, las flores de agave, los puentes naturales y las viejas aspas de los molinos de viento desafían las condiciones meteorológicas. Mientras tanto, el incansable Atlántico no puede evitar entretener a surfistas de todo el mundo.

Faro

La costa occidentale dell'Algarve è un luogo per gli amanti della natura e per chi ama la solitudine. Qui i fiori di agave, i ponti naturali e le pale dei mulini a vento sfidano gli elementi. E l'instancabile Atlantico intrattiene i surfisti di tutto il mondo.

Faro

De westkust van de Algarve is een val voor natuurliefhebbers en individualisten. Hier trotseren agavebloemen, natuurlijke bruggen en de verweerde wieken van windmolens de elementen. De onvermoeibare Atlantische Oceaan laat zich er ondertussen niet van afbrengen surfers van over de hele wereld te onderhouden.

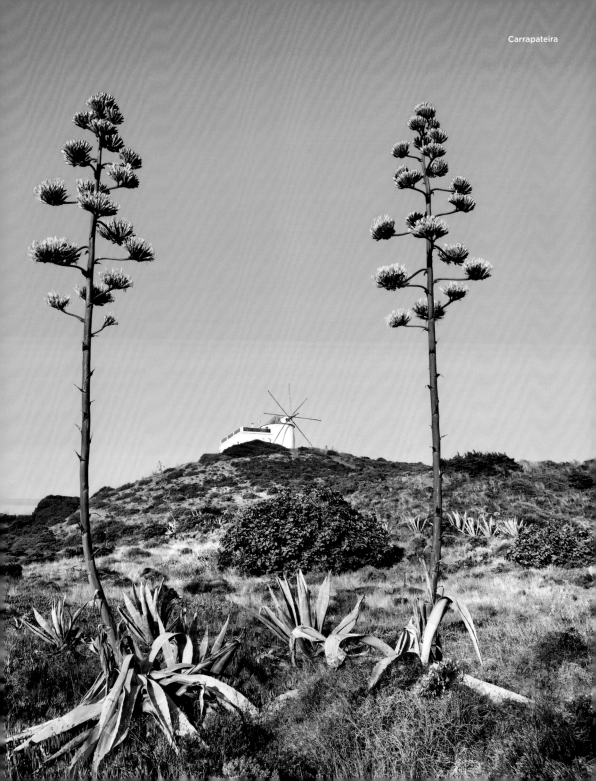

Carrapateira

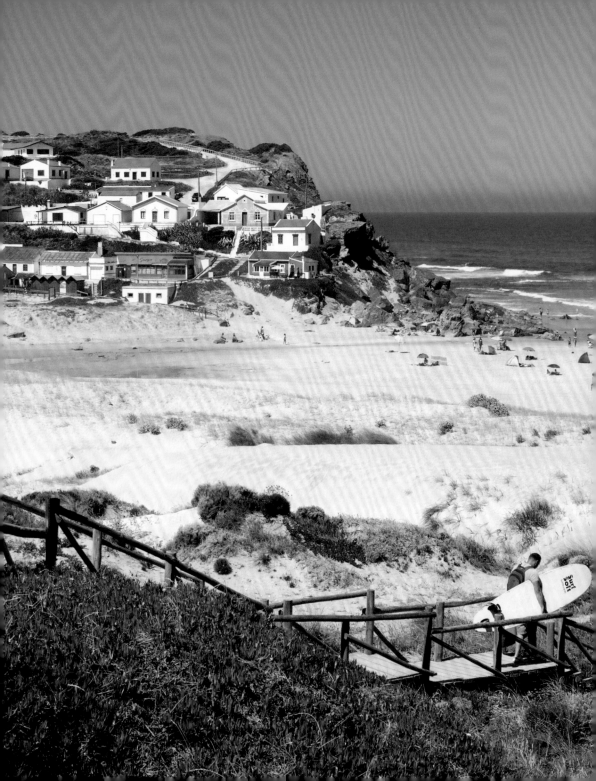

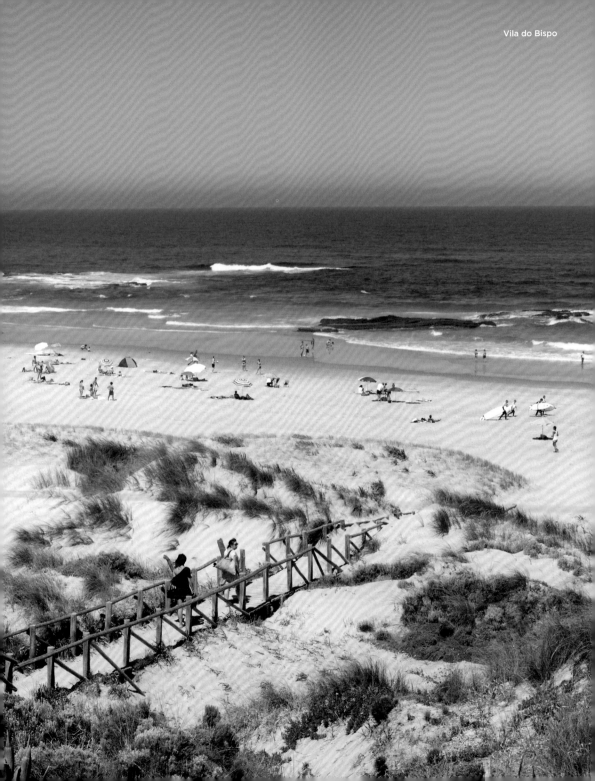

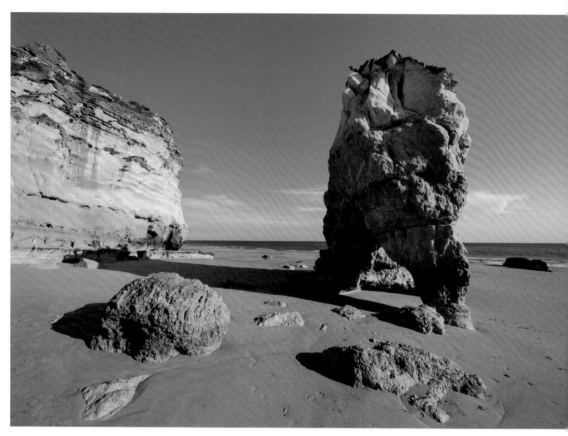

Praia do Amado
Amado Beach

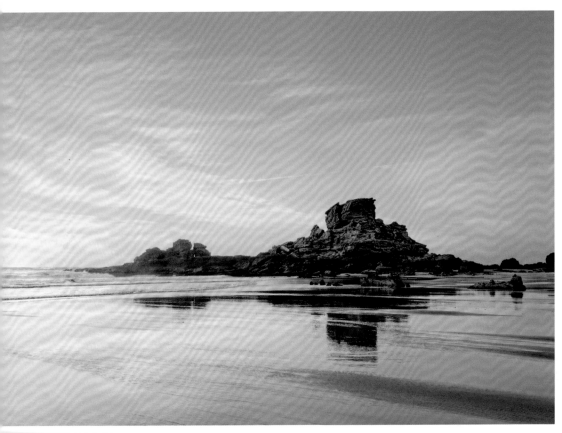

raia do Castelejo
Castelejo Beach

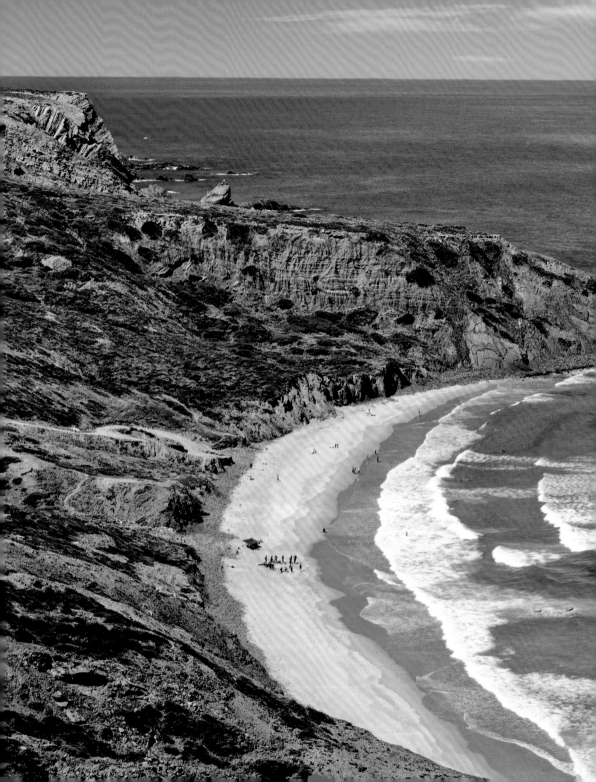

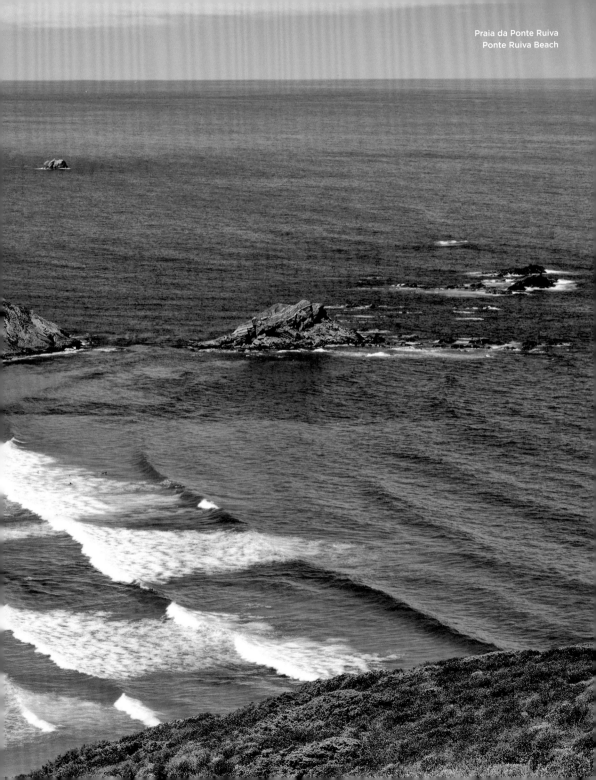

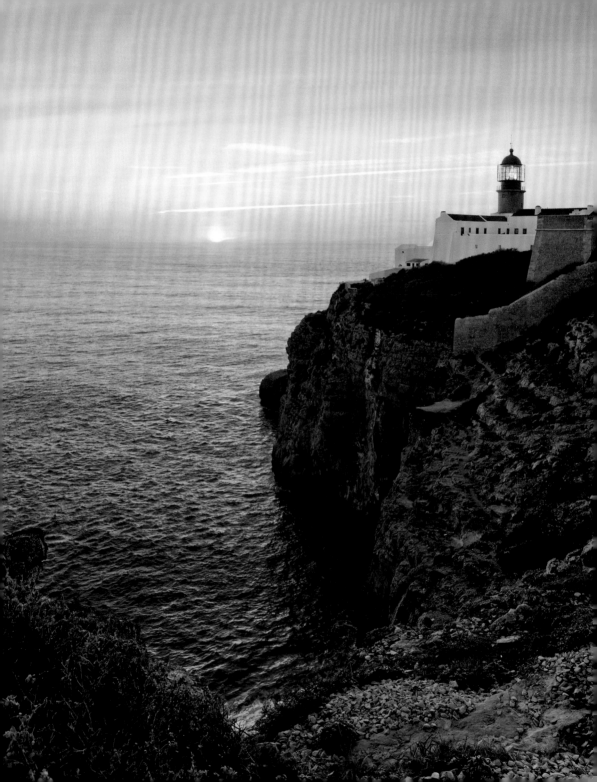

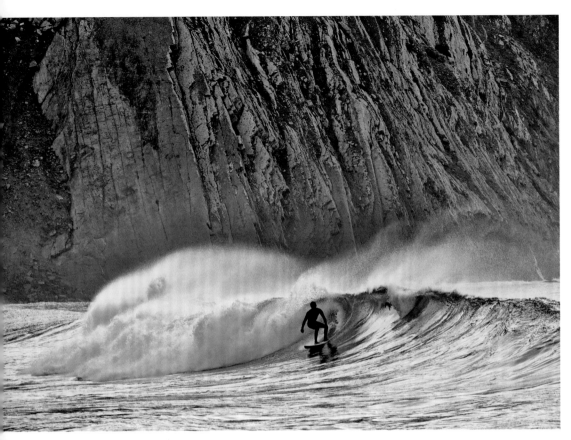

Praia do Beliche, Sagres
Beliche Beach, Sagres

Cabo de São Vicente, Sagres

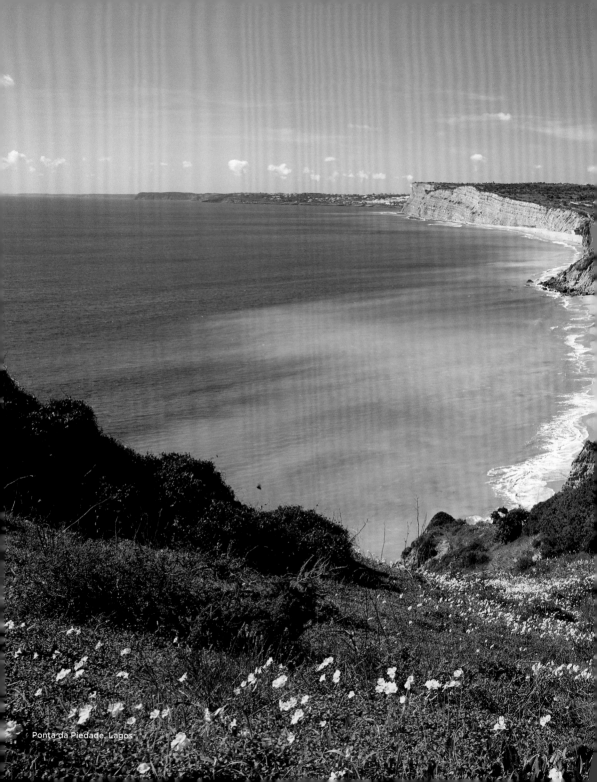

Ponta da Piedade, Lagos

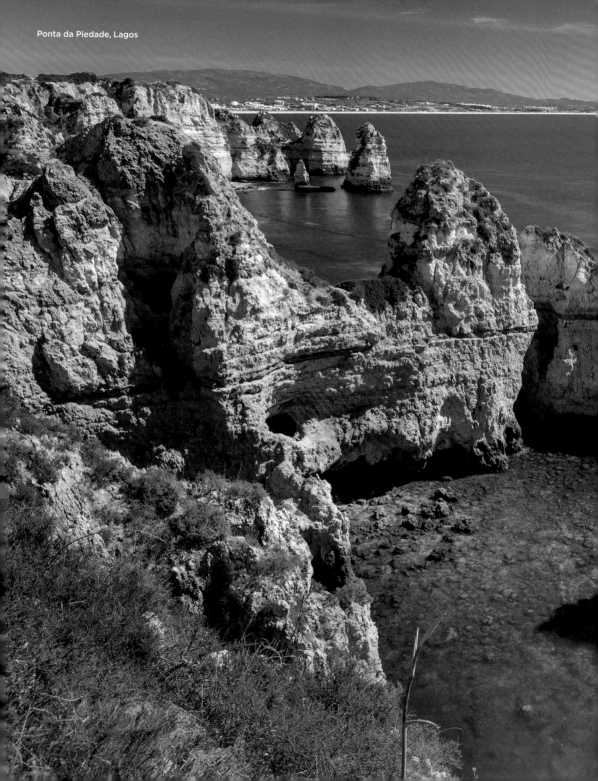
Ponta da Piedade, Lagos

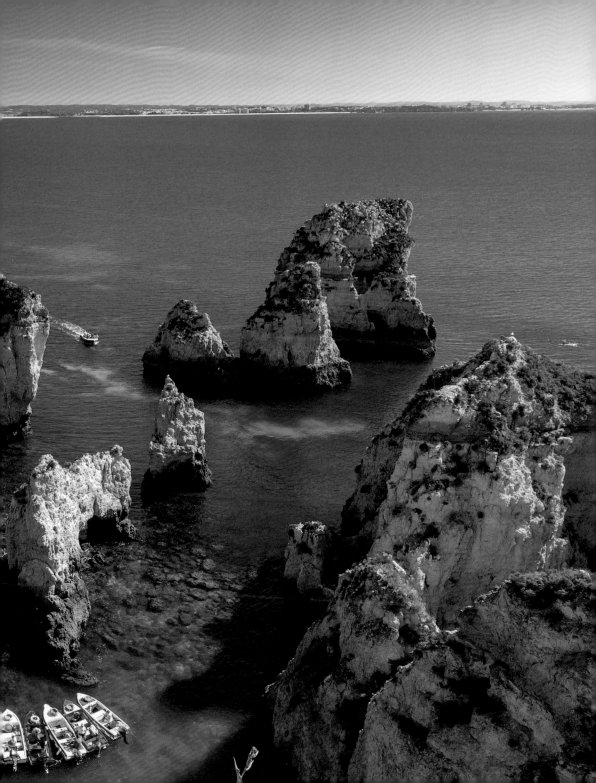

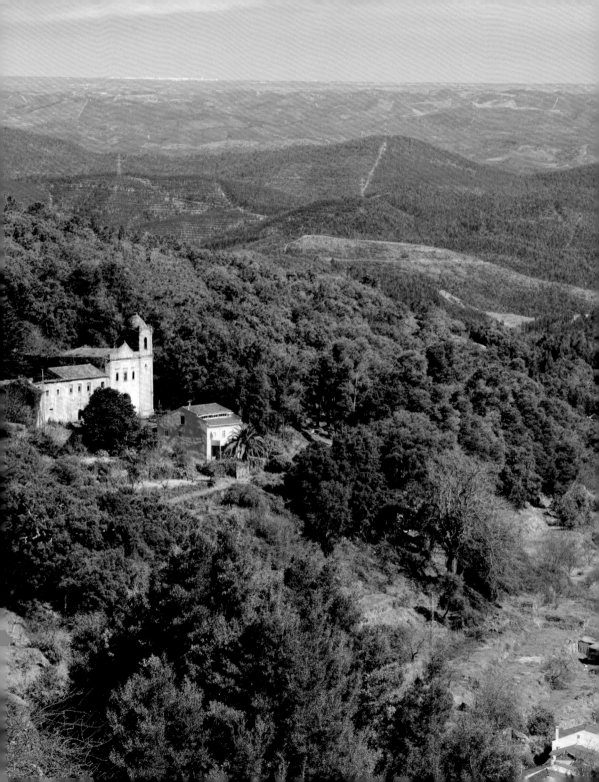

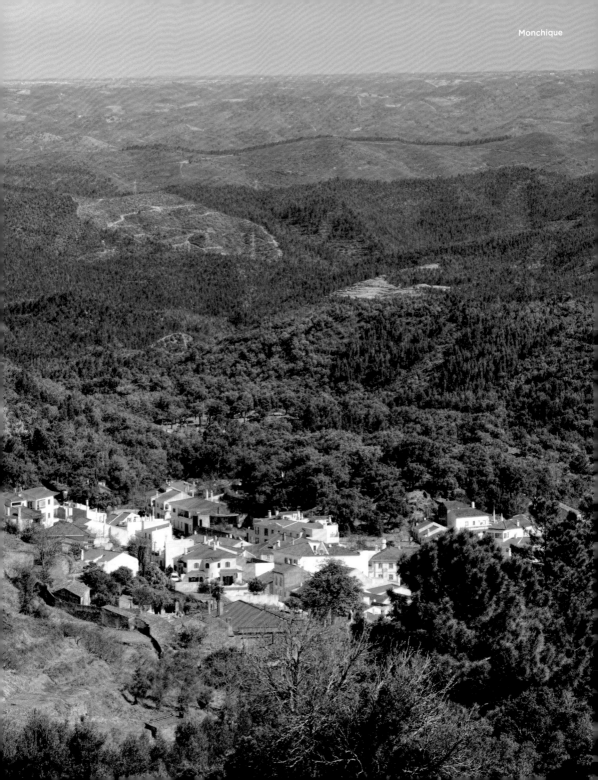

Sobreiros
Cork oaks

Pedaços de Cortiça, São Brás de Alportel, Faro
Pieces of cork bark, São Brás de Alportel

Serra de Monchique
The Serra de Monchique rises to an altitude of 902 metres. The town bearing the same name forms a nice contrast to the coastal towns such as Lagos, with their rugged rocky coasts. Here, Portuguese cork oaks grow on the flanks of the low mountain ranges, and whose bark supplies the wine industry all over the world.

Serra de Monchique
La Serra de Monchique s'élève à 902 mètres d'altitude. La chaîne de montagne forme un joli contraste avec les villes côtières aux côtes rocheuses et accidentées, comme Lagos. Les chênes-lièges portugais poussent sur les flancs de ces basses montagnes, et leur écorce enchante l'industrie vinicole du monde entier.

Serra de Monchique
Die Serra de Monchique erhebt sich immerhin bis zu einer Höhe von 902 Metern. Der gleichnamige Ort bildet einen hübschen Kontrast zu Küstenstädtchen wie Lagos mit ihren zerklüfteten Felsenküsten. Auf den Flanken des Mittelgebirges gedeihen derweil die portugiesischen Korkeichen, deren Rinde die Weinindustrie in aller Welt beglückt.

Serra de Monchique
La Serra de Monchique se eleva hasta los 902 metros de altitud. Con sus escarpadas costas rocosas, la región que ha adoptado este mismo nombre forma un bonito contraste con pueblos costeros como Lagos. Mientras tanto, los alcornoques portugueses crecen en las laderas de las sierras bajas, cuya corteza deleita a la industria vitivinícola de todo el mundo.

Serra de Monchique
La Serra de Monchique sorge a 902 metri di altitudine. Il luogo, che porta lo stesso nome, forma un bel contrasto con le città costiere come Lagos con le sue brusche coste rocciose. Le querce da sughero portoghesi crescono sui fianchi delle basse catene montuose, la cui corteccia colma di gioia l'industria vinicola di tutto il mondo.

Serra de Monchique
De Serra de Monchique rijst in elk geval op tot een hoogte van 902 meter. De gelijknamige plaats vormt een mooi contrast met kustplaatsen zoals Lagos met hun ruige rotskusten. Ondertussen groeien Portugese kurkeiken op de hellingen van het middelgebergte, waarvan de bast de mondiale wijnindustrie gelukkig maakt.

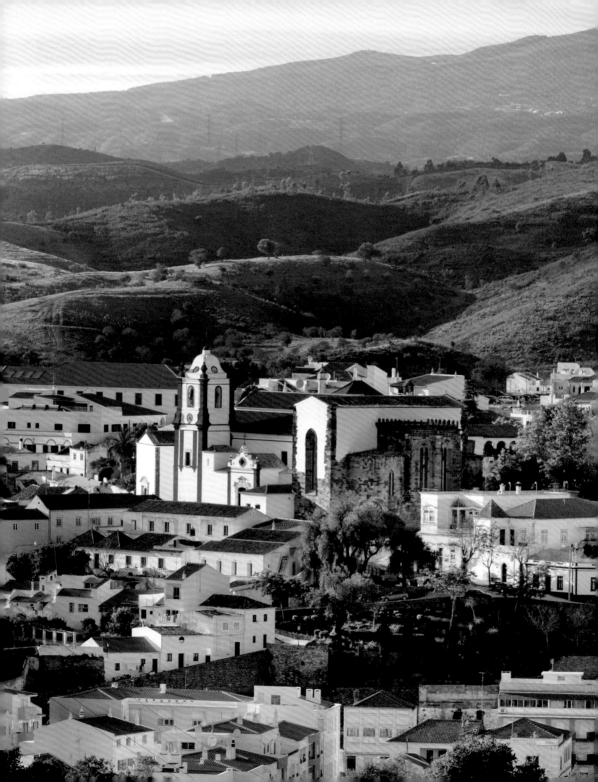

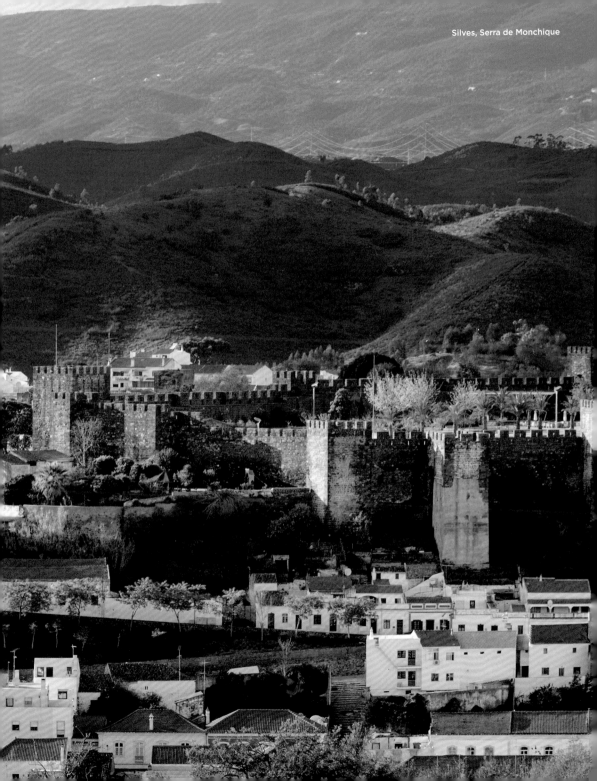

Silves, Serra de Monchique

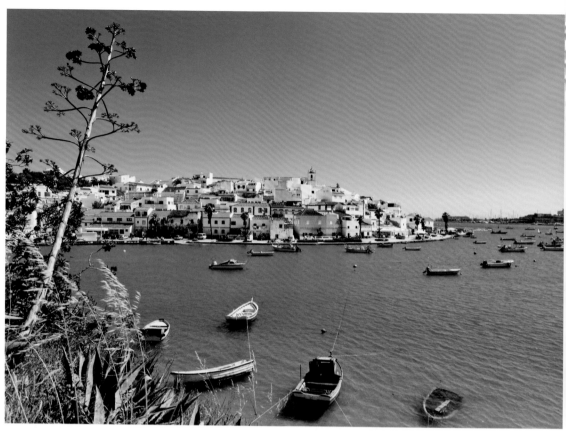

Portimão

Portimão

The port city of Portimão is still today a
centre of fish processing. Unlike many
holiday resorts, the everyday life of
the residents has hardly changed. The
hinterland region of Silves, on the other
hand, has undergone a remarkable
transformation: under Moorish rule it was
the centre of power in the Algarve, but
today tourists come first and foremost.

Portimão

La ville portuaire de Portimão est encore
aujourd'hui un centre de transformation du
poisson. Contrairement à de nombreuses
stations balnéaires, la vie quotidienne
des résidents n'a guère changé depuis
des années. L'arrière-pays de Silves,
en revanche, a subi une transformation
remarquable : sous la domination
mauresque, c'était le centre du pouvoir
en Algarve ; aujourd'hui, il attire surtout
les touristes.

Portimão

Die Hafenstadt Portimão ist bis heute ein
Zentrum der Fischverarbeitung. Anders
als in vielen Ferienorten hat sich der Alltag
der Bewohner kaum verändert. Das im
Hinterland gelegene Silves hat hingegen
einen bemerkenswerten Wandel hinter sich:
Unter maurischer Herrschaft lag hier das
Machtzentrum der Algarve, heute kommen
in erster Linie Touristen.

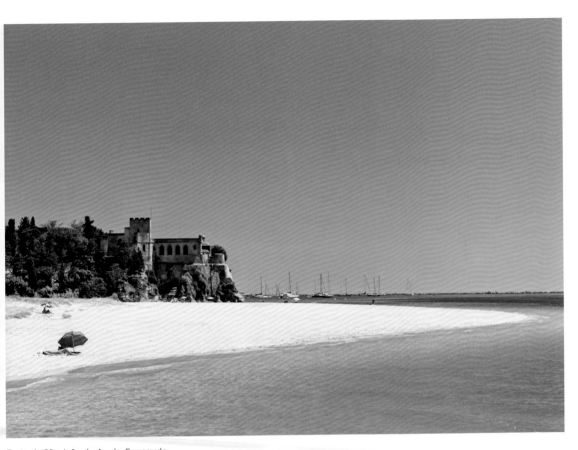

Forte de São João do Arade, Ferragudo
Fort of São João do Arade, Ferragudo

Portimão

La ciudad portuaria de Portimão sigue siendo un centro de procesamiento de pescado. A diferencia de lo que ha ocurrido en muchos destinos turísticos, aquí la vida cotidiana de los residentes apenas ha cambiado. Sin embargo Silves, que se encuentra en el interior, ha sufrido una notable transformación: bajo el dominio árabe era el centro de poder en el Algarve; hoy en día, los turistas son lo primero y más importante.

Portimão

La città portuale di Portimão è ancora oggi un centro di lavorazione del pesce. A differenza di molte località di villeggiatura, la vita quotidiana dei residenti è rimasta pressoché invariata. L'entroterra di Silves, invece, ha subito una notevole trasformazione: sotto il dominio moresco è stato il centro del potere in Algarve, oggi ospita per lo più i turisti.

Portimão

De havenstad Portimão is nog altijd een centrum van visverwerking. Anders dan in veel vakantieoorden is het dagelijks leven van de bewoners nauwelijks veranderd. Het in het achterland gelegen Silves heeft daarentegen een opmerkelijke transformatie ondergaan: onder Moorse heerschappij lag hier het machtscentrum van de Algarve; tegenwoordig komen toeristen op de eerste plaats.

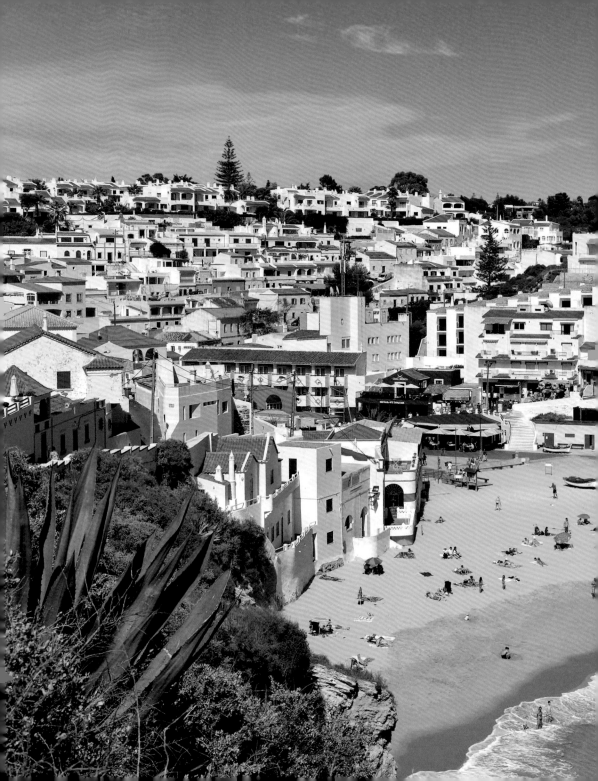

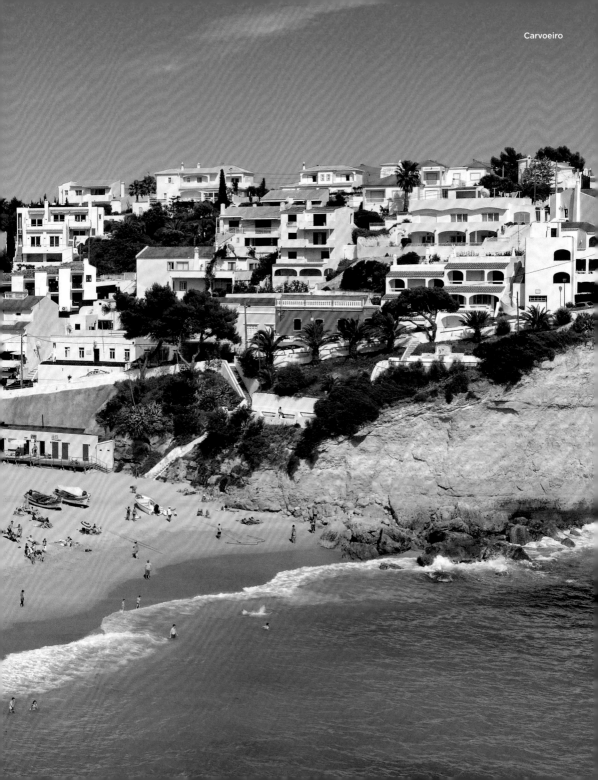

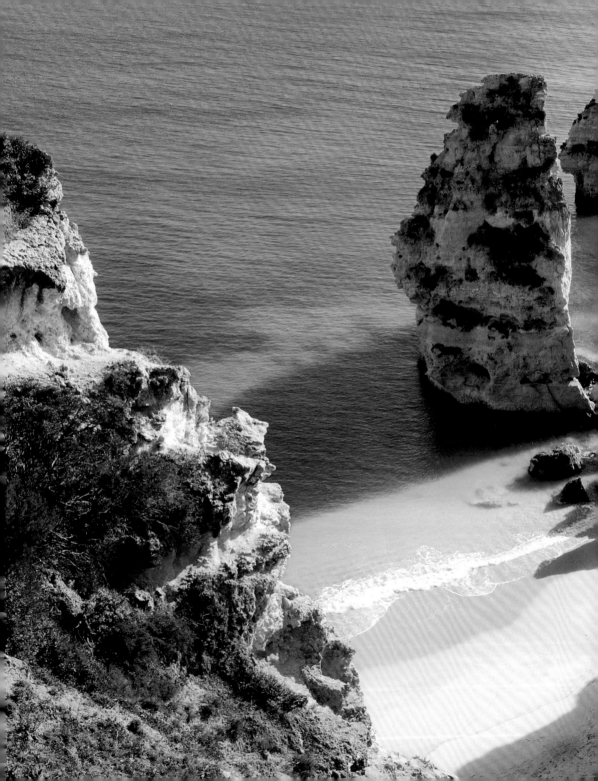

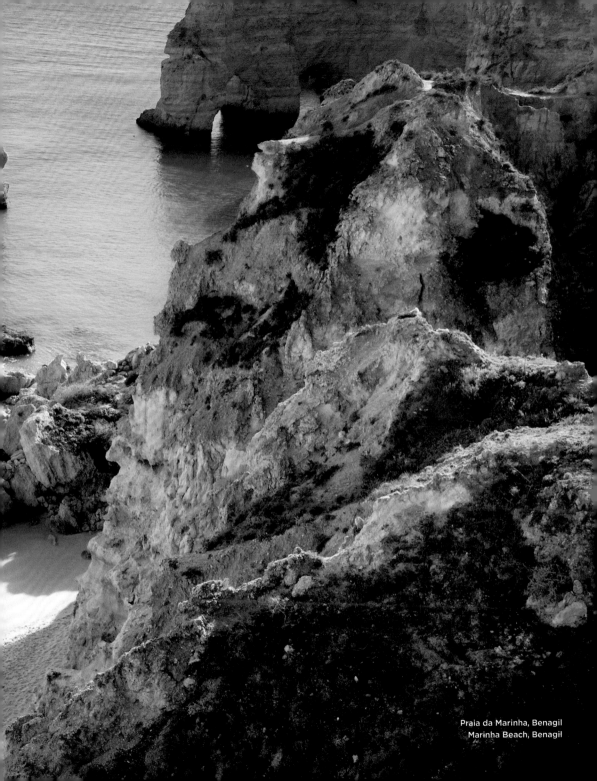

Praia da Marinha, Benagil
Marinha Beach, Benagil

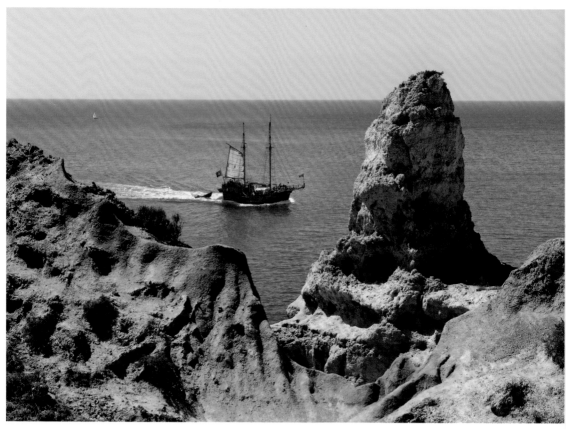

Algar Seco, Carvoeiro

Carvoeiro

Carvoeiro shows nature in all its creativity here, where shapely bays line up in close succession, with rock needles and caves serving as attractive photographic motifs. Occasionally, a pirate ship tries to steal their show.

Carvoeiro

À Carvoeiro, la nature a été particulièrement créative ; des baies bien formées s'y alignent, rythmées par des aiguilles de roche et des grottes très photogéniques ; parfois, un bateau pirate leur vole la vedette.

Carvoeiro

Bei Carvoeiro hat die Natur ihre ganze Kreativität ausgespielt: hier reihen sich formschöne Badebuchten in enger Taktung aneinander, wobei sich Felsnadeln und Höhlen als attraktive Fotomotive andienen. Gelegentlich versucht ihnen ein Piratenschiff die Schau zu stehlen.

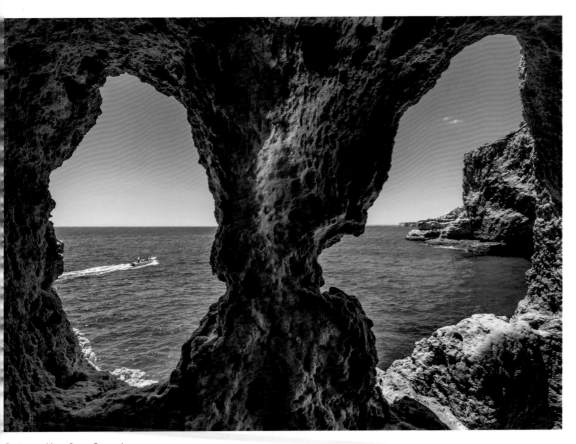

Gruta em Algar Seco, Carvoeiro
Rock Cave, Algar Seco, Carvoeiro

Carvoeiro

En Carvoeiro, la naturaleza ha puesto a prueba toda su creatividad: aquí, bahías bien formadas se alinean a un ritmo cercano, con pináculos y cuevas que sirven como atractivos motivos fotográficos. Ocasionalmente, un barco pirata intenta robar su espectáculo.

Carvoeiro

A Carvoeiro la natura ha messo alla prova tutta la sua creatività: qui, baie sagomate si allineano a ritmo serrato, con roccia appuntite e grotte che fungono da suggestivi motivi fotografici. Occasionalmente, una nave pirata cerca di rubare l'attenzione.

Carvoeiro

Bij Carvoeiro heeft de natuur al haar creativiteit in de strijd gegooid: hier rijgen fraai gevormde baaien zich in een strak ritme aaneen, waarbij spitse verticale rotsen en spelonken zich aandienen als aantrekkelijke motieven voor een fotoserie. Af en toe probeert een piratenschip de show te stelen.

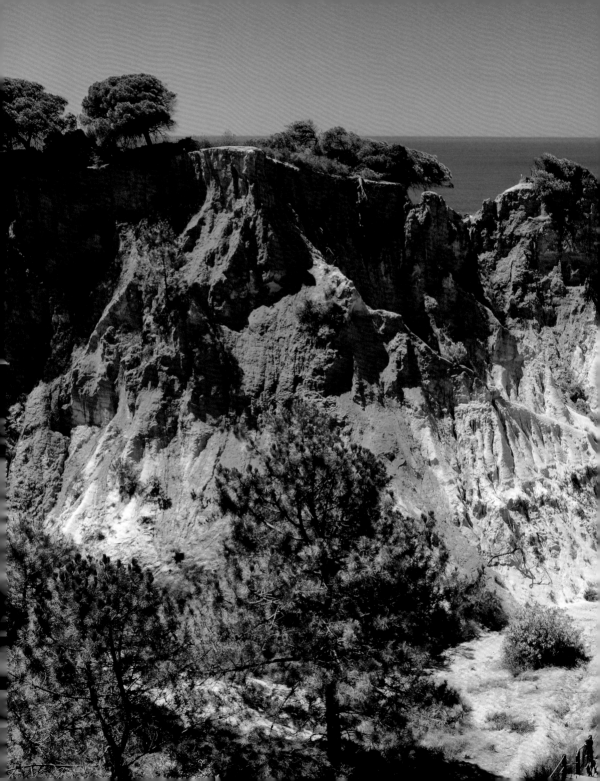

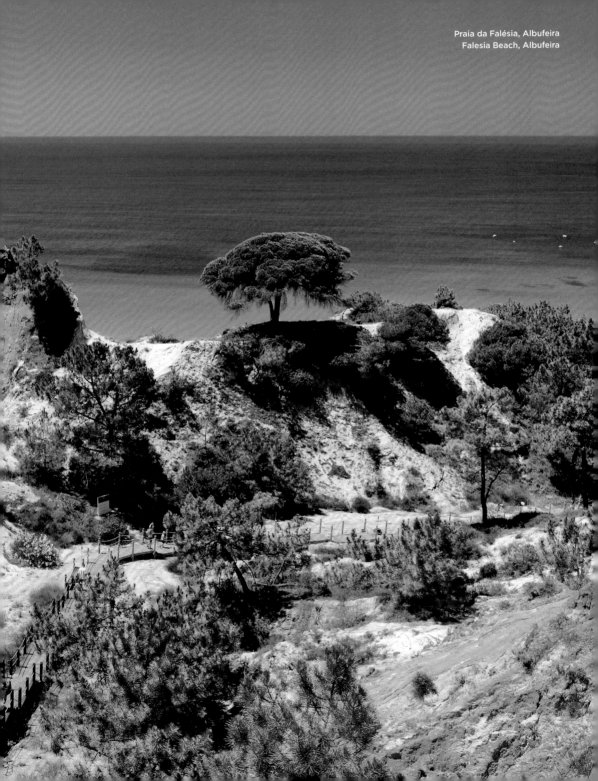

Praia da Falésia, Albufeira
Falesia Beach, Albufeira

Grutas de Benagil
Caves of Benagil

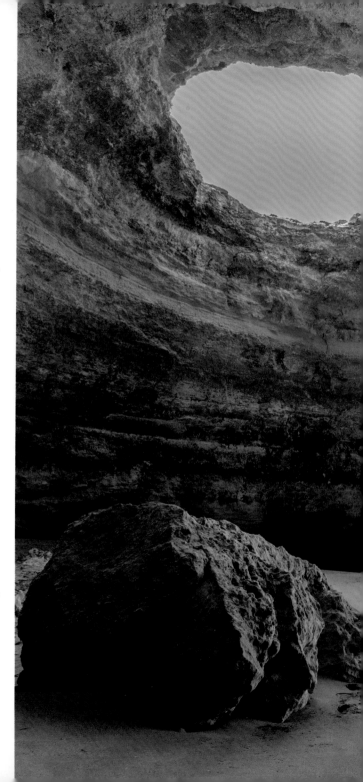

Rocky Algarve

A rock cave with sea views, several entrances
and a skylight? Nothing seems impossible in the
so-called Rocky Algarve. The caves of Benagil,
however, are not for the water-shy visitor, as if
you want to view this curiosity you'll have to
cross about 100 metres of ocean to enter the
cave from the water.

Grottes de l'Algarve

Une grotte rocheuse avec vue sur la mer,
plusieurs entrées et un puits de lumière ? Rien
ne semble impossible dans l'Algarve. Les grottes
de Benagil, cependant, ne sont pas accessibles
au visiteur timide ; pour admirer cette curiosité,
il vous faudra parcourir environ 100 mètres dans
l'océan afin d'accéder à cette grotte par les eaux.

Felsalgarve

Eine Felsenhöhle mit Meerblick, mehreren
Eingängen und Dachluke? Nichts scheint
unmöglich an der sogenannten Felsalgarve.
Die Höhlen von Benagil indes sind für den
wasserscheuen Besucher nicht zu erkennen. Wer
das Kuriosum in Augenschein nehmen möchte,
muss etwa 100 Meter im Ozean zurücklegen, um
die Höhle vom Wasser aus betreten zu können.

Barlovento del Algarve

¿Una cueva rocosa con vistas al mar, varias
entradas y un tragaluz? Nada parece imposible
en el llamado Barlovento del Algarve. Las cuevas
de Benagil, sin embargo, no son visibles para
aquellos visitantes a los que no les guste el agua.
Para ver esta curiosidad de la naturaleza, hay
que avanzar unos 100 metros por el océano para
poder entrar en la cueva desde el agua.

Scogliere di Algarve

Una grotta rocciosa con vista sul mare,
diversi ingressi e un lucernario? Nulla sembra
impossibile nelle cosiddette Scogliere di Algarve.
Le grotte di Benagil, tuttavia, non sono visibili ai
visitatori che temono l'acqua. Se volete vedere
questo spettacolo, è necessario nuotare per circa
100 metri nell'oceano per entrare nella grotta
dall'acqua.

Algarve

Een grot met uitzicht op zee, meerdere ingangen
en een daklicht? Niets lijkt onmogelijk aan de
zogenaamde Rotsenalgarve. De grot bij Praia
de Benagil is echter niet te zichtbaar voor
bezoekers met watervrees. Wie deze curiositeit
met eigen ogen wil zien, moet ongeveer 100
meter in de oceaan afleggen om de grot vanuit
het water te kunnen binnengaan.

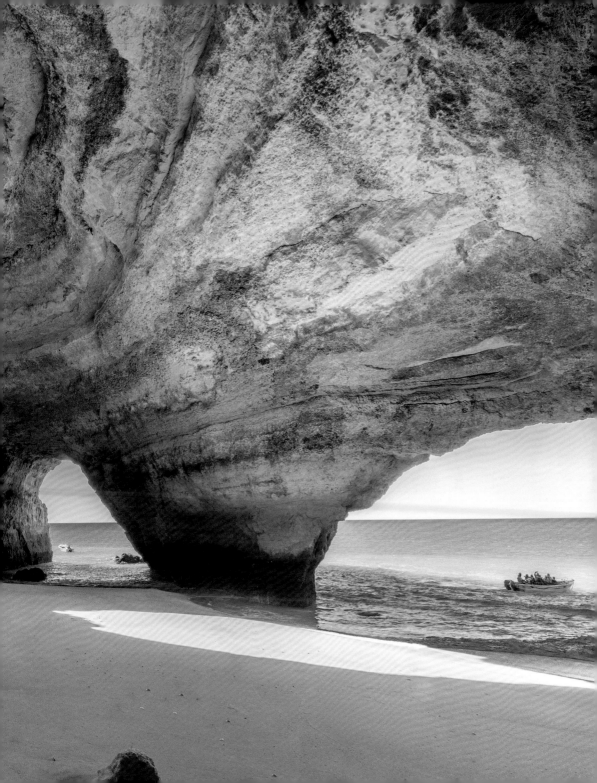

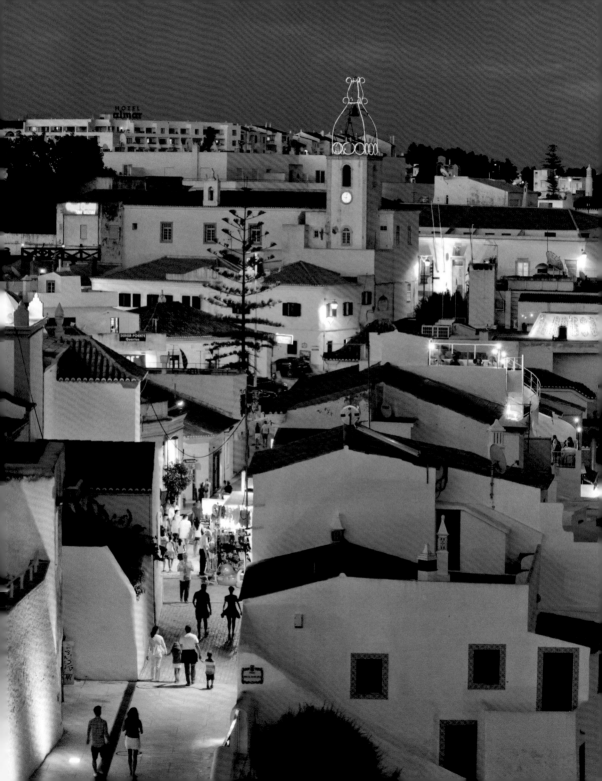

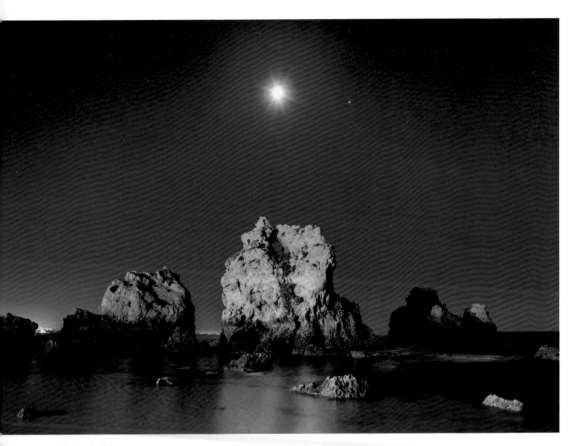

Praia de São Rafael, Albufeira
São Rafael Beach, Albufeira

Albufeira

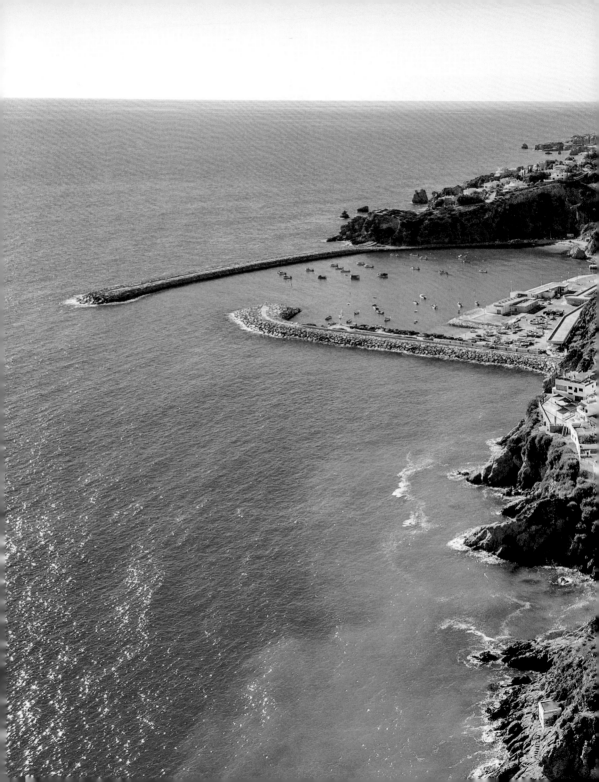

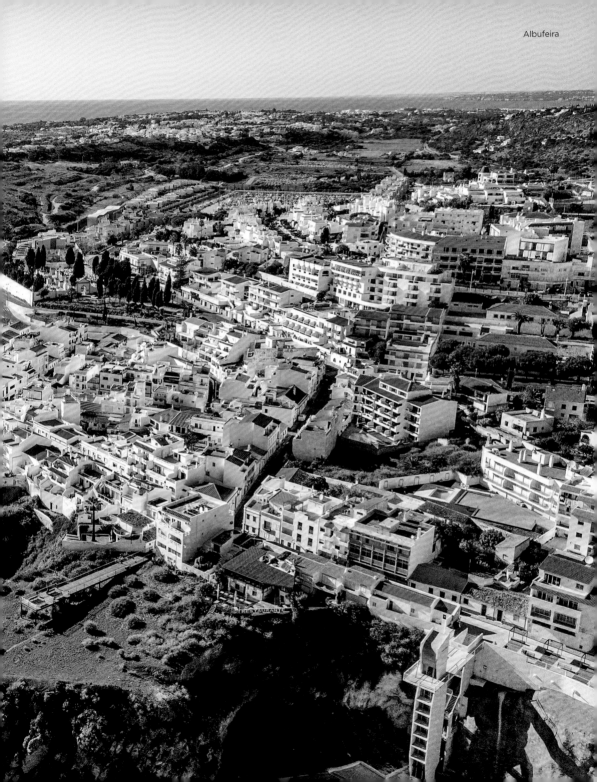

Amendoeiras, Loulé
Almond trees, Loulé

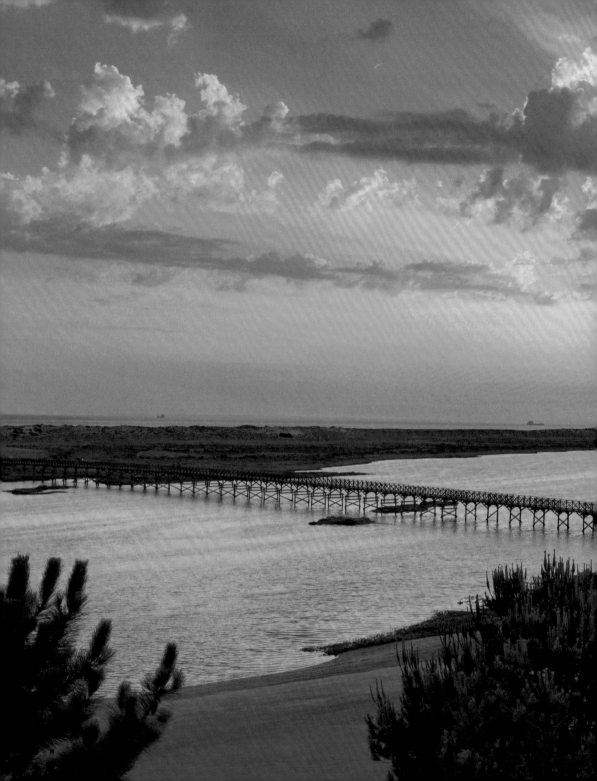

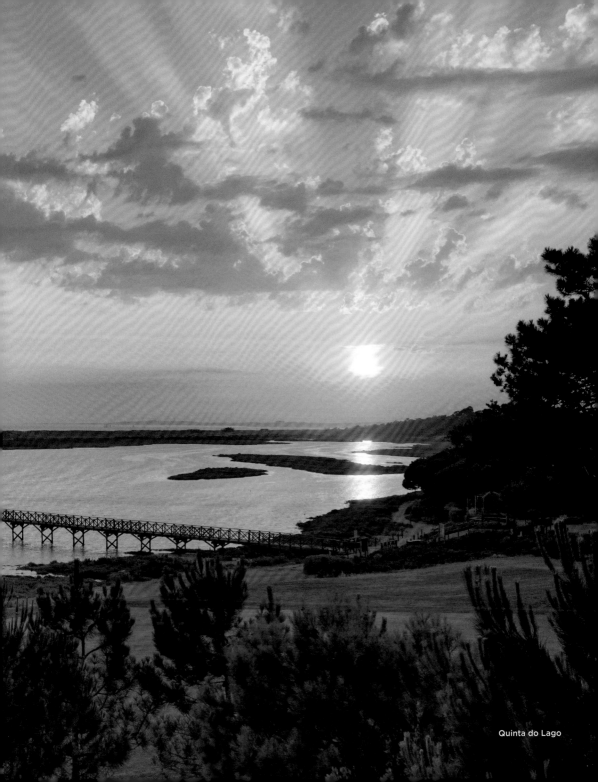

Quinta do Lago

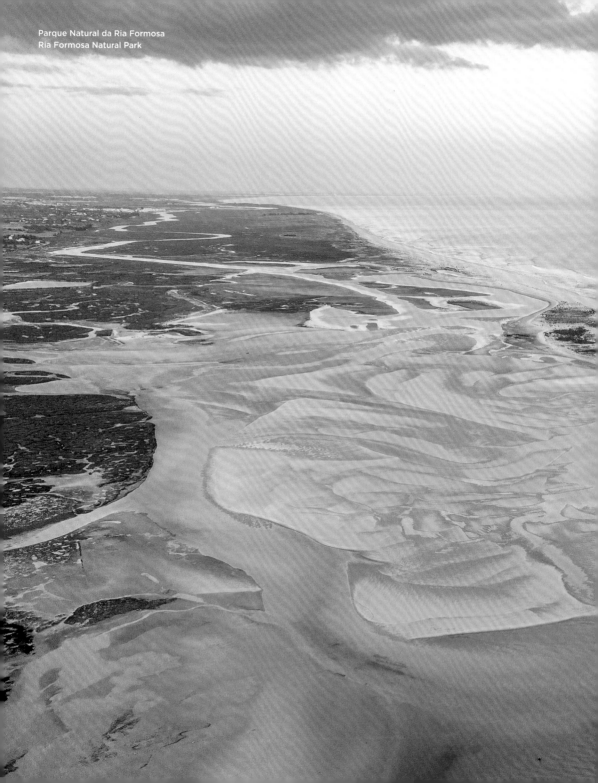

Parque Natural da Ria Formosa
Ria Formosa Natural Park

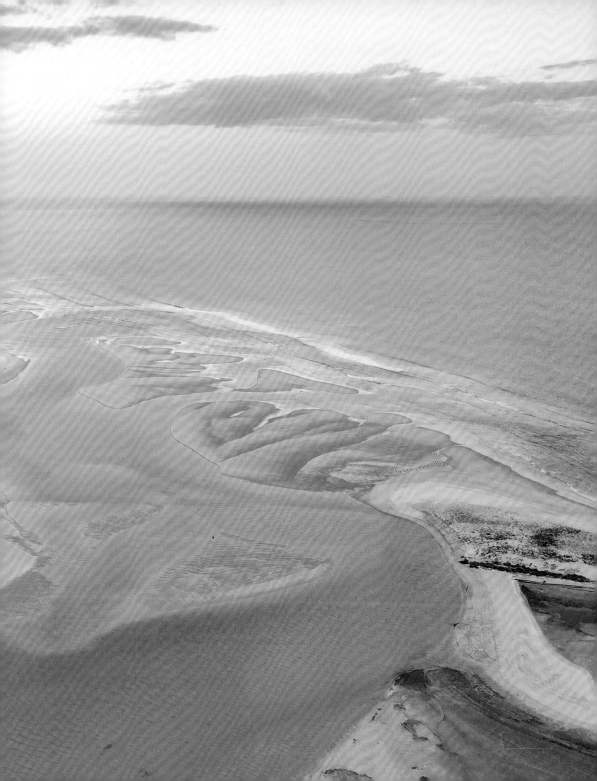

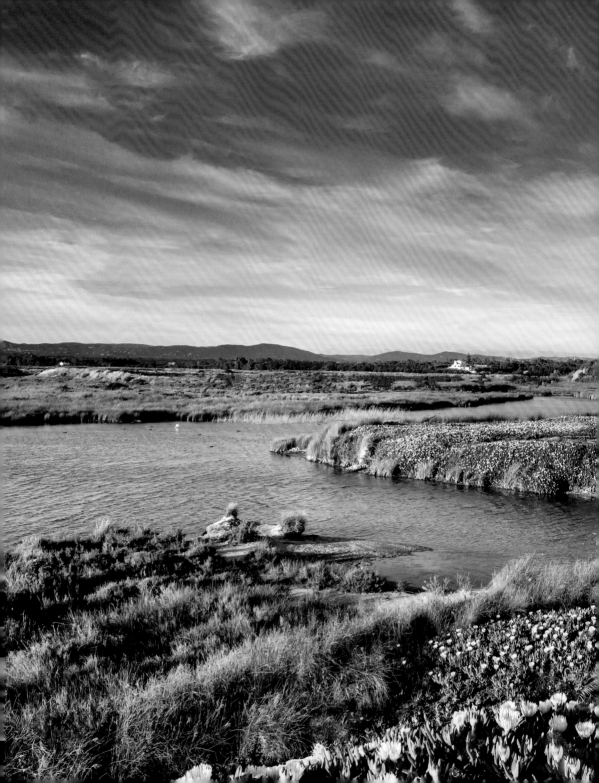

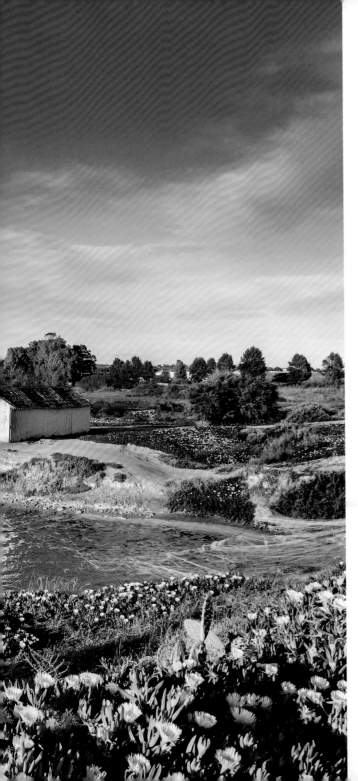

Parque Natural da Ria Formosa
Ria Formosa Natural Park

Sandy Algarve

The Sandy Algarve in Portugal's southeast shows a noticeably different face, compared to its counterpart. Here, in the Parque Natural da Ria Formosa, a lagoon-like wetland spreads out which seems to have frozen in time. The alleys in the old town of Faro also seem sluggish and cautious, but this major town of the Algarve is always bustling.

Sotavento

Le sud-est de l'Algarve, le Sotavento, est sensiblement différent de l'ouest de la région. Le Parque Natural da Ria Formosa s'étale dans une zone humide et lagunaire qui paraît hors du temps. Les ruelles de la vieille ville de Faro semblent elles aussi endormies, mais l'endroit est toujours animé.

Sandalgarve

Die Sandalgarve in Portugals Südosten zeigt ein merklich anderes Gesicht als ihr Pendant. Hier breitet sich mit dem Parque Natural da Ria Formosa ein lagunenartiges Feuchtgebiet aus, das wie aus der Zeit gefallen scheint. Träge und bedächtig wirken auch die Gassen in der Altstadt von Faro, doch das Oberzentrum der Algarve ist durchaus geschäftig.

Sotavento del Algarve

El Sotavento del Algarve en el sureste de Portugal muestra una cara notablemente diferente a la del compañero Barlovento. Aquí, con el Parque Natural da Ria Formosa, se extiende un humedal parecido a una laguna que parece haber caído con el paso del tiempo. Los callejones del casco antiguo de Faro también parecen lentos y pausados, pero el centro urbano del Algarve es bastante dinámico.

Spiagge in Algarve

Le spiagge nel sud-est del Portogallo mostra un volto notevolmente diverso rispetto alla sua antagonista. Qui, con il Parque Natural da Ria Formosa, si estende una zona umida lagunare che sembra essere ferma nel tempo. Anche i vicoli del centro storico di Faro sembrano lenti e avveduti, ma in realtà il centro dell'Algarve è molto affollato.

Zandalgarve

De Zandalgarve in het zuidoosten van Portugal heeft een duidelijk ander gezicht dan zijn tegenhanger. Hier strekt zich met het Parque Natural da Ria Formosa een laguneachtig moerasgebied uit dat niet meer van deze tijd lijkt te zijn. Traag en bedachtzaam komen ook de steegjes in de oude binnenstad van Faro over, maar het centrum van de Algarve is tamelijk bedrijvig.

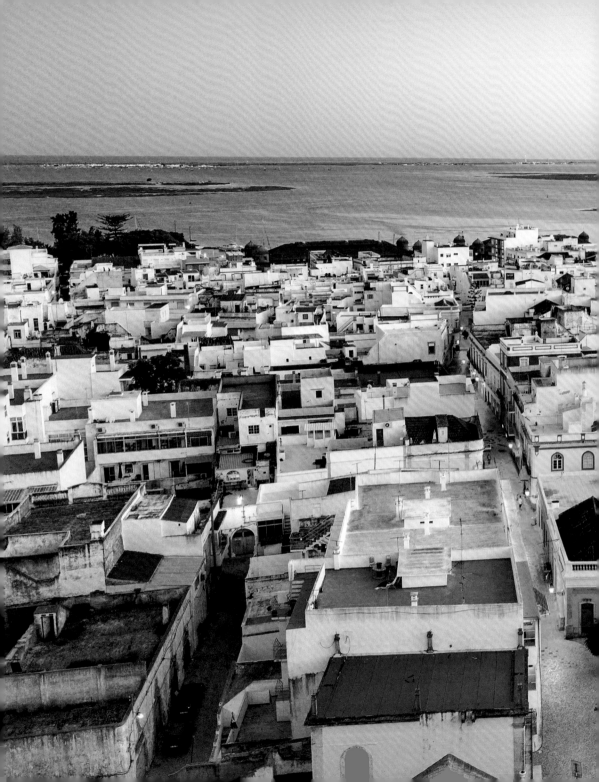

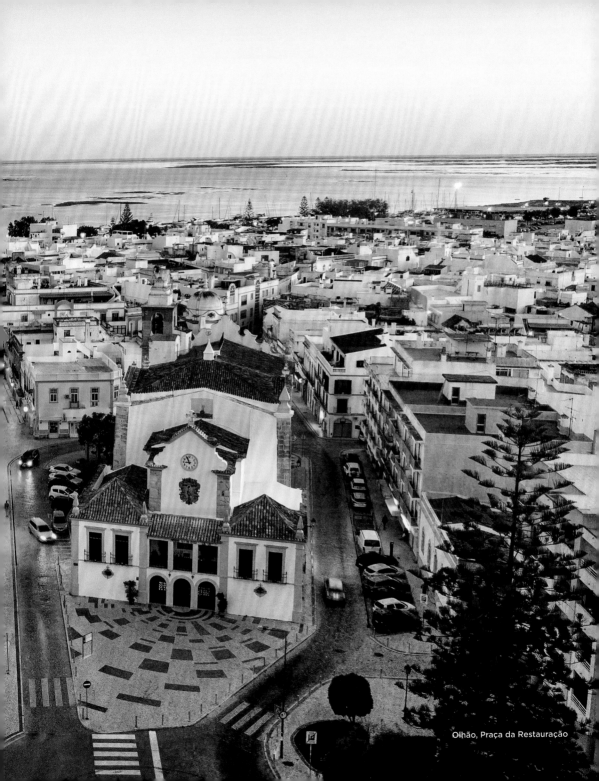

Olhão, Praça da Restauração

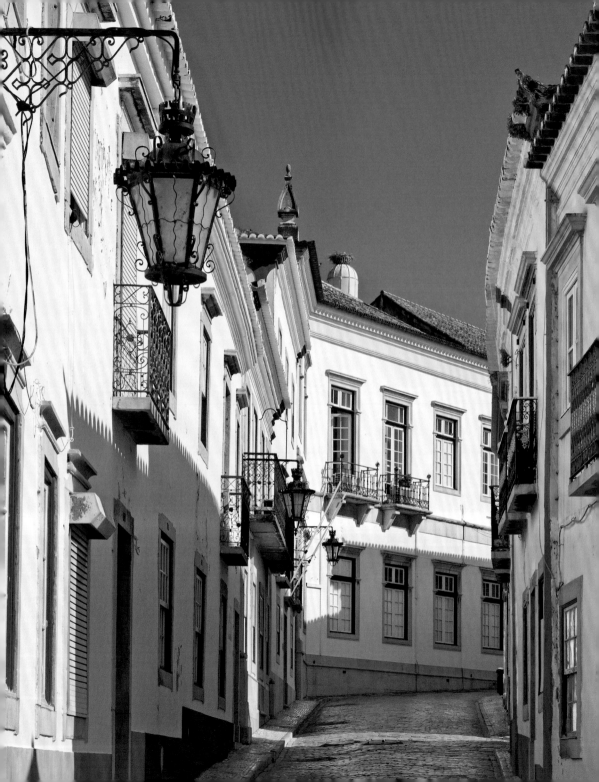

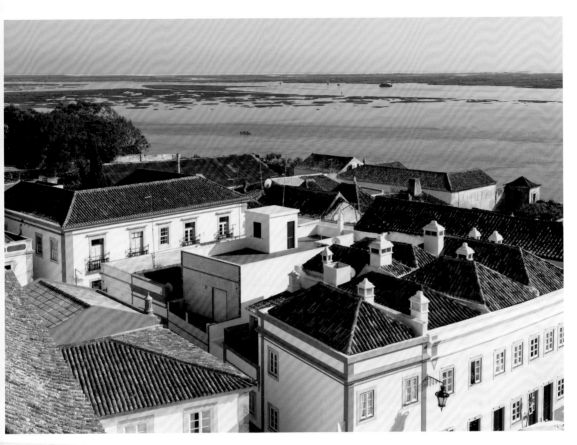

Cidade de Faro
Faro City

Cidade de Faro
Faro City

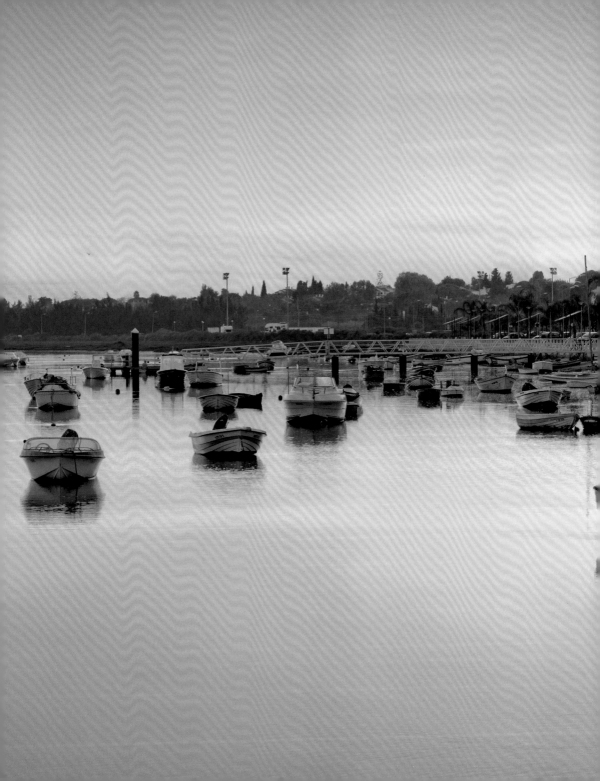

Santa Luzia

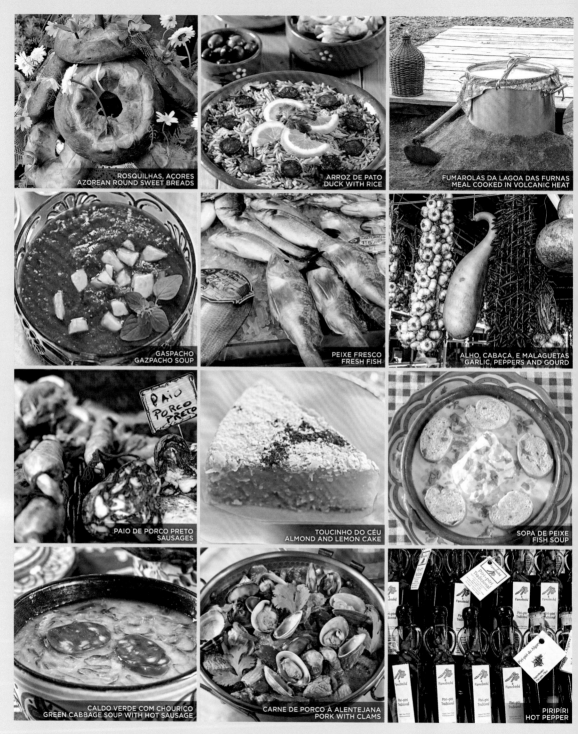

ROSQUILHAS, AÇORES
AZOREAN ROUND SWEET BREADS

ARROZ DE PATO
DUCK WITH RICE

FUMAROLAS DA LAGOA DAS FURNAS
MEAL COOKED IN VOLCANIC HEAT

GASPACHO
GAZPACHO SOUP

PEIXE FRESCO
FRESH FISH

ALHO, CABAÇA, E MALAGUETAS
GARLIC, PEPPERS AND GOURD

PAIO DE PORCO PRETO
SAUSAGES

TOUCINHO DO CÉU
ALMOND AND LEMON CAKE

SOPA DE PEIXE
FISH SOUP

CALDO VERDE COM CHOURIÇO
GREEN CABBAGE SOUP WITH HOT SAUSAGE

CARNE DE PORCO À ALENTEJANA
PORK WITH CLAMS

PIRIPÍRI
HOT PEPPER

384

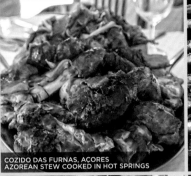

COZIDO DAS FURNAS, AÇORES
AZOREAN STEW COOKED IN HOT SPRINGS

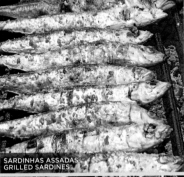

SARDINHAS ASSADAS
GRILLED SARDINES

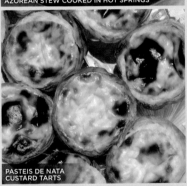

PASTEIS DE NATA
CUSTARD TARTS

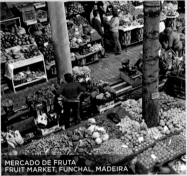

MERCADO DE FRUTA
FRUIT MARKET, FUNCHAL, MADEIRA

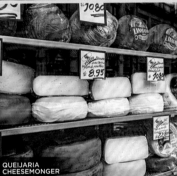

QUEIJARIA
CHEESEMONGER

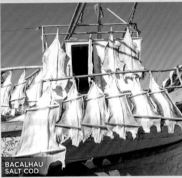

BACALHAU
SALT COD

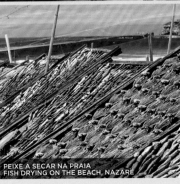

PEIXE A SECAR NA PRAIA
FISH DRYING ON THE BEACH, NAZARÉ

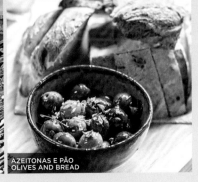

AZEITONAS E PÃO
OLIVES AND BREAD

Gourmet delights

The best regional products include bacalhau (dried or salt cod), grilled sardines, chouriços (sausage), gazpacho and Pasteis de Nata (custard in puff pastry).

Plaisirs gourmands

Au Portugal, les gourmets aimeront déguster les produits régionaux, comme le bacalhau (morue séchée), les sardines grillées et le chorico (saucisse). Un gazpacho frais aide à supporter les journées très chaudes de l'été, tandis que l'incomparable Pasteis de Nata (flan pâtissier sur une pâte feuilletée) se savoure en toute occasion.

Schlemmereien

Zu den regionalen Köstlichkeiten gehören Bacalhau (getrockneter Kabeljau), gegrillte Sardinen und chouriços (Wurst). Eine Gazpacho kühlt an heißen Sommertagen, während die Pasteis de Nata (Puddingteilchen in Blätterteig) immer schmecken.

Exquisiteces gourmet

Los gourmets pueden disfrutar de productos regionales en Portugal. Entre estos se incluyen el Bacalhau (bacalao seco), sardinas a la parrilla y el fuerte chorizo. Un gazpacho fresco ayuda a superar los calurosos días de verano, mientras que los incomparables Pasteis de Nata (pequeñas raciones de pudin en hojaldre) están siempre riquísimos.

Delizie gastronomiche

I buongustai possono assaporare prodotti regionali in Portogallo. Tra questi figurano il bacalhau (merluzzo secco), le sardine alla griglia e il chouriço (salsiccia). Un fresco gazpacho aiuta a superare le calde giornate estive, mentre le incomparabili pasteis de nata (pasticcino alla crema in pasta sfoglia) sono sempre un'ottima scelta.

Gastronomie

Fijnproevers kunnen in Portugal genieten van regionale producten. Daartoe behoren bacalhau (gedroogde kabeljauw), gegrilde sardines en pittige chouriços (worst). Een koele gazpacho helpt om warme zomerdagen door te komen, terwijl de onvergelijkbare pasteis de nata (bladerdeegbakjes met pudding) in alle situaties lekker smaken.

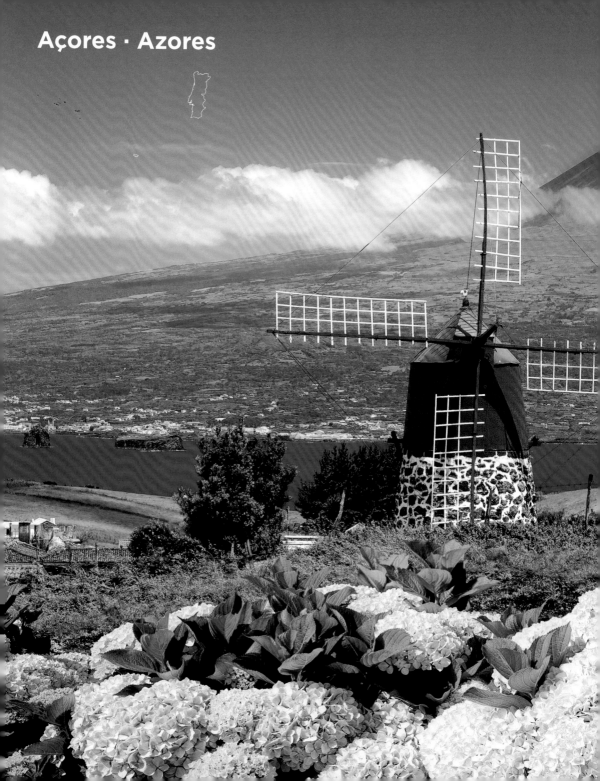

Açores · Azores

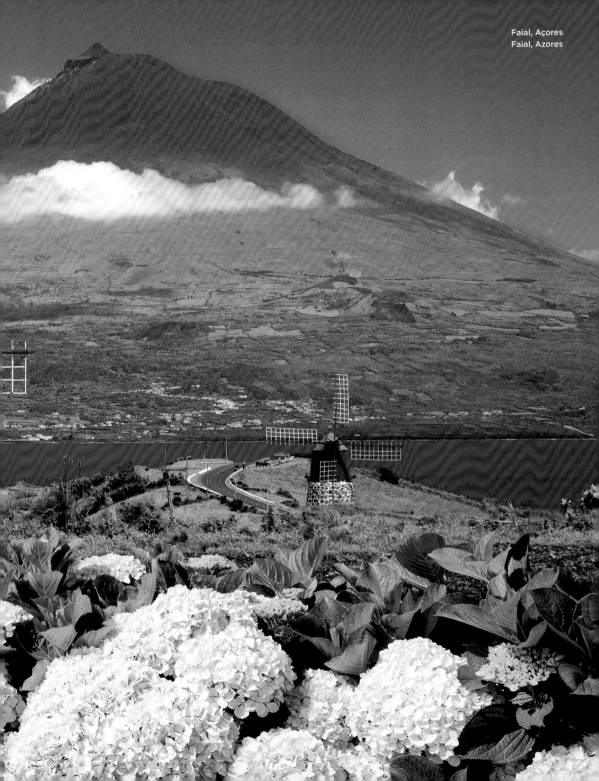

Barreiro da Faneca, Santa Maria

Santa Maria

Hydrangea beds set before windmills and volcanic cones? This is not a utopia, this is the Azores. Situated 1369 kilometres west of the Portuguese mainland, the archipelago is very fertile and the volcano of Cabeço Gordo, located on the island of Faial, sports an elegant cone. Its steeply sloping caldera is only visible to visitors at an altitude of 1043 metres.

Santa Maria

Un lit d'hortensia au pied des moulins à vent et des volcans ? Ce n'est pas utopique aux Açores. Situé à 1369 kilomètres à l'ouest du continent portugais, l'archipel est très fertile – et Cabeço Gordo, situé sur l'île de Faial, possède un cône volcanique très impressionnant. Sa vallée en forte pente n'est visible qu'à partir de 1 043 mètres d'altitude.

Santa Maria

Hortensienbeet vor Windmühlen und Vulkankegel? Das ist auf den Azoren keine Utopie. Die 1369 Kilometer westlich des portugiesischen Festlandes gelegene Inselgruppe ist sehr fruchtbar – und der auf der Insel Faial gelegene Cabeço Gordo verfügt über einen formschönen Kegel. Seinen steil abfallenden Talkessel sehen Besucher erst in 1043 Meter Höhe.

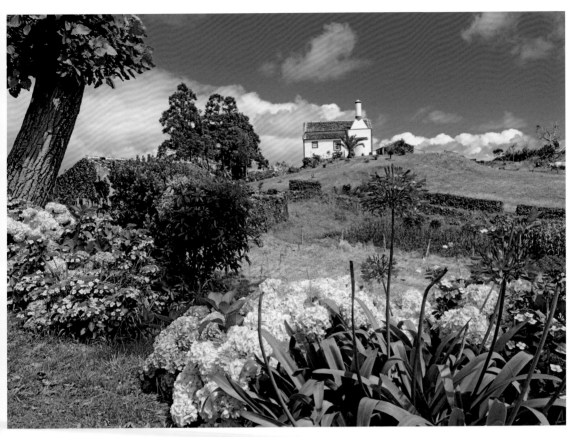

Santo Espírito, Santa Maria

Santa Maria

¿Un macizo de hortensias delante de los molinos de viento y conos volcánicos? Esto no es una utopía en las Azores. Situado a 1369 kilómetros al oeste de la península portuguesa, el archipiélago del Cabeço Gordo es muy fértil, y el Cabeço Gordo, situado en la isla de Faial, tiene un elegante cono volcánico. Su escarpada cuenca sólo es visible para los visitantes a una altitud de 1043 metros.

Santa Maria

Un'aiuola di ortensie di fronte a mulini a vento e coni vulcanici? Non è un'utopia nelle Azzorre. Situato a 1369 chilometri a ovest della terraferma portoghese, l'arcipelago di Cabeço Gordo è molto fertile – e Cabeço Gordo, situato sull'isola di Faial, ha un elegante cono vulcanico. La sua conca in forte pendenza è visibile solo a 1043 metri di altitudine.

Santa Maria

Hortensiaborder voor windmolens en een vulkaankegel? Dit is op de Azoren geen utopie. De 1369 kilometer ten westen van het Portugese vasteland gelegen eilandengroep is uiterst vruchtbaar – en Cabeço Gordo, gelegen op het eiland Faial, beschikt over een prachtig gevormde kegel. Zijn steil aflopende dalketel is voor bezoekers pas zichtbaar op een hoogte van 1043 meter.

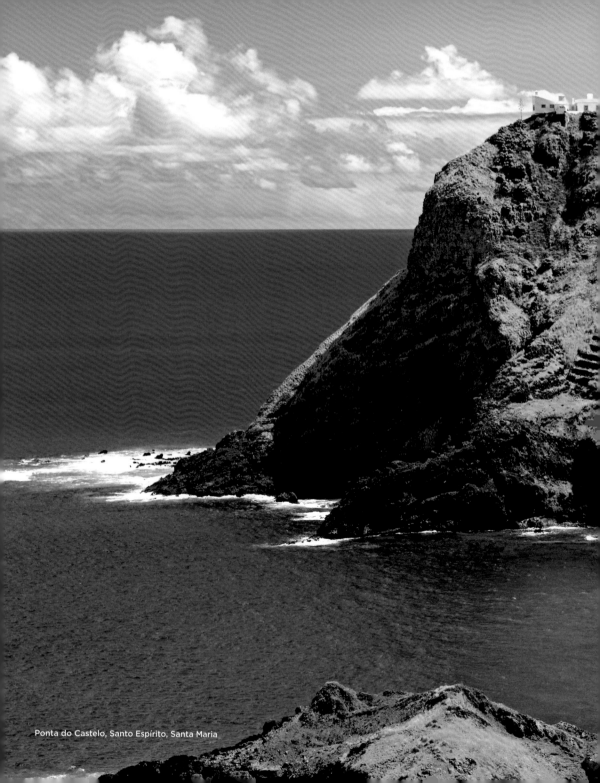

Ponta do Castelo, Santo Espírito, Santa Maria

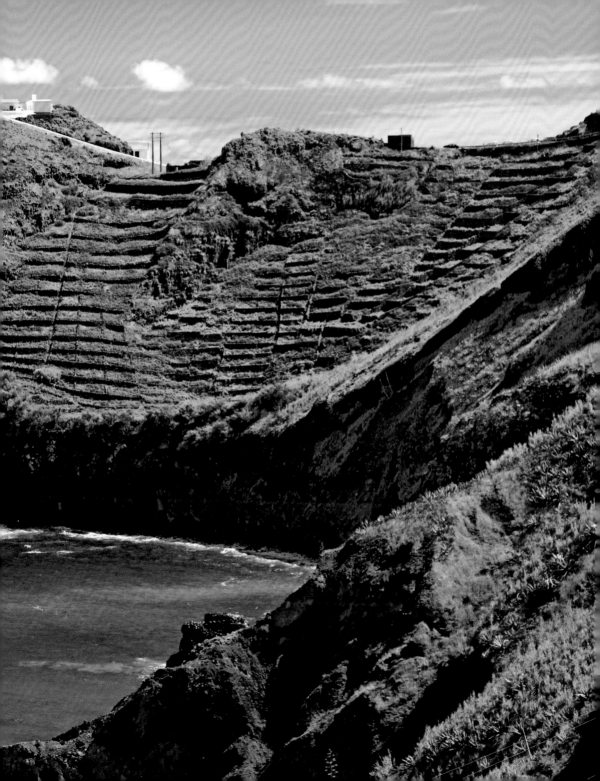

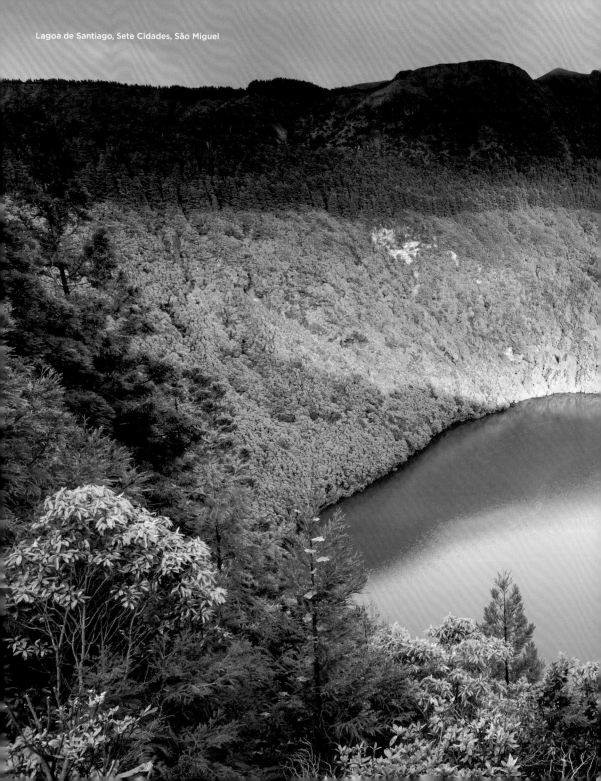
Lagoa de Santiago, Sete Cidades, São Miguel

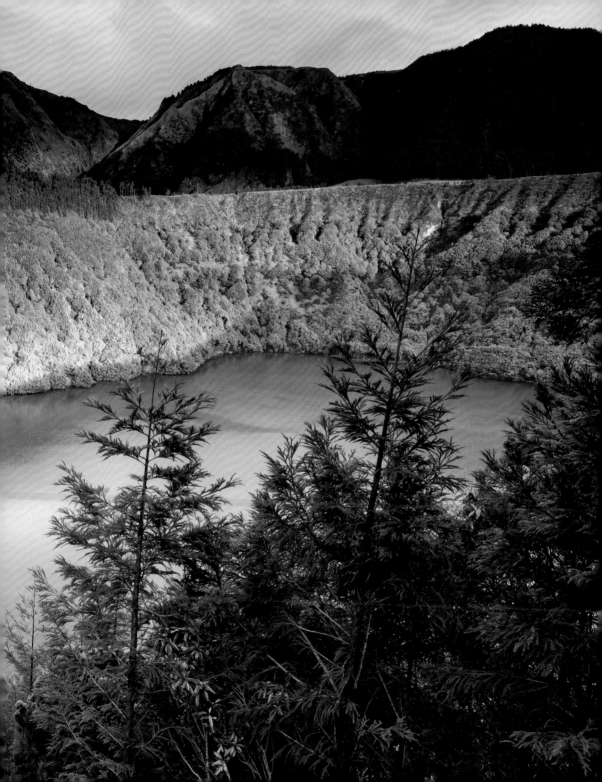

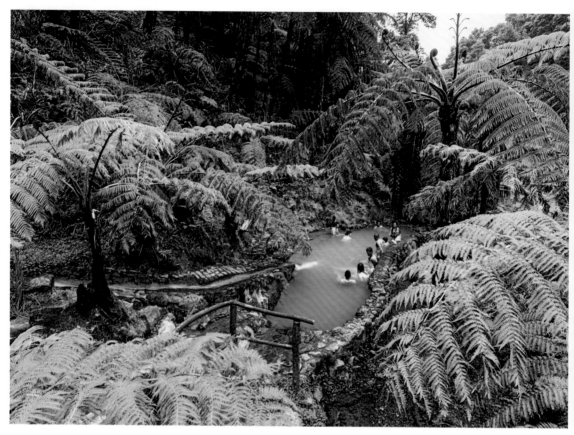

Caldeira Velha, São Miguel

Santa Maria & São Miguel
Winegrowers on the island of Santa Maria have to contend with arduous steep slopes. The neighbouring island of São Miguel, however, seems to prefer to concentrate on the artful collection of water, be it in the volcanic crater lake of Lagoa de Santiago, or in the natural swimming pool at Caldeira Velha.

Santa Maria & São Miguel
Les vignerons de l'île de Santa Maria doivent composer avec des pentes abruptes et ardues. Quant à l'île voisine de São Miguel, il s'agit de réussir à collecter l'eau pour les vignes de façon astucieuse – que ce soit dans le lac volcanique Lagoa de Santiago ou dans la piscine naturelle Caldeira Velha.

Santa Maria & São Miguel
Weinbauern müssen auf der Insel Santa Maria beschwerliche Steillagen in Kauf nehmen. Die Nachbarinsel São Miguel scheint sich indes lieber auf das kunstvolle Auffangen von Wasser zu konzentrieren. Sei es im Vulkansee Lagoa de Santiago oder im Naturschwimmbecken Caldeira Velha.

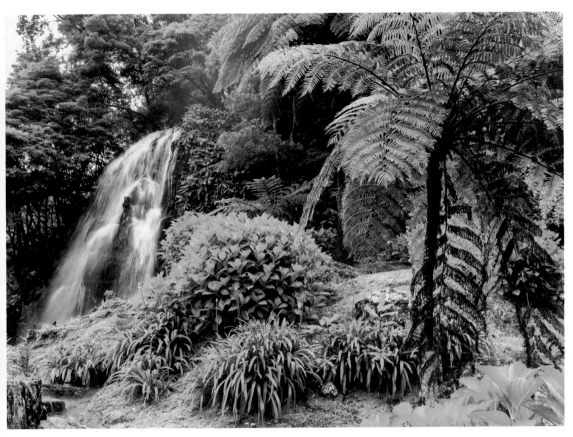

Parque Natural da Ribeira dos Caldeirões, São Miguel
Ribeira dos Caldeirões Natural Park, São Miguel

Santa Maria & São Miguel

Los viticultores de la isla de Santa María tienen que aceptar las arduas y empinadas pendientes. La isla vecina de São Miguel, sin embargo, parece haberse decantado por una ingeniosa colección de agua. Ya sea en el lago volcánico Lagoa de Santiago o en la piscina natural Caldeira Velha.

Santa Maria & São Miguel

I viticoltori dell'isola di Santa Maria devono affrontare pendii scoscesi e impegnativi. La vicina isola di São Miguel, tuttavia, sembra preferire concentrarsi sulla raccolta dell'acqua. Sia nel lago vulcanico Lagoa de Santiago o nella piscina naturale Caldeira Velha.

Santa Maria & São Miguel

De wijnboeren op het eiland Santa Maria moeten lastige steile hellingen op de koop toe nemen. Het naburige eiland São Miguel lijkt zich intussen liever te concentreren op het kunstig opvangen van water. Of dat nu in het vulkaanmeer Lagoa de Santiago is of in het natuurlijke zwembassin Caldeira Velha.

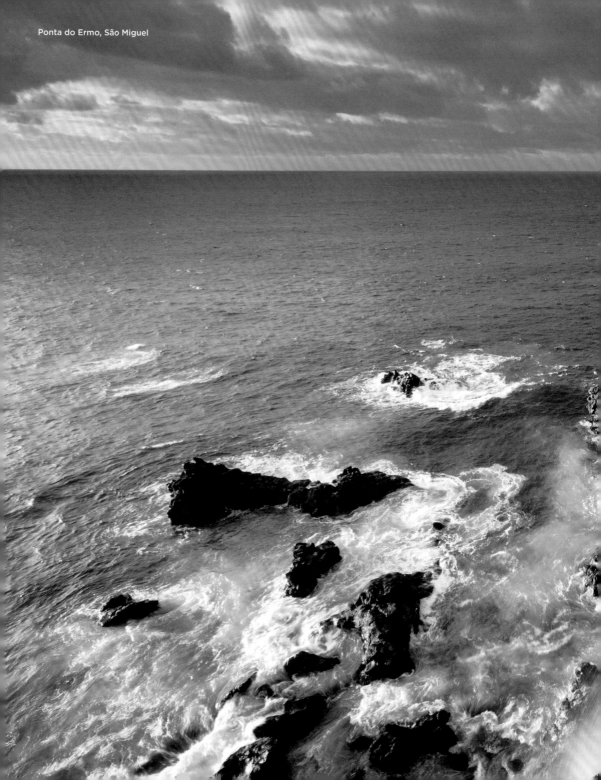

Ponta do Ermo, São Miguel

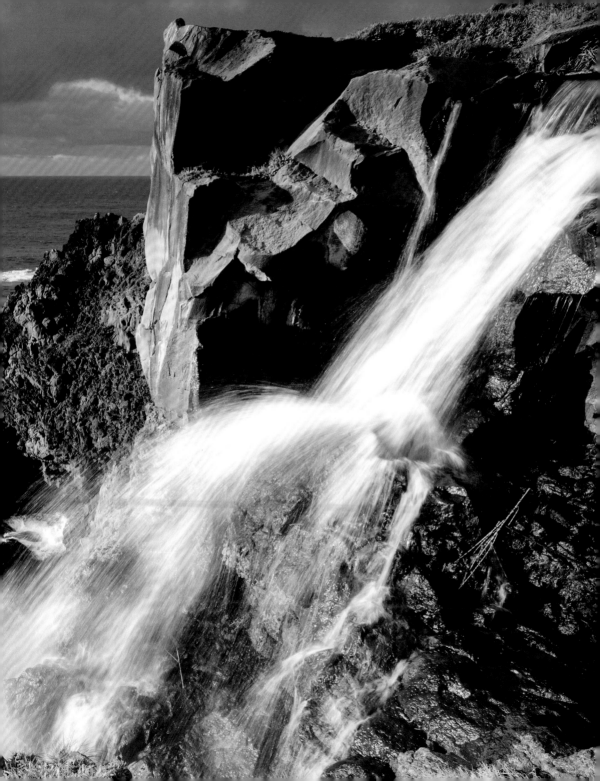

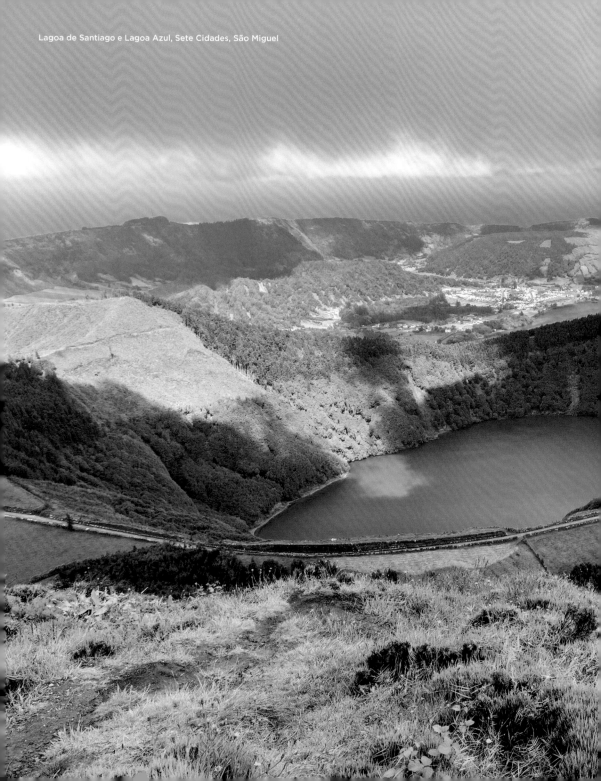

Lagoa de Santiago e Lagoa Azul, Sete Cidades, São Miguel

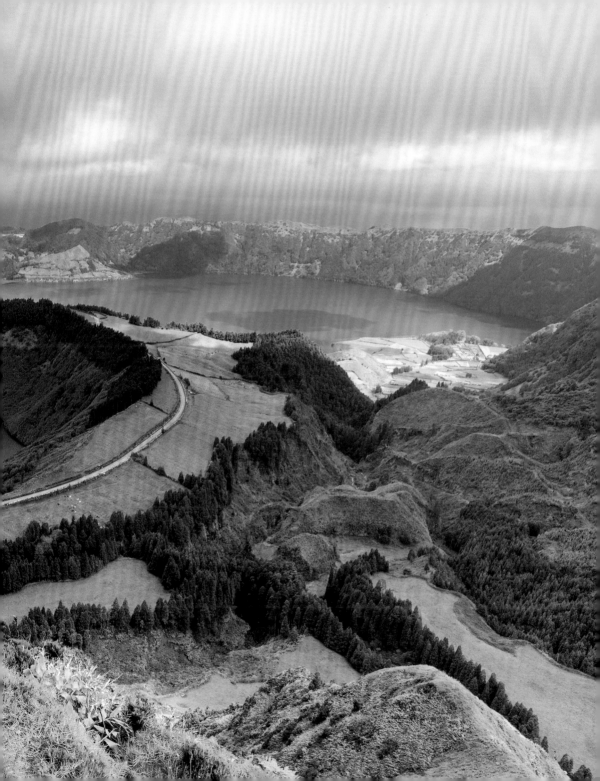

Fumarolas das Furnas, São Miguel
Hot spring in Furnas São Miguel

São Miguel

The volcanic activities of the past have given São Miguel, the largest island in the Azores, its face. But nature has not yet tired, as we may see from the hot geothermal springs in the village of Furnas, which are so hot that the inhabitants of the surrounding area use them to cook the national dish of Cozido, a hearty stew.

São Miguel

Les activités volcaniques du passé ont transformé São Miguel, la plus grande île des Açores. Mais la nature n'a pas encore dit son dernier mot : les sources du village de Furnas sont si chaudes que les habitants des environs y cuisinent le ragoût national, le cozido.

São Miguel

Die vulkanischen Aktivitäten der Vergangenheit haben der größten Azoreninsel São Miguel ein Gesicht gegeben. Noch aber ist die Natur nicht müde: Die Quellen in der Ortschaft Furnas sind derart heiß, dass die Bewohner in der umliegenden Erde das Nationalgericht Cozido garen, einen deftigen Eintopf.

Cozido das Furnas, São Miguel

São Miguel
Las actividades volcánicas del pasado le han puesto cara a São Miguel, la isla más grande de las Azores. Pero la naturaleza aún no se ha cansado: las aguas termales del pueblo de Furnas están tan calientes que los habitantes preparan cocido en la tierra de alrededor.

São Miguel
Le attività vulcaniche del passato hanno plasmato il volto di São Miguel, la più grande isola delle Azzorre. Ma la natura continua il suo lavoro: le sorgenti nel villaggio di Furnas sono così calde che gli abitanti della zona circostante cucinano lì il piatto nazionale Cozido, uno stufato misto.

São Miguel
Vulkaanactiviteiten uit het verleden hebben São Miguel, het grootste eiland van de Azoren, een gezicht gegeven. Maar de natuur is nog niet moe: de bronnen in het dorp Furnas zijn zo heet dat de bewoners het nationale gerecht cozido, een stevige stoofpot, laten garen in de omliggende aarde.

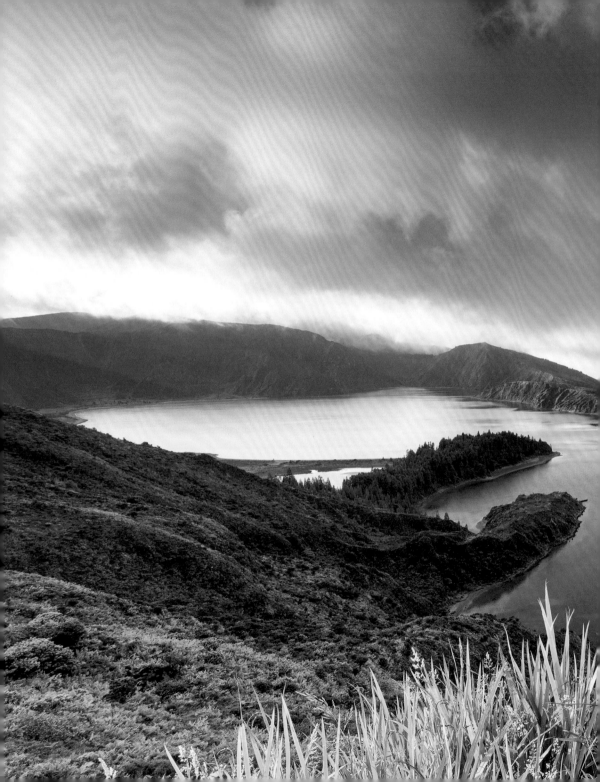

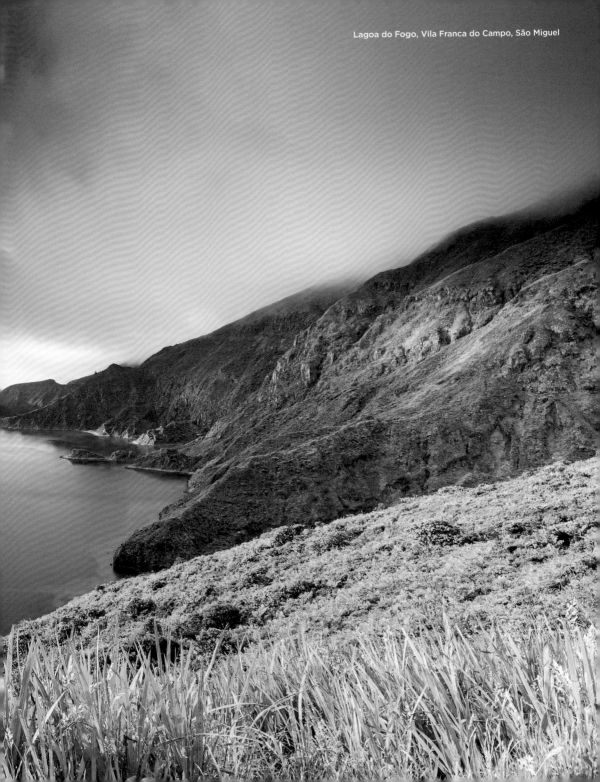

Lagoa do Fogo, Vila Franca do Campo, São Miguel

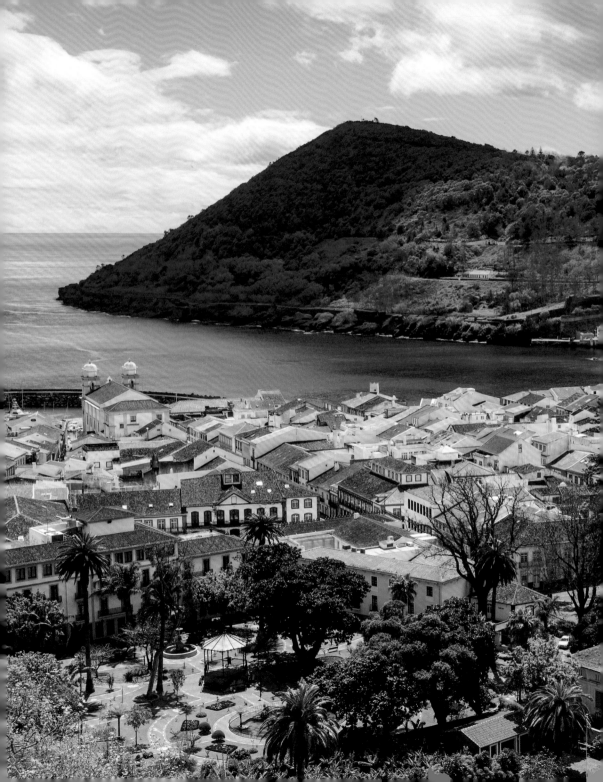

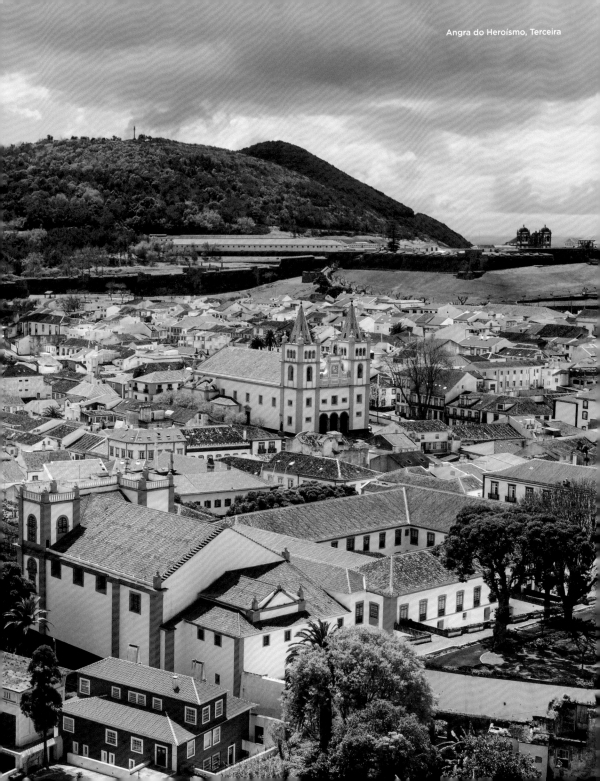

Angra do Heroísmo, Terceira

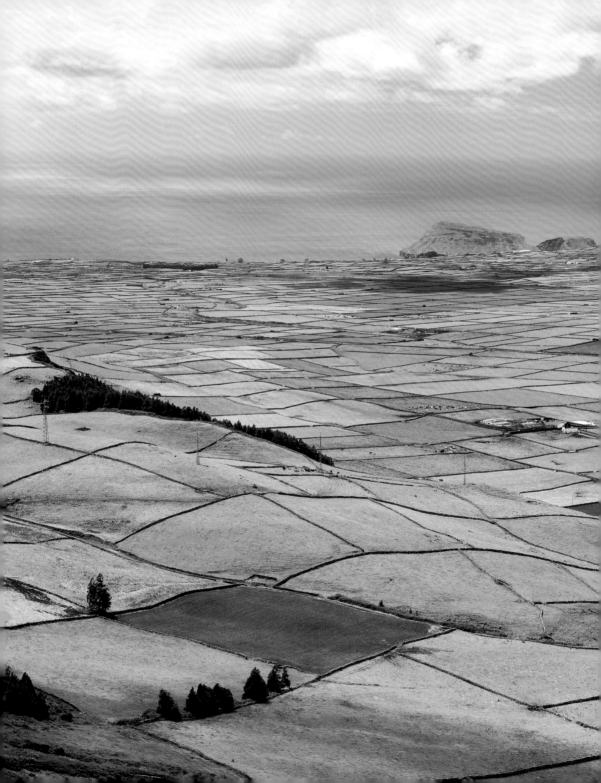

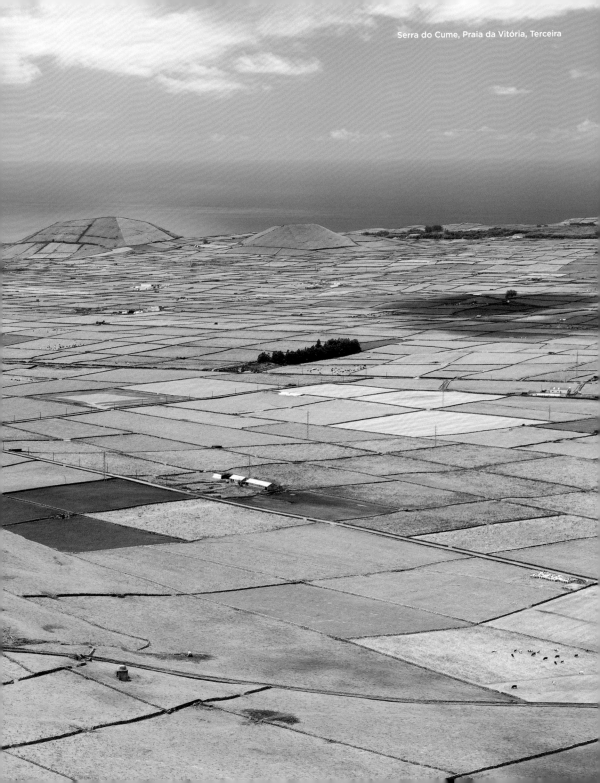

Serra do Cume, Praia da Vitória, Terceira

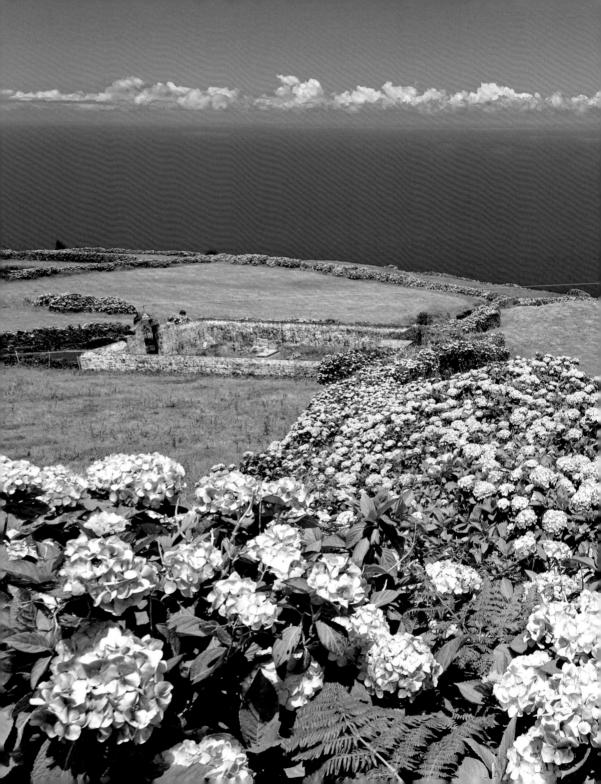

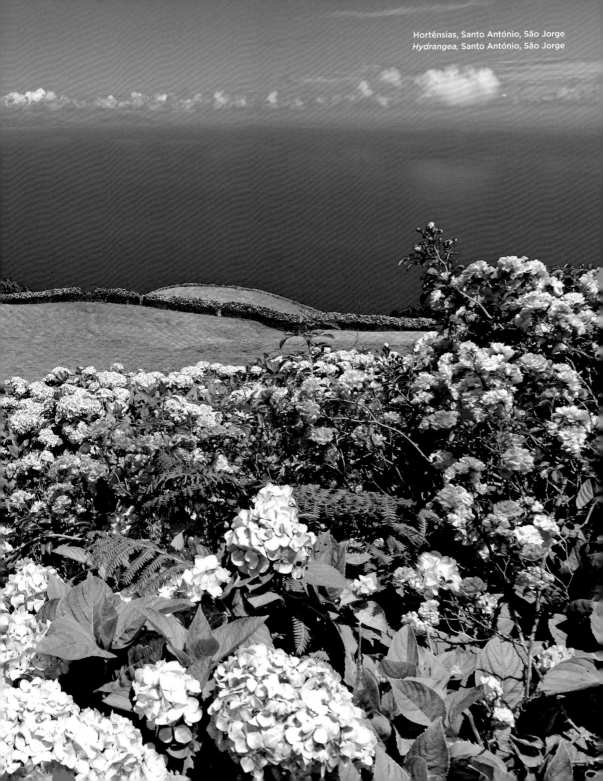

Hortênsias, Santo António, São Jorge
Hydrangea, Santo António, São Jorge

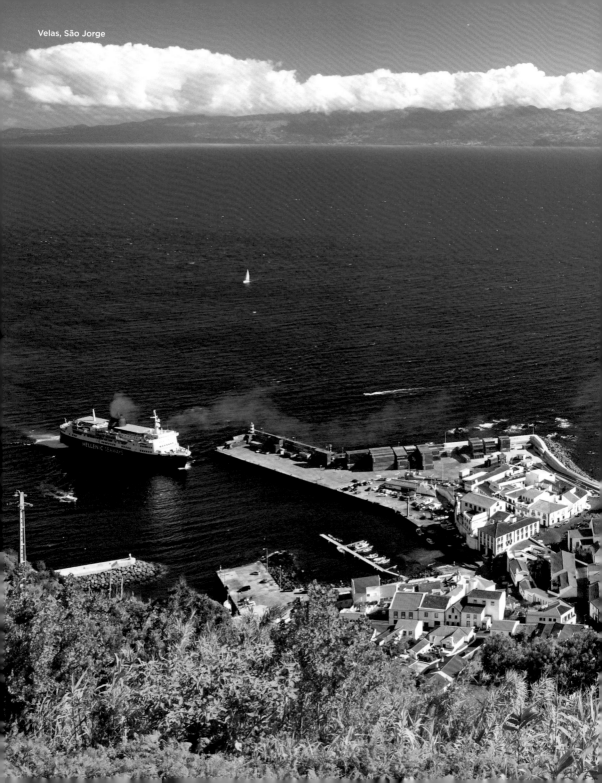
Velas, São Jorge

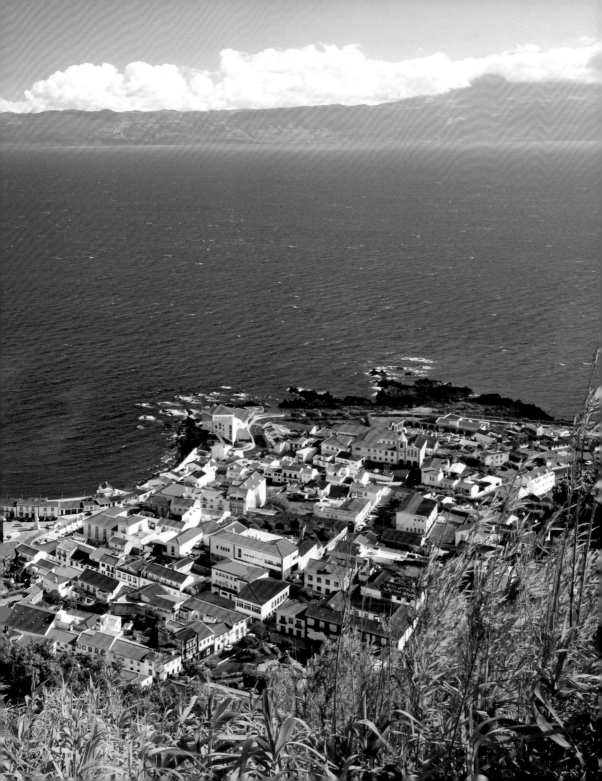

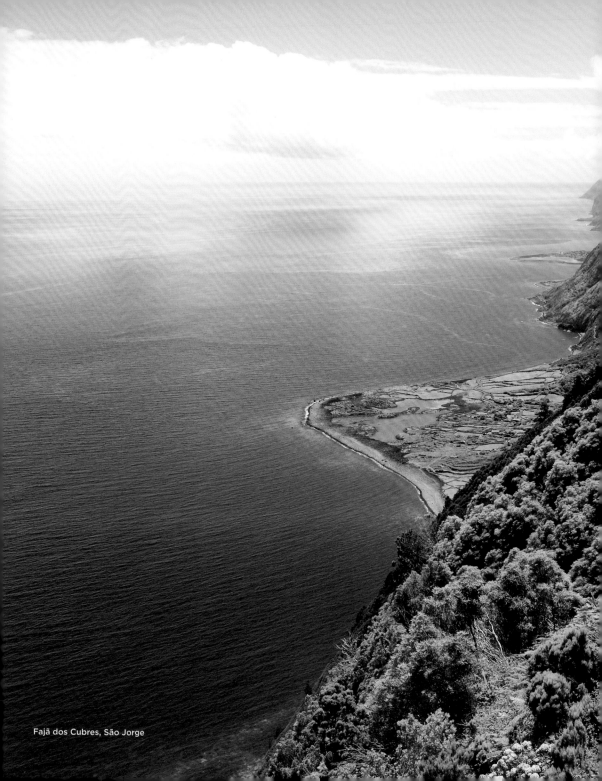

Fajã dos Cubres, São Jorge

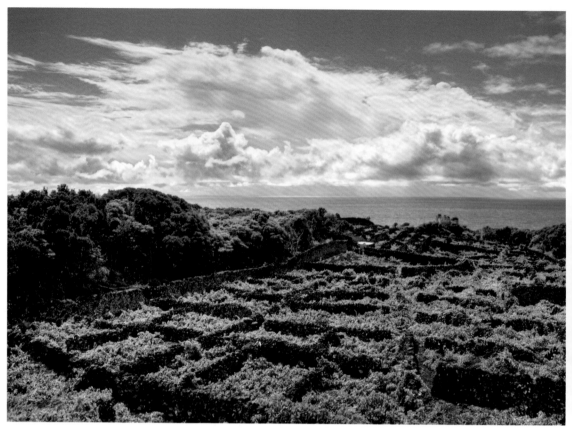

Pico

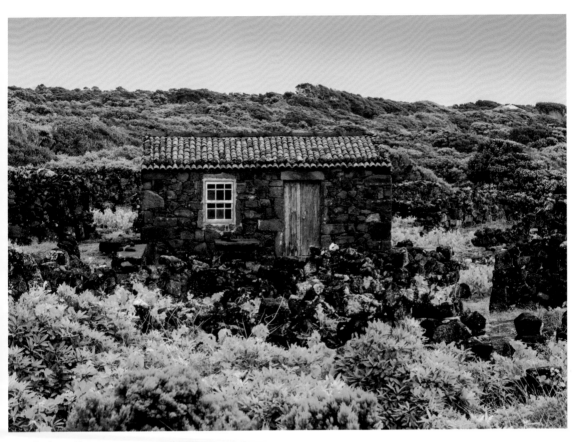

Porto Cachorro, Pico

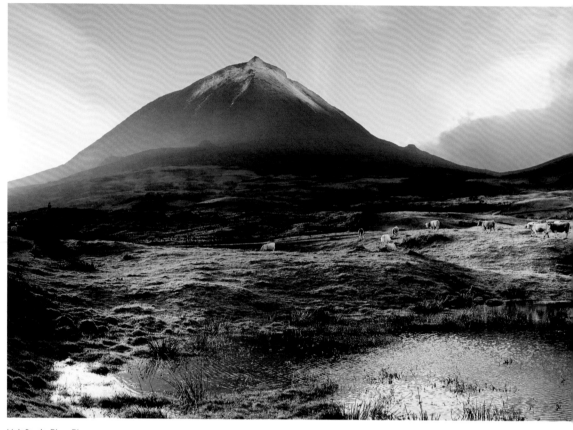

Vulcão do Pico, Pico
Mount Pico, Pico Island

Pico

Intense colours are an outstanding feature
of the archipelago. Be it the rich blue of
the Atlantic, the green of the fields or the
red and purple tones of the floral world.
On Pico Island, the colour palette is often
complemented by white, as the top of
Mount Pico, at 2351 metres, is high enough
for snow and ice.

Pico

Les couleurs intenses sont une
caractéristique exceptionnelle de l'archipel,
qu'il s'agisse du bleu riche de l'Atlantique,
du vert des champs ou des tons rouges et
violets de la flore. Sur Ilha do Pico, le blanc
vient souvent compléter cette palette
de couleurs, car le sommet de Ponta do
Pico (2 351 mètres) est assez haut pour se
recouvrir de neige et de glace.

Pico

Intensive Farben sind eine hervorstechende
Eigenschaft des Archipels. Sei es das satte
Blau des Atlantiks, das Grün der Felder
oder die Rot- und Lilatöne der Blumenwelt.
Auf der Ilha do Pico wird die Farbpalette
nicht selten von Weiß ergänzt, denn der
Gipfel des Ponta do Pico ist mit 2351
Metern hoch genug für Schnee und Eis.

Pico

Los colores intensos son una característica destacada del archipiélago. Ya sea el azul intenso del Atlántico, el verde de los campos o los tonos rojos y morados del mundo floral. En la Ilha do Pico, la paleta de colores se complementa a menudo con el blanco, ya que la cima de la Ponta do Pico tiene 2351 metros de altura, suficiente para la nieve y el hielo.

Pico

L'arcipelago è caratterizzato da colori intensi. Che si tratti del ricco blu dell'Atlantico, del verde dei campi o dei toni del rosso e del viola dei fiori. Su Ilha do Pico, al resto dei colori si aggiunge spesso il bianco, dato che la cima di Ponta do Pico è alta 2351 metri, abbastanza per la neve e il ghiaccio.

Ilha do Pico

Intensieve kleuren zijn een opvallend kenmerk van de archipel. Of het nu gaat om het verzadigde blauw van de Atlantische Oceaan, het groen van de velden of de rode en paarse tinten van de bloemen. Op het Ilha do Pico wordt het kleurenpalet vaak aangevuld met wit, omdat de top van de Ponta do Pico met 2351 meter hoog genoeg is voor sneeuw en ijs.

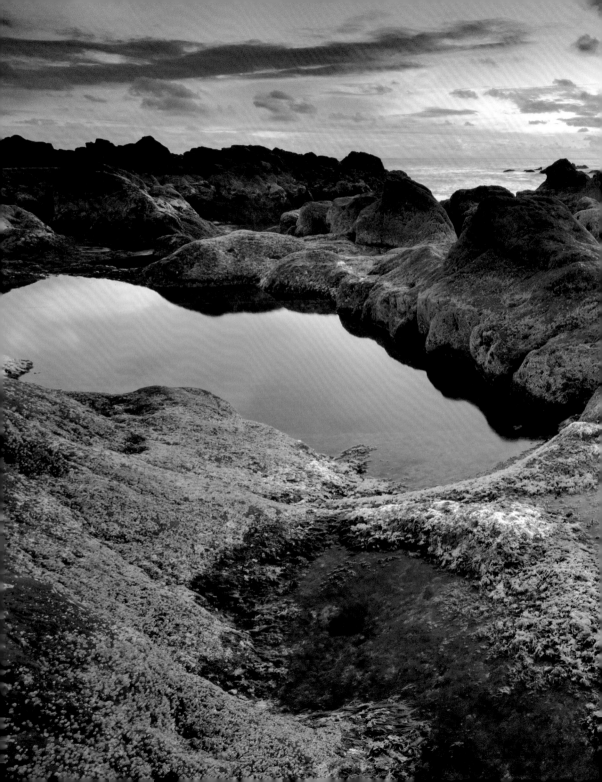

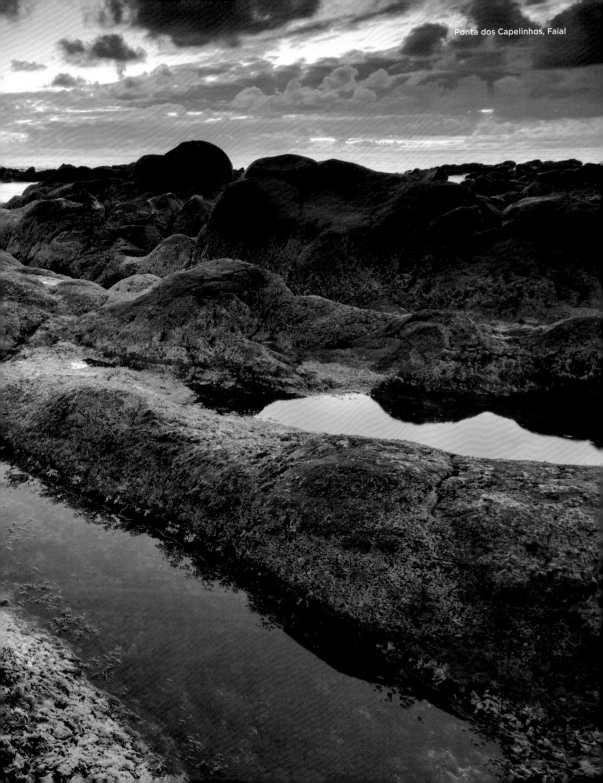

Ponta dos Capelinhos, Faial

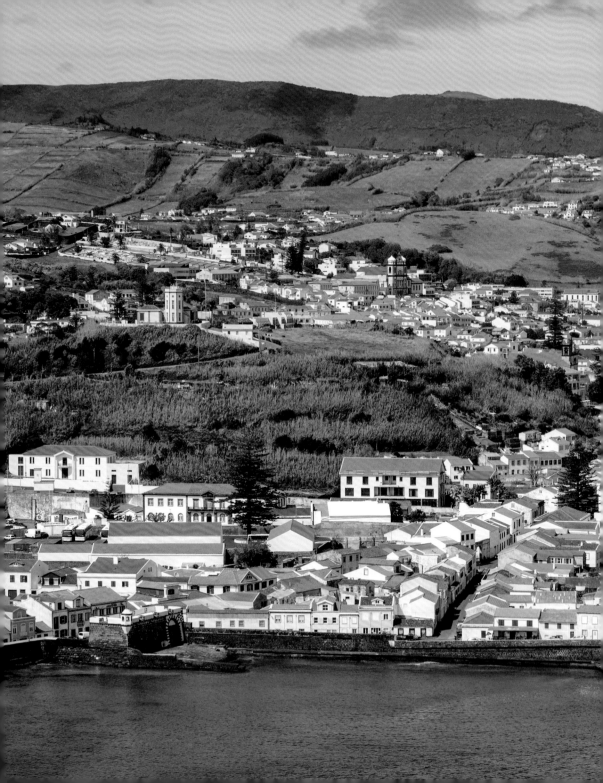

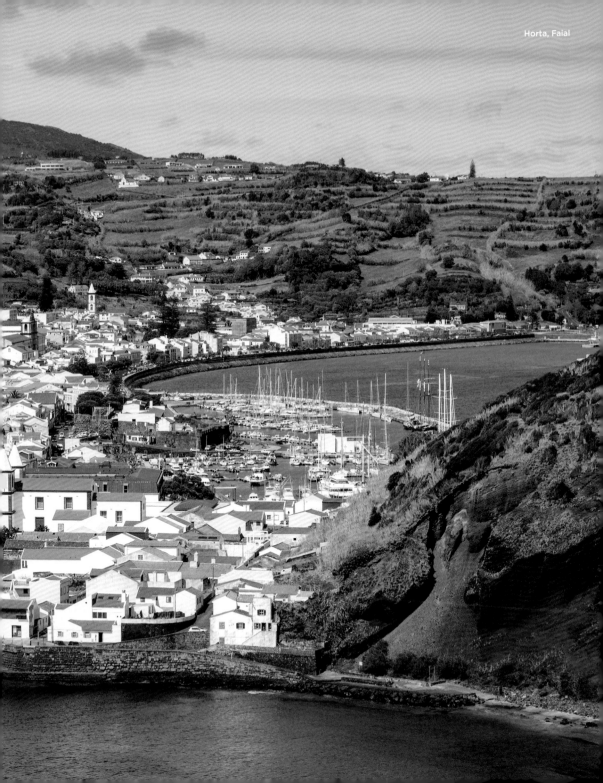
Horta, Faial

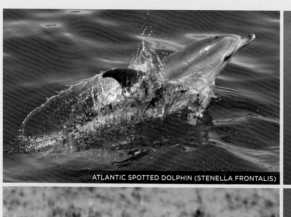

ATLANTIC SPOTTED DOLPHIN (STENELLA FRONTALIS)

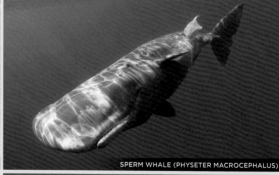

SPERM WHALE (PHYSETER MACROCEPHALUS)

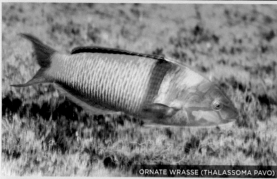

ORNATE WRASSE (THALASSOMA PAVO)

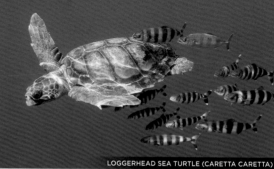

LOGGERHEAD SEA TURTLE (CARETTA CARETTA)

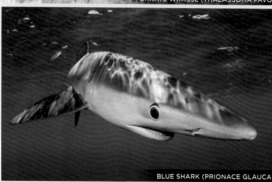

BLUE SHARK (PRIONACE GLAUCA)

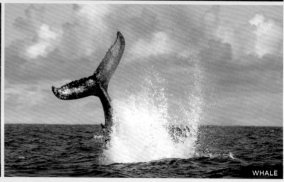

WHALE

Under water

Although there is plenty for the visitor to see in the Azores without getting one's feet wet, those who take the plunge on a diving expedition are in for a treat. The waters around the archipelago teem with diversity and are populated by, amongst others, whale sharks, manta rays and sperm whales—a blue paradise.

Sous l'eau

Même sans se mouiller les pieds, les visiteurs des Açores peuvent apercevoir beaucoup de choses ; mais ceux qui osent plonger sont récompensés par des paysages sous-marins d'une grande diversité : les eaux autour de l'archipel sont peuplées de requins-baleines, de raies manta et de cachalots – un paradis bleu.

Unter Wasser

Auch ohne nasse Füße bekommen Besucher auf den Azoren wahrlich genug zu sehen. Doch wer einen Tauchgang wagt, wird mit dem Anblick einer großen Diversität belohnt: Die Gewässer rund um das Archipel werden unter anderem von Walhaien, Mantarochen und Pottwalen bevölkert – ein blaues Paradies.

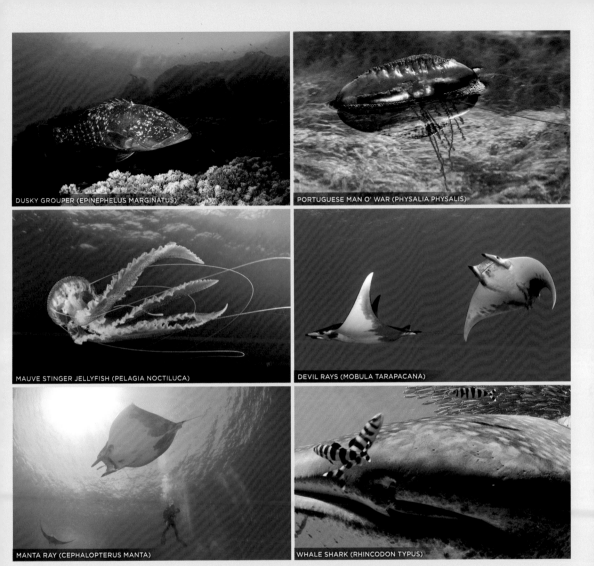

DUSKY GROUPER (EPINEPHELUS MARGINATUS)

PORTUGUESE MAN O' WAR (PHYSALIA PHYSALIS)

MAUVE STINGER JELLYFISH (PELAGIA NOCTILUCA)

DEVIL RAYS (MOBULA TARAPACANA)

MANTA RAY (CEPHALOPTERUS MANTA)

WHALE SHARK (RHINCODON TYPUS)

Bajo el agua

Incluso sin necesidad de mojarse los pies, los visitantes de las Azores pueden ver suficiente. Pero aquellos que se atrevan a bucear, serán recompensados con un fondo marino de lo más diverso: las aguas alrededor del archipiélago están pobladas por tiburones ballena, mantarrayas y cachalotes: es el paraíso azul.

Sott'acqua

Anche senza bagnarsi i piedi, i turisti delle Azzorre hanno abbastanza da vedere. Ma chi osa un tuffo viene premiato con la vista di una grande diversità: Le acque intorno all'arcipelago sono popolate da squali balena, mante e capodogli – un paradiso blu.

Onder water

Ook zonder natte voeten krijgen bezoekers van de Azoren genoeg te zien. Maar wie een duik aandurft, wordt rijkelijk beloond met de aanblik van een grote diversiteit. De wateren rond de archipel worden bevolkt door walvishaaien, reuzenmanta's en potvissen – een blauw paradijs.

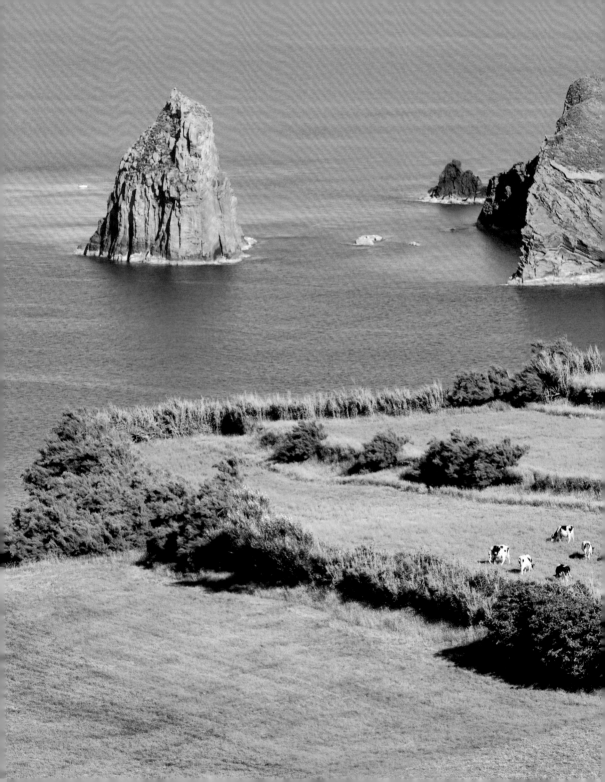

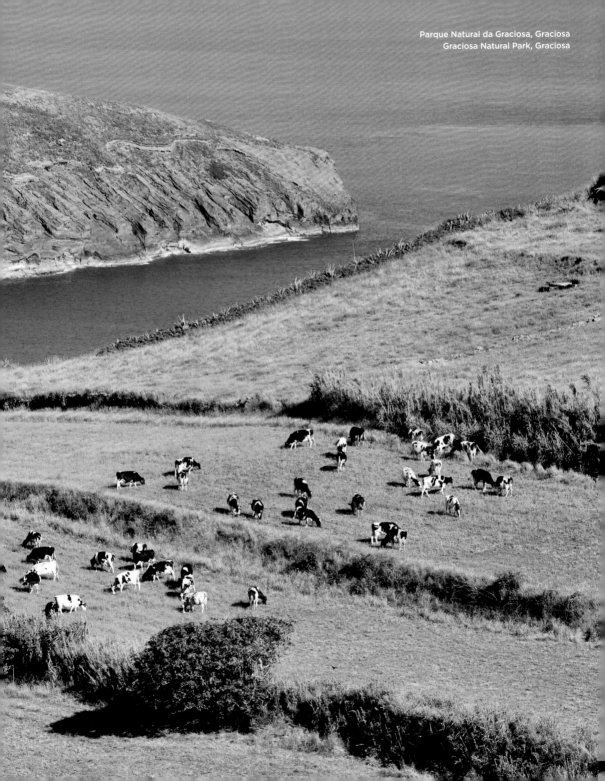

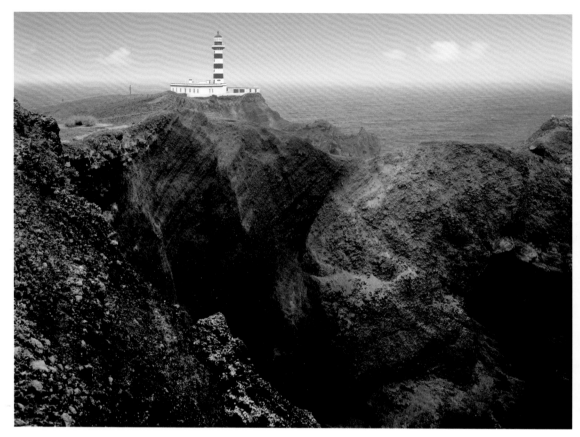

Ponta da Barca, Graciosa

Graciosa

Thanks to steeply rising cliffs on the northernmost island of Graciosa, the meteorological term 'Azores High' seems to take on a whole new meaning. The Furna do Enxofre lava cave shows, however, that it can also go down deep: 183 steps lead down a spiral staircase. Those who negotiate this way are welcomed by a less than pleasant smell of sulphur.

Graciosa

Avec les falaises abruptes de Graciosa, son île la plus septentrionale, l'archipel des Açores dévoile une nouvelle facette de ses paysages. La grotte de Furna do Enxofre est l'occasion d'en découvrir également les profondeurs, via un escalier en colimaçon de 183 marches. Ceux qui empruntent ce chemin sont accueillis par une odeur de soufre un peu moins agréable.

Graciosa

Dank steil aufragender Klippen scheint der Begriff „Azorenhoch" auf der nördlichsten Insel Graciosa eine ganz neue Bedeutung zu bekommen. Die Höhle Furna do Enxofre beweist indes, dass es auch tief hinab gehen kann: 183 Stufen führen eine Wendeltreppe hinab. Wer den Weg in Kauf nimmt, wird von einem wenig angenehmen Schwefelgeruch begrüßt.

Furna do Enxofre, Parque Natural da Graciosa, Graciosa
Furna do Enxofre, Graciosa Natural Park, Graciosa

Graciosa

Gracias a la empinada subida de los acantilados, el término anticiclón de las Azores de la isla más septentrional de Graciosa parece adquirir un significado totalmente nuevo. No obstante, la cueva Furna do Enxofre demuestra que también se puede ir había abajo hasta alcanzar una gran profundidad: 183 escalones una escalera de caracol. A aquellos que acepten el reto les dará la bienvenida un olor a azufre no muy agradable.

Graciosa

Grazie alle ripide pareti rocciose, il termine "Alta delle Azzorre" sull'isola più settentrionale di Graciosa sembra assumere un significato del tutto nuovo. La grotta Furna do Enxofre dimostra però di poter scendere anche in profondità: 183 gradini scendono per una scala a chiocciola. Per chi vi si addentra, viene accolto da un odore di zolfo poco piacevole.

Graciosa

Dankzij de steil omhoogstekende kliffen lijkt de term 'Azorenhoog' op het noordelijkste eiland Graciosa een heel nieuwe betekenis te krijgen. De grot Furna do Enxofre bewijst echter dat het ook diep naar beneden kan gaan: 183 treden leiden via een wenteltrap omlaag. Wie de tocht aandurft, wordt begroet door een weinig aangename zwavelgeur.

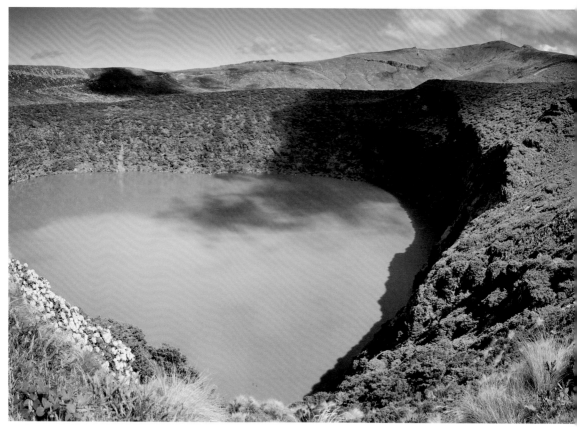

Caldeira Comprida e Caldeira Funda, Flores

Flores

The fourth smallest island of the Azores
owes its name to its unique variety of
plants: an incredible splendour of flowers
covers the volcanic island all the way to the
rugged rocky coast. The spectacular crater
lakes of Calderia Comprida and Calderia
Funda are only two of the seven volcanoes.

Flores

La quatrième plus petite île des Açores
doit son nom aux fleurs splendides – dont
une variété unique – qui recouvrent ses
terres jusqu'à sa côte rocheuse escarpée.
Flores compte sept volcans, parmi lesquels
les spectaculaires Calderia Comprida et
Calderia Funda, célèbres pour leurs lacs
de cratère.

Flores

Die viertkleinste Insel der Azoren
verdankt ihren Namen ihrer einzigartigen
Pflanzenvielfalt: eine unglaubliche
Blumenpracht überzieht die Vulkaninsel
bis hin zur der schroffen Felsküste.
Die spektakulären Kraterseen Calderia
Comprida und Calderia Funda sind nur
zwei der insgesamt sieben Vulkane.

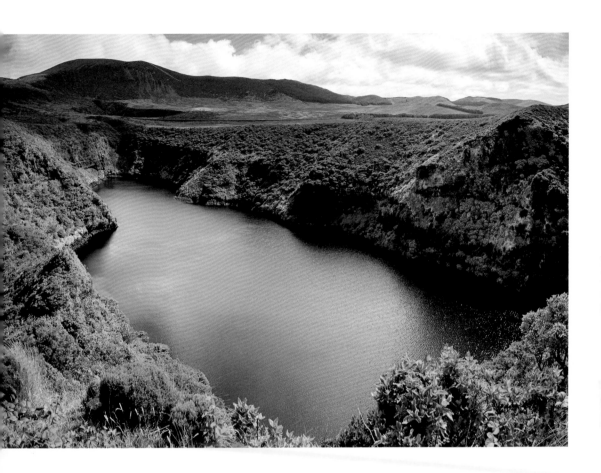

Flores

La cuarta isla más pequeña de las Azores debe su nombre a su variedad única de plantas: un increíble esplendor de flores cubre la isla volcánica hasta la escarpada costa rocosa. Los espectaculares lagos del cráter Calderia Comprida y Calderia Funda son sólo dos de los siete volcanes que hay en total.

Flores

La quarta isola più piccola delle Azzorre deve il suo nome alla sua varietà unica di piante: un incredibile splendore di fiori ricopre l'isola vulcanica fino all'aspra costa rocciosa. Gli spettacolari laghi cratere Calderia Comprida e Calderia Funda sono solo due dei sette vulcani.

Flores

Het vierde kleinste eiland van de Azoren dankt zijn naam aan de unieke variëteit aan planten: een ongelooflijke pracht van bloemen bedekt het vulkanische eiland tot aan de ruige rotskust. De spectaculaire kratermeren Calderia Comprida en Calderia Funda zijn slechts twee van de zeven vulkanen.

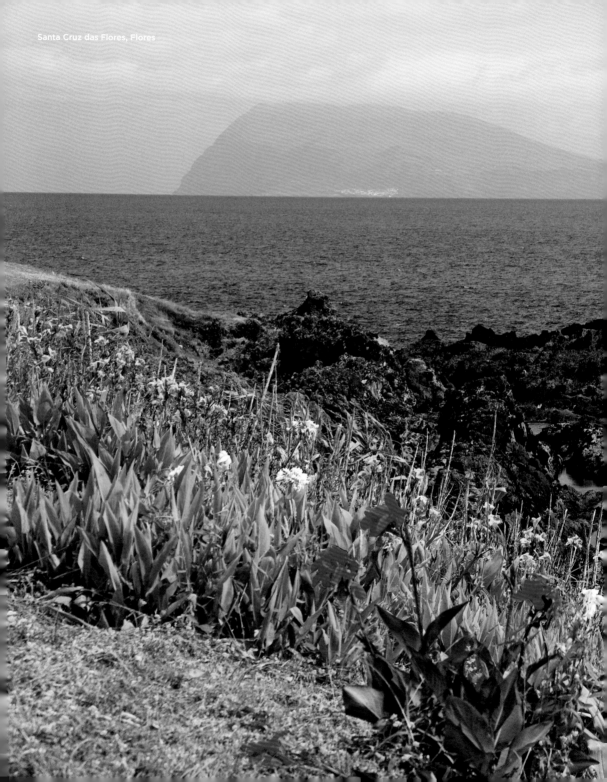

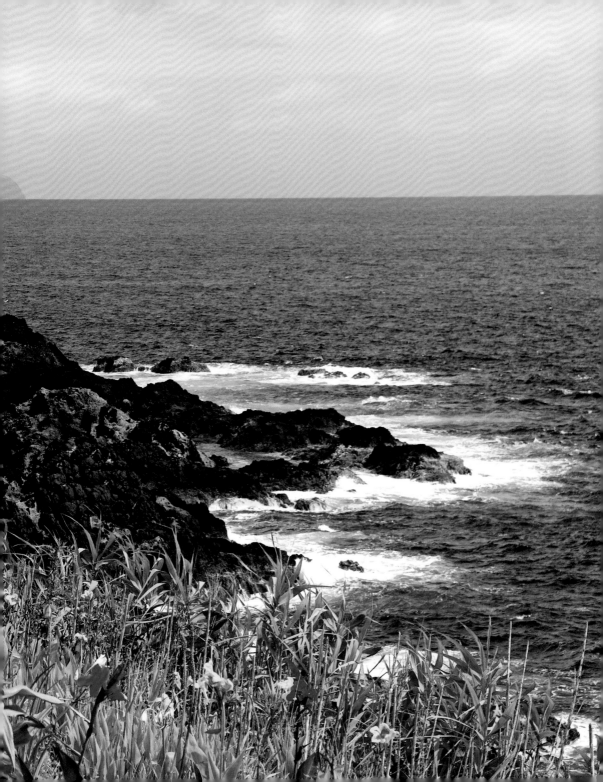

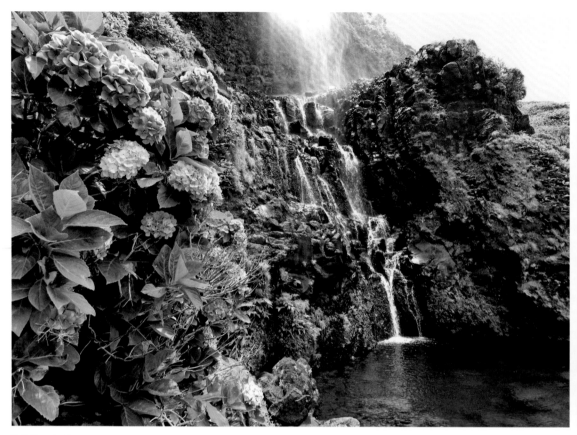

Fajã Grande, Flores

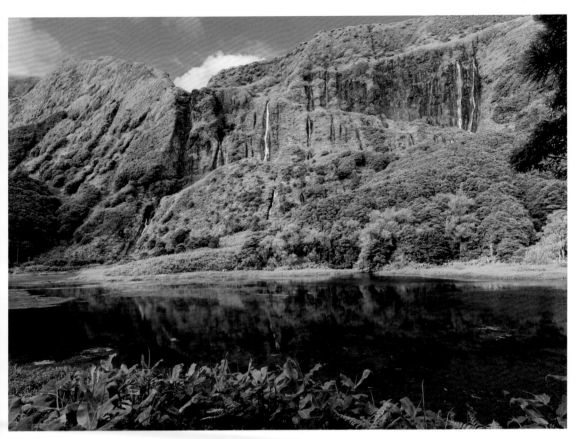

Fajãzinha, Flores

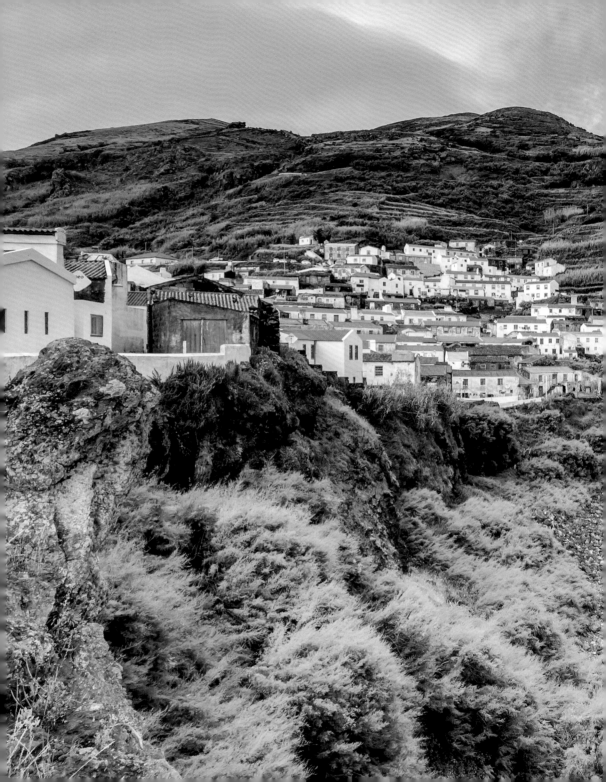

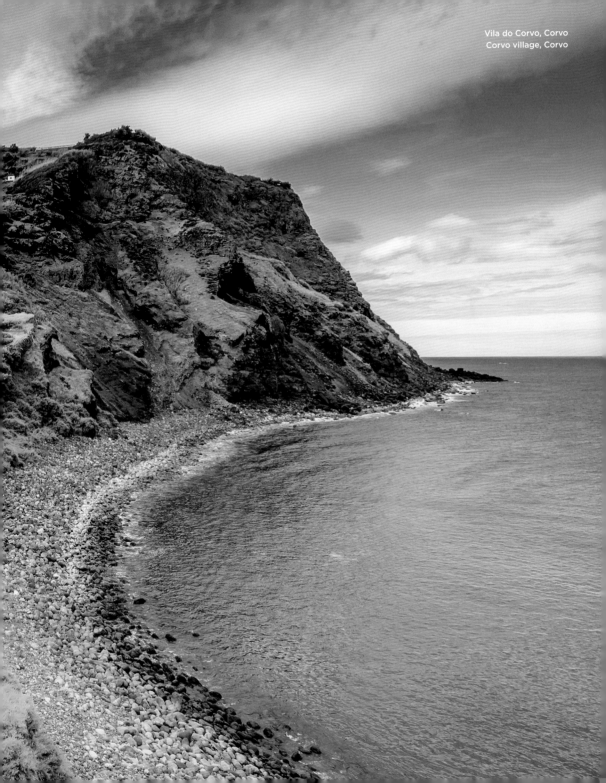

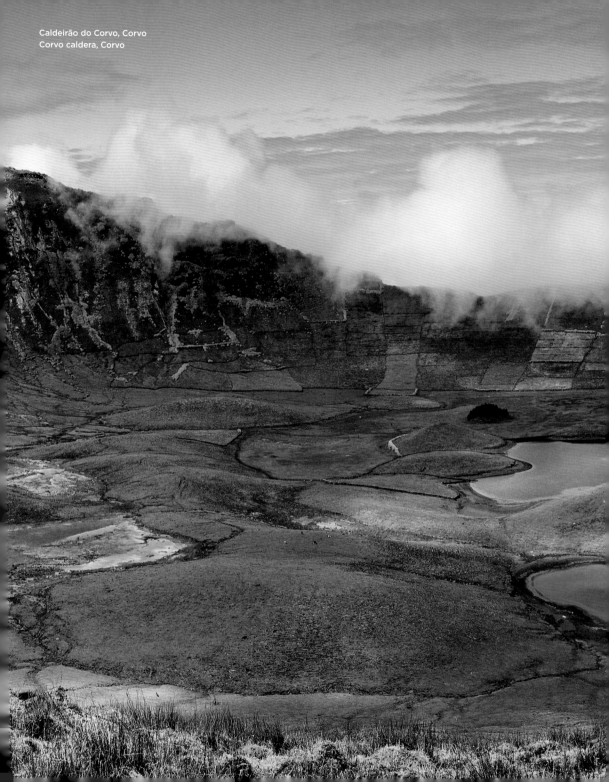

Caldeirão do Corvo, Corvo
Corvo caldera, Corvo

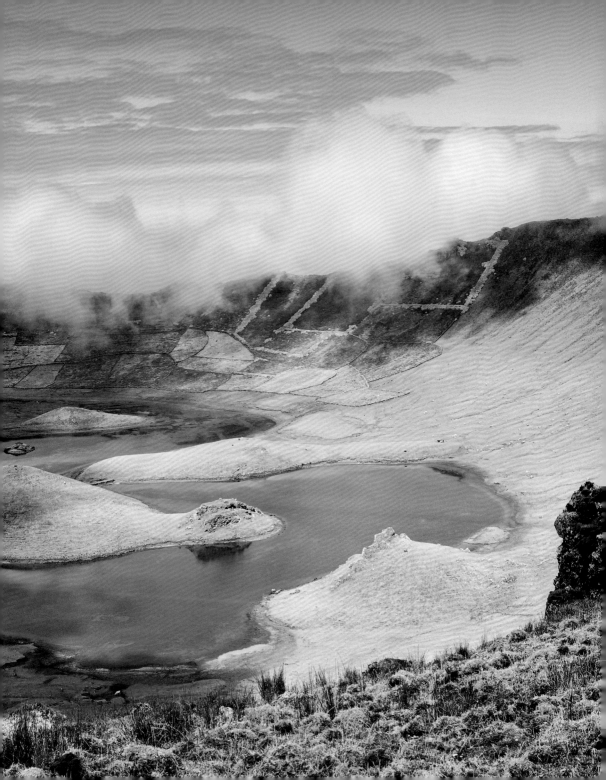

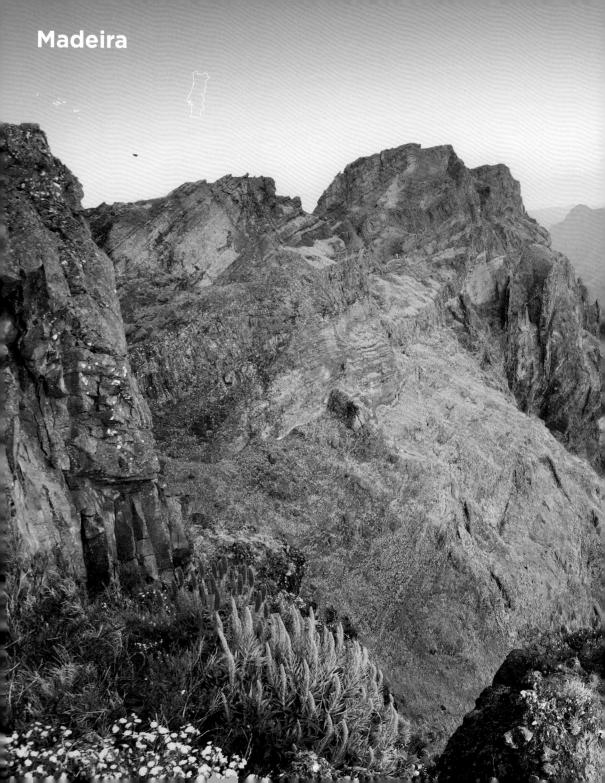

Madeira

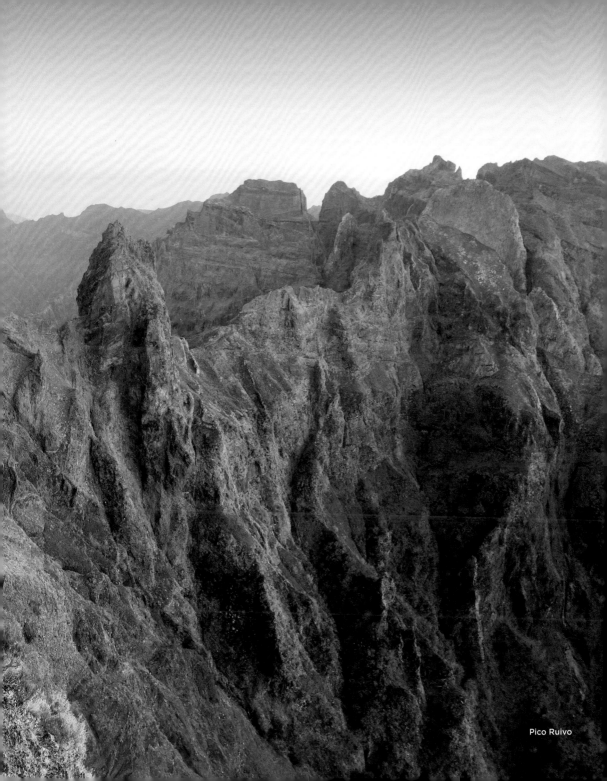

Pico Ruivo

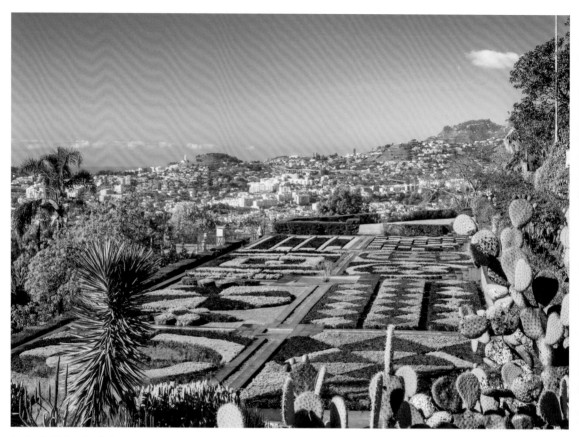

Jardim Botânico, Funchal
Madeira Botanical Garden, Funchal

Madeira

Madeira is widely known as the Flower Island. Whether in adventurous mountain locations, on artistic terraces, or in a premium position with a view of the ocean—everywhere, extravagant looking plants such as the deep red *Aloe arborescens* thrive. Thanks to its location, the island can also be considered exotic: it stands a proud 951 kilometres from Lisbon.

Madère

Madère est largement connue sous le nom d'île aux fleurs. Dans les montagnes escarpées, sur les terrasses ou dans les endroits privilégiés avec vue sur l'océan, partout s'épanouissent des plantes extravagantes comme l'*Aloe arborescens* rouge profond. De par sa situation géographique, l'île peut également être considérée comme un lieu exotique : elle se trouve à 951 kilomètres de Lisbonne.

Madeira

Madeira ist weithin als Blumeninsel bekannt. Ob in abenteuerlicher Berglage, auf kunstvoll angelegten Terrassen oder in Premiumlage mit Blick auf den Ozean – überall gedeihen extravagant anmutende Pflanzen wie die tiefrote *Aloe arborescens*. Das Eiland darf auch dank seiner Lage als exotisch gelten: bis nach Lissabon sind es stolze 951 Kilometer.

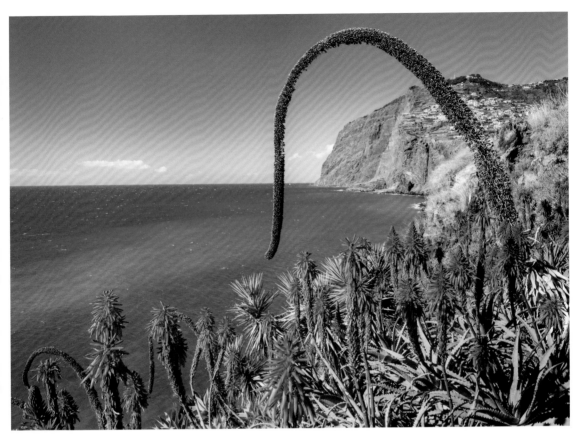

Cabo Girão

Madeira

Madeira es ampliamente conocida como la Isla de las Flores. Ya sea en lugares de montaña aventureros, en terrazas artísticas o en una ubicación privilegiada con vistas al océano, en todas partes prosperan plantas de aspecto extravagante, como el *Aloe arborescens* de color rojo intenso. Gracias a su ubicación, la isla también puede considerarse exótica: se encuentra a 951 kilómetros de Lisboa.

Madeira

Madeira es ampliamente conocida como la Isla de las Flores. Ya sea en lugares de montaña aventureros, en terrazas artísticas o en una ubicación privilegiada con vistas al océano, en todas partes prosperan plantas de aspecto extravagante, como el Aloe arborescens de color rojo intenso. Gracias a su ubicación, la isla también puede considerarse exótica: se encuentra a 951 kilómetros de Lisboa.

Madeira

Madeira is algemeen bekend als 'bloemeneiland'. Of het nu op avontuurlijke berglocaties is, op artistiek aangelegde terrassen of op een toplocatie met uitzicht op de oceaan – overal gedijen extravagant uitziende planten zoals de dieprode *Aloë Arborescens*. Ook door zijn ligging kan het eiland als exotisch worden beschouwd: de afstand tot Lissabon is een ferme 951 kilometer.

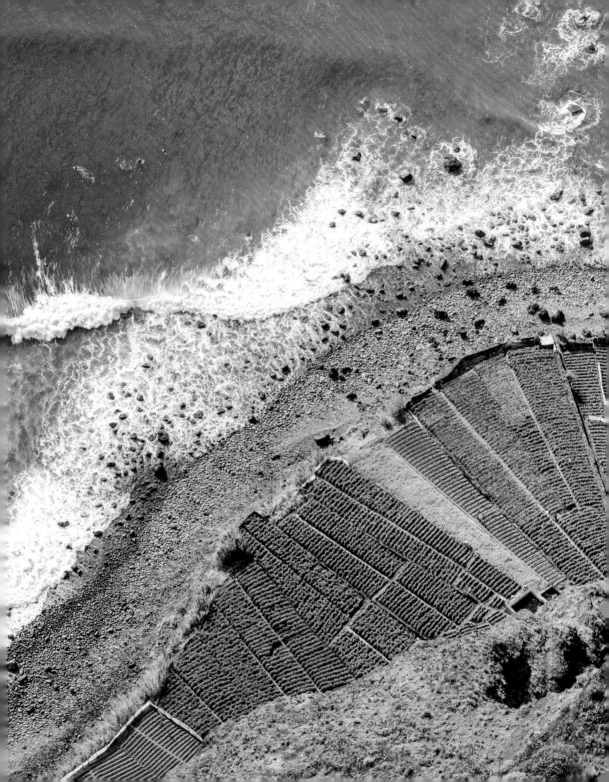

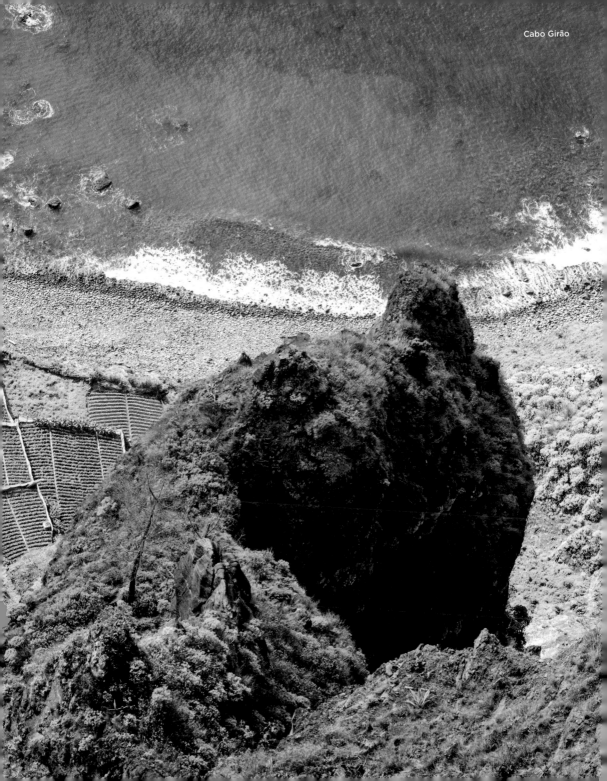

Vinho da Madeira
Madeira wine

Madeira (wine)

Viniculture is not an easy thing on this mountainous island. Nevertheless, the island, which only measures a maximum of 22 by 57 kilometres, is home to an unmistakable tipple: Madeira wine has a liqueur-like character because, like port, it is sprinkled with brandy. This trick also makes the Madeira very durable for long periods of time.

Madère (vin)

La viticulture n'est pas une activité aisée sur cette île montagneuse. Néanmoins, Madère, qui mesure un maximum de 22 sur 57 kilomètres, a développé une technique bien particulière : le vin de Madère a en effet un caractère liquoreux car, comme le porto, il est enrichi d'eau-de-vie. Grâce à cette astuce, il se conserve très bien.

Madeira (Wein)

Der Weinbau ist auf der bergigen Insel keine einfache Sache. Dennoch ist das maximal 22 mal 57 Kilometer große Eiland die Heimat eines unverwechselbaren Tropfens: der Madeira-Wein hat einen likörhaften Charakter, weil er ebenso wie der Port mit Branntwein aufgespritet wird. Durch diesen Kunstgriff ist der Madeira zudem sehr lange haltbar.

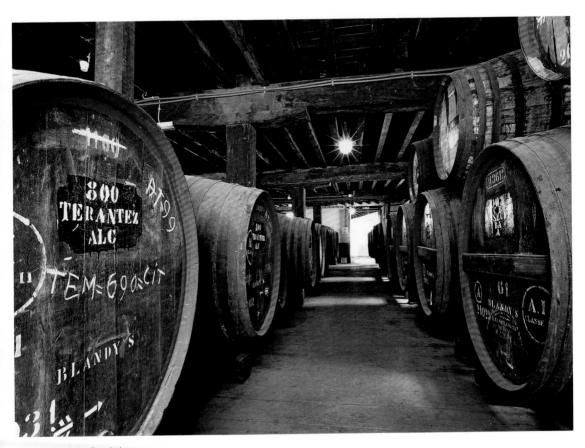

Vinho da Madeira, Funchal
Madeira wine, Funchal

Madeira (vino)

La viticultura no es algo fácil en la isla montañosa. Sin embargo, la isla, con un tamaño máximo de 22 por 57 kilómetros, alberga una inconfundible caída: el vino de Madeira tiene un carácter licoroso porque, al igual que el vino de Oporto, tiene un toque de brandy. Este truco también hace que el Madeira dure mucho tiempo.

Madera (vino)

La viticoltura non è una cosa facile sull'isola montuosa. Tuttavia, l'isola, che misura al massimo 22 km per 57 km, è caratterizzata da un nettare inconfondibile: il vino di Madeira ha un carattere liquoroso perché, come il porto, è rinforzato con il brandy. Questo trucco aumenta di molto la conservazione del Madera.

Madera

Op het bergachtige eiland is wijnbouw geen eenvoudige zaak. Het eiland van maximaal 22 x 57 kilometer is echter de geboortegrond van een onmiskenbare drank: madera. Deze wijn heeft een likeurachtig karakter omdat hij net als port wordt verrijkt met brandewijn. Door deze kunstgreep is madera bovendien erg lang houdbaar.

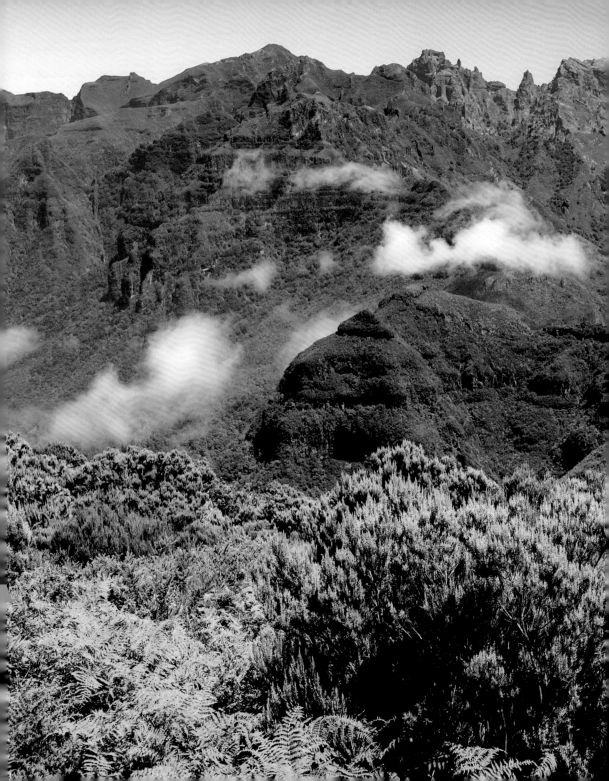

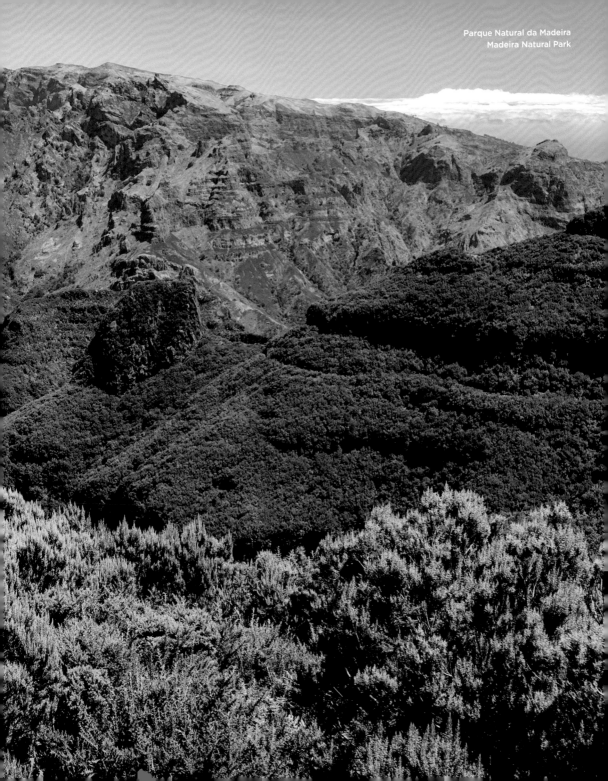

Levada da Serra do Faial, perto Ribeiro Frio
Levada da Serra do Faial, near Riberio Frio

Laurisilva, or laurel forest

In places where Madeira is not in floral bloom, the island shows its enchanted sides. The laurel forest, Laurisilva, occupies an impressive 20 percent of the island's surface, with the trees being overgrown with ferns and mosses due to the lush foggy rainfall. All of this results in a wonderful hiking area, sometimes with some unexpected shelter.

Forêt de laurier de Laurisilva

Au-delà de ses moments de floraison, l'île présente également d'autres aspects enchanteurs. La forêt de laurier de Laurisilva occupe ainsi 20 % de la surface de l'île, et les arbres sont envahis de fougères et de mousses en raison des précipitations brumeuses et luxuriantes. L'endroit offre un abri inattendu, ainsi que de nombreuses opportunités de randonnées.

Lorbeerwald Laurisilva

Wo Madeira nicht in voller Blüte steht, zeigt die Insel ihre verwunschenen Seiten. Der Lorbeerwald Laurisilva nimmt stolze 20 Prozent der Inseloberfläche ein, aufgrund der üppigen Nebelniederschläge sind die Bäume mit Farnen und Moosen bewachsen. Dies alles ergibt ein herrliches Wanderrevier mit manch unverhofftem Unterschlupf.

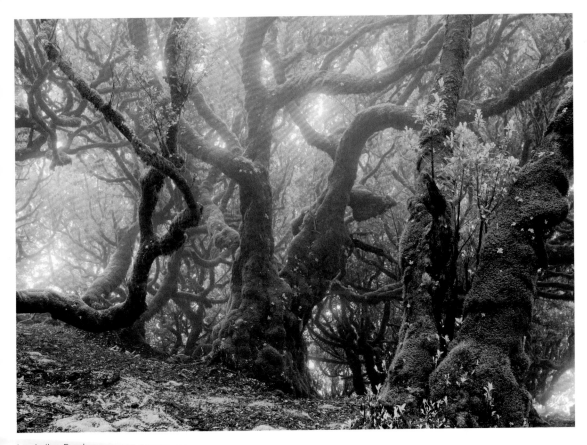

Laurissilva, Fanal
Laurel forest, Fanal

Bosque de Laurisilva

Donde Madeira no está en plena floración, la isla muestra sus lados encantados. El bosque de Laurisilva ocupa un impresionante 20 por ciento de la superficie de la isla, y los árboles están cubiertos de helechos y musgos debido a las exuberantes lluvias nebulosas. Todo esto da como resultado una maravillosa zona de senderismo con un refugio inesperado.

Foresta Laurisilva

Quando Madeira non è in piena fioritura, l'isola mostra i suoi lati incantati. La foresta di lauri, Laurisilva occupa il 20 % della superficie dell'isola, gli alberi sono ricoperti di felci e muschi grazie alle abbondanti pioggerelle leggere. Tutto questo si traduce in una meravigliosa area escursionistica con rifugi nascosti.

Laurierbos Laurisilva

Daar waar Madeira niet in volle bloei staat, toont het eiland zijn betoverde kanten. Het laurierbos Laurisilva beslaat een indrukwekkende 20 procent van het eilandoppervlak en als gevolg van de overvloedige nevelflarden zijn de bomen overwoekerd met varens en mossen. Dit alles resulteert in een prachtig wandelgebied met onverhoopte schuilplaatsen.

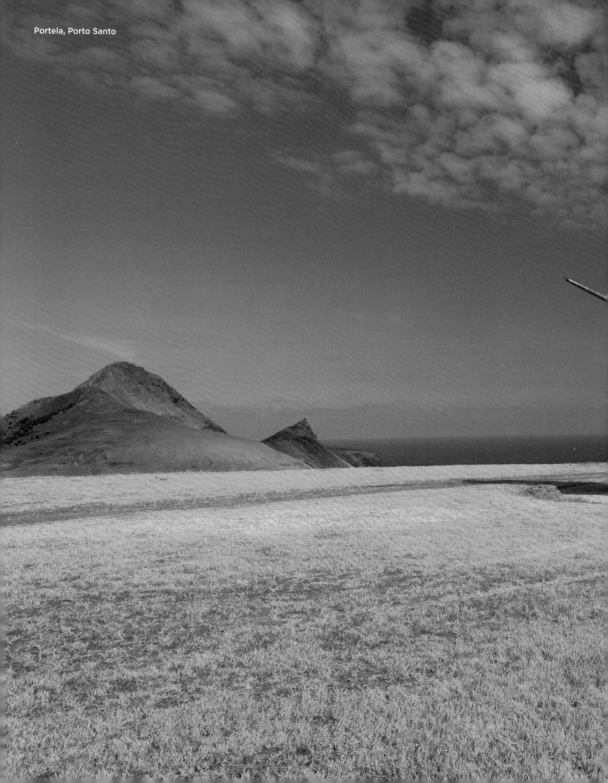

Portela, Porto Santo

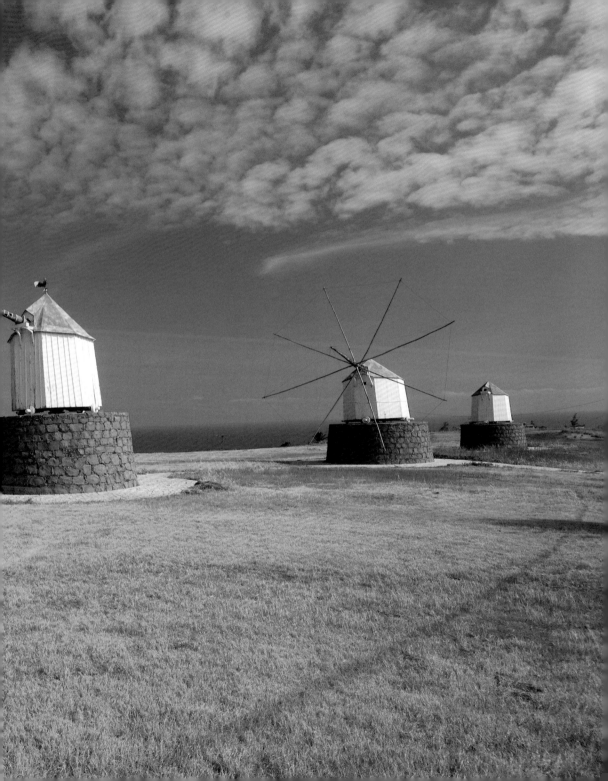

Ilha das Flores
Madeira—"The Flower Island"

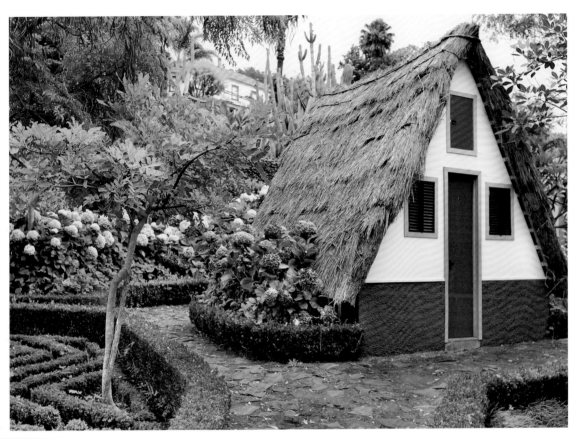

Casa Tradicional, Jardim Botânico, Funchal
Traditional house, Madeira Botanical Garden, Funchal

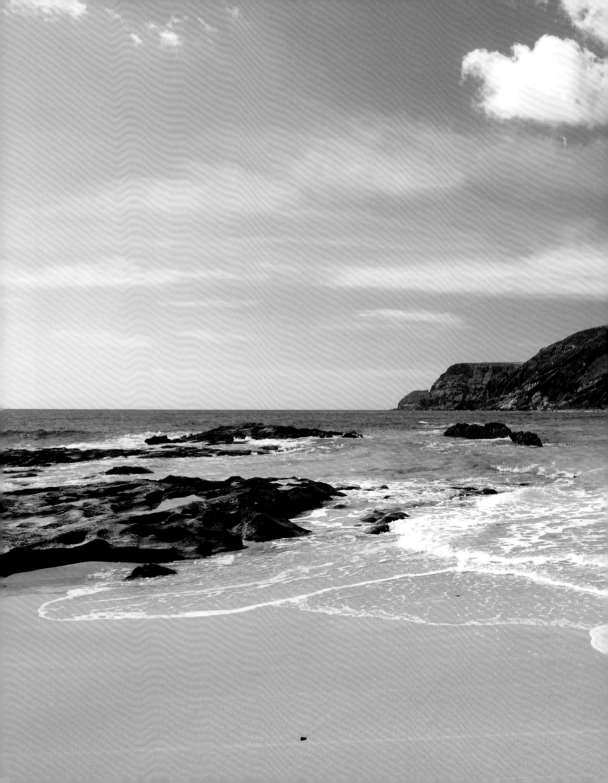

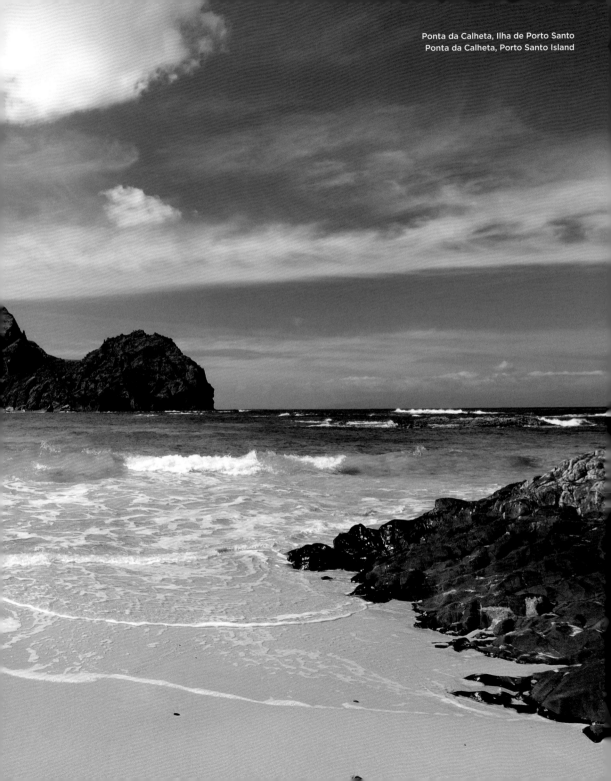

Ponta da Calheta, Ilha de Porto Santo
Ponta da Calheta, Porto Santo Island

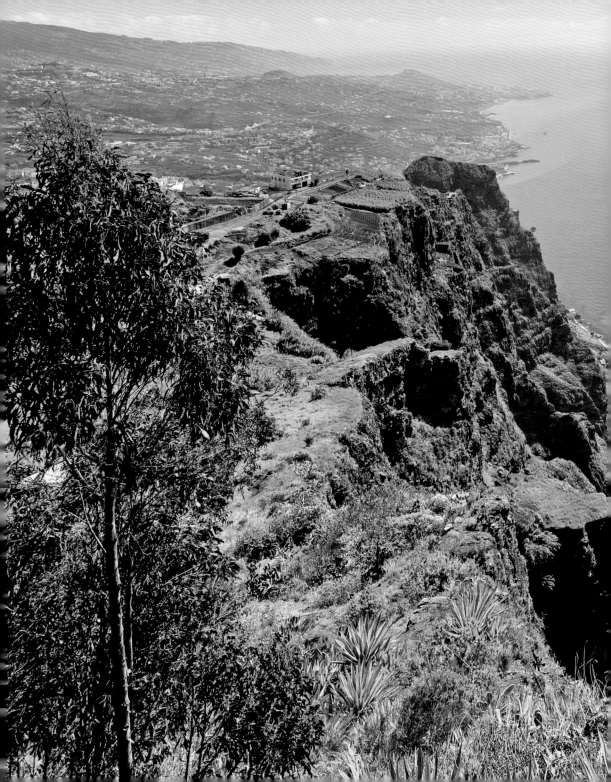

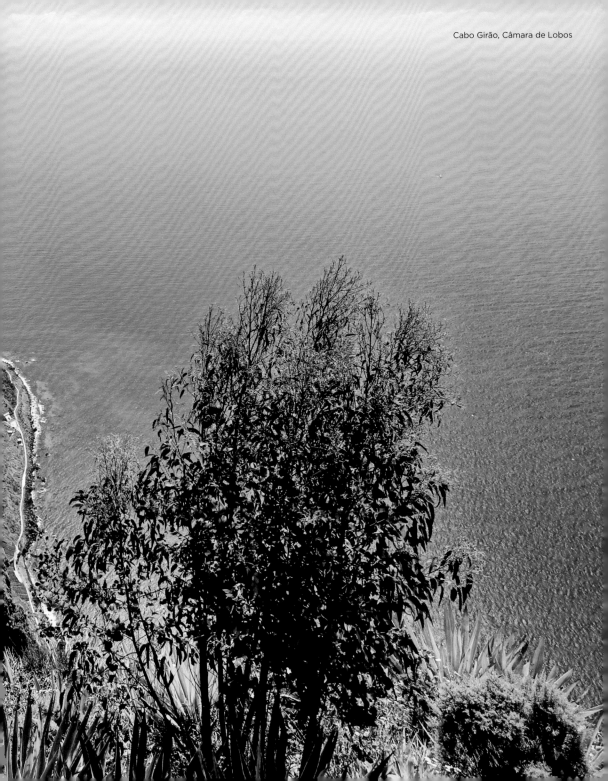

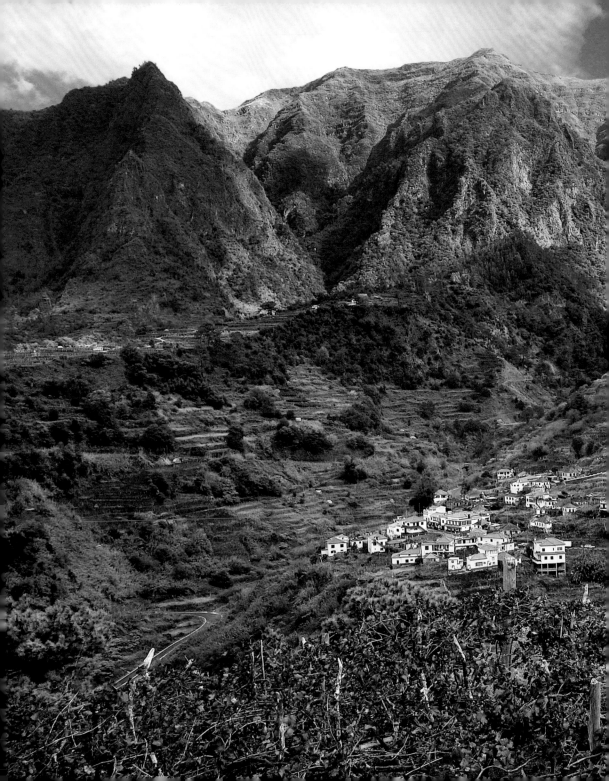

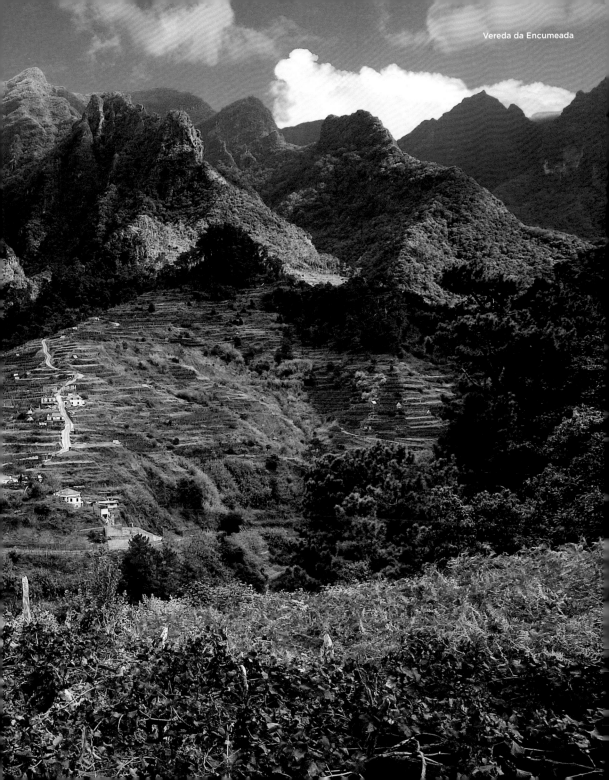
Vereda da Encumeada

Arco de São Jorge, Santana

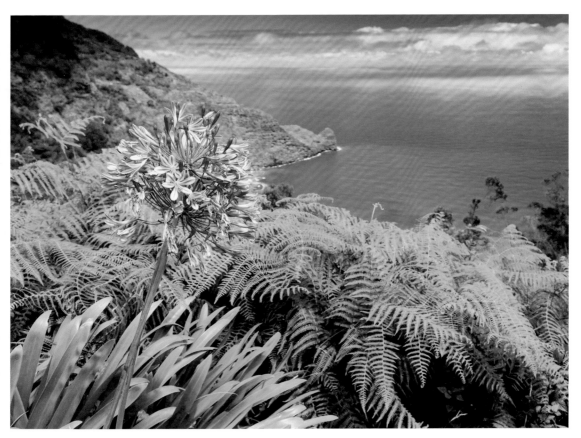

Aagapantos
Agapanthus flower

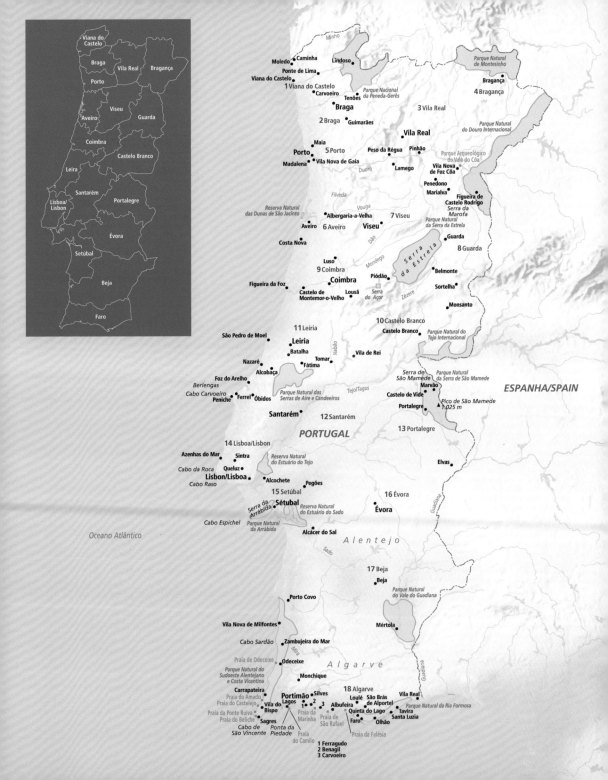

KÖNEMANN
© 2020 koenemann.com GmbH
www.koenemann.com

© Éditions Place des Victoires
6, rue du Mail – 75002 Paris
www.victoires.com
Dépôt légal : 1er trimestre 2020
ISBN: 978-2-8099-1785-7

Series Concept: koenemann.com GmbH

Responsible Editors: Jennifer Wintgens, Jenny Tiesler
Picture Editing: Susanne Mack, Jennifer Wintgens
Art Direction: Oliver Hessmann
Layout: Regine Ermert
Colour Separation: Prepress, Cologne
Text: Ralf Johnen
Translations: koenemann.com GmbH
Maps: Angelika Solibieda
Front Cover: Huber Images / Cornelia Dörr

Printed in China by Shyft Publishing / Hunan Tianwen Xinhua Printing Co., Ltd

ISBN:978-3-7419-2522-1